ART&IDEAS

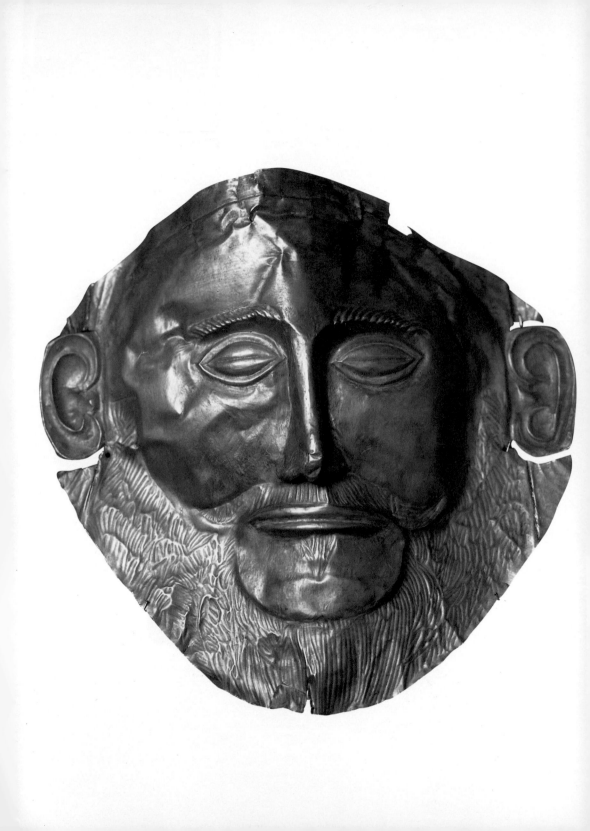

Greek Art

Opposite
Funerary mask
from Shaft
Grave V at
Mycenae,
c.1600 BC.
Gold; h.26 cm,
10³⁄₄ in.
National
Archaeological
Museum,
Athens

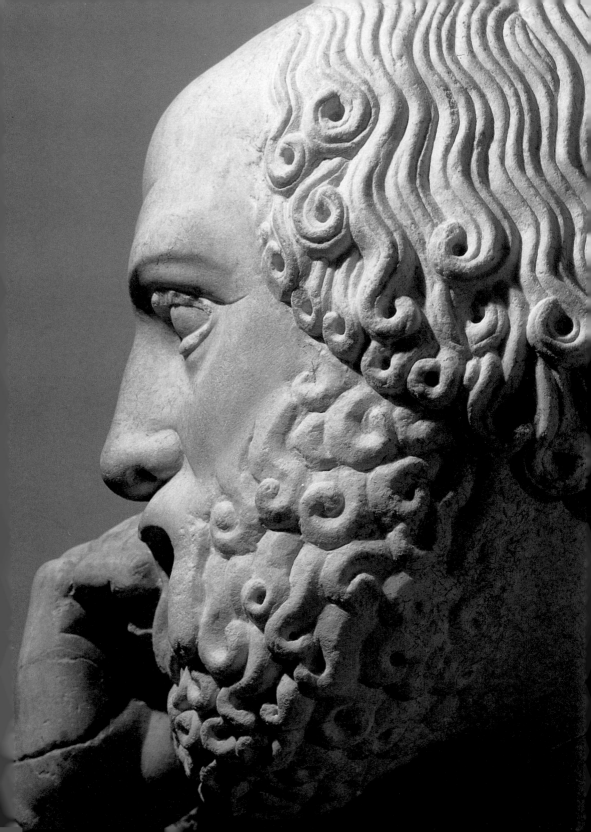

Some Greek artists signed their work, but otherwise we know little of their careers or personalities. However, we can gain some insight into what Greek society expected of them from early literature. In Book XVIII of Homer's *Iliad*, silver-footed Thetis, the mother of Achilles, sets out on a very important mission. She has just witnessed her son's determination to avenge, at Troy, the death of his best friend. Fearing for his safety, Thetis seeks to procure for Achilles a form of protection that will render him superior to any of his Trojan opponents. Her maternal instinct is strengthened by her divine connections. Thetis seeks out no mortal craftsman for this commission, but Hephaistos, technician of the Olympian gods.

1
Head of the
seer from the
east pediment
of the temple
of Zeus at
Olympia,
*c.*460 BC.
Marble;
Archaeological
Museum,
Olympia

She finds Hephaistos at his anvil, labouring away. He is a bulky, lame and asthmatic figure, begrimed and absorbed by his work. But from the heat and chaos of his workshop come wonders. Thetis interrupts him as he is constructing some robotic tripods – wheeled ceremonial bowls that can move back and forth of their own accord. What she requests of · Hephaistos is no less marvellous: a suit of armour so splendid, in fact, that just to describe the shield consumes all of Homer's poetic energies. Homer imagines a flurry of hissing and high-temperature hammering, as if this were iron-working rather than bronze, and he is rather vague about the actual embossing technique that Hephaistos employs; but we may forgive him that. His description of the decoration of the shield of Achilles is enthusiastic and magnificent.

Homer reports that the shield was made of five superimposed layers of bronze. The cumulative circular expanse was massive, yet it was all packed with decorative detail. First, Hephaistos fashioned images of the cosmos. This shield will contain life,

the universe and everything. Within his microcosm Hephaistos presents two cities. The first is a city at peace. Here are weddings and feasts, and women standing at their porches. There is a dispute, but it is being settled in court by grave, elderly magistrates. Then Hephaistos shows a city at war. Walls are besieged, and spears are flying in the thick of battle. Homer does not need any lessons in describing how that happens. We pass from this contrast of cities to gentler, more decorative rhythms. These are the scenes of the agricultural year: the passage of seasons from ploughing to reaping, harvest and vintage. The poet describes how the artist depicts the plough making its way across a field. At the turn of the furrow, the ploughmen slake their thirst with mellow wine. 'The field grew black, like real tilth, although it was made of gold,' says Homer. 'That was the marvel of the work.'

More amazements are generated by the skills of Hephaistos. He depicts reaping and binding, propitiatory sacrifices and picnics in the grass; he lays out a vineyard and shows plump, dark grapes being gathered in wicker baskets by girls and youths, singing as they work. Chasing his gold and tin, Hephaistos produces cattle, 'mooing as they trot along from barn to pasture, where rushes sway beside the chuckling stream'.

This is what literary critics know as *ekphrasis*: the 'speaking-out' of an image, the translation of a picture into words. Homer articulates the designs of the shield of Achilles with such eagerness that he leaves us almost licking our lips for a drop of whatever the thirsty ploughmen are drinking. Yet beyond the description of an exceptional, divinely made *objet d'art*, what are we told here about the Greek criteria of appreciation for art and the Greek definition of the proper business of artists? Certain images from the prehistoric Greek repertoire may be summoned to give some figurative notion of what Homer was envisaging: embossed and chased

2
Embossed shield from Crete, possibly imported from Cyprus or Asia Minor, 8th century BC. Bronze; diam. 27 cm, 10⅝ in. Archaeological Museum, Heraklion

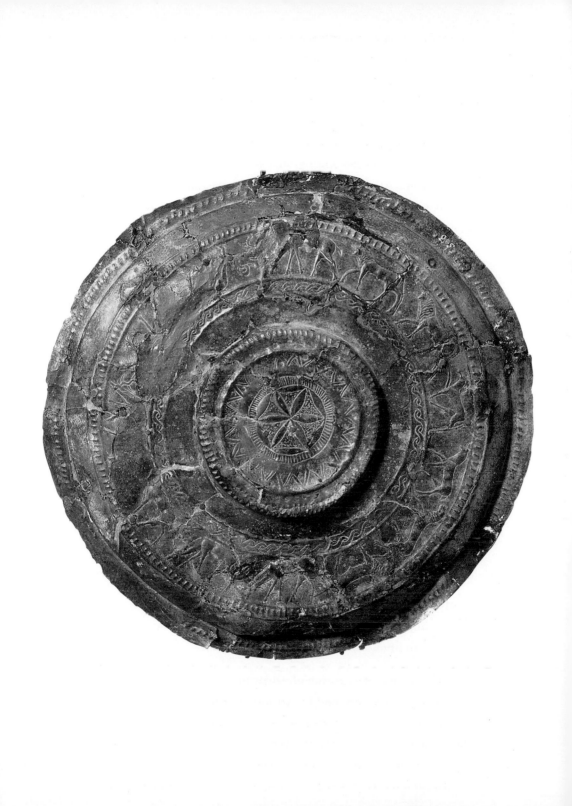

shields survive (2) and we even possess contrasted scenes of cities at peace and at war (see 14). But Hephaistos stands for the divine or ideal artist, and his handiwork, as Homer dares to describe it, is an idealization of what all Greek artists should be doing. So when Homer stresses that the ploughed field turned black 'like real tilth'; when he claims to hear the grape-gatherers singing, the cows mooing, and the stream chuckling, he is only half-exaggerating the effect of such ideal art on its viewers. This degree of realism, of animation no less, is an absolute measure of perfection. What Hephaistos achieves is what all mortal artists should aspire to achieve.

Homer's enchantment by the shield of Achilles is infectious; and, as we shall see, his criterion for recognizing artistic achievement – the realism, or illusionism of a work of art – would remain a central, determining feature of the subsequent course of Greek artistic activity. But it is worth noting how a poet characterizes an artist here. Poets and bards generally enjoyed high profiles in Greek society; but the same cannot be said of artists. For Homer's audience, Hephaistos, though divine, was portrayed as a repugnant type. He was born lame and deformed; his mother, Hera, disowned him at birth, and the other Olympians are described by Homer as laughing 'unquenchably' at the clumsiness of Hephaistos when waiting at table. He was sexually frustrated and, in mythology, notoriously molested both Athena and Aphrodite. His habitat is a hot and horrid workshop, full of noise and sweat and hissing irons. In short, he was an unenviable figure.

Yet Hephaistos was powerful. Quite apart from his elemental association with fire and his cosmic reputation for causing volcanic eruptions, he manifests his power as a craftsman in more subtle ways. Plotting revenge on his mother, he fashions for her a superb golden throne. Delighted with the gift, Hera proudly sits herself on this throne and is immediately

shackled to it by secret bonds. She cannot move, and no one save Hephaistos can release her. The other deities plead with the stubborn Hephaistos to set Hera free. But in the end, the only one who can persuade Hephaistos to relent is Dionysos: and that is by getting the master craftsman obliviously drunk.

The intriguing power of Hephaistos is properly conveyed by Homer. When, in Book VII of his *Odyssey*, Homer describes the palace of King Alkinous of Phaeacia, he takes trouble to mention that the figures of lions and dogs guarding the entrance to the palace, made out of gold, silver and bronze, were designed by Hephaistos: potential intruders should take note, because the sort of dogs or lions made by Hephaistos would be able to bite, such was the extent of his capacity for animation. Homer tells us that Hephaistos did, in the end, find a consort: she is called *Charis*, 'Grace'. Yet there is the impression, not only in Homer but through-out Greek literature, that craftsmen generally were more feared than respected for their power; more despised than applauded for their marvellous works. We need to try to clarify this apparent tension between the artist's role and his esteem in Greek society.

Homer's near-contemporary, the farmer-poet Hesiod, writing in the seventh century BC, described artists as *ptochoi*, 'beggars'. Beyond the disparagement implied by that term is the reflection of what we know to have been a steady reality for Greek artists, which is that they were peri-patetic: not necessarily vagrants or scroungers, but moving to wherever work was on offer. In Hesiod's time, the circuit of various athletic festivals around Greece demanded, for example, that bronzesmiths move from one site to another, setting up temporary workshops and turning out the many petty votives, prizes or souvenirs required by the gathering. Hesiod unwittingly sheds some positive light on artistic activity in general. In his discursive, poetic farming manual,

the *Works and Days*, he declares that there are two types of strife among humans. One is malicious: the strife that foments quarrels, war and violence. The other is kindlier. This is the strife that bestirs men from their natural laziness. A man watches his neighbour working hard and getting rich, and in emulation, he seeks to equal or, better still, outstrip that neighbour.

For Hesiod this strife is a goddess, Eris; perhaps 'spirit of competition' or 'rivalry' is a better translation of her meaning in ancient Greek. Hesiod himself had an indolent brother, to whom he sternly recommended devotion to Eris. It was Friedrich Nietzsche (1844–1900) who extended the application further when he declared: 'It was Hesiod's divine Eris, ambition, that gave the Greek genius its wings.' Nietzsche had in mind the regular theatrical competitions at Athens, which gave rise to the works of those enduringly great dramatists, Aeschylus, Sophocles and Euripides, but his remark applies just as well to the fine arts. A great deal of evidence, from the purely anecdotal to the historically precise, can be mustered to demonstrate a spirit of intense competition prevailing among Greek artists. And it does not seem over-imaginative to presume that this atmosphere essentially nourished the rapid development of figurative style, which is, for many, the defining achievement of Greek art.

The anecdotal evidence is entertaining enough to occupy us briefly, though its value lies more in how it determined the stereotype of the artistic genius in later Western art, rather than in what it tells us about ancient Greek artists themselves. Typical of the nature of these stories is the tale recorded of the private rivalry between two celebrated fourth-century BC painters, Apelles and Protogenes. Apelles broke into the studio of Protogenes and left behind as a mark of his presence a very fine, straight line, drawn freehand. Protogenes responded by juxtaposing an even finer and straighter line. Apelles returned and drew another yet

finer. Such duelling with individual skill is a common theme. There is likewise the story of the painter Zeuxis, who did a still life of a bunch of grapes and fooled some birds into pecking at them. 'I can deceive not just birds, but humans,' boasted a rival, Parrhasios. Parrhasios invited Zeuxis to his studio, and Zeuxis demanded to see the convincing work in question. 'It's behind that curtain,' says Parrhasios; and Zeuxis, leaning forward to pull the curtain, finds that is just where he has been tricked. It is a painted curtain.

These are generic attestations of artistic vanity, but they are not without foundation in actual circumstances. When we are told that contests were staged between sculptors, where a theme might be specified and a prize awarded to the best submission, this is really only another way of framing the ancient Greek process of commissioning. An inscribed pillar beneath a dramatic winged victory figure (*Nike*) at Olympia declares that one Paionios himself 'was victorious' (*enika*) in the competition for the statue's commission in 424 BC. Several different surviving copies of figures of a female warrior appear to confirm an ancient story about a contest held between four or five Classical sculptors to make a study of an Amazon for the temple of Artemis at Ephesus. And inscriptions survive which make it clear that architectural contracts were awarded as a result of competing designs being put up for public judgement.

In the course of this book there will be regular references to painted pottery, which was undoubtedly only a 'minor' art in ancient Greece. We are forced to use it as evidence primarily because it has been recovered in abundance, whereas larger-scale painting has virtually vanished from the archaeological record. This is a good juncture at which to justify the retrospective elevation in status of vases and their decoration, and we should begin by noting that even among potters, whom modern parlance would perhaps prefer to term 'craftsmen' rather than 'artists', there was both formal

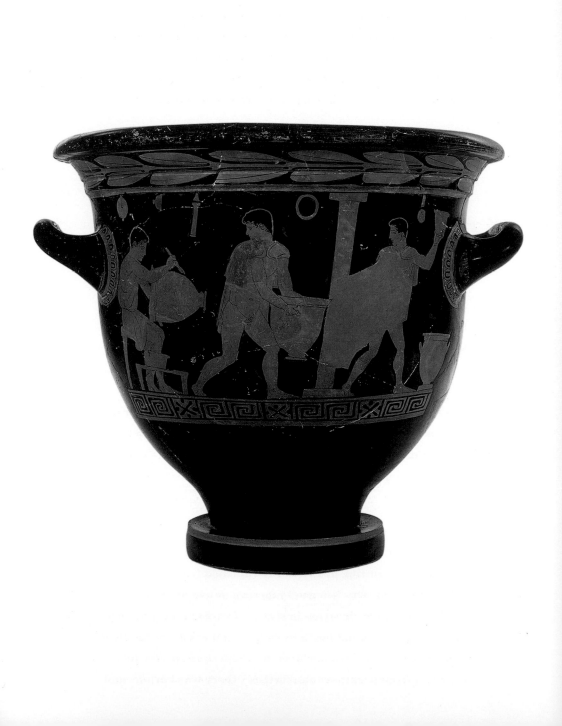

and informal rivalry. The first-century AD Roman encyclopedist Pliny recorded that in the temple at Erythrai there were two wine jars on display, dedicated not because of their contents but rather on account of their unusually thin-walled fabric. They were, says Pliny (*Natural History*, XXV.161), the result of a challenge between a master potter and one of his apprentices as to who could throw the finest clay. Then we have the testimony of inscriptions such as the following from Athens, dated to the fourth century BC: 'All Greece has judged Bakkhios as rightfully carrying off the first prize of those craftsmen whose skill is to combine earth, water and fire [*ie* making pots, or terracottas]. And in those skills for which the city has established contests, he has won the crowns in all of them' (*Inscriptiones Graecae*, II–III.3.6320).

Prize-winner as he was, Bakkhios may not have been paid much for his work. It is a truism of our understanding of ancient Greek attitudes that any activity which involved getting dirty and embroiled in manual labour was regarded as best avoided. Such work was deemed 'banausic', which literally implies working with a furnace, but could be extended to cover any sweat-generating or mechanical work. Even if an artist became rich, as some sculptors seem to have done, he was still liable to disdain from 'well-born' Greeks; the sort, for instance, who populate the pages of Plato's dialogues. But neither poor remuneration nor low social status precludes the type of decent self-regard which ennobles 'craft' with 'art'; nor that personal effort which invades the collective 'workshop' (3) with the poetic or romantic power of 'inspiration'.

The Greek language has, as it happens, no resources for distinguishing between the 'craftsman' and the 'artist'. The term 'makers' (*technitai*) covers anyone from carpenters to silver-chasers. 'Skill', 'dexterity' and 'initiative' are all implicit in the general root word for both art and craft,

techne. This is not to deny a hierarchy of media in terms of artistic importance: painters of large public murals and sculptors of colossal cult statues undoubtedly won greater fame and rewards than those who decorated small pots or baked clay figurines. But a concept of achievement and innovation prevailed at every level of the production of images. This is why we can justifiably treat vase-painters as 'artists'.

Some scholars, nauseated by the grossly inflated prices that Greek vases and sculptures can fetch on the modern art market, argue that we have foisted upon the ancient Greeks a false esteem for artists. They dismiss the anecdotes preserved in mostly Roman sources as the sort of stories which connoisseurs like to invent in order to add a tincture of personal interest to pieces in their collection. Just as the private lives of modern artists are prone to be glamorized for the sake of art as investment, so the Romans – who became greedy collectors of Greek antiquities, especially statues – embroidered the biographies of Greek artists. Undoubtedly there is such embroidery in the literary record, especially regarding the unnerving powers of deceptive illusion attributed to ancient paintings or statues. But try as we might, the artist can never be removed from even a strictly social account of Greek art.

Signatures of artists appear among the earliest records of Greek literacy, and as soon as artists sign their work, art historians are obliged, like ancient viewers, to take note of names. In fact there are many Greek artists whose names were celebrated in antiquity, but for whom we possess no directly attributable work. The work of the jousting wall-painters mentioned previously, for example – Zeuxis, Parrhasios, Apelles and Protogenes – has entirely perished. Conversely, there were some artists who did *not* sign their work, and for them names have been invented. Such invention of names has been particularly important in the classifi-

cation of painted vases, and is largely the work of one scholar, J D Beazley (1885–1970). Following a technique of attribution devised by certain connoisseurs of Italian Renaissance painting (in particular, Giovanni Morelli), Beazley (see 254) 'identified' literally hundreds of artists, most of whom once worked in an area of ancient Athens, the Kerameikos, known for its specialization in producing vases. The identification method is essentially scientific, relying on the patient scrutiny of those features of figurative draughtsmanship which are done, as it were, subconsciously: ear lobes, ankle bones, eyes and so on. Like the detective, or even the psychoanalyst, the attributionist attempts to uncover those crucial details not evident to the cursory gaze. In Beazley's system, many names came from the vase-painters' own signatures. Others had to be conjured up on the basis of peculiarities of style (thus 'The Elbows-Out Painter'), or subject ('The Painter of the Woolly Satyrs'), or simply derived from museum location ('The Berlin Painter').

To those coming to it for the first time, this type of classification can seem forbidding, artificial and even misguided. No more accessible to the beginner is the equivalent process in sculpture, where determining the style of a named Classical sculptor often depends on studying the various Roman copies of his work, and trying to gauge which elements of the various copies relate most closely to the original (now lost) work. But scepticism about such approaches should not obscure their ultimate justification, which is that individual artists patently competed with each other in ancient Greece.

Within the realm of painted vases, the engaging strength of Hesiod's Eris can readily be demonstrated. A group of Athenian potters and painters working in the last quarter of the sixth century BC have been called 'the Pioneers', because they were adventurous with a new technique of decoration known as 'red-figure' painting. The novelty of this technique will be discussed later (see Chapter 4); for now, we can note

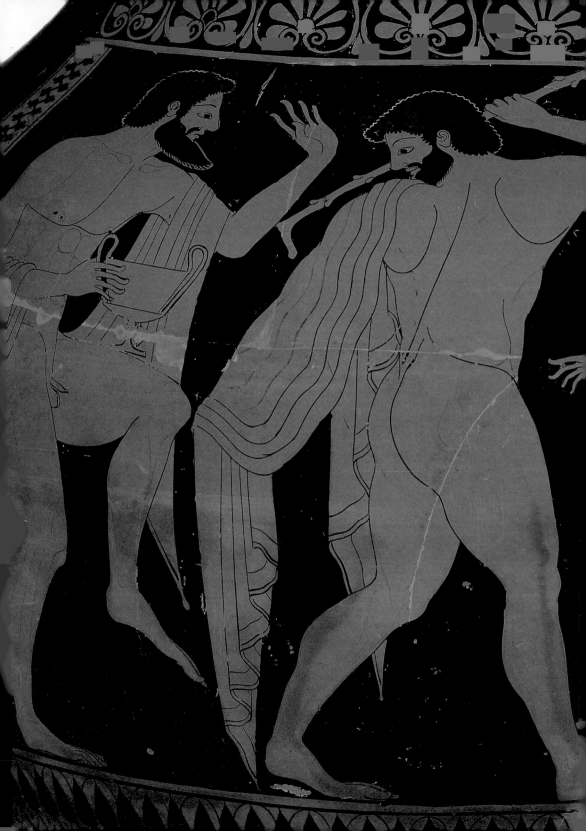

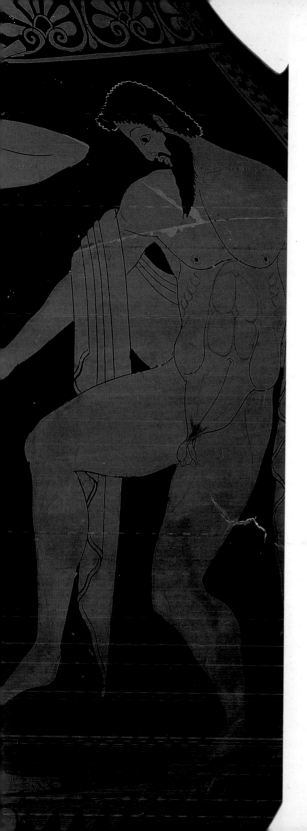

4–5
Athenian red-
figure amphora
painted by
Euthymides,
c.510 BC.
Staatliche
Antiken-
sammlungen,
Munich
Left
Detail showing
three symposi-
asts
Below
Complete vase
showing
reverse side

merely that it enabled a greater freedom of line in drawing figures, a freedom which these 'Pioneers' exploited both eagerly and self-consciously. They not only signed their names – Euphronios, Euthymides, Smikros, Phintias – but drew caricatures of each other, cracked in-house jokes on the surfaces of their pots, and openly contested their respective abilities at drawing. On one wine jar, Euthymides drew three drinkers getting merry; their clothes slipping off, their feet lifting in the first stomping rhythms of a dance (4). All three figures are presented in what is known as a three-quarters view; that is, neither side on, nor front on, but somewhere in between. The central figure, shown moving sideways but also looking backwards, is a particularly virtuoso example of the degree of difficulty posed by the three-quarters view. The lines of anatomical indication here may be few, but they have to be perfectly placed if the figure is not to seem awkward or akimbo. Euthymides not only judged those lines perfectly, he knew it too, and in his signature on the work – *egrapsen Euthymides ho Polio*, 'Euthymides, son of Polias, drew this' – he could not resist adding, *hos oudepote Euphronios*, 'as never Euphronios'.

As Beazley saw, this tag – which amounts to, 'See if you can manage this, Euphronios!' – was 'a gay challenge to a comrade, not a cry of senile jealousy'. The accomplishment of an ambitious figure, or detail of a figure, was signalled with every intention of arousing envy. Alongside another 'Pioneer' figure is the phrase *euge naichi*! or 'absolutely right!' And it is to Euthymides that the awesome credit goes, as E H Gombrich noted in his *Story of Art*, for representing the first ever foot seen front on in the known history of world art.

So perhaps it is not so outrageous that from the humble economic and social circle in which Euthymides, Euphronios and their contemporaries once operated have come vases that today are promoted as 'great' works of art. The first Greek

6–7
Athenian red-figure calyx krater painted by Euphronios, c.515–510 BC. h.45·7 cm, 18 in. Metropolitan Museum of Art, New York
Right
Complete vase
Overleaf
Detail showing the body of the warrior Sarpedon being removed from the Trojan battlefield

vase to fetch a price of a million dollars was, in fact, an enormous mixing bowl by Euphronios (6). Looking at its central scene (7), the removal of Sarpedon's body from the Trojan battlefield by two winged personifications of Sleep and Death, we may appreciate the fruits of intense rivalry within the pottery-producing area of Athens. Not only is this a manifestation of the skills of figurative representation, such as foreshortening, but those skills are used to create a fine work of epic pathos. They are the means to a marvellous end.

Creating 'marvels' was, as we saw, the business of the divine artist-technician Hephaistos. It was also the brief of the arch-artist in mortal mythology, Daidalos. Daidalos is saluted

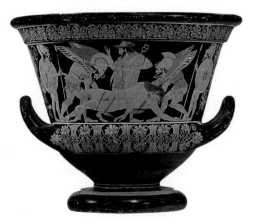

in the literature as a *protos heuretes*, a 'first finder' of all sorts of useful things: the saw, the axe, the plumb line, the drill and carpenter's glue. He is also, in the fables of early Greece, a pioneer of human transport by sailing boat and aviation. He exemplifies the passions of rivalry amply enough: jealous of the work done by his nephew and apprentice Talos, he went so far as to drown the boy. But above all, Daidalos was celebrated for making 'lifelike' images. While on the island of Crete, he fashioned a cow so lifelike that it was impregnated by a bull (and eventually spawned the monstrous half-man, half-bull creature known as the Minotaur). The statues he made of humans were rumoured to

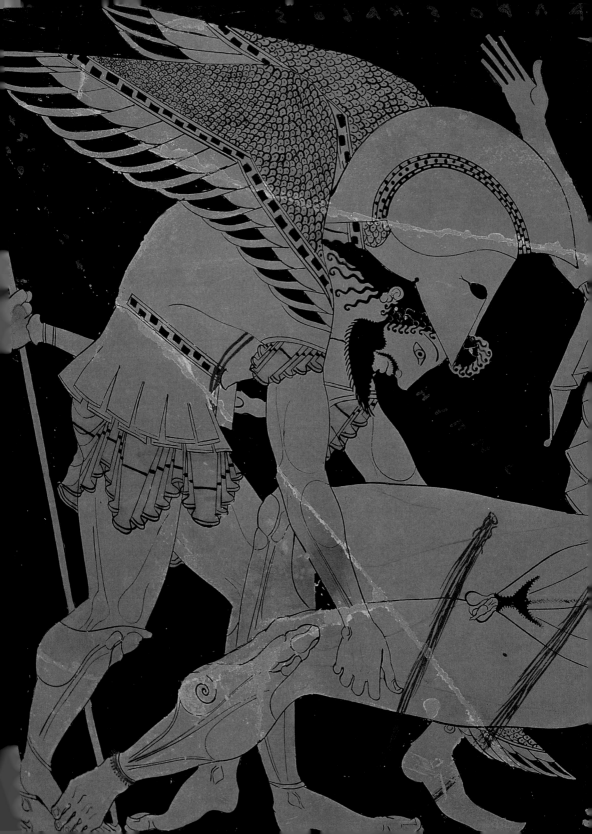

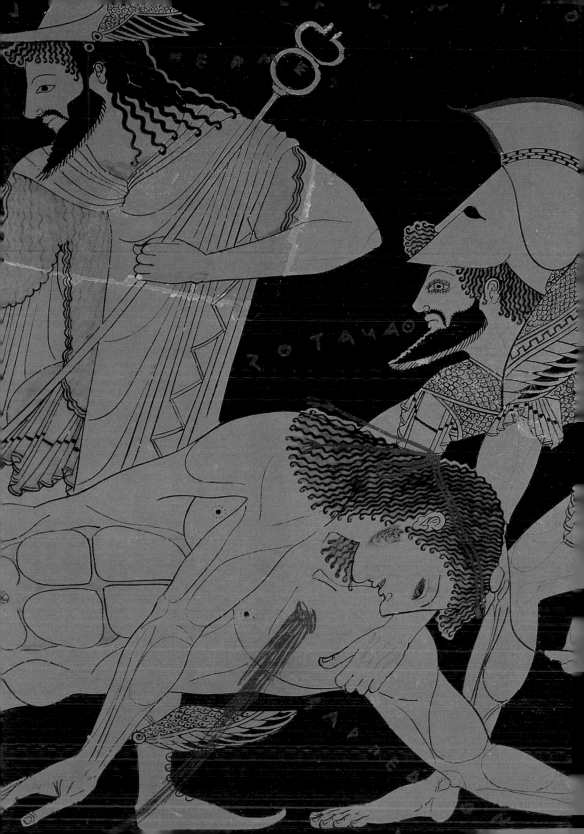

be capable of movement, so true to life was their appearance.

Fabulous as the image of Daidalos is, it serves as a nice paradigm for the position of the artist in ancient Greece. Why were Euphronios and Euthymides challenging each other to improve on their draughtsmanship? Because, like Daidalos, they aimed at enchanting the customers of their vases with a show of skill. Usually (though not necessarily) this skill was specifically displayed in the representation of naturalistic figures. Quite apart from what we have witnessed in Homer, many sources could be quoted to show that the ancient viewers of Greek art were chiefly impressed by an artist's ability to make images as close to reality as possible. Ultimately, the 'virtual reality' created by Greek artists would cause philosophical worries; but for Hephaistos, Daidalos, Euphronios, Parrhasios and their like, there was a premium of general approval to be secured by aiming for the deceptively lifelike. So it was that although artists were to some extent subject to collective scorn and led unenviable lives (Hephaistos, as we have seen, was such; and there is a vein of malignancy attached to artistic enterprise throughout the Daidalos stories), they nevertheless enjoyed a certain privilege. They were, as one scholar has put it, the 'secret heroes' of Greek civilization; the unacknowledged legislators, the hidden persuaders, the image-makers.

Underpinning this privilege of image-making is the fact that Greek culture was a religious one, and that religion was anthropomorphic. It depended, that is, on visualizing its deities in human form. The theology behind this need not concern us here, nor should we be distracted by the very few dissentient voices raised against anthropomorphism from within Greece (there were plenty of outside enemies in due course: most vehemently, Christians and Jews). Graven images, painted images, images moulded and fired in a kiln: these were the essential vehicles of belief, and it was the job of the artist to produce them. This function actually

8
Pheidias's colossal statue of Zeus at Olympia, original *c.*435 BC. h.estimated at *c.*14 m, 45 ft (imaginary reconstruction by Sian Frances)

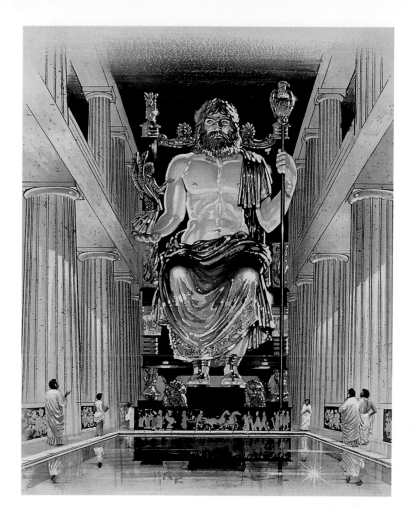

gave the artist not a marginal, but a perfectly central role
in society. He might have paint under his fingernails or
marble dust in his hair, but he was a maker of marvels:
literally, things to be worshipped and held in awe.

Now this may not have applied to the vase-painters. Some
of their vessels were used for pouring libations and for
other religious purposes, but most simply belonged to the
rituals of drinking, and as such involved no deity other than
Dionysos, the god of wine. Otherwise, their work may be
conceived as a reflection of grander projects in temples
and public places. For large-scale painters and sculptors,
however, the religious role entrusted to them gave distinct

possibilities for an enhanced status. The same is true of architects. Success within their own specializations, and public acclaim for that success, took a small proportion of Greek artists into the spheres of a creative élite.

In a sense this was inevitable, precisely because of the nature of religious commissions. A statue of a deity was theologically considered to contain some of the spirit or soul of that deity. So whoever made the central cult figure of a Greek temple must have been reckoned, in some vague, unspecified way, to have special insight into the nature of a deity's appearance: to be, as it were, divinely connected. And so it is no surprise to learn of the celebrity of one sculptor, Pheidias, who made several such cult figures, most famously the Athena Parthenos for the Parthenon of Athens and the figure of Zeus for the temple of Zeus at Olympia. Neither survives, but credible reconstructions of both can be imagined (8 and 149). Faced with the most colossal and extravagant of them, the Olympic Zeus (8), we should not be amazed that Pheidias, 'banausic' as he was, is recorded as having mixed closely with politicians such as Perikles. This is the artist in charge of huge budgets, for the Zeus was a type of statue known as 'chryselephantine', meaning that large quantities of gold and ivory, not to mention many other precious materials, went into its making.

Artists at this level were not only practitioners of their skills; they were also theorists. Though none properly survives, handbooks of theory and method are known to have been written by a number of outstanding and influential individuals. Theodoros, the architect of the early sixth-century BC temple of Hera on Samos, wrote one such handbook, in which he outlined technical problems, rules of proportion and design, and instructions for the deployment of tools (some of which he is believed to have 'invented': the square, the level and the lathe). Iktinos, chief architect of the Parthenon, is also known to have scripted his own set

of principles. The mid-fifth-century BC sculptor Polykleitos wrote a treatise called the *Canon*, apparently establishing a geometrical technique for making the most aesthetically pleasing statues of the human form. And when we read that Pheidias was 'overseer' (*episkopos*) of all the sculptural decoration of the Parthenon, we must assume not so much a prodigious workman as a master designer; someone who set out the blueprints and models for lesser associates to follow. Those lesser associates, certainly, earned little more than what was required to keep themselves and their families in modest sufficiency. That was more or less the lot of most artists in ancient Greece. But the potential for lionization was there for a few.

The opportunities for artists did vary from city to city. In Athens, a massive amount of both private and public funds was directed at art, while the Spartans were notoriously tight-fisted in that respect. But on the whole, and allowing for fluctuations over time, Greece was a place where, generally speaking, artists flourished. That is, there were a great many of them. Homogeneity of style and a sense of ethnic identity were nurtured by virtue of the peripatetic life: thus many vase-painters were of non-Athenian and some even of non-Greek extraction, and when records of large projects survive, they reveal veritable circuses of expertise, temporarily assembled. A good example is the fourth-century BC temple of Asklepios at Epidaurus; if nothing else, it represents a masterpiece of logistics in bringing together skilled individuals from all over the Greek-speaking world. Sanctuaries were always the most promising places for artists to work, not only because of the demands of an anthropomorphic cult, but also because they were the focus for so much competitive patronage between the many Greek city-states.

Despite the snobbery that prevailed against him, the Greek artist made himself indispensable in this way. More than that, he became a generic embodiment of Greekness. Other

cultures recognized the traditions of skill built up by Greek artists and recruited those artists when they could. In the East, the Persian ruler Darius I would boast, on inscriptions marking the creation of his great campus at Susa towards the end of the sixth century BC, that he had used Greek masons and sculptors. At the same time, the Persian occupation of eastern Greece caused many Greek artists to emigrate westwards, where they found generous patrons in the Etruscans of central Italy. And when eventually Greek political power in the Mediterranean was displaced, first by the Macedonians, then by the Romans, Greek artists simply adapted themselves to new commissions and carried on working. Alexander the Great had a team of hand-picked artists – a painter, a sculptor, a gem-cutter: all Greek – to propagate his image. Although many of the artists remain nameless, we know that the Romans continued the Etruscan practice of assigning artistic projects to Greeks. The first 'Etruscan' vase-painter to sign his name (in the fifth century BC) was a Greek, Praxias. The most celebrated artist of the time of the emperor Augustus was a Greek, Pasiteles. Apollodorus, a Greek, was in charge of architectural design under the emperor Trajan. And so it goes on. As the Roman poet Virgil admitted (*Aeneid*, VI, 846–7), Romans were good at ruling the world, but when it came to extracting forms from marble or bronze, then that was the inalienable right of the Greeks.

In the following chapters, the emphasis is largely on the historical and social contexts of Greek art, and at times it may seem that the artist is submerged by forces greater than he can control. There is a valid reason for this: myths, manners and institutions cannot be excluded from any account of the shaping of art, and no Greek artist ever worked in anything remotely like hermetic conditions. But it is always worth remembering that Greek art was 'strife'-born, or striven for, by individuals.

1

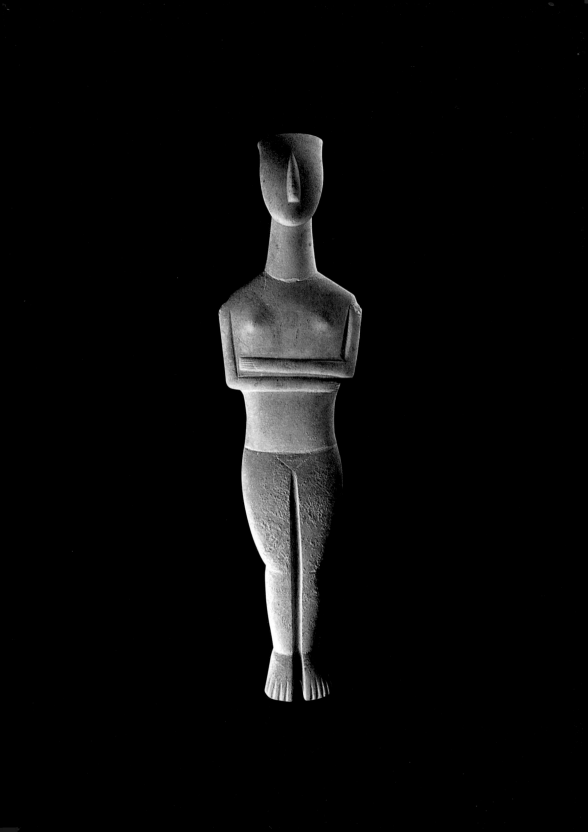

The origins of Greek art are elusive, and a continued topic of debate in modern scholarship. This is primarily because the Classical Greeks constructed their own origins, not only artistic but also ethnic. Such constructions owe nothing to archaeology, but a great deal to the imaginative enterprise of self-definition, and were precisely intended to obscure historical realities. As we have seen, the mythology of Daidalos allowed the Greeks to claim the 'invention' of various artistic techniques: Daidalos enabled the Greeks to ignore the manifold borrowings that their early artists made from culturally senior neighbours in the Aegean; the Hittites, the Egyptians, the Assyrians and the Phoenicians. Further legends developed to comfort the Greeks with a network of enchanting and generally home-bred ancestors.

So it was that the Classical Greek ethnic identity of being 'Hellenic' came about from an eponymous hero active in the mythological infancy of the world; and so it was that the different dialects of the Classical Greek language were accounted for by reference to various offspring of this hero. His name was Hellen, and he was (depending on different versions of the myth) either the son or brother of Deucalion, who in this primal cosmology survived a great flood sent by Zeus. The three sons of Hellen were Doros, Xuthus and Aeolos; from Xuthus, in turn, came two sons, Akhaios and Ion. Of these, Doros settled his people predominantly in Crete, the Peloponnese and northwestern Greece; Aeolus in Boeotia and northeastern Greece; and Ion in Attica, Euboea, the Cyclades and eastern Greece.

9
Cycladic
figurine,
c.2500 BC.
Marble;
h.63 cm,
24¾ in.
Goulandris
Collection,
Museum of
Cycladic and
Ancient Greek
Art, Athens

That is the broad aetiological explanation of how the principal dialects of Greek – Doric, Aeolic and Ionic – came into existence. They are distinctions we shall need to remember when we begin to look at the orders of Greek architecture; but for now it is enough to register the fact that it was not until the fifth century BC that Greeks began to use the term 'Hellenes' to refer to all Greek-speakers generally, and defined an area, 'Hellas', to denote territory inhabited by such Greek-speakers. The historian Herodotus, writing in the mid-fifth century BC, can describe a temple where Greek deities are worshipped as a 'hellenion', speak of pledges sworn 'by all the Greek gods', and appeal to such a factor in history as 'Greekness' (*to hellenikon*). But his successor Thucydides, writing at the end of the fifth century BC, notes that this is a relatively new denomination. As Thucydides points out, it was not used by Homer when describing the various contingents of Greek forces encamped outside Troy; and Homer is judged to reflect usage of the eighth century BC. So the notion of Greece or 'Hellas' as a geographical and ethnic entity must have arisen between the eighth and fifth centuries BC and only when the concept had gained currency did it then become possible (and popular) for Greeks to define non-Greek speakers as 'barbarians' (*barbaroi*, because their languages sounded like a babble of 'bar-bar-bar', or 'rhubarb, rhubarb').

How seriously the Greeks of the fifth century onwards took the stories of Hellen, Doros, Ion and so on is hard to tell. Athenian playwrights such as Euripides made use of them, manipulating plots and genealogies as it suited them. It can hardly be a coincidence that in the penultimate decade of the fifth century, just when Euripides produced his *Ion*, in which the Athenian king Erechtheus is made a grandfather of Ion, a temple for the worship of Erechtheus was designed according to the Ionic order (see 164). We may have occasion to refer to certain sanctuaries as either mainly Dorian (such as Olympia) or Ionian (such as Delos) and we may need to in-

voke 'Ionian taste' to explain, for example, certain developments in sixth-century sculpture. But ancient Greece was never a nation, rather a collection of surprisingly heterogeneous city-states. These banded together, more or less, when threatened by barbarian enemies – in the fifth century the Persians, in the fourth the Macedonians – but otherwise they fought among themselves and followed their own political programmes, including colonization abroad. Language and religion (which included a round of communal festivals, like the athletic games at Olympia, Nemea, Corinth and Delphi) were the two main binding forces of Panhellenic unity. To those we should add art. But that returns us to the issue: when does Greek art begin?

Even with the mythology of Hellen and so on behind us, it is impossible to decide forensically what constitutes 'Greek'. The archaeology of the Aegean prior to the tenth century BC is often called 'Prehellenic', implying that the term 'Hellenic' cannot properly be used of the prehistoric cultures of this area. In order of chronological sequence these cultures begin in what archaeologists would term the late Stone Age or Neolithic period, with an arguable 'emergence of civilization' in the Cyclades from around 3000 BC. Some metal tools of copper were being used in this period; by 2500 BC the alloy of copper with tin was making a more durable medium, bronze, and so the 'Bronze Age' begins. Bronze prevails up to the working of the next metal, iron, around 1000 BC, and within the span of the Bronze Age comes first Minoan culture, then Mycenaean.

When the writing system associated with the latter of these cultures, Mycenaean 'Linear B', was deciphered in 1952, there was an immediate appreciation of its fundamental 'Greekness'. Among the syllabic formulae used by the scribes of the Mycenaean palaces at Knossos on Crete (10) and at Mycenae, Pylos, Thebes and Tiryns on the Greek mainland are distinctly recognizable prototypes of Greek words. For

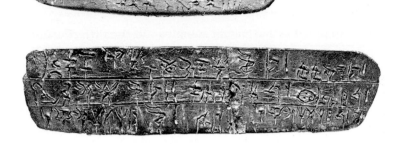

10 Left
Two Linear B
tablets from
Knossos.
Terracotta.
British
Museum,
London

11 Right
Early Cycladic
vessel, c.2800–
2300 BC.
Terracotta.
Goulandris
Foundation,
Museum of
Cycladic and
Ancient Greek
Art, Athens

12
Far right
Early Cycladic
figurine of a
hunter-warrior,
c.2800–
2300 BC.
Marble.
Goulandris
Foundation,
Museum of
Cycladic and
Ancient Greek
Art, Athens

example, the Classical Greek word for 'king' is *basileus*: in the Linear B script we find the syllabic formula *qa-si-re-u*, once probably pronounced as *guasileus*. Even more significantly, Linear B versions of the names of Classical Greek deities and heroes have been identified: *a-ta-na* must anticipate Athena, *po-se-da*, Poseidon, and *a-ki-re-u* is a plausible precursor of Achilles. So should an account of the earliest Greek art begin with the Mycenaean period, that is, 1600–1200 BC?

The apparently Hellenizing script of the Mycenaeans is not, however, an original and independent phenomenon. It derives from a parent system, known as 'Linear A': and Linear A, used during the period 1800–1500 BC, is associated with the Crete-based culture that we refer to as Minoan (after the legendary King Minos of Crete). While scholars mostly agree that the underlying language of Mycenaean Linear B must be Greek, it has so far proved impossible to demonstrate the same Hellenic identity for Minoan Linear A. Yet if there is a supposed relation of parentage here, and a geographical overlap of the two cultures (hence Knossos was first a Minoan palace, then taken over and redeveloped by the Mycenaeans), should the earliest manifestations of Greek art be sought among the Minoans?

It is beyond the scope of this book to tackle that question on purely linguistic criteria. But it is possible to assess the

rival claims for the earliest Greek art on other grounds, beginning with the peculiar art of the Cycladic islands in the third millennium BC (9, 11, 12). A series of marble figures, mostly small-scale and produced between 2800 and 2300 BC, popularly represents the artistic face of this culture; they have become keenly collected, partly because they satisfy a modern taste for simplicity or abstraction of form (see 9 in particular). At the Museum of Cycladic and Ancient Greek Art in Athens, which houses the most comprehensive collection of these figures, there is no doubt of the modern Greek claim to them. Made from the white marble in which islands such as Naxos and Paros are so rich, and shaped by abrasion with pumice or emery (also locally available), they are certainly distinctive. However, although attempts have been made to isolate individual sculptors for them, the Cycladic figures remain obscure in their purpose and identity. Very few have been recovered from sound archaeological contexts. It is supposed that they were laid in graves, perhaps as company for the deceased, though many graves otherwise rich in deposited goods do not include them. It has also been argued that they represent divinities, and there is speculation that they may have formed the focal points of household shrines. But apart from saluting their pseudo-modernistic appearance, we can do little with

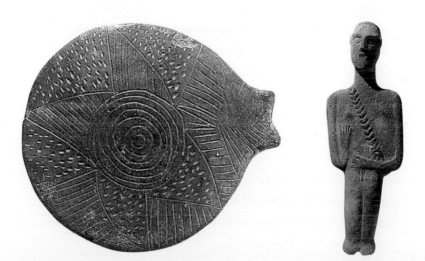

these figures. There is no proof that Greeks later in anti-
quity had any idea of their existence or were in any way
influenced by them. So it seems wrong to locate the
origins of Greek art here.

What of the Minoan claim? Here it is worth considering
some literary evidence, though it is frustratingly imprecise.
Greeks at the time of the philosopher Plato (in the mid-
fourth century BC) may have had some inklings of a prehis-
toric culture, which, though it had entirely disappeared,
in a sense belonged to them. Plato himself has generated a
vast quantity of modern speculation by telling the story of
a large island, once lying beyond the Pillars of Hercules
(which was how the Greeks knew the Strait of Gibraltar),
in the midst of a great ocean. It was ruled by Atlas, son of
Poseidon, and its inhabitants were initially of divine
ancestry. For many years this island, Atlantis, enjoyed
uninterrupted peace and prosperity. But the divine element
in its population weakened and Atlantis degenerated. It
was then shattered by earth tremors, engulfed by tidal
waves and sank entirely from view.

According to Plato, it was the meticulous Egyptians who
kept the record of this proto-Greek civilization on Atlantis.
Notwithstanding Plato's location of the island beyond the
Mediterranean (in the ocean we now accordingly know as
'Atlantic'), and his chronology of nine millennia past,
several scholars have been tempted to see in the Atlantis
myth some dim Greek remembrance of Minoan civilization,
perhaps disastrously damaged by the eruption of the
volcano on Thera (modern Santorini) around 1500 BC.
Some of the details of the civilization described by Plato –
he speaks, for instance, of certain bull-hunting rituals con-
ducted within great palaces – seem uncannily close to
features characteristic of Minoan Crete. Did ancient mem-
ory of the Theran eruption become cast in the form of the
myth of the lost Atlantis?

13
Fisherman
from the West
House,
Akrotiri,
c.1450 BC.
Fresco;
h.109 cm,
43 in.
National
Archaeological
Museum,
Athens

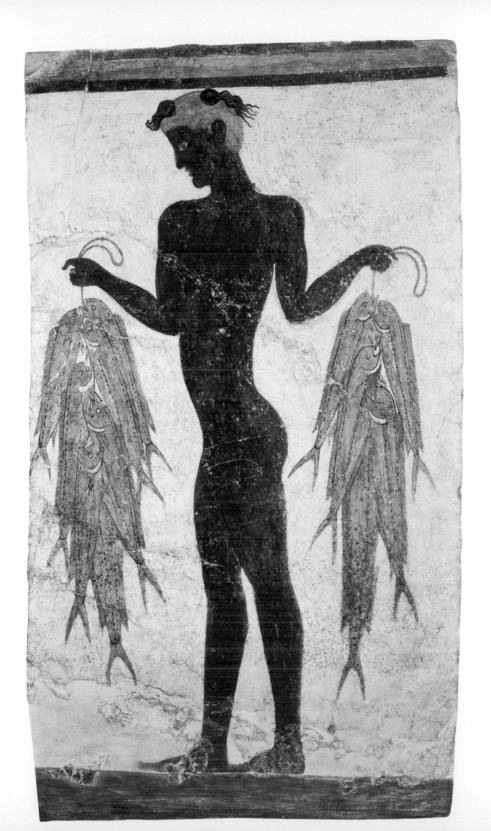

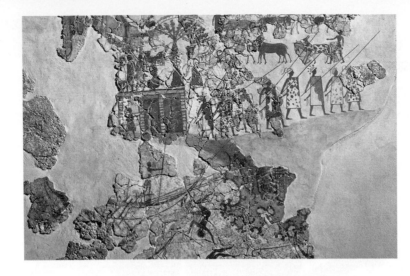

14
Mural from the
West House,
Akrotiri,
c.1450 BC.
Fresco;
h.40 cm,
15¾ in.
National
Archaeological
Museum,
Athens

Whatever the answer to that, the Theran volcano at least
preserved for us a series of Minoan frescos that would never
have been glimpsed by Classical Greeks. One of the settle-
ment sites on Thera covered in lava was Akrotiri, a nucleus
of one- or two-storeyed houses. The walls of these houses
were painted, and in some cases their ceilings and floors too.
The decoration was occasionally geometric and repetitive,
but more often figurative, with many landscape elements.
Both local and possibly exotic flora are represented – palms,
papyrus plants, crocuses and lilies – and certainly there is a
vein of fantasy in the pictures, with not only lions prowling
about, but also griffins (the griffin is half-lion, half-bird of
prey). Among the apparently realistic figure scenes are a
fisherman carrying two good catches of mackerel (13) and
a pair of youths boxing, each with one fist encased in a glove
or protective wraps. The most delicate painting so far found
at this site is from a building called the West House, whose
murals are done in miniaturist style. Although no narrative
structure can be fixed upon the scenes – unlike Egyptian
paintings of this period and earlier, we have no hieroglyphics
to help us decode the iconography of these Minoan pictures –
it looks as though a local world view is reflected here (14).
We see a walled city of flat-roofed, double-storeyed houses;

vignettes of pastoral agriculture, with shepherds in hairy cloaks tending to sheep and goats; and signs of the wider world, with the ritual blessing of ships, files of warriors and a projected or actual disaster: a vessel upturned, her crew floundering in the sea.

At Akrotiri, nothing like a palace has yet been discovered, though the settlement belongs to a period when Minoans elsewhere in the Aegean used palatial buildings as their characteristic centres of social organization. During the second millennium BC, three Minoan palaces became prominent on Crete: at Knossos (15–20) and Mallia in the north, and at Phaistos in the south. Later a fourth emerged, at Zakro on the eastern tip of the island. These complexes were residential (for a ruling dynasty and its retainers), religious (containing cult shrines), industrial (with areas given over to the production of objects in metal, clay and stone) and administrative (with considerable capacity for storage of primary goods such as oil, and archives of clay tablets evidently used in a bureaucratic capacity). Since they were built of mud-brick and timber on shallow stone foundations, the palaces were prone to fire damage, and indeed it seems that all of them, with the exception of Knossos, were destroyed around 1450 BC. But their architecture was

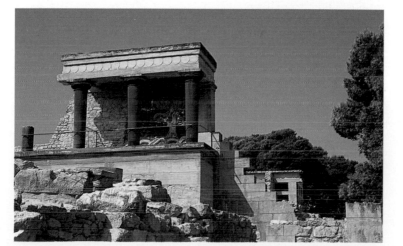

15
The north entrance to the Palace of Knossos, c.1600–1400 BC (as reconstructed by Sir Arthur Evans)

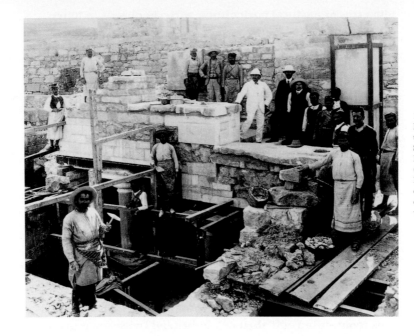

16
Restoring
the Grand
Staircase at
Knossos, 1900
(Sir Arthur
Evans stands
on the stairs
dressed in a
white suit)

creative and ambitious. Ample halls (17), monumental stair-
ways, sunken chambers, light wells and clay-pipe drainage
systems were features of the Minoan palace; and columns
were commonly used to create impressive entrances and
cool porticos. Walls were generally plastered and at first
painted with a colour wash; later, figured scenes of the sort
preserved at Akrotiri were added, sometimes with height-
ened plaster relief (20).

Mycenaean equivalents to the Minoan palaces on Crete
first appeared in the Peloponnese, at Mycenae and Tiryns
in the Argolid area, and at Pylos on the coast of Messenia.
To the north, in Boeotia, further palaces arose at
Orchomenos and Thebes. Though their functions appear
to have been very similar to the Minoan centres, substan-
tial architectural differences may be noted for these
Mycenaean types. The key element is the *megaron*, a
galleried hall whose central feature was a hearth. It was
approached by a prominent porch and might include an
antechamber too. Around flanking corridors many smaller
rooms might cluster. But the *megaron* – literally, 'large

room', or 'hall' – was, with its central fireplace, the focal point of palace life. The recovery of thrones in such rooms encourages the theory that this is where Mycenaean royalty conducted its business. At Knossos the original appearance of such a *megaron* has been partially reconstructed for the benefit of visitors or at least the personal gratification of its original excavator, Sir Arthur Evans.

He commenced his privately funded campaign at Knossos in 1900, at first intrigued to find out more about the undeciphered sign-language glimpsed on a single clay tablet. Soon he was following what he called Ariadne's thread into a palatial labyrinth which yielded all the trappings of regal style – such as the bull's horn drinking cup (*rhyton*; 18) and symbols of power, which the double axes (19) must be. Piet de Jong, the architect who helped Evans with the restoration at Knossos during the 1920s, also produced a vision of the throne room at Pylos (21).

The Mycenaean culture as such was identified subsequent to the dramatic 1876 excavations by the German entrepreneur Heinrich Schliemann at Mycenae in the central

17
A hall in the Palace of Knossos (reconstruction)

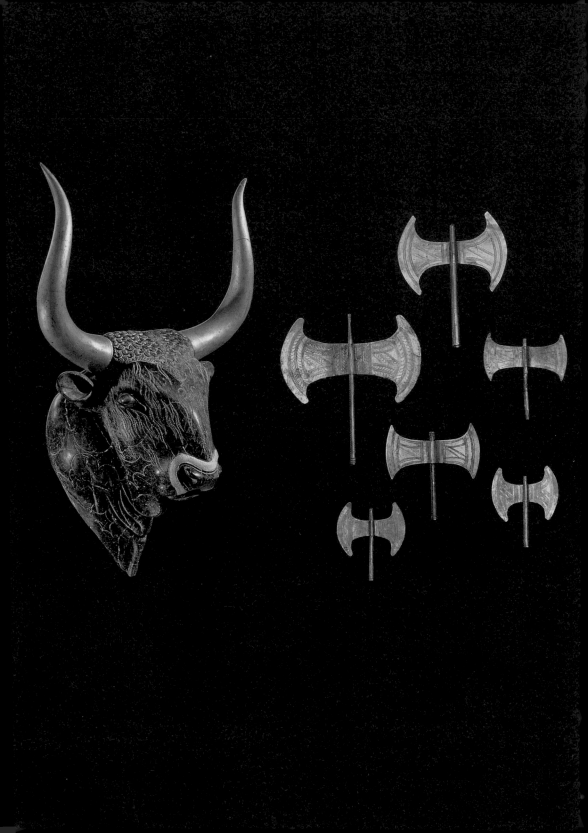

Peloponnese. Though some would characterize Schliemann as more of a buccaneer than an archaeologist, his enthusiastic hunt for a reality behind the heroes of Homeric fable effectively created academic respect for prehistoric archaeology in the Aegean. After recovering (and illicitly removing) from the Turkish site of ancient Troy what he believed to be the regal treasures of Priam, Homer's last king of Troy, Schliemann turned to Mycenae, where already in the second century AD travellers were being shown old tombs of legendary figures. These included the grave of one of the Greek heroes of the Trojan War, Agamemnon. According to a very powerful legend, Agamemnon's family – the 'House of Atreus', named after Agamemnon's father – was cursed. Accordingly, Agamemnon's return from Troy was far from triumphant: his wife Clytemnestra had taken up with a lover, Aegisthos, and the new couple murdered the old hero.

Schliemann's discoveries at Mycenae were extraordinary at the time, and remain so. They included several golden face masks, originally attached to interred bodies (see frontispiece). Although he did not in fact telegram Athens with the news that he had 'gazed upon the face of Agamemnon', Schliemann did believe that he had uncovered some historical reality behind the web of legend and tragedy at Mycenae. As we shall see, more sophisticated archaeological analysis cannot allow the coincidence of Homeric stories with Schliemann's finds, at either Mycenae or at Troy. But a brief assessment of Schliemann's digs, taking account of subsequent work at Mycenae, will clarify our view of the claim that Mycenaean art may generally be the true forerunner of Greek art.

Schliemann concentrated his activity on the graves which fall into three types at Mycenae. First there are the shaft graves, which belong to the earliest period of the city (from 1600 BC). These were rectangular trenches, sunk into the earth or soft rock to a depth of up to several metres. Their

18
Bull's head *rhyton* from Knossos, *c*.1500–1450 BC. Serpentine with shell inlay and gilt-wood horns; h.30·5 cm, 12 in (without horns). Archaeological Museum, Heraklion

19
Miniature Minoan axe heads, *c*.1500–1450 BC. Gold; average width *c*.8 cm, 3⅛ in

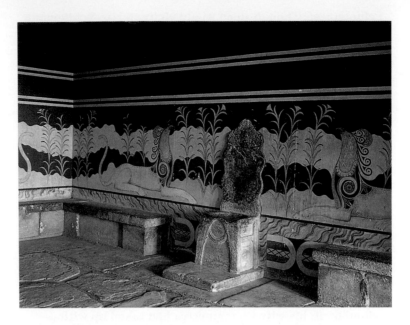

walls were lined with rubble, the floors pebbled, and roofs
made of timber. Bodies were inhumed within (though
Schliemann tried desperately to argue, following the
Homeric prescription of cremations for burial, that some
exposure to fire had been sustained), and the graves were
covered with a roof. They were marked with decorated slabs
or *stelai* outside, and arranged in circles, presumably accord-
ing to families or kinship groups. The two such circles at
Mycenae are known simply as 'Circle A' and 'Circle B'. Circle
B, marginally the earlier of the two, contained twenty-four
graves. Circle A, mostly discovered by Schliemann, contained
only six, exceedingly rich in their contents; and this circle
was eventually enclosed within the hefty walls that were
thrown around the citadel in the mid-thirteenth century BC.

The second type of grave at Mycenae is the chamber tomb.
These tombs were created by cutting a corridor or *dromos*
into the side of a hill, which would then open into a cham-
ber, where deceased members of a particular family were
laid out. The chamber tomb developed into a third type,
known as the tholos tomb, which may be described as an

architecturally more substantial version of the same idea. Façades were built and the chambers were elaborated with stone corbel vaulting. The best-known of this type – and, at a diameter of over 14 m (46 ft), the largest – is the 'Treasury of Atreus' (22–3), datable to about 1250 BC and contemporary with Mycenae's virtual heraldic emblem, the Lion Gate (25).

It is a prosaic but necessary deflation of Schliemann's discoveries to point out that the gold-laden shaft graves of Circle A at Mycenae (24) are three centuries too early to qualify as resting-places for Agamemnon and his family. If there ever was a Trojan War, and if its heroes could ever be isolated in any sort of historical existence, then both ancient and modern sources agree that this should be just prior to the supposed decline of Mycenaean civilization in 1200 BC. However, certain items from both the graves at Mycenae and the nearby houses seem nicely attuned to the magnificence of palatial life celebrated in Homer's poetry. In Book IV of the *Odyssey*, the palace of Menelaos in Laconia is awesomely likened to the court of Olympian Zeus: wide-eyed visitors are bathed and massaged by maidservants, generously fed, given wine in gold cups and generally dazzled by the cumulative gleam of copper, gold, amber,

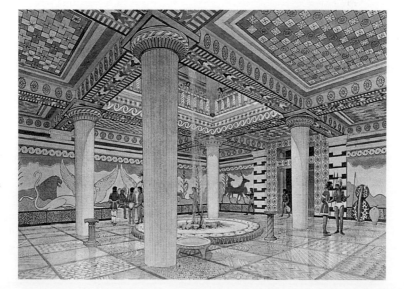

21
The Throne Room at the Mycenaean Palace of Pylos, *c*.1500 BC (reconstruction drawing by Piet de Jong)

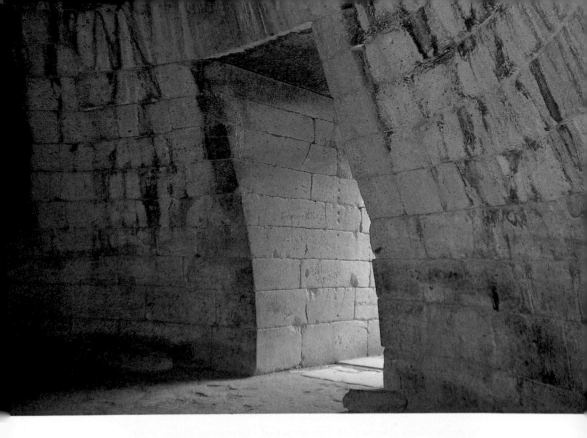

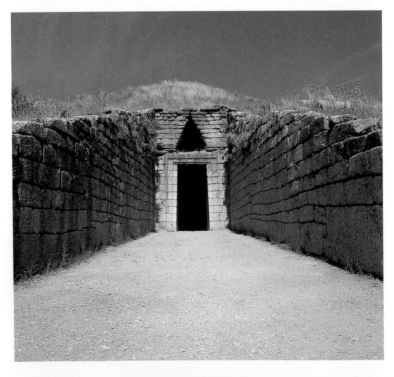

silver and ivory. A silver *rhyton* from Shaft Grave IV of
Circle A (27) adds martial tenor to such richness, showing
warriors around a walled and terraced city fighting with
spears, slings and bows and arrows. From one of the houses
at Mycenae comes an ivory in high relief of one such
warrior, complete with a boar's tusk helmet (29). Shaft
Grave IV also yielded a delicately inlaid dagger (30), featur-
ing the classically royal imagery of the lion hunt. A further
touch of regal heraldry, similar to the Lion Gate, is illus-
trated by another ivory, perhaps once the lid of a casket
(26), showing a pair of confronted sphinxes, above a base of
fluted columns, with 'horns of consecration': the stylized
bull's horn motif which is believed to have been a significant
icon in the service of Mycenaean ritual.

The finds from Mycenae are quantitatively exceptional, but
not unparalleled in quality. From a tomb at Vapheio in
Laconia comes a set of relief-decorated gold cups (32) dating
from the fifteenth century BC. The workmanship of the cups

22–23 Left
The Treasury
of Atreus,
Mycenae,
*c.*1250 BC
Above
Interior
Below
Entrance

24 Right
Grave Circle A,
Mycenae.
Aerial view
with the Lion
Gate in the
foreground

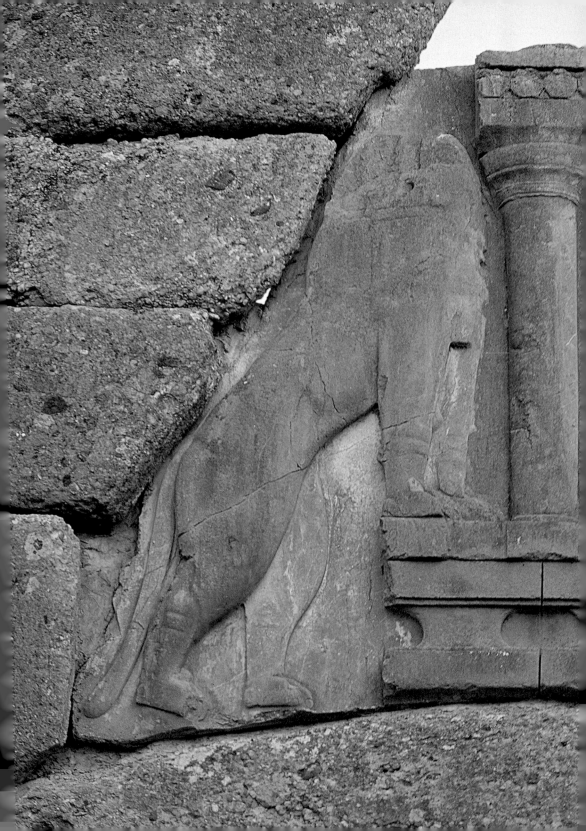

25
The Lion Gate,
Mycenae,
*c.*1250 BC.
Limestone

is thought to be Cretan; and we may note here a significant overlap in Minoan and Mycenaean iconography in the fascination with bulls. Meanwhile, Tiryns has yielded plentiful evidence for a type of blue enamel or glass-paste decoration similar to lapis lazuli, whose effect Homer knew and described. Even on humble painted pottery there are certain attestations to a kind of princely lifestyle that one is tempted to label 'Homeric'. On a characteristic Mycenaean vessel, the two-handled jar, we see figures proudly trundling out in their chariots (33), just as if they were Achilles and Patroklos riding along together.

26 Left
Plaque with sphinxes, from the House of the Sphinxes, Mycenae, 13th century BC. Ivory; h.8·1 cm, 3¹⁴ in. National Archaeological Museum, Athens

27 Right
Rhyton with siege scenes, from Shaft Grave IV, Mycenae, c.1600 BC. Silver; h.22·9 cm, 9 in. National Archaeological Museum, Athens

28 Far right
Cup from Shaft Grave IV, Mycenae, 1550–1500 BC. Gold; h.12·6 cm, 5 in (without handle). National Archaeological Museum, Athens

It is hardly surprising that Schliemann fell into the trap of reading Homer's poetry as if it were written by a war correspondent, and we may forgive those more recent archaeologists who, knowing that Homer's grand old man Nestor was traditionally located as master of Pylos, called the Mycenaean site there the 'Palace of Nestor'. But we must resist the temptation to play the game of matching Mycenaean remains to the poetic ambience described by Homer. As we shall see, the Greeks of the eighth century BC

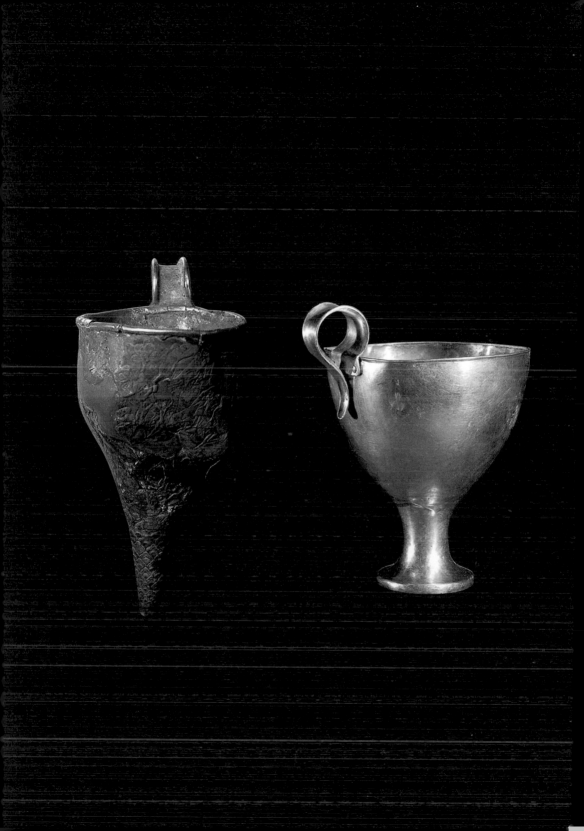

29
Warrior wearing boar's tusk helmet, from the House of the Shields, Mycenae, 14th century BC. Ivory; h.7·3 cm, 2⁷/₈ in. National Archaeological Museum, Athens

30
Dagger from Mycenae, *c.*1600 BC. Bronze inlaid with gold, silver and niello; l.23·8 cm, 9¹/₂ in. National Archaeological Museum, Athens

31
Hexagonal box from Shaft Grave V, Mycenae, 1550–1500 BC. Gold on wood; h.8·5 cm, 3³/₈ in. National Archaeological Museum, Athens

32
Cup from a tomb at Vapheio, 15th century BC. Gold; h.7·9 cm, 3¹/₈ in. National Archaeological Museum, Athens

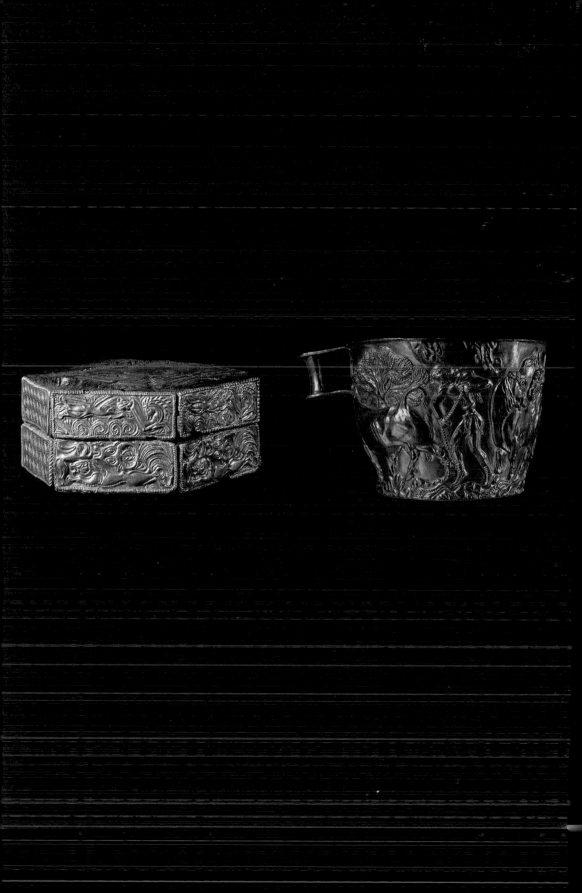

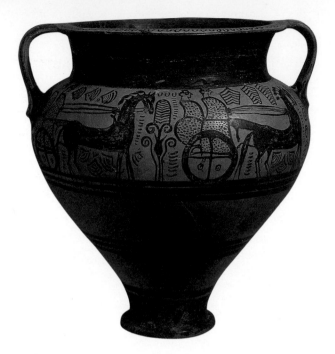

33
Two-handled
jar decorated
with chario-
teers, from
Maroni,
1400–1300 BC.
h.42 cm,
16½ in.
British
Museum,
London

were aware of a prehistoric heritage which they regarded
as heroic, and to some extent this awareness accelerated
the development of figurative art in Greece from the eighth
century onwards, as artists constructed graphic versions
of heroic tales. But there is also a great deal of dissonance
between Homer's evoked past and the Mycenaean world
as we understand it archaeologically; and indeed, anyone
who studies the information about Mycenaean society
provided by the Linear B tablets (mostly from Knossos and
Pylos) must conclude that Mycenaean art itself includes
a fair amount of fantasy. True, it is documented in the tablets
that the ruler of Knossos could command 400 chariots. But
the day-to-day activities of the Knossos administration were
not so much concerned with heroic warfare as sedulously
peaceful matters. There was a passion for making inventories
and listing whatever belonged to the ruling administration,
right down to the names of the cows ('Dapple', 'Dusky' and so
on) and the number of sheep. A decimal system of counting
recorded totals and deficits, and new taxes were ingeniously
devised. Everything points to a feudal society, tightly

controlled from the palace bases by the ruling dynasts and
their scribes.

A few tablets from Pylos may indicate shortages of essential
goods, and perhaps some troop movements, prior to the
destruction of the palace. At Pylos, as elsewhere, this is reck-
oned to have happened around 1200 BC. As yet, we have little
idea of what precipitated this Mycenaean demise, though it
is often referred to as 'the catastrophe', and may have been
part of a wider destructive process around the Aegean. It
may be significant that some Mycenaean centres, unlike their
Minoan equivalents or predecessors, were walled and forti-
fied on a colossal scale. But whatever the cause and nature
of this catastrophe, it seems to have marked an end to the
carefully monitored systems of government recorded in
Linear B. Greece was then plunged into the cultural obscu-
rity of what is called 'the Dark Age'.

This Dark Age is usually reckoned to cover the period from
1200 to 800 BC. By its 'darkness' is entailed a loss of literacy,
a disappearance of monumental building and an eclipse of
figurative art. In some Mycenaean cities, a debased sort of
habitation seems to have continued: at Mycenae and Tiryns,
for example, it is possible to speak of a 'sub-Mycenaean'
population, subsisting within the city structures but not
adding to them. It is a bleak picture that is often painted,
yet perhaps the bleakness has been exaggerated for the sake
of a good historical narrative. (If a Dark Age is established,
the possibilities for a dramatic renaissance then arise.) Was
the gap between Mycenaean palace systems and the essen-
tially urban culture of historic Greek civilization really as
great as the 400 years of the Dark Age imply?

In archaeological terminology, the end of the Mycenaean
period is conveniently close to a change in metallic chrono-
logy. The period that we have surveyed so far, from roughly
3000 to 1200 BC, is more or less equivalent to the Bronze
Age. Thereafter (though some would date its beginning more

strictly to 1000 BC) we enter the Iron Age. The shift in metal
preference and availability may be marked by Homer's
account of the making of the arms of Achilles, described
in the Introduction. Homer wants his poetic armour to be
made of bronze, perhaps knowing that his olden heroes had
relied on the metal (and a full example of Mycenaean bronze
armour has survived, from a tomb at Dendra in the Argolid),
but in fact the high-temperature process of manufacture that
he describes is suitable for working iron, not bronze.

But what happened to the gold, the art and the literacy? We
remain perplexed about what happened, around 1200 BC, to
Mycenaean culture as such. Plague, climatic change, civil
war and economic collapse have each been invoked as causes
of Mycenaean demise; so too an invasion or encroachment
of 'Dorians', a still mysterious unit of mythical Greek ethni-
city thought to have filtered down from the north and occu-
pied those southern and western parts of mainland Greece
populated by the Mycenaeans. Certainly the massive or
'Cyclopean' walls with which Mycenaean centres were forti-
fied, by contrast to their open Minoan equivalents, argue a
degree of endemic warfare. With regard to literacy, it might
be claimed that a precipitate failure of the bureaucratic
system it served was enough to bury the skill of writing,
especially if it had been the restricted preserve of an élite.
But within the historical darkness of the sub-Mycenaean
period, archaeology is beginning to shed some significant
light. While it remains accurate to claim that *some* decline
in material standards is apparent in the Dark Age, we may
now point to certain key areas where the gaps between the
Mycenaean period and 'early Greece' proper have been filled.
One site in particular, Lefkandi, should be credited with
providing us with this extra illumination.

Lefkandi, on the island of Euboea, was a settlement with
Mycenaean pedigree. Around the fifteenth century BC there
was a nucleus of substantial buildings occupying a hilltop

area of about six hectares. This settlement is known as Xeropolis. It was not a palatial site, but important enough to be attacked, seemingly, on and off throughout the later Mycenaean period. Yet a population survived beyond the wider Mycenaean collapse; a sub-Mycenaean community, which might be initially characterized as egalitarian prior to the emergence, around 1000–950 BC, of a distinct local chieftain. The rise of this chieftain is hypothesized from the discovery of an extraordinary building at a landmark in the Lefkandi area called Toumba.

As its name suggests, Toumba is part of a cemetery. To those who excavated it, this hillock must have seemed at first simply a large tumulus or burial mound, but what emerged was more than a burial. Two people were indeed buried in a shaft grave here, apparently a man and a woman. The woman had been inhumed, the man cremated within a textile-lined, bronze amphora. In an adjacent pit were found the skeletons of four horses, presumably a sacrificed chariot team. Among her several precious funerary trappings, the woman wore a pair of gold disks, with spiral decoration, on her breasts. By the vessel containing the ashes of the man were an iron sword, a spearhead and a whetstone. The textile within the vase had presumably served as the funerary shroud draped over the body prior to its burning. The remains of a structured pyre were noted within the area enclosed by the building. There were signs that this pair had been shown homage for some years after their burial, with an offering platform constructed nearby and drinking vessels strewn around. According to later Greek tradition, it is possible to imagine a funerary cult on the basis of this evidence, with descendants or followers of the deceased couple paying their respects at least annually. For this reason, the building in which the graves were housed has been termed a 'hero-chapel', or *heroon*, by its excavators.

It may indeed have served as such. It has also been

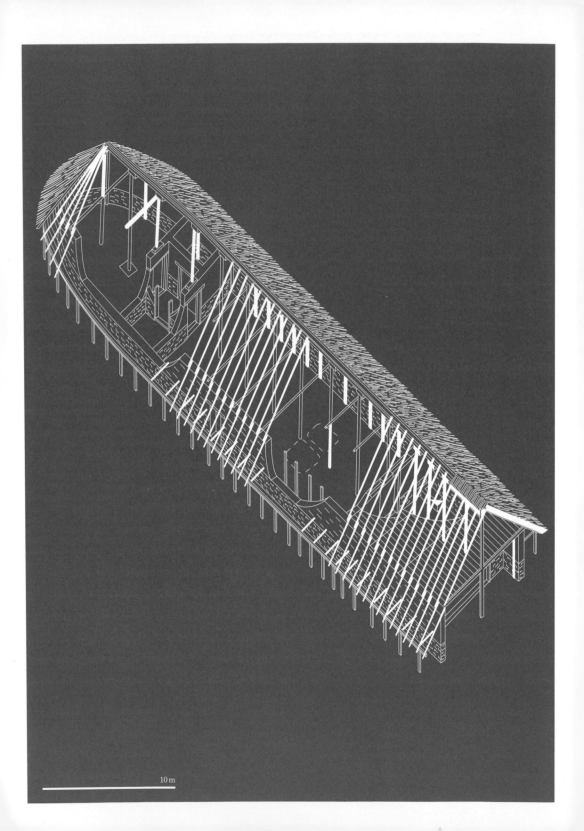

10 m

construed as the actual house of the deceased pair, converted on their premature deaths into a sanctuary, and then, about fifty years later, dismantled and covered with a mound. If so, it must be seen within the genre of the 'Long House', typically the seat of a chieftain or leader in a ranked society. Compounded with the richness of the two graves within the building, this points to more complex development inside the parameters of the Dark Age than is usually supposed.

But whatever its social significance, the Lefkandi structure demands the scrutiny of anyone concerned with the genesis of Greek architecture. We have noted, very briefly, the presence of columns in Minoan and Mycenaean buildings. At Knossos, in particular, the form of these columns appears to anticipate what we shall later recognize as the Doric order. But here at Lefkandi is a disposition of wooden posts that strongly resembles the peripteral or exterior-colonnaded form of the Greek temple. For the building in which the graves were found, whether it was designed as a Long House for the living or a *heroon* for the dead, was apsidal in shape and bordered by a crude but very definite peristyle (34). At about 15 m (49 ft) wide and 45 m (148 ft) long, its dimensions certainly look towards the size of the classic Greek temple, though the walls, built of mud-brick on a base of roughly shaped stones, were hardly monumental. The form of the design is, however, unmistakable, and with a date of 1000–950 BC, it prefigures the first known Greek peripteral temples – either the temple of Artemis at Ephesus, or the rival temple of Hera on Samos – by at least 200 years.

So far, no building of those intervening centuries has been recovered which looks as if it might illustrate an element of continuity between the Lefkandi structure and what are usually taken to be the earliest manifestations of Greek temple design. But it is always worth remembering the motto that 'everything is older than we think', and applying this wisdom to Greek art and architecture. On a smaller scale,

34
Axonometric
reconstruction
of the Toumba
building,
Lefkandi,
c.1000–950 BC

but no less importantly, Lefkandi has furnished another
example of that wisdom. One of the graves of the cemetery,
datable to about 900 BC, yielded a curious four-legged,
hybrid terracotta figure (35). This might be designated some
childish monster, except that with the benefit of later Greek
mythology and iconography we can describe this figure
with more confidence as a 'Centaur' – half-man, half-horse.
Centaurs, in Greek mythology, tend to roam around on the
margins of the civilized world, and generally cause trouble
whenever they get any closer to it. For instance, the west
pediment of the temple of Zeus at Olympia, carved around
460 BC (see 133), depicts the brawl that breaks out when a
legendary Greek tribe, the Lapiths, invites the Centaurs to
a wedding feast (the Centaurs get drunk and start molesting
some of the Lapith women). We do not know what stories
about Centaurs might have been spun at Lefkandi during the
Dark Age, but it is a fair guess that, just as the tales of glory-
soaked warriors and palaces inlaid with lapis lazuli never
disappeared during this time, but survived to be collected by
Homer, so the business of weaving new mythologies contin-

ued. The Lefkandi Centaur will have had a cultural context; he is not a freak of some remote artistic fancy.

The settlement at Lefkandi appears to have been destroyed and abandoned by about 700 BC. We are left to wonder how typical it once was of Dark Age society. The quantity of gold and faïence jewellery deposited in the tombs from sub-Mycenaean times to the end of Lefkandi's existence does not indicate an impoverished community. Though the source of the gold is not clear, other objects from the site suggest trade contacts with the Near East and Egypt, perhaps via Cyprus, not to mention regular exchanges with the nearby mainland areas of Attica and Boeotia. Would our image of the Dark Age disappear if we were able to excavate more sites like this?

The absence of a properly figurative style of decorating pottery is sometimes advanced as proof of supposed artistic impoverishment during the Dark Age, though this argument can be sustained only by those who have no patience with abstract expression. The characteristic style of this period is one made up of geometric patterns. Its first phase is accordingly known as Protogeometric; subsequently, it becomes Geometric, with basic stages of Early, Middle and Late Geometric. In fact, it is not true to say that figures are entirely absent from this style. They are simply very rare intruders upon the purity of Protogeometric patterns, not much more frequently admitted to Early Geometric, and then increasingly featured, but always as stylized and unnaturalistic forms, on Middle and Late Geometric wares. From a purely aesthetic point of view, most modern viewers would probably agree that the most successful of Protogeometric or Geometric pots are those that make no concessions to human or animal forms, but concentrate instead on producing a decoration that strengthens the tectonic shape of the vessel itself.

The most accomplished examples of Protogeometric decoration are highly sympathetic to the potter's art. The turning of pots on a manually operated wheel had been practised by

35
Centaur figure
from Lefkandi,
c.900 BC.
Terracotta;
h.36 cm,
14¹⁄₈ in.
Archaeological
Museum,
Eretria

the Mycenaeans, but evidently a faster wheel was developed
in Protogeometric times, producing crisper outlines for a
dependable repertoire of vase types. Most in demand were
jugs (*oinochoai*) and amphorae: wine jars with handles either
attached, in lug-fashion, to their sides, or else making a
looped join between shoulder and neck. The anthropomor-
phic language used when describing Greek vases – we shall
speak of their feet and their bellies, their shoulders, mouths
and lips – may seem at first odd, but it looks as though
Protogeometric artists understood its implications for their
own abstract strategies.

Casting a glance backwards, we may register that Minoan
and Mycenaean painted pottery was a well-explored field
for artistic expression. No less than sixty-eight different
shapes have been identified in the morphological range of
Mycenaean vases, while certain styles of Minoan production,
such as the eggshell-fine Kamares ware, are still saluted for
their technical achievement. Naturalistic motifs predomi-
nate, and may seem fresh to the point of modern, especially
when they are derived from marine fauna such as octopuses
(36). Compared to such predecessors, the geometricized
stereotypes of Dark Age decoration seem stale and unin-
spired. Yet it has been suggested that Dark Age painters
geometricized the Minoan–Mycenaean naturalistic motifs

36
Mycenaean
stirrup jar
decorated with
an octopus,
from Tomb 39,
Langhada, Kos,
12th
century BC.
Archaeological
Museum, Kos

37
Protogeometric
belly-handled
amphora
decorated with
concentric
circles,
from the
Kerameikos
cemetery, 10th
century BC.
Kerameikos
Museum,
Athens

as a matter of choice. Some of the patterns they used were devices with a straight Mycenaean pedigree, such as the triple wavy line used to emphasize a vessel's widest section. Others turned the swirling tentacles of a Mycenaean vase-hugging octopus into tidy roundels. A fetish for mathematical neatness is a hallmark of the best Protogeometric vases: entirely typical is the concentric circle, often deployed on the shoulder of a vase like an abstract epitome of breasts, or perhaps eyes (37). Such circles or semicircles were produced by constructing a new tool, the multiple brush attached to a compass.

More efficient kilns ensured more careful regulation of firing and perhaps higher firing temperatures, and these gave to Protogeometric pottery the extra sheen of its lustrous black glaze. It is a truth of the ancient world generally that metal vessels were more prestigious than their terracotta equivalents; a truth that we often forget, since pottery survives so much better than metal, which could always be melted down by those who raided tombs in antiquity. Here that truth may be relevant to understanding the dynamics of Protogeometric style. Though they left plenty of pots largely unglazed, painters were perhaps reluctant to detract from the metallic effect of the plain glaze when they

did use it. This would explain why their work so often seems restrained, if not minimalist.

Athens was the leader in the Protogeometric style; it first appeared there around 1050 BC. Further early examples come from Thessaly in the north. By 900 BC, the style had spread widely, from Ithaca to the Dodecanese islands. Its development into Early Geometric is accordingly staggered from region to region, with Athens always ahead in setting new fashions. To reduce stylistic shifts to a matter of fashion may sometimes be to trivialize the process, but in this case it is hard to fathom any other reason for change. The transition from Protogeometric to Early Geometric is marked by apparent dissatisfaction with the mesmeric circles and semicircles produced by the multiple brush and compass. Instead more rectilinear patterns are preferred, such as the meander (38) or the running crenellation.

Human figures are still exceptional. Marginally less shy in their appearance on these Early Geometric pots (produced from 900 to 850 BC) are horses, birds, deer and goats. They begin to appear more frequently during the Middle Geometric period (850 to 800 BC). But it is not until the

38
Early Geometric amphora with a meander pattern, from the Kerameikos cemetery, 875–850 BC. h.72·2 cm, 28½ in. Kerameikos Museum, Athens

Late Geometric phase (800 to 700 BC) that vases, by now
sometimes of massive dimensions, are regularly populated
with figures. Whether human or animal, or representational
of objects such as ships or weapons, these are still very much
part of a patterning scheme that depends on the repetition
of predictable, geometricized shapes. As we shall see in the
next chapter, there were certain new social functions being
assumed by pottery, which encouraged figurative themes in
its decoration. But since one theory about the 'arrival' of
figures on Greek vases holds that it was due to a rediscovery,
during the eighth century BC, of old Mycenaean images, we
perhaps ought to close this chapter with a consideration of
that theory; and make some final assessment of how far we
have got with our search for the beginnings of Greek art.

Undoubtedly the eighth century saw a heightened curiosity
among the Greeks for their prehistoric past. An archaeologi-
cal catalogue can be made of between forty and fifty old
Mycenaean sites or monuments that attracted attention
from eighth-century visitors. This attention mostly took the
form of an offering trench laid out as a focus for worship.
Libations would be poured, and drinking or pouring vessels
then dedicated in the trench, sometimes inscribed 'to the
hero'. The diffusion of Homeric stories through Greek
communities during the eighth century must have nourished
such reverential interest, but there were also wider reasons
behind it. As agriculture shifted during the Dark Age from
nomadic pastoralism to more settled arable farming, local
communities legitimized their claims to property by invoking
ancestral occupation. If a Mycenaean tomb marked part of
the claimed landscape, it was convenient for local people to
imagine that their great-grandparents had been buried
there, and honour the site with overt devotions. Or, as those
communities evolved into cities, it became politic for certain
prehistoric places to be annexed, on similar grounds of
ancestral ownership, in order to establish territorial extent.
Not surprisingly, then, we find several different places in the

mid-Peloponnese claimed during the eighth century as shrines to Agamemnon: the fiercest rivals were Mycenae and Argos, both asserting their rights to the proprietorial and historic identity afforded by the hero.

Herodotus (I.68) has a nice story about a blacksmith in Tegea who came across a prehistoric grave in his back garden and was amazed by the size of the bones inhumed there. In the mid-fifth century BC, an Athenian politician named Kimon annexed the island of Skyros as Athenian property and brought back to Athens a set of colossal exhumed bones said to be those of Theseus, the mythical figure who had united Attica and Athens. The standard Homeric formulae for describing the awesome strength of the heroes at Troy must have been quoted on such occasions – Trojan Hector, for example, easily lobs across the battlefield a boulder which 'nowadays two of the best men in a city could scarcely heave onto a wagon' (*Iliad*, XII.445). The fact that Homer has his heroes cremated must then have been discreetly forgotten. But it may be worth noting that the bodies found by Schliemann at Mycenae were judged to have been six-footers, which is unusually tall for prehistoric individuals.

We know that some Mycenaean relics were in circulation from at least the eighth century onwards. At Eretria, not far from Lefkandi on Euboea, a collective tomb created for six warriors at the end of the eighth century included among its grave accoutrements a Mycenaean bronze spearhead, an heirloom perhaps used as a sign of princely power by one of the warriors. Mycenaean chamber tombs must have been prone to collapse, especially if anyone attempted to build on top of them. Examples of antique metalwork, armour and pottery from Mycenaean tombs will have been encountered as much by accident as any intentional robbing.

Should this 'discovery' of prehistoric ancestors be confined to the eighth century alone? The problem with arguing a 'renaissance' in Greece – on the presumption of a 400-year

long period of depopulation, economic failure and cultural bankruptcy – is that it over-dramatizes the evidence. Hero cults, for example, were not a new phenomenon created by the popularity of Homeric epic. Homer knew perfectly well what a hero cult was, and so did his heroes. It is precisely the prospect of being worshipped back at home that sends Homer's Lycian warrior Sarpedon into battle; and, as we have seen (6–7), Sarpedon's desire for eternal commemoration is indeed fulfilled. Homer is not so much shaping an ideology of heroes as responding to it. Some heroes from olden times never made it into his epic: a good example is the Athenian hero Akademos, whose Bronze Age burial mound was where Plato would found the school accordingly known as the Academy. But the evidence from Lefkandi can leave us in no doubt that the cult of heroes existed long before the composition of Homeric epic.

Greek writers in the historical period, including the generally rationalist fifth-century BC historian Thucydides, believed in the Trojan War as an event that had taken place in Greek prehistory. And 'knowing the past' was a concept for which the Greeks had a word, *archaiologia*. Archaeology in the modern sense was not something that they practised, however. To get at a scientific understanding of how things had actually happened in the past was not important to them. What was important was simply to maintain the faith in the heroic past as a principle of religious credibility. If Agamemnon, Achilles and Ajax never existed, then what was the fate of the gods who sponsored them?

Much of Greek art was devoted to producing images of deities. The heroes, as demigods, were envisioned with equal enthusiasm, especially since so many prominent Greeks would trace their family descent to some ultimately heroic figure. The sixth-century tyrants of Athens, Peisistratos and his sons, did nothing unusual when they advertised a genealogy that started in Pylos with Homer's Nestor. It is clear

that very many Greeks in the historical period believed that they had ancestors who could be traced to the prehistoric era we now denote as 'Mycenaean'. No wonder that by the second century AD, when the traveller Pausanias went there, Mycenae itself was virtually the tourist centre that it is today. (Pausanias was shown the Lion Gate and the tombs of Atreus, Agamemnon and Electra.)

We should combine this record of a heritage culture with two strands of evidence already followed in this chapter. First, the revelation that the Linear B script of the Mycenaeans is a prototype of the language of the ancient Greeks; and second, the gradual archaeological illumination of the supposed Dark Age, which is making it much easier to understand how a collective knowledge of Mycenaean culture escaped oblivion. As far as the language goes, we must still come to terms with the fact that eighth-century Greeks became literate thanks to an external influence, the Phoenicians, whose alphabet forms the basis of Greek script. But an essential continuity with the Mycenaean past was sustained orally, and the result is Homeric epic, with its endearingly anachronistic coalition of features spanning over half a millennium.

Greek art, then, may be said to begin with the Mycenaeans, *ie* around 1600 BC. But the Greeks were also aware of the Mycenaean collapse *c*.1200 BC and some realignment of peoples around the Aegean at that period. Such awareness is what we should understand by the myths of Doros, Ion etc. Mythologizing was the Greek way of transforming time-bound events into the realm of the timeless: so it was that they veiled the acquisition of their alphabet in the complex story of Cadmus, who came from Phoenician Tyre to Greek Thebes, originally in search of his sister Europa and (via many adventures) brought the art of writing to Greece. However this happened, it was a crucial innovation for a culture already obsessed with the power of telling stories. It is to the dynamic interaction of art and storytelling that we now turn.

2

If what we surveyed in the previous chapter was 'prehistory', then when does 'history' begin? Though it sounds like a highly arguable matter, this question can conventionally be given a specific answer: 776 BC. The Greeks themselves arrived at the date, and fixed on it the inauguration of the great four-yearly festival at the sanctuary of Olympia, the Olympic Games. There were stories about Herakles founding the festival and also about its genesis in the funeral celebrations of Pelops, the hero whose grave was supposed to be at Olympia. There were, of course, developments in the various events and protocols of the games, which seem originally to have emphasized equine contests such as chariot-racing. But the fixture of the date of 776 BC became a useful tradition in ancient chronology. It enabled historians from at least the third century BC onwards to compute events in terms of successive 'Olympiads', assuming an unbroken four-yearly cycle, and regular lists of event-winners, from 776 BC. Not surprisingly, the date has since been convenient not only for those who imagine a 'Greek renaissance' in the eighth century BC, but also as a marker for opening general accounts of Greek history (such as the prime Victorian *History of Greece* by George Grote).

Excavations at Olympia over the last century have often been dramatic in their finds, but have forced no major revisions to this traditional chronology. Though the site was undoubtedly frequented in the Bronze Age, substantial traces of cult activity there are not evident much before the eighth century. The first great bronze victory tripods, awarded to successful athletes and gratefully dedicated by them in the sanctuary, belong to this period (41). Once the festival had been institutionalized, it attracted not only more

39
Late Geometric amphora showing a funeral ritual, from the Dipylon cemetery, Athens, c.750 BC. h.155 cm, 61 in. National Archaeological Museum, Athens

distant participants, but also teams of itinerant craftsmen, who put up temporary workshops at Olympia and set about producing trophies and souvenirs. To make small, solid, cast-bronze figurines did not require much specialist equipment. Clay was needed for the mould; a kiln could be constructed on the spot. So it may be assumed that most of the thousands of little bronze offerings recovered from the early layers of excavation at Olympia were made there too. To call them 'souvenirs' is to trivialize their purpose, however. The simplest of them, in the crude shape of an ox or suchlike, may represent the prayers of pilgrims for agricultural prosperity. More ambitious statuettes imply hopes or thanks for success in the games themselves. So we find some tiny charioteers among these early deposits (40), their arms eagerly held out as if thundering along with the reins.

The presence of figures at Olympia (and at other sanctuaries too, though not in such quantity) at a date more or less around 776 BC is a comfort to those who place trust in ancient chronological tradition. But what does it mean in terms of art history? The temptation is obviously to begin the

40
Statuette from Olympia, 8th century BC. Bronze; h.14 cm, 5½ in. Archaeological Museum, Olympia

41
Tripod-
cauldron from
Olympia,
c.900 BC.
Bronze;
h.65 cm,
25½ in.
Archaeological
Museum,
Olympia

continuous story of Greek art here. From the miniature essay
in solid bronze casting, done in clumsy geometric form, we
will embark on a tale of technical exploration that takes us
to full-scale and sophisticated, naturalistic statues. The little
eighth-century charioteer of Olympia will develop into the
mature fifth-century charioteer of Delphi (see 115). It is then
easy to believe that Greek art was driven by a collective
desire on the part of artists to produce ever more realistic-
looking figures. Moreover, it is true that there was an
unusually accelerated change in the style of figurative repre-
sentation in Greece, over the course of little more than 200
years. Yet we must not become too absorbed in the evident
demonstrations of new artistic skills during this period. For
'new' is only relative: the techniques used by Greek artists
had been known elsewhere for many years (in Egypt, for
example, large-scale bronzes were being cast as early as the
third millennium BC). Since we have lost virtually all
remains of one extremely important medium – wood – in the
development of figurative art, it is unwise to go hunting for
the presumed 'origins' of a particular Greek style as such. A
much more cogent enterprise is to try to clarify the demands
being made on artists in the eighth century and beyond.

At Olympia the opportunities for bronzesmiths multiplied as
the sanctuary expanded to welcome more visitors. The estab-
lishment of a circuit of games and meetings in the eighth
century fostered interaction between artists from various

parts of the Greek-speaking world, and offered work to those from further afield too. Olympia stayed pre-eminent, well into its period of Roman patronage; but not far behind in terms of inter-Greek status were the meetings at Delphi, at Isthmia near Corinth and at Nemea in the northern Argolid.

In very broad terms, the period between 1200 and 800 BC in Greece has been termed a transformation 'from pasture to *polis*' ('city-state'). The settlement of land for arable farming, as opposed to the nomadic patterns of grazing livestock, tended to stabilize local communities. In turn such communities favoured the establishment of institutions: social, religious and political. These would eventually become the structures that made up the Greek unit of local identity known as the *polis*. What we witness from the eighth century onwards is the consolidation of those structures. In literal terms, architecture was essential to the process, but the output of images was hardly less important. In areas of increasing social complexity, images provided a precious system of signposting.

It is against such a general background that we should resume our account of vase-painting. The significance of this medium is undoubtedly exaggerated, due to its unusual capacity for archaeological survival. But at least we can register, in fairly precise chronological terms, the arrival of figures on painted pottery. Unwelcome in the abstract range of Protogeometric decoration, they only begin to appear piecemeal in the regional variants of Early and Middle Geometric. Then there is a perceptible intrusion. It seems gentle enough with animals, because the painters made no effort to render them naturalistically. A file of grazing deer and waterfowl, for instance, becomes simply another band of geometric motifs amid many other bands (42); a pair of horses will be harnessed for their heraldic possibilities, not presented as studies of equine anatomy. However, although it is also true that

42
Late Geometric krater from Kourion, Cyprus, c.750 BC. h.115 cm, 45⅜ in. Metropolitan Museum of Art, New York

human figures are geometricized no less strictly than animals, we cannot help regarding the humans with extra interest. Suddenly, an element of performance has entered the decorative scheme. Even if their torsos are rendered as triangles, these people are engaged in activities that we can recognize.

The date assigned to the start of this figurative Late Geometric vase-painting is around 770 BC, remarkably close to the traditional inception of the Olympic Games. The place is Athens; but we can be even more specific than that. The vases on which the figures appear are large vessels. They are for the most part tall, belly-handled amphorae or wide-brimmed kraters. Relative to the normal dimensions of these shapes, they may be described as 'monumental'. On the evidence of stylistic homogeneity in their decoration, it looks as though many of them were produced by a single workshop. Since their provenance can be generally traced to the area of an ancient Athenian cemetery by the entrance to the city, known as the Dipylon, this workshop has been called the 'Dipylon Workshop' (and some scholars presume to identify an artist, whom they hail as the 'Dipylon Master').

What were the vases doing in a cemetery? Their excavation makes it clear that they did not serve as repositories for cremated bones, and indeed they were not originally buried at all. Rather, they stood on top of graves as markers (*semata*). Some have been found with holes knocked through their bases, suggesting perhaps an improvised access for the pouring of libations to the grave beneath. So we appear to have a clear function for these pots. Although it was a passing fashion, and highly localized, this function should help us determine the meaning of the figured decoration.

And so it does, at least partly. On one of the earliest of the big grave-marking amphorae (39), we see a figured panel on the most prominent part of the vase and it presents no problems of interpretation. Among the multiple bands of mean-

der keys and other abstract motifs there is a file of grazing deer, as well as a line of recumbent deer, but they do not attract our attention as the central panel does. Here we see a plangent ritual depicted, the event the Greeks called the *prothesis*, the 'lying-in-state' of a dead person. The ancient Greek funeral has been described as a three-act drama, and this *prothesis* was the first act. In reality it could last over a fortnight. The deceased, having been washed and embalmed, was laid out on a couch, to be mourned by family and friends. In due course, the drama would be completed: the body transported ceremonially by wagon to the cemetery (what was called the 'carrying out', or *ekphora*), and then, in the final act, either cremated and buried, or simply buried.

During the *prothesis*, wailing laments or threnodies were sung. The figures on our amphora have their arms akimbo in the posture of overt bereavement (they should be imagined as slapping their heads, or even tearing their hair, as the figures shown on the neck of a slightly later amphora; 43), including those kneeling or sitting under the couch. The smaller-scale figures may be children or slaves. As for the deceased, it must here be a woman, given the long skirt. We can appreciate to what extent this is conceptual art by the chequered design above the couch; this must be the woven blanket used to cover the corpse during the *prothesis*. On the neck of another Late Geometric pot we see a figure hurrying along with just such a shawl (44). On our amphora panel, the artist has considerably lifted up this cover, so that we too can see the object of communal grief.

44
Late Geometric amphora from Athens, 8th century BC.
h.30 cm, 12 in.
Metropolitan Museum of Art, New York

The vases that once marked the graves in the Dipylon cemetery in early eighth-century BC Athens have figures on them for a reason, then: to complement their purpose as markers, or signposts. As such, we can readily make sense of the figurative imagery: it helps define the funerary purpose of the object. Since amphorae were normally used as storage jars, the image of the *prothesis* on a large amphora standing out

in open ground would at least detach it from its normal func-
tion and give it a special identity. Although the decoration is
conceptual rather than illusionistic, there is no reason to
suppose that the vase does not in some sense open a window
onto eighth-century BC Athens: it gives us a picture, that is,
of the sort of ritual enacted at an eighth-century funeral.

This does not, however, explain everything. The *prothesis*
scenes are not isolated. The big grave-marking vases also
feature some clearly militaristic images. They may be
processional, with warriors marching along and chariots
assembling, or they may show pitched combat, on land or
at sea, with vicious hand-to-hand exchanges, bodies
toppling and corpses piling up (45). In association with the
funerary purpose of the vases, are we to assume that these
battles represent the mode of death? A grim vignette of
eighth-century existence is thereby indicated. In fact, the
vase-painters have sent out a very strong message about
the chronology of these battle scenes. By the inclusion of
one highly archaizing attribute, they have warned us not to
take the fighting portrayed here as contemporary fighting:
the shield is a geometricized version of a type with sides
curved inwards, more or less in the shape of a figure-of-eight,
known to have been in use in Mycenaean times. It is unlikely
to have been in use during the eighth century, when the
completely round shields of the Classical Greek infantry
were already appearing. So it seems to be deployed artisti-
cally as a token of the past, to create a distance between
the actual event of the funeral and the rumbustious violence
below. The question is: why?

To answer that question we must ourselves indulge in some
anachronism and speed forward to the beginning of the
fourth century BC. The philosopher Sokrates has been put
on trial in Athens and condemned to death. He takes the
charge, as we might say, 'philosophically'. His reasoning
proceeds like this. Death must be one of two things: either

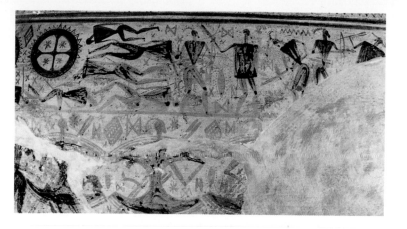

45
Fragment of a
Late Geometric
krater showing
combat, from
the Dipylon
cemetery,
Athens, 8th
century BC.
h.38 cm,
15 in (height
of original vase
c.100 cm,
39½ in).
Musée du
Louvre, Paris

one passes into oblivion and there is no consciousness of
anything; or else, as most religions promise, the soul is
transferred to some other place. If it is the former, then
there is nothing to be feared: it will be just like a long sleep,
undisturbed by dreams. If it is the latter, then what is there
to worry about? As Sokrates says to those who have
condemned him (Plato, *Apology*, 40–1):

If death is a transition to another place, and it is true that there
we shall find (as the poets say) all those who have gone before,
what could be better than that? … What would not any one of
you give to converse with Orpheus and Musaeus and Hesiod and
Homer? I, at least, would die many times over, if this is what
happens. It would be marvellous, in my opinion, for me to be able
to meet up with Palamedes and Ajax and other heroes of the past
who died from miscarriages of justice, and compare my situation
with theirs … and what would one not give to be able to put
questions to Agamemnon, who led the great army against Troy,
or Odysseus, or Sisyphus, or the thousands of other men and
women one might mention? It would be absolute bliss, to be with
them and talk to them.

The clients of funerary vases in the eighth century BC were
not literate, and we have no way of telling if their beliefs in
an afterlife resembled the attitude of Sokrates. But, as we
noted in the last chapter, the eighth century was a time of

widespread enthusiasm for the heroes of the past, and we know that it became fashionable for prominent families in Athens to trace back ancestries to Homeric figures. (There is a theory, incidentally, which argues that it was in the course of exploring old Mycenaean tombs for heroic relics that Greeks in the eighth century came across examples of the figurative art of the Mycenaeans and developed their own figure style as an act of virtual homage or emulation.) So might we see in the juxtaposition of funeral scenes with excerpts or evocations of the heroic life some statement of belief? If the patrons of these vases imagined that there was an underworld containing a community of heroes, to which death gloriously consigned them, or that they were descended from the very men who once upon a time battled it out on the Trojan plain, then the iconography, linking the contemporary funeral with antiquated warriors, begins to make sense.

It remains impossible to say how far a specifically Homeric identity can be attached to these massed figure scenes. The

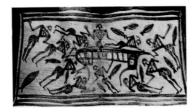

neck of a wine jug or *oinochoe* decorated with a shipwreck (46–7) – one man straddling the keel of an upturned boat, his shipmates adrift among fish – has suggested to some an episode from the *Odyssey*, perhaps the end of Book XII, when Odysseus alone survives a hurricane at sea. But of course there are no labels on the vase to confirm this particular identification. On some of the battle scenes there appears to be a pair of warriors not just fighting together, but physically joined. Since Homer mentions some formidable Siamese twins, Aktorione-Molione, who were killed by Nestor in some pre-Trojan encounter, it is difficult to resist supposing that these Homeric curiosities were not intended. But since there is no labelling of figures at this pre-literate stage, we can rarely be sure of supposed epic connections. Typical of the interpretative difficulties that arise is a krater of around 735 BC, showing a ship fully staffed with two banks of rowers, and a man and woman apparently about to embark (48). The man has the woman by the wrist, so it may be a forced abduction. Several mythical possibilities suggest themselves: Paris seizing Helen and taking her off to Troy; Jason taking Medea; or Theseus leading Ariadne from Crete? All or none are possible, though perhaps a little indicator is given by the wreath or garland in the woman's hand; it may be the magical 'Crown of Light' with which Ariadne illuminated her own retrieval by Theseus in the labyrinth of Knossos.

Speculation about the epic influences on the development of figurative art in eighth-century Greece is warranted by the phenomenon we have already mentioned: the general tendency to blur the cognitive boundaries of what was 'heroic' and what was 'contemporary' or 'generic'. It does not matter if the artists' knowledge of epic tales was entirely received from the oral delivery of those tales by travelling bards or rhapsodes. Moreover, it makes no sense, in this period, to distinguish epic traditions from folkloristic storytelling.

The songs a painter heard when being dandled on his grand-

48 Overleaf
Athenian Late Geometric spouted krater, c.735 BC. h.30 cm, 12 in. British Museum, London

46–47
Late Geometric *oinochoe*, c.750 BC. Staatliche Antikensammlungen, Munich
Far left
Composite photograph showing the complete shipwreck scene around the neck
Left
Complete jug

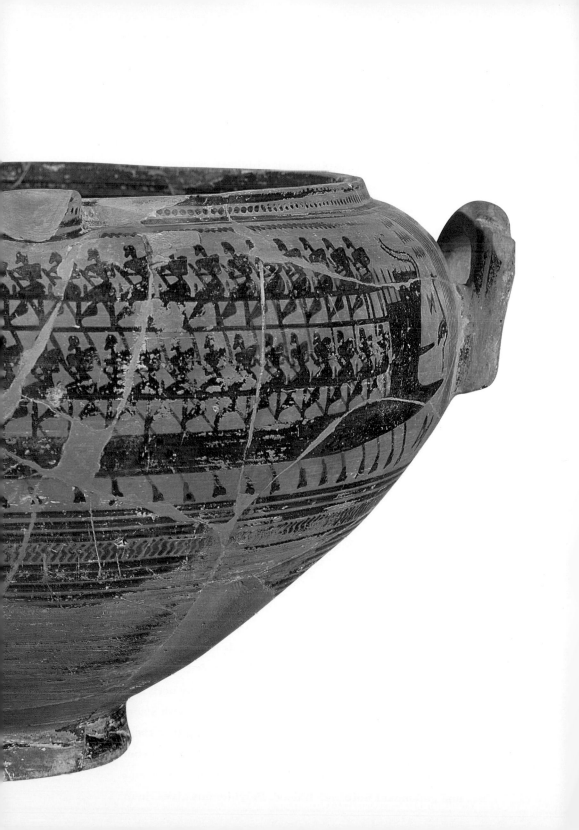

mother's knee were songs that belonged to the community, and the canonization of certain tales into 'Homeric' epic was made possible only by an ethnic sharing of those tales. Of course there were many local variants, and no doubt the itinerant poets added details of local colour to delight a particular audience, but it was in this period that structures of narrative became established, which we can recognize as 'classics'. To speak of 'canonization' is to evoke a Greek word, *kanon*, meaning 'reed' or 'rod': a unit of standard measurement. Early Christian scholars used the word to specify lists of texts deemed worthy of preservation, to create a body of literature that defined the orthodox against the irregular. What happened in the eighth century BC was the beginning of a similar process in Greek culture. Eventually a set of stories would literally be instituted: the stories that all members of the Greek-speaking world could count on having in common. Certain social practices, such as the official drinking party, or symposium, at which poets would perform, accelerated the diffusion of tales. The contribution of art towards this process of canonization was crucial.

We may trace the artistic process as it occurred around one specific narrative during the seventh century BC. This is the story which appears in Book IX of Homer's *Odyssey*, as Odysseus relates his seaborne adventures to King Alkinous of Phaeacia. It is the fantastic tale of a colony of monsters called the Cyclopes: huge, shaggy, one-eyed beasts who lived in caves rather than cities, and knew none of the trappings of civilization. Blown towards their island, Odysseus and his shipmates attempt to curry the friendship of one of these Cyclopes, called Polyphemus, by arriving at his cave with a large bottle of wine. It is done with some trepidation: as Odysseus says, he had a feeling that they were going to find themselves 'face to face with some being of colossal strength and ferocity, to whom the law of man and god meant nothing'. Indeed, Polyphemus gives them

an ungrateful reception: after hearing Odysseus' plea for hospitality, he seizes two of the shipmates, dashes them against the floor as if they were puppies, tears them apart and devours them, flesh and bones and all. He rolls a great boulder across the entrance to his cave, so that they are all trapped. So much for a convivial supper. In the morning, he takes two more men and eats them for breakfast. Blocked in the cave by a boulder that they could never move by themselves, Odysseus and his men seem doomed to be the dietary relief of a monster whose usual fare is cheese and milk from his herd of plump sheep.

Polyphemus goes off for the day on his shepherding duties, and Odysseus hatches a plan. He takes a staff which Polyphemus has left in the cave – a staff the size of a ship's mast – and sharpens it to a point, which he hardens in the fire. He conceals it under some mounds of dung. He briefs four of his shipmates with the job of wielding the stake in due time; but first, he needs to get Polyphemus to go to sleep. When the giant returns in the evening, and again takes up two of the men for his meal, Odysseus comes forward with a bowl of the wine he had brought with him. 'Here,' he says, 'have some wine to wash down that meal of human flesh, and taste for yourself what kind of vintage we have stored in our ship's hold.' Polyphemus indeed finds it a good nectar and asks for another bowl; and another, and another. Polyphemus asks to know the name of his benefactor, in order that he may return the kindness. As the giant begins to show signs of befuddlement, Odysseus volunteers his name: 'They call me Nobody,' he says. 'Well, Nobody,' grunts Polyphemus, 'I shall eat you last. That shall be your gift.'

Moments later, Polyphemus slumps to the floor of the cave, drowsy with drink. This is the time to strike. Odysseus and his four chosen companions hold the point of the sharpened pole in the heat of the fire, then drive it sizzling into the single eye of Polyphemus, who utters a tremendous bellow.

Staggering blindly around the cave, he shrieks for help from other giants in the vicinity. Here the ruse of Odysseus pays off, for when these other Cyclopes gather outside and ask what is the matter, and who is attacking him, Polyphemus simply cries 'Nobody! Nobody is attacking me!'; so they leave him, saying that he must be sick. He then gropes for the boulder at the mouth of the cave, rolls it away and squats there, intending to catch the men as they try to slip out.

The next stage of the plan is ingeniously simple. Odysseus and his men cling to the underbellies of the flock of Polyphemus as it passes out of the cave. Hanging beneath the fleeces of the sturdy rams, they manage to deceive the giant. He is left blinded and raging against the taunts of the now cocky Odysseus, who steals the sheep to complete his revenge.

Reading this story as Homer tells it, we can understand its memorable appeal: a giant with an appetite for human flesh, apparent doom in a dark cave, and a cunning stratagem for escape. The inclusion of drunkenness from mellow Greek wine no doubt added to the suitability of the tale for performance at a symposium. Perhaps that is why the painters who decorated vases used for institutional drinking purposes liked to 'illustrate' the story for their patrons. But, as E H Gombrich has demonstrated, what most encouraged Greek artists to join in the activity of storytelling was the fundamental nature of that storytelling. Homer and his colleagues were shaping a type of narrative that went in quite a different direction from the narratives of other cultures. Other cultures, in Egypt and the Near East for example, had their stories, but those stories, such as the epic of Gilgamesh, were chiefly concerned with telling *what* happened. The Greeks had a different priority: they liked to describe *how* something happened. Homer loves to imitate voices, create direct speech and empathize with his characters. In the story of Polyphemus, for example, he gives us a very

tender moment, as the giant is patting the sheep to which Odysseus is clinging: Polyphemus recognizes it as his favourite ram, 'always the first to crop the lush shoots of grass, first to trot down to the flowing stream ... now you are last of all. Are you hurt by what has happened to your master, blinded by a rogue and his wretched accomplices?' This is a detail of pathos that humanizes even a vicious giant. No wonder that when tales were told in this manner, artists were eager to translate them into visual terms; and, more importantly, were eager eventually to make them as realistic and convincing as possible.

The first known depiction of the Polyphemus story appears on a krater. In the symposium, the krater was the vessel used for mixing wine with water, and as such often served as the ceramic centrepiece of the party. Early in the seventh century BC, an émigré Greek from Euboea who had settled in the West, perhaps at Etruscan Cerveteri, painted on the side of a krater the crux of the Polyphemus story: the moment when Odysseus and his four helpers drive the pointed shaft into the eye of the monster. He then signed the painting with the words, written in retrograde script, *Aristonothos epoiesen*, 'Aristonothos made [this]'. It is a curious name, meaning literally 'best bastard', but we are grateful enough for its appearance here. This is one of the first signatures on a Greek work of art, and indeed one of the first certainly identifiable scenes of Homeric epic in Greek art. The twin phenomena – literacy and canonical epic – may not be unconnected: since our earliest Greek inscriptions, in fact, are in regular poetic metre, some scholars salute Homer as the historical catalyst of the adoption of letters in Greece.

At any rate, it is hard to believe that this Aristonothos had not heard, or possibly even read, a version of the Polyphemus story very close to the one we have in our copy of Homer (which is essentially the literary text codified in Athens during the sixth century BC). The object behind the slumped

Polyphemus is identifiable as a pole supporting piles of cheese, as if Aristonothos were aware of Homer's description of the interior of the cave, including as it does 'baskets laden with cheeses' among the milking gear. Can it really be no more than coincidence that Aristonothos has shown us five men – Odysseus plus his four companions – ramming home the stake?

Although fragmentary, a similar vessel from Argos evidently shows the same story (49), and here the artist may also have had echoing in his mind Homer's graphic description of the blinding: 'We twisted our pole with its red-hot point like a drill in his eye, till blood boiled up round the burning wood.' On the neck of a large amphora once used as a coffin for the remains of a young boy at Eleusis, near Athens, although the artist ran out of space for his figures (50), he remembered that Polyphemus was drunk when the stake was driven home, and so shows the giant clutching a type of drinking cup known as a *skyphos*.

Subsequent figurative versions of the story try to squeeze more elements in: on the inside of a drinking cup produced in Sparta, several different moments of the narrative sequence have been reconciled, as we see Odysseus and his men with the stake at the same time as actually offering the wine cup to the Cyclops, who is only halfway through his cannibalistic meal (51). Such chronological compressions are the distinguishing feature of a type of Greek artistic narrative known as 'synoptic', since it wants to put more into a narrative scene than space can reasonably accommodate, and therefore relies on the viewer remembering what happens. Such are the expectations or assumptions of artists in a culture where canonical mythology exists. While we can salute the astonishing circulation of one particular story across the Greek world in the seventh century BC, we should also remind ourselves of what a task it could be to render mythology in pictures. Let us

49
Fragment of a bowl, showing the blinding of Polyphemus, mid-7th century BC. h.25 cm, 9¾ in. Archaeological Museum, Argos

50 Right
Amphora from
a grave at
Eleusis, Attica,
mid-7th
century BC.
h. 142 cm,
55⅞ in.
Eleusis
Museum

51 Far right
Drinking cup
from Sparta
showing the
blinding of
Polyphemus,
c.550 BC.
diam. 21 cm,
8¼ in.
Cabinet des
Médailles,
Bibliothèque
Nationale,
Paris

look again at the Eleusis amphora (50). The principal scene on the body of the vase is also a recognizable story. On the far right of the picture as we see it, a pair of dark legs is running away; they belong to the hero Perseus, who has just decapitated the monstrous gorgon Medusa, whose face could turn men to stone. On the other side of the vase is the headless body of Medusa, seen sideways on, left floating as it were in mid-air. In the centre, two skirted figures are running after Perseus with their arms outstretched. Between them and the fleeing hero is a statuesque lady with a spear: she must be the goddess Athena, who helped Perseus in his deed.

All early instances of figurative myths are exciting, but perhaps the significant iconographic interest of this scene lies in the depiction of the two central figures. They must be Medusa's sisters and fellow-gorgons, known as Sthenno and Euryale. The seventh-century poet Hesiod describes them as the embodiments of 'great Fear' (*megas Phobos*), and perhaps the painter of this vase had heard that description of his subjects. But how did that help him to visualize their appearance? This is one of the earliest, if the not the earliest, of gorgon images in Greek art. So there was no stereotype of the image available to the artist. He was bound to invent one. If we look closely at the vase, we see that his solution was rather bizarre, in the light of the gorgon stereotype that later emerged (52). He chose to make their faces out of tripods; the sort of tripods dedicated at sanctuaries in this period, with protrusions of griffins or snakes from their bowls. Such protrusions here become the ears or hair of the gorgons. On the tripod bowl faces he painted a sort of nose, two great bulging eyes and a wide slash of a mouth, filled with serrated teeth. The result was striking, though not so far as we know ever repeated by any later artist. It was a brave piece of painting, necessarily experimental.

52
Amphora attributed to the Berlin Painter, showing a gorgon. From Vulci, early 5th century BC. Staatliche Antiken-sammlungen, Munich

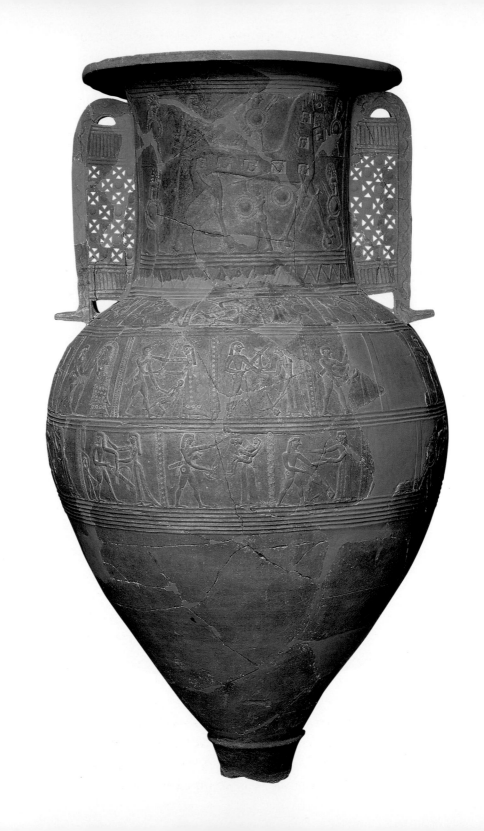

A further reminder of the problems archaic artists faced in providing their communities with images of familiar stories is shown by an example of relief decoration from the Cyclades (53). On the capacious walls of a storage jar or *pithos* from the island of Mykonos, the artist has given us key emblems of a sombre epic theme. It is the fall of Troy (*Ilioupersis*), and on the neck of the vase we are shown the military ruse that led to the events described on the main body of the *pithos*. The Greeks gained access into the besieged city of Troy by means of a great hollow wooden horse which they gave to the Trojans, ostensibly as a gift. Despite the warnings of their priest Laocoön, the Trojans took in the horse, not knowing that it was filled with Greek troops. At night, the Greeks poured out, and Troy was sacked.

53
Storage jar showing scenes from the fall of Troy, from Chora, Mykonos, mid-7th century BC. h.13 cm, 5⅛ in. Archaeological Museum, Mykonos

There is an ambiguity in this scene as it is presented here: warriors are apparently moving around and on top of the great horse, and we cannot be sure if they are intended as Greeks disembarking or suspicious Trojans. But the artist has helped his viewers by adding some special windows to the horse. So we, the viewers, may see what the Trojans never did: warriors, sitting at the windows like passengers in an aircraft. Perhaps, then, they resolve the ambiguity: it is *these* figures who will enact the savageries we see below.

In the multiple panels below, there does not seem to be any sort of continuous narrative, but rather a series of snapshots, more or less similar in content, whose cumulative power is precisely one of repetition. Apart from one warrior shown tumbling dead, the panels show women, some with their children, remonstrating with or defending themselves against armed men. In later scenes of the fall of Troy, painters usually isolated three specific incidents of this sort: the rape of the prophetess Cassandra, the seizure of Helen (whose abduction by Priam's son Paris started the whole war) and the assault on Hector's wife,

54
Pediment from
the temple of
Artemis, Corfu,
showing
Medusa,
*c.*600–580 BC.
Limestone;
h.315 cm,
124$\frac{1}{8}$ in
(at centre).
Archaeological
Museum, Corfu

Andromache, and his little boy Astyanax. The death of
Astyanax is often gruesomely poignant, as he is battered
to death by a Greek (Neoptolemos, son of Achilles)
swinging him by the ankles. One of the panels on this
pithos may depict that particular incident, though other
children are suffering too. The pre-eminent concern of
the artist here seems not so much a chronicle as an evoca-
tion: like the Spanish artist Francisco de Goya (1746–1828)
selecting motifs to lay bare the horrors of war. Yet without
an epic basis, the images are only semi-potent. The Greek
epigram often quoted in discussions of ancient artistic
narrative – 'a poem is a speaking picture, a picture is a
silent poem' – does not in fact help us to understand
what is happening in this archaic period. Images rarely
epitomize stories. Artists relied on the factor of epic
canonization, and the formulaic, almost incantatory
language of oral poetry to supply the links and lacunae
of their representations. Art and text were interrelated,
but not interchangeable.

It was the nature of this interrelationship that enabled
the sculptors of the earliest temple pediment decoration
in Greece to assemble a medley of images and present
them as if they formed a coherent whole. This was at the
temple of Artemis on Corfu (ancient Corcyra), which in
the late eighth century BC was an island colonized by
Corinth. The surviving limestone pediment decoration
(54), executed in high relief, has at its centre a myth that we
have already encountered: the gorgon Medusa, snakes
flying from her head (and making a neat belt for her dress),
running in a sideways direction but facing us head-on,
her eyes bulging and her tongue flashing out. This time
she still has her head. Yet immediately to either side of
her are traces of figures who should not, logically, be there.
One is the winged horse, Pegasos; the other is a youth,
who must be Medusa's offspring, Chrysaor. Perseus is not
represented, but according to the legend (recounted in

two seventh-century poems by Hesiod, the *Shield of Herakles*, 216ff., and the *Theogony*, 270ff.), Pegasos and Chrysaor were born at the moment when he decapitated the gorgon.

How can these two figures be present when Medusa still has her head? The answer lies again in the penchant of early Greek artists to give us a synoptic version of a story, in which sequential events may be compressed in defiance of chronological unity. There are two very good reasons, in the context of this temple, why Medusa should retain her head. The first is that, as a grotesque and florid mask, her face has the power to inspire fear in its beholders: she marks a holy place. In such a capacity a gorgon's head (known as a *gorgoneion*) would often be used to signify a sacred vicinity, like the gargoyles of a Gothic church. Secondly, we should remember that this was probably a Corinthian-funded temple. The story of Perseus had special local associations for Corinth, a city which used both the gorgon's head and the motif of flying Pegasos as emblems on its early coinage. The people of Corfu were duly reminded, by Medusa's visage, of Corinthian power.

As the pediment narrows out, further images join the medley. Two great crouching panthers are next, reminding us that this is a temple dedicated to the goddess Artemis, who was known as 'Mistress of the Beasts' (*potnia theron*), and is often depicted with a pair of lions or other predatory felines at her command. So have the sculptors also relaxed the unity of Medusa's person and allowed her to adopt the vengeful role of Artemis here? This is very likely. Then, in the corners of the pediment, any unity of scale is abandoned, as relatively diminutive figures appear: one sitting on a throne, apparently being threatened; others prostrate, or falling to the onslaught of a thunderbolt. Episodes of primal cosmology – Zeus battling against the Titans – may be intended; the figure on the throne has also been inter-

preted as Priam of Troy, suffering the Greek invasion of his city. Depending on which stories are applied to the images, a vague unity of theme can just about be mustered for the entire medley: perhaps punishment and guilt, as the gorgon chases Perseus, Zeus strikes down the Titans for attempting to climb up to heaven, and Priam pays the price for failing to discipline his son Paris, whose abduction of Helen from Sparta started the whole war. But this is a rather desperate attempt to impose a single message on the monument.

The Corfu pediment testifies to a measure of inexperience in its medium. Some attempts at large-scale limestone decoration are known from a temple at the Cretan site of Prinias, but apart from these there is little else prior to the Corfu pediment with its disunity of time, scale and perhaps even theme. Within a century, sufficient experience had been gathered to resolve those disunities. The essential quality of Greek narrative, stressing not so much *what* happened as *how* it happened, propelled artists in the direction of naturalism. Synoptic compressions of stories would accordingly be eschewed, just as the conceptual, geometric forms of figures were left behind. This drive towards naturalism is the single most important contribution of the Greeks within the general history of art. We shall now try to locate its energetic progress inside the expanding physical and intellectual horizons of Greece in the seventh and sixth centuries BC.

3

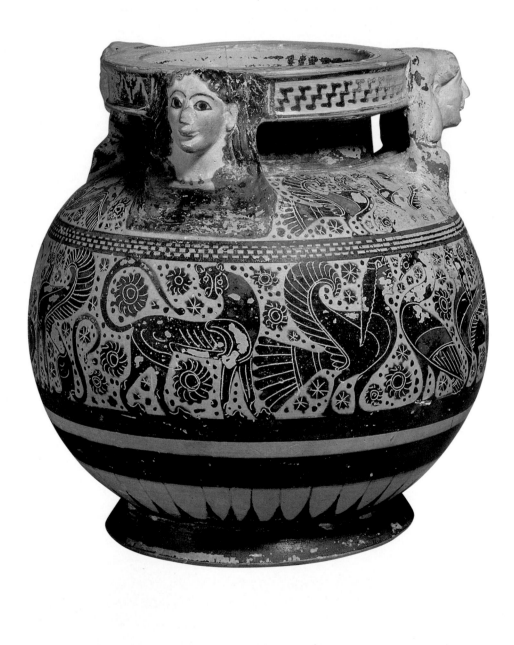

The Greeks had no satellite maps of the world, but they
had the imagination to create a metaphor for a heavenly
overview of their geographical situation. As Plato put it:
they were like frogs around a pond. In broad terms, that
pond was the Mediterranean Sea.

The Greek colonization of the shores of the Mediterranean
was geographically superficial but historically profound.
The metaphor of the frogs around a pond was apt because
Greek colonists stayed close to the water. Wherever possible,
they colonized areas of deeply indented coastline, which
enabled them to retain their vicinity to the seaboard and at
the same time exploit the surrounding land. They naturally
made contact, whether hostile or amicable, with indigenous
populations and gradually created extensions of territory
inland. But the coast-clinging nature of the colonies forms
a conspicuous pattern.

Historically, the Greek colonies may be said to have laid
the basis of 'Classicism' in the West. The diffusion of Greek
institutions, philosophies, science, art and culture relied on
the process of colonization. At the most direct level, ideas
travelled because people travelled. The colonies offered
opportunities for innovative minds to try out new schemes of
politics, town-planning and social organization. At the same
time, certain canonical forms of Greek culture – in poetry,
for example, and architecture – were transmitted abroad.
The colonists passionately valued their Hellenic identities,
but were also keen to assert independence. Their situation
may be characterized by a story told in connection with a
key military event towards the end of the fifth century BC,
when a fleet dispatched from Athens to attack the colony of

55
Corinthian
pyxis,
*c.*600–575 BC.
h.19 cm, 7½ in.
Ashmolean
Museum,
Oxford

Syracuse in Sicily came to grief. The Syracusan Greeks had
no compunction about destroying their Athenian Greek
aggressors: this was in fact part of the wider inter-Hellenic
conflict which we call the Peloponnesian War. But it is said
that when some captured Athenian sailors were brought to
the port of Syracuse, they were shown mercy on one condi-
tion: that they perform for the colonists some of the choruses
by the Athenian playwright Euripides. The incident may be
apocryphal, but it has general plausibility as an epitome of
the Greek colonial situation.

The origins of colonization can be fixed in the early eighth
century, when, around 770 BC, pioneers from Eretria and
Chalkis planted a small settlement at Pithekoussai on the
island of Ischia, in the Bay of Naples. The archaeological
traces of these pioneers show them to have been not bounty-
hunters but traders and craftsmen, interested in gaining
access to raw metals from Elba and central Italy. Though
Pithekoussai cannot be termed a proper colony – the Greeks
would have referred to it rather as an *emporion*, or 'trading-
post' – its founders may be seen as setting the shape of things
to come. For metalworkers, artists, architects, stonemasons
and sculptors were germane to the colonial effort. The initial
motives for making the journey may have been focused
economically on land – its shortage at home, its abundance
elsewhere – but land brought space for buildings, new avail-
abilities of materials, and soon enough the sort of prosperity
that translated into artistic commissions.

Colonization concentrated the minds of the Greeks. If they
were going abroad to establish new cities, the question
naturally arose: what makes a city? What we witness during
the seventh and sixth centuries BC, when most of the Greek
colonies were established around the Mediterranean, is a
sharpening of the definition of the concept of 'the city'. In
the eighth century BC, in its Homeric usage, the word *polis*,
or city, signifies 'citadel', a fortified place. By the end of the

sixth century, its connotation is quite different. *Polis* then
implies not only an assemblage of buildings and walls, it also
denotes a state of mind; an attitude. Those who live in the
polis, including those who dwell in the rural hinterland on
which it depends, think of themselves as belonging not so
much to a particular household (*oikos*), nor even to an
extended family (*genos*); they are part of a *polis*, which is
much more than a fortified place in which to take refuge in
times of danger. The *polis* is a community which cultivates
guardian deities, and requires temples and shrines for
the accommodation and worship of Olympian gods and
goddesses, or heroes from the past. The *polis* can reproduce
itself: hence the colonizing movement, which must always
be treated as the business of individual city-states, not
some kind of general Greek empire-building. The *polis* is
defended by those whom it serves: hence warfare becomes
conducted in a manner that requires not élite squadrons of
aristocratic cavalry, but massed ranks of infantrymen.
Each man carries a large round shield that overlaps with
the shields of those on either side of him: this is the disci-
pline known as the phalanx (56–7), and it is a military
arrangement precisely suited to the Greek *polis*. When one
polis was not fighting another, there had to be central places
where the many independent cities could get together and
share what was culturally common to them: poetry, athletics
and religion. Hence the phenomenon of the Panhellenic sanc-
tuaries, such as Olympia, Delphi and Delos. Their monumen-
tal development did not occur in isolation: though they may
have been situated in remote and sparsely populated parts
of Greece, these sanctuaries must be regarded as part of the
ideological brickwork of the archaic *polis*.

The relationship between cities, sanctuaries and colonies
has a complex importance for our understanding of Greek
art, for the typical *polis* has fairly been described as a 'city
of images', a place not so much adorned as supported by art.
Art provided a prime means of expression by which colonies

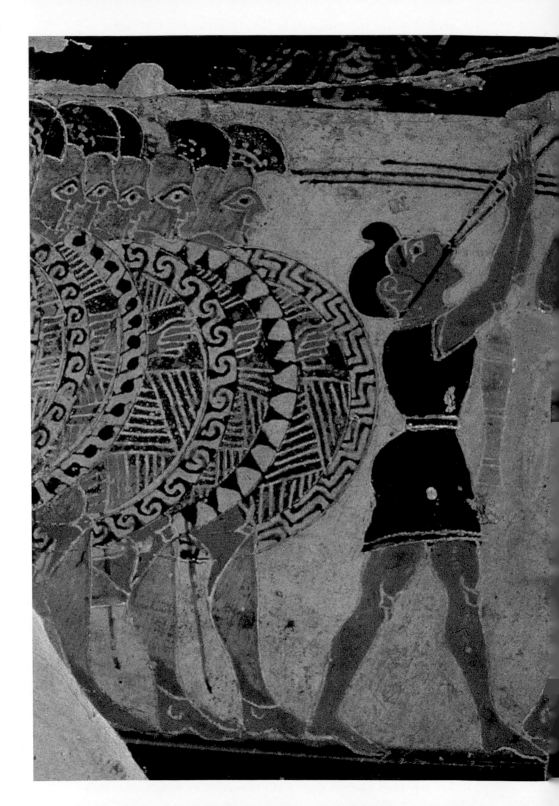

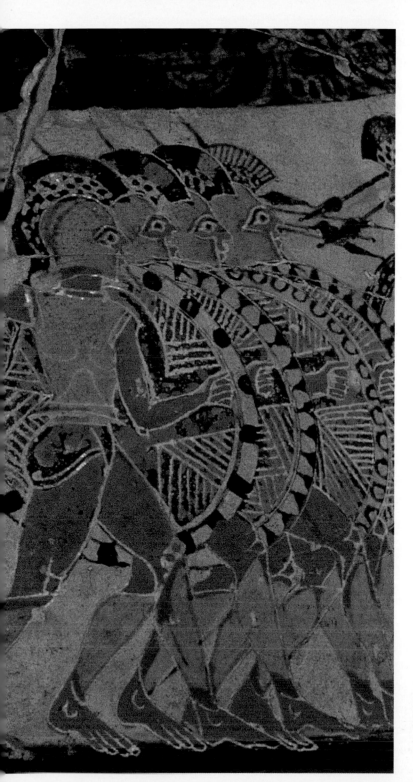

could demonstrate their success; and sanctuaries, especially the Panhellenic sanctuaries, offered virtually inexhaustible opportunities for art and its display. Deities theologically imagined in human form would be gladdened to see themselves replicated in one medium or other, and one does not have to be a jaded cynic to acknowledge what the Greeks recognized perfectly well themselves: that conspicuous expenditure on art was a serious instrument of political rivalry.

One warning note should be sounded here: levels of artistic activity varied from *polis* to *polis*, and actual power cannot always be accurately measured by the size of temples, quantities of statuary or general lavishness of archaeological remains. Thucydides, at the outset of his narrative of the Peloponnesian War, makes exactly this point when he observes that posterity would scarcely believe that a contest between Sparta and Athens would end in Sparta's victory. Sparta indeed now seems a rather undistinguished and rustic place when its remains are compared with the ambitious marble antiquities of Athens. With that cautionary exception heeded, we may accept the basic factor of competitive display at work in this triangular rapport of city, sanctuary and colony. One city is a good example of what will unfold in the course of this chapter: neither Athens, nor Sparta, but that centre which was overtly hailed with the epithet 'wealthy' (*aphneios*): Corinth.

On the isthmus connecting the Peloponnese with Attica and northern Greece, Corinth had a reputation as the generic port of trade. She controlled sea routes both east and west, and facilitated traffic across the isthmus by constructing a towpath (*diolkos*), whereby ships could be dragged the short distance overland on rollers. Naturally enough, the goods passing through this centre included many items from the further eastern parts of the Mediterranean, and the early figured styles of Corinthian art show the influence of those

58
Clay model of a building, a votive offering from the sanctuary of Hera, near Perachora, mid-8th century BC (restoration drawing)

areas, in particular the Levant. Phoenician traders exposed local artists to the patterns and motifs of Assyrian and Hittite decoration, and the resultant style on Corinthian pottery is broadly orientalizing in effect, with multiple registers dominated by lions, sphinxes and panthers (55). In due course, a huge hill-top sanctuary, 'High Corinth', would be developed for the use of the many mariners who frequented the port: in Roman times the temple of Aphrodite there would be staffed by a thousand priest-esses. But the development of Corinth as an archaic *polis* is best indicated by an earlier sanctuary at Perachora, on the tip of the Corinthian Gulf, dedicated to Hera (60). Why this seashore site was originally reckoned to be sacred to Hera is obscure, but its early importance as a place of pilgrimage for Corinthians, whose political territory it may have defined, is perhaps summarized by one mid-eighth-century BC votive offering, a clay model of a building (58). Whether this was intended as a replica of a domestic dwelling or a temple we cannot be sure: since Hera was the goddess entrusted with the care of house and home, the domestic alternative is as plausible as the religious. But it does give a neat image of architecture that was not yet megalithic: not using, that is, large pieces of stone in its

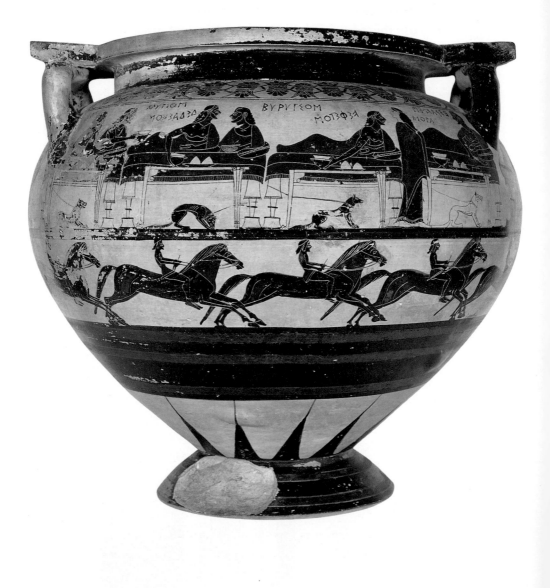

construction. There is a single room, whose curved back gives it an apsidal appearance, and a porch, supported by two pairs of posts (presumably wooden). The wide eaves suggest a thatched roof, as does the steep pitch of the gables. But the cognitive implications of this model are perhaps more important than what it tells us about early Greek architecture. At Perachora, in common with other sanctuaries around Greece, the quantity and quality of personal dedications rises noticeably from the eighth century onwards. Generously loaded graves, meanwhile,

59
Corinthian krater showing Herakles at a banquet with King Eurytios, c.600 BC. h.46 cm, 18 in. Musée du Louvre, Paris

60
Ruins of the sanctuary at Perachora, Gulf of Corinth

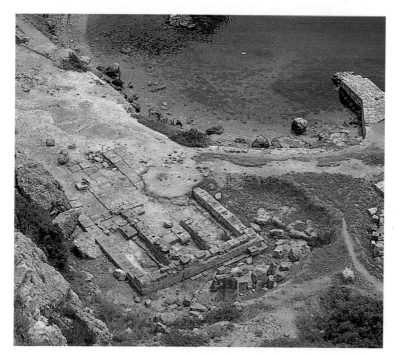

became less common. The institution of communal cult practice gradually asserted precedence over family devotions.

In Corinth, according to Herodotus, craftsmen enjoyed more respect than elsewhere in Greece. Accordingly, it is from Corinthian artists that we get some of our earliest illustrations of the institutional fabric of the archaic *polis*. Around 650 BC a Corinthian vase-painter, working on an almost miniaturist scale, produced a remarkably clear image of a

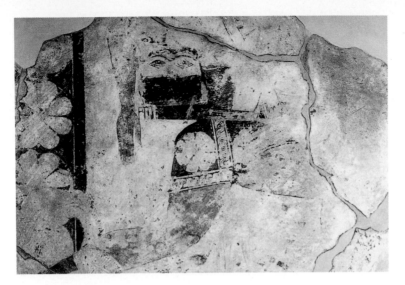

phalanx engagement (56–7): we see how the soldiers, wearing
full-mask helmets, body corselets and greaves, carry the
overlapping shields in their left hands and jab with spears
in their right; the contest will be settled the moment one
front line breaks, and the terrible instance of the first clash
is heightened by a piper behind the ranks, raising the adren-
alin levels. A gentler image is presented by the painter of a
large Corinthian krater, at the beginning of the sixth century
BC (59): here Herakles, for once, is doing nothing violent,
but relaxing at drinks with King Eurytios, whose daughter,
Iole, he covets. Since the krater was the central vessel of the
symposium, the imagery of sharing wine is suitable enough.
The other side of the vessel shows warriors in action; under
one of the handles is a vignette of the Homeric hero Ajax
committing suicide; and a continuous minor register around
the vase contains galloping horsemen. The social function
of the symposium – literally a 'coming together' of men who
trained and fought in the same units, to drink and listen to
epic recitals – finds complete reflection in the decoration
of this vase.

If Corinth had not been destroyed in antiquity and subse-

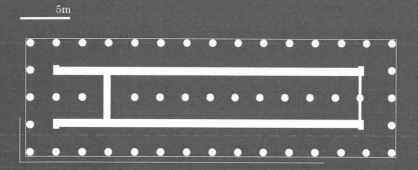

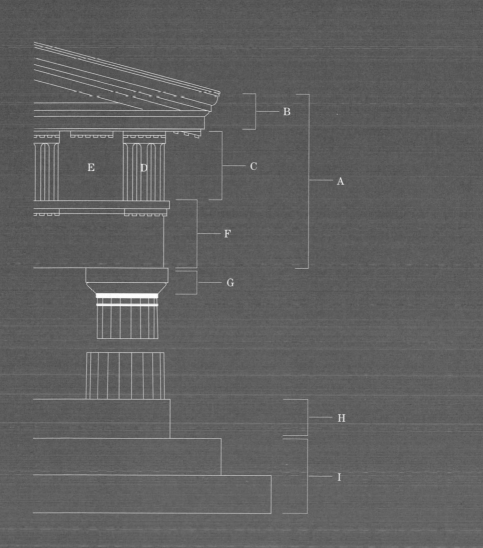

quently rebuilt, we might have found there traces of the
earliest Greek temple-building. By tradition, the Doric
order was a Corinthian 'invention'. Despite direct evidence,
however, and despite a lack of scholarly consensus as to
which Greek temple first shows proper Doric traits, we
can see the relics of Corinthian dynamism at Thermon, in
northwest Greece. Here, around 640–630 BC, Corinthian
craftsmen seem to have assisted in the erection of a temple
to Apollo. Long and narrow in proportions, its exterior
colonnade (comprising five columns at the front and fifteen
along each side) was probably wooden, raised on a stone
platform or stylobate (62). Walls may have been mud-brick,
but the roof was tiled, and the gutter was lined with figura-
tive, terracotta antefixes. The entablature – the frieze area
between the column capitals and the gutter – was wooden.
In the gaps created by the crossbeams resting above the
capitals, painted terracotta plaques were inserted. This
is where Corinthian hands betray themselves, since the
painting has much in common with the well-documented
styles of Corinthian painted pottery. We may again note a
favourite Corinthian subject, Perseus and Medusa, on one
of these panels (61). The spaces these panels occupied on
the temple at Thermon would become the metopes of the
Doric entablature, which when constructed in stone were
often carved with relief decoration; the ends of the wooden
crossbeams would become stylized as the triglyphs, the
'thrice-cloven' blocks which sat on the architrave over
the columns. The various components of the full Doric
order (63) can only be understood as translations of carpen-
try into stone; and the reason they survived, even when they
had no remaining structural significance, was precisely
because the wooden originals were once sacrosanct.

So in various ways, Corinthian art mirrors the essential
changes taking place in Greece as the *polis* developed;
and Corinth participated as eagerly as any other city-state
in the creation of colonies, with her most powerful clone,

64 Left
Kouros from
Tenea,
550 BC.
Marble;
h.153 cm,
60½ in.
Staatliche
Antiken-
sammlungen,
Munich

65 Right
Kouros from
Attica,
c.610–600 BC.
Marble;
h.184 cm,
72½ in.
Metropolitan
Museum of
Art, New York

Syracuse, founded as early as 733 BC. But certain artistic phenomena in this period cannot be explained in local terms, not even with recourse to the vague process of orientalizing. Take, for example, a statue found in Corinthian territory, at Tenea, which belongs to the mid-sixth century BC (64), or a similar, slightly earlier figure from Attica (65). This is a type of young male figure we know generically as a *kouros*: a 'youth', or 'stripling'. He has some of the poetic attributes of the god Apollo: long hair, broad shoulders, athletic waist and a suggested spring in his step; and when statues like this are placed at sanctuaries, or used to mark graves, we may assume that the image was intended to honour Apollo or the chthonic gods. Before we can begin to discuss the meaning of art such as this, we have to answer two fundamental questions. The production of life-size stone figures is not easy: how did the Greeks gain the technical capacity to do it? Secondly, since art was rarely art for art's sake in the ancient world, why did they do it?

The answers to these questions have wider implications, which help explain parallel developments in other media and fields of activity. If the Doric order is rooted in wooden prototypes, then where did the confidence arise to build in stone? Could the production of tiny, solid, cast-bronze figures naturally lead the Greeks to large-scale, hollow-cast adventures?

Scholars traditionally take one of two explanatory routes here. One route is the extension of the term 'orientalizing' and the invocation of direct technical influences from Egypt and the Near East. Focus then falls heavily on areas of the Greek world where we know that interaction between Greeks and orientals took place. The island of Samos, and in particular its large sanctuary to Hera, is one such place. So too is the Greek outpost of Naukratis in the Nile Delta, officially established in the early sixth century by no less than twelve co-operating Greek city-states. If Greek traders were increasingly exposed to the monumental

stone temples and statues of Egypt, and oriental bronzes were being brought in some quantity to sanctuaries such as the Heraion on Samos, then (as this argument goes) these were the stimuli which spurred Greek craftsmen to emulate their neighbours.

The alternative path is less commonly taken. It involves proposing an automatic progression by Greek artists from small-scale media to larger projects. It is difficult to prove this, since much of the intermediate evidence is supposed to have been wooden, and wood rarely survives in the archaeological record. However, the argument has some advantages when it comes to accounting for style. If Greek stone sculptors *did* learn their trade from Egyptian masters, it is odd that their first efforts should be so dominated by geometric patterns – triangular torsos, volute-shaped ears and so on – when Egyptian forms of the period were gently naturalistic.

Anyone who has sailed down the Nile will favour the orientalizing explanation. It seems inconceivable that Egypt did not play a great part in the early formation of Greek art, especially since traditions of Egyptian learning were admitted by the Greeks to have shaped, for example, their ideas about mathematics. Moreover, Egypt shared certain deities with the Greeks: Herodotus recognized, for example, that the Egyptians had a goddess, Neth, who corresponded to the Greek Athena. But attempts to arrive at forensic proof concerning the origins of monumental Greek art and architecture are generally fruitless and perhaps even pointless. What we should be asking is not *where* the first stone statues and temples come from, so much as *why* they were needed?

Phrased in that way, the question turns us back in the direction of the sites where monumental Greek art first appeared: the sanctuaries. Rather than generalize about the motives for display of art at these places, we may consider a series of specific dedications, whose cumulative nature should give us

some understanding of what the Greeks stood to gain by more ambitious commissions.

The earliest known Greek marble statue is the figure at Delos dedicated by a young girl called Nikandre (66). At a little under 2 m (6 ft) high, she is a bold debutante in the medium. Looked at sideways-on, the word 'plank-like' suggests itself, because in depth the statue stays at a mere 17 cm (7 in) or so. But there was space, along the left side of her close-fitting skirt, for the statue to speak its purpose. The inscription reads: 'Nikandre dedicated me to [Artemis] the far-shooter. Excellent among women, the daughter of Deinodikes the Naxian, sister of Deinomenes, she is now wife of Phraxos.'

So this was a votive offering, from a woman proud of her family connections and status on Naxos. Inscription and style would date the statue to about 650 BC. It was probably made on Naxos, from the plentiful white marble available on the island. That it was brought across to Delos (about a day's sailing away) shows the importance of that sanctuary: the inscription only makes sense if those who saw it recognized the standing not only of Nikandre, but also the three men in her life. The statue may have been intended as an image of Artemis herself (bronze attributes or attachments were originally inserted into her hands), and divine gratification is generated by the conspicuous expenditure here. It is not just that marble, compared to wood, is more difficult and time-consuming to carve; but the costs of transport were a challenge too. Though the statue would have been brightly painted, its material would have been evident enough to all those frequenting the precincts of Delos. The credit, or kudos, to Nikandre and her family was registered locally, but it must also have reflected the power of Naxos beyond the Cycladic sphere.

This aspect of the use of marble for sculpture – its sheer mass, its labour-intensiveness, its implications therefore of 'conspicuous consumption' – must explain why it be-

66
Votive offering dedicated by Nikandre at Delos, c.650 BC. Marble; h.175 cm, 69 in. National Archaeological Museum, Athens

came appropriate for religious art and architecture. Much later theological sources tell us that the Greek custom of representing deities in human form relied on using the best and most precious forms and materials on earth. That is, the gods were believed to be delighted by temples and statues in proportion to the time and expenditure incurred in their making. The durability of marble was an extra bonus. Its translucence hardly mattered; in fact, to reduce its glare in bright sunshine, the marble of a Greek temple was generally painted with a light-coloured wash. But the pre-eminent reason for its adoption was the value it symbolized. Nikandre's statue seems to have been carved by a sculptor, or sculptors, trained in the making of wooden images: what the Greeks referred to as *xoana*. The commission to work in marble set a new measure for subsequent devotees to match in their pieties at Delos.

A little later, still in the second half of the seventh century BC, the Naxians brought over to Delos a colossal image of Apollo, some five times life-size. The statue is now reduced to assorted fragments, including its giant torso. But the inscription surviving on the base strikes a note of irrepressible artistic pride. 'I am one stone, statue and base,' it declares. Though it may never have been true, this boast is made poignant by a number of discarded statues in the quarries on Naxos. One, perhaps intended as a similarly grand image of the bearded god Dionysos, may be seen at the site of Apollonas (67). It lies in the trench from which the marble block was quarried, and we appreciate that as much of the statue as possible was carved – to within a centimetre or two of its finished form, in some places – before efforts were made to shift such a weight. In this case, a fault appeared in the stone at a late stage. Such are the risks of working in marble. No wonder, then, that the Naxians were so overtly excited about their success in transporting a colossus of Apollo to the god's sacred island. The sheer size of their

67 Right
Head of bearded colossus, 6th century BC. Marble. Apollonas, Naxos

68 Far right
Line drawing of King Tuthmosis III, overlaid with a grid, from a tomb at Thebes, c.1460 BC. Gesso-coated board; h.36·4 cm, 14½ in. British Museum, London

image implied that they had captured more of Apollo's nature than any smaller statue of the god. This was his 'theophany', his masterly apparition at his place of worship. In terms of its form, the Naxian's visualization of the 'far-shooter' set a virtual standard: naked, broad-shouldered, athletic, long-haired, carrying his bow; this is how poets would describe him, and how he would appear for centuries (see 112).

Did Egypt supply technical models for such ambitious projects? Quite possibly, though direct apprenticeship seems unlikely. The Egyptians, working in granite, had

evolved precise systems for laying out grids on blocks of stone and working inwards according to the matrix provided by the grid (68). The Egyptians had also developed the metal tools necessary for quarrying and carving hard stone. Greeks visiting the Nile sites will have witnessed Egyptian expertise: one later Greek historian, Diodorus Siculus, tells us about a couple of sculptors based in eastern Greece who made a statue separately in two halves, which joined together perfectly thanks to the deployment of the

Egyptian grid system. More importantly, Greeks who travelled down the Nile will have absorbed the general monumental effects of temple complexes laid out and decorated with stone rather than timber or terracotta. To return to the ostentation of the Naxians on Delos, we should note a third dedication made in the early sixth century: the avenue of roaring lions (69). These make perfect sense on the terrace at Delos: Apollo's sister Artemis, as Mistress of the Beasts, can be imagined deploying these lions as intimidating guardians of the sanctuary, and Naxos as a city-state perhaps also saw herself as protector. The form of the lions

69
Avenue of
Lions at the
sanctuary of
Leto, Delos,
c.600–575 BC.
Marble;
h. c.170 cm,
67 in
(each lion)

70
Avenue of the
Sphinxes,
temple of
Amun, Karnak,
c.1800 BC

has echoes in contemporary Cycladic painted pottery, though it is hard to believe that the idea of the avenue of animals does not ultimately derive from the lines of recumbent sphinxes on view (since about 1800 BC) by the temples of Karnak (70) and Luxor at Egyptian Thebes.

The competitive endowment of Panhellenic sanctuaries by individual city-states, however, was chiefly what inspired the move towards monumentality, and competition between these sanctuaries compounded the process. Apollo, conceived by the poets not only as 'far-shooting' but also 'far-ranging', and able to translate himself from one place

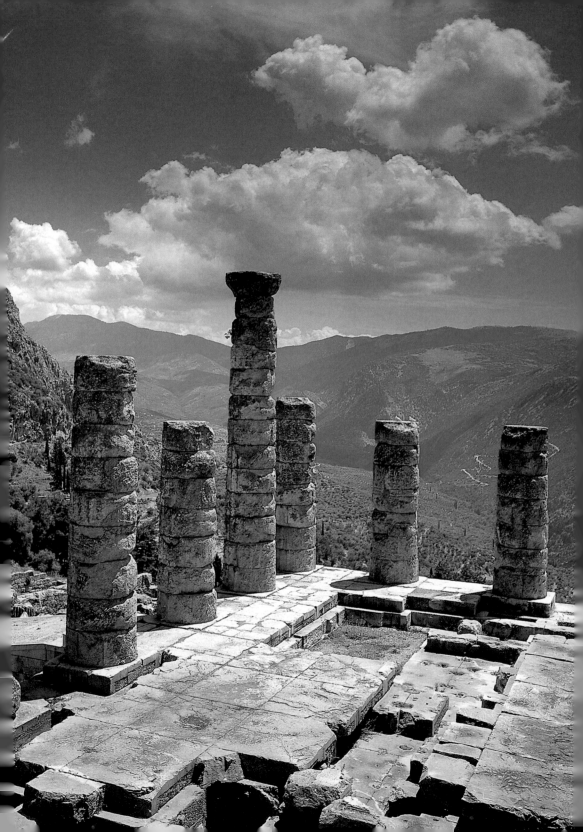

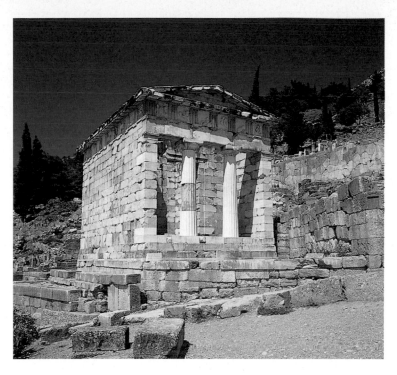

71
Temple of
Apollo, Delphi,
late 6th
century BC

72
Treasury of the
Athenians,
Delphi, early
5th century BC

to another 'swift as a thought', was not confined to Delos.
At Delphi (71–4), in the midst of the mountains, the
tradition was that his voice could be heard from a deep
fissure. This tradition transformed the spot into a prime
meeting place for all Greeks. The religious understanding
was that Delphi harboured messages from the god: those
who sought his advice or guidance went to the temple built
around the crack in the ground (71), heard a priestess
gabbling and possessed by Apollo's own words, and worked
out interpretations with the help of temple staff. In effect,
what happened was that because it was frequented by so
many people (not only ethnic Greeks) from different parts of
the Mediterranean, Delphi became the most efficient store-
house and market for that most precious commodity: infor-
mation. The records of the messages or oracles delivered to
would-be colonists, for example, may sound retrospectively
rather vague and poetic ('Go west … follow a dove' etc), but
the likelihood is that the Delphic priesthood was indeed a
relatively reliable counsel. So it was that some city-states

constructed their own individual hostels at Delphi, where pilgrims could meet and stay. Many also set up chapels or treasuries: architectural gems which in themselves attested the prosperity of their sponsors (72). The island of Siphnos, for example, enriched by its gold and silver mines, contributed a very ornate and distinctive pedimental building around 525 BC, along the approach path to the main temple where all could see it. Such treasuries were also more aggressively symbolic of power, since the strength of a partic- ular *polis* could be effectively demonstrated by the display of booty and trophies captured in war. When they were not fighting on the battlefield, Delphi offered these states a stadium for athletic contest (74).

So, although Delphi seems more remote from their immed- iate sphere of political influence, it is no surprise to find the Naxians bringing their statues this distance. They dedicated a marble sphinx (73), raised high on an Ionic column, in the early sixth century; perhaps they had pretensions to be guardians of Delphi as well as Delos. But competition here was strong. Its keen nature is amply attested by a pair of statues now in the Archaeological Museum at Delphi, known as Kleobis and Biton (75). Dedicated at the sanctuary around 580 BC, they appear (from a fragmentary inscription) to have been made by one Polymedes of Argos. Since they constitute a pair of heroic young men, perhaps brothers, or even twins, and were made in Argos, it is tempting to relate these figures to a historical tale about two Argives who were commemo- rated at Delphi.

The story of their apotheosis is worth retelling. It comes in the context of a moralizing discourse on the futility of wealth by the Athenian law-giver Solon, as reported by Herodotus (I.131). The archetypal magnate, King Croesus of Lydia, asks Solon which people he considers to have gained supreme happiness. Among others, Solon nominates two young men from Argos, Kleobis and Biton. They were the sort of young

73
Naxian Sphinx from Delphi, dedicated c.560 BC. Marble; h.232 cm, 91⅜ in. Archaeological Museum, Delphi

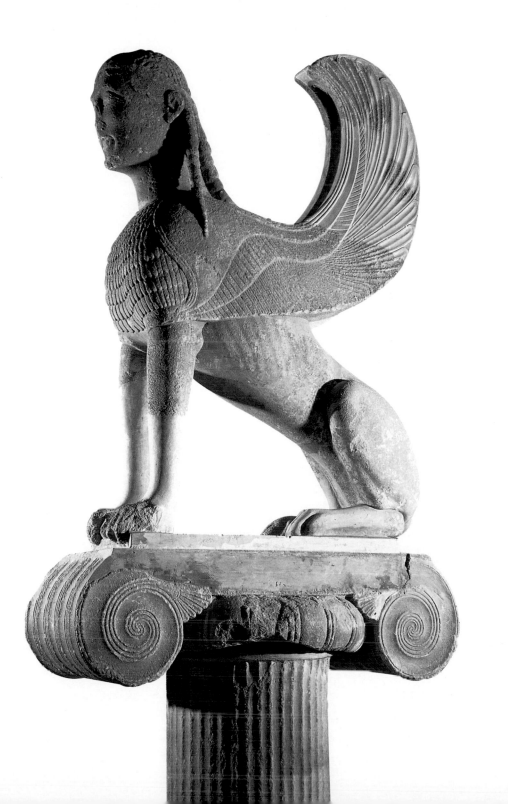

74
The stadium at Delphi, as
elaborated by Herodes Atticus
in the 2nd century AD

men who brought credit to the city-state, winning prizes in athletic contests and so on, but their great moment of glory came about by accident. Their mother, a priestess of Hera, was due to celebrate a festival of the goddess at the Argive Heraion, which lies some 10 km (6 miles) out of Argos itself. The oxen due to haul this lady and her priestly impedimenta in a slow ritual procession to the sanctuary were late returning from the fields. So her sons volunteered themselves for the job of traction. They dragged their mother and her cart up to the temple, where devotees crowded around, applauding their stamina and congratulating their mother on her fine offspring. She in turn thanked the goddess Hera for Kleobis and Biton, and prayed to Hera to grant the boys the greatest blessing on earth. After they had participated in the ceremonies of sacrifice and feasting, Kleobis and Biton fell asleep in the temple. They never woke up.

So this is the perfect happiness: to be assumed by Hera, the prize for exceptional piety. Croesus may have understood the message, for although his exchange with Solon seems mythical, we do know that around 550 BC he generously endowed the temple of Artemis at Ephesus with a set of decorated marble columns. But what is most significant for us is the subsequent dedication made by the Argives for Kleobis and Biton. As Herodotus notes, they commissioned statues of the boys, and sent them to Delphi, as a mark of special respect.

Even if the statues now in the Archaeological Museum are not Kleobis and Biton (the alternative suggestion is that they may represent the divine twins Castor and Pollux), we can still ask: why Delphi? Would it not have been more appropriate to place the statues of the boys in the place where they died, at the Argive Heraion? The crux is, however, that Delphi was a Panhellenic sanctuary, whereas the Argive Heraion was not. The figures of Kleobis and Biton, therefore, were politically manipulated. They were

presented as paragons of Argive manhood. Their stocky, foursquare presence at Delphi exemplified not only levels of piety prevailing at Argos, and physical commitment, they were also commemorated as mainstays of the city-state, and as such relayed to the rest of the Greek world the solidity, the togetherness, of the citizens of Argos.

Hence the genre of the *kouros* statue. When they were first found, these figures (plural *kouroi*) were thought to be images of Apollo. When executed on a colossal scale, some were indeed intended to represent the god. But they have a flexible range of significance. Some were grave-markers, like the *kouros* from Tenea (see 64). Others were votive offerings (76). At one sanctuary of Apollo at Mount Ptoion in Boeotia, a ghostly army of 120 such offerings once clustered. At the colony of Megara Hyblaea, a doctor called Sombrotidas was remembered as or by a *kouros*. For all we know, Sombrotidas died in hunched or flabby old age, but this was how he wanted to be remembered by posterity: in his prime,

76
Kouros from Samos, inscribed 'Leukios dedicated [me] to Apollo', c.575–550 BC. Marble; h.100 cm, 39½ in. Archaeological Museum, Vathi, Samos

a virtual Apollo, an aristocrat defined by naked physical beauty. Beauty had both moral and political connotations. The Greek phrase 'beauty and goodness', *kalos k'agathos*, was not simply a matter of mere coincidence. It was a necessary equation.

The total number of *kouroi* in the Greek world by the end of the sixth century has been estimated at around 20,000. In itself, this quantity says something about the intense generation of art by competitive emulation. It is also clear from the stylistic development of this particular statue type that there was competition among sculptors to refine or advance its appearance. The *kouros* has been described as a 'standardized symbol of interaction' within the Greek world, a sign of Greekness; and as such it functioned in the sanctuaries of the Aegean and beyond. But the form was not so standardized as to inhibit experiment. The geometric patternings of the early *kouroi* (see 65) yielded under two pressures. The first was religious anthropomorphism: for if Apollo was believed to manifest himself in the near-convincing likeness of a gloriously athletic young man, then statues representing him must aim to convince the viewers too. They should see a statue with animate potential. This led directly to the second pressure on artists: to move away from abstraction towards naturalistic form. The artist who could produce the most lifelike image gained the most rewards for his effort.

'To contend for the prize' (*agonizesthai*) is a Greek verb with many metaphorical applications. Lovers, philosophers, politicians, warriors, not to mention artists, are all liable to contend for the prize. The whole of Greek culture has been described as 'agonistic', or competition-driven. So it may be opportune at this point to examine the source of the metaphor. Generally, this means the institution of formal athletic games; and in particular, we should consider the rise of the pre-eminent sanctuary of their celebration, Olympia.

A fragment of an early sixth-century BC Athenian vase conjures up the atmosphere (77). Its painter, Sophilos, was one of the first self-identified masters of decoration in the style we refer to as 'black figure': that is, figures painted in black on the natural buff background of a fired pot, their inner details etched with a stylus, plus some colours added in brushwork. Sophilos intended to evoke the games staged for the hero Patroklos, as recounted in Book XXIII of Homer's *Iliad*: the epigraph makes that clear. But the surviving vignette of a crowd in a tiered wooden grandstand, cheering on the racing chariots, is tellingly vivid. Sophilos can count on recognition of this scene as a generic and popular event.

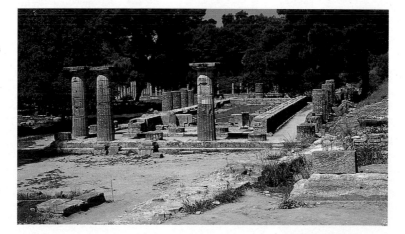

77
Fragment of an Athenian black-figure bowl painted by Sophilos, *c*.580 BC. National Archaeological Museum, Athens

78
Temple of Hera, Olympia, *c*.590 BC

At Olympia, the racing stadium was laid out properly in the sixth century, originally in view of the altars and temples of Zeus and Hera. The structures of the various athletic disciplines were codified over time, beginning with running races, then subsequently incorporating chariot- and horse-racing, and the pentathlon – discus, javelin, long jump, sprinting and wrestling – as well as boxing and an all-in fighting challenge called the *pankration*. There was no sham amateurism and little in the way of what we might call 'sportsman-like' behaviour. Winning was of paramount importance. The last man in a race was not clapped home, but booed with derision. Predictably, perhaps, the victory lists at Olympia came

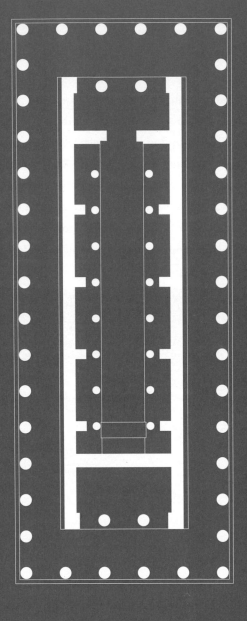

10m

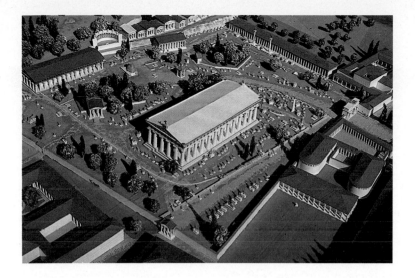

to be dominated by representatives of the colonial states, who enjoyed signalling their successful detachment abroad.

So, intense athletic competition – to the point of death, if we believe anecdotal records – took place at Olympia. But Olympia was foremost a sanctuary, and its success in hosting games was mirrored by expenditure on art and buildings not so much to improve facilities for visitors as to glorify the presiding deities, Zeus and Hera. Hera's temple was older: a wooden prototype was replaced with a more substantial Doric structure around 590 BC (78–9). Though this was constructed from a mixture of materials (limestone, bricks and a colonnade of wood, subsequently 'upgraded' to limestone), it was strong enough to support enormous multi-coloured terracotta decorations above its pediments. From the period of this temple comes a colossal female head, in limestone (82). It too may be part of the roof decoration (the 'high-flying' figures or *akroteria*), although it has also been taken as a part of the cult image of Hera herself (the visage is suitably forbidding).

At Olympia, as at Delphi, individual city-states created treasuries for the display and dedication of trophies (80). Again, the colonial states feature prominently: in the line of trea-

79 Opposite
Temple of Hera
at Olympia,
c.590 BC
Above
Plan
Below
Reconstructed
elevation

80 Above
Model of the
sanctuary at
Olympia. The
temple of Hera
is at the top
left and the
temple of Zeus
is in the
centre; the
small buildings
above are the
treasuries.
Surrounding
buildings
belong mostly
to the Roman
period

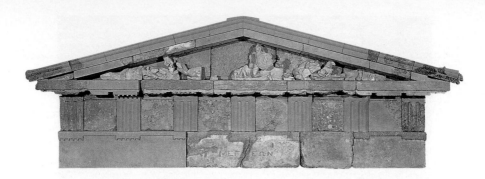

81
Pedimental
sculpture of
the gods versus
the giants,
from the treas-
ury of the
Megarians at
Olympia,
c.510 BC.
Marble;
h.84 cm,
33 in (at
centre).
Archaeological
Museum,
Olympia

82
Colossal head,
perhaps of
Hera, from the
temple of Hera
at Olympia,
c.600 BC.
Limestone;
h.52 cm,
20½ in.
Archaeological
Museum,
Olympia

suries jostling together on the northern edge of the sacred precinct of Olympia, there are representatives from Syracuse, Gela and Selinus in Sicily, Metapontum and Sybaris in southern Italy, Cyrene on the north African coast and Byzantium on the Bosphorus. But the highly politicized ambience of both the sanctuary and the games at Olympia is perhaps best illustrated by one of the few treasuries dedicated by a mainland Greek state, Megara. Towards the end of the sixth century, the Megarians set up a chapel comparable in size to others already erected, and commissioned limestone relief sculpture for its decoration. A later witness recorded: 'in the gable of the treasury is wrought in relief the battle of the gods and the giants, and above the gable is a shield with an inscription stating that the treasury was dedicated by the Megarians from the spoils of the Corinthians' (Pausanias, VI.19.2). We have lost the inscribed shield, but the sculpture of the little pediment remains (81), and, though badly damaged, there are the gods; Zeus (in the centre), Athena, Herakles, Poseidon and Ares, each striking down one of the giants, those earthly primordial forces who in Greek cosmology once challenged heavenly power. The theme is ostensibly 'religious', confirming the authority of Zeus, but in thanking Zeus for their victory over nearby Corinth, the Megarians cannot resist heroizing a local war as if it were justified in terms of cosmic world order. The prominence of the shield-message over the imagery would have suggested as much to all passers-by.

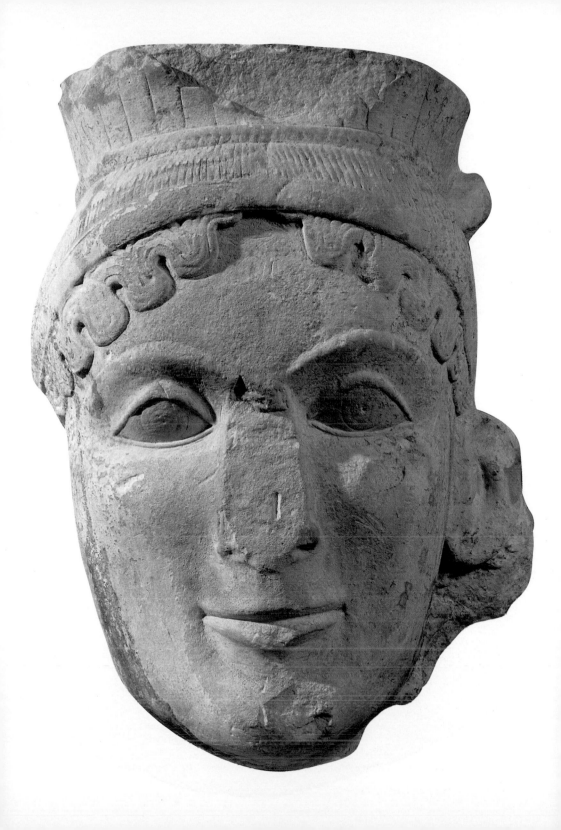

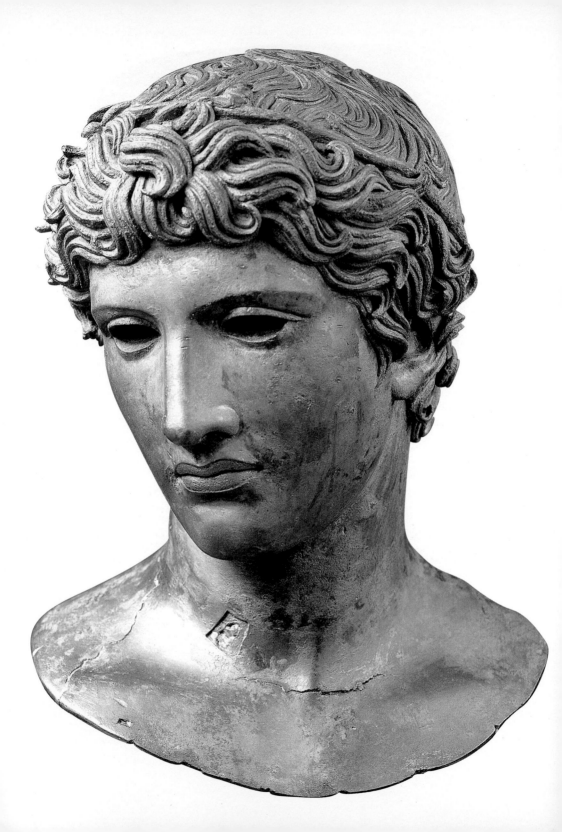

'War minus the shooting' is how ancient sport, no less than modern, may be understood. The Greeks were simply more open about that function, and even allowed the boundaries of sport and actual war to overlap, in the sense that athletic training was directly linked to military discipline. By the end of the sixth century, the Olympic programme officially included the event of a foot race in armour, where participants sprinted in the panoply of the infantry fighter or 'hoplite'. Vases painted as prizes give us a good idea of how such contests looked. Though not in themselves valuable, these vases once contained precious olive oil, and a successful athlete could win a substantial supply of it for his family. Victors, often depicted in sculpture (83), were also awarded crowns of olive leaves. Usually such crowns were made separately from the sculpture and most have been lost. In general the depiction of athletic disciplines entered the repertoire of all figured vessels (84–5).

A fundamental tenet of the Greek *polis* was that its male citizens kept in training in order to be able to fight on behalf of the community. By the end of the sixth century, the collective commitment towards military service earned for those involved the right to decide issues of government: hence 'democracy', or citizens' power, from which those who did

83
Head of an athlete, copy of a 5th-century BC original. Bronze; h.33 cm, 13 in. Musée du Louvre, Paris

84–85
Athenian black-figure amphora, c.540 BC. h.36 cm, 14¹⁄₈ in. Staatliche Antikensamm-lungen, Munich
Below
Complete vase
Overleaf
Detail showing a footrace in armour

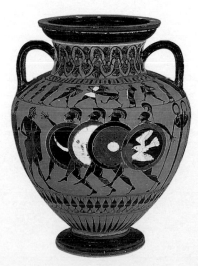

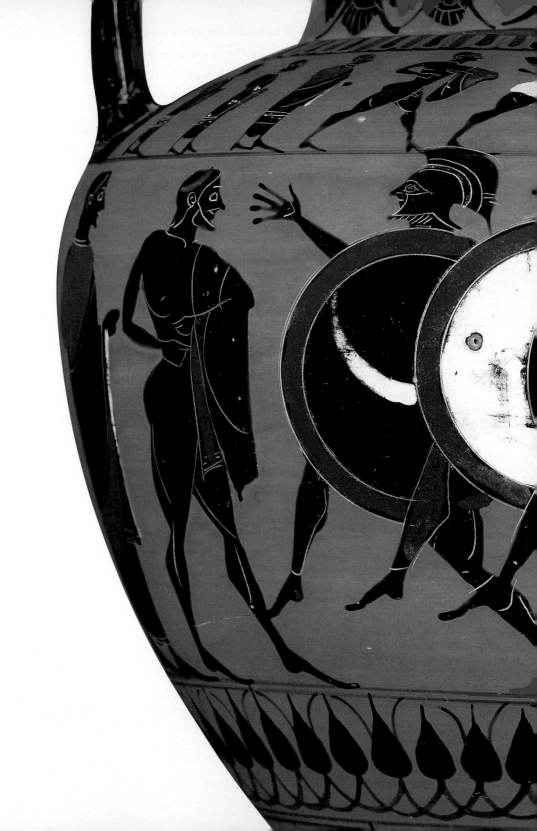

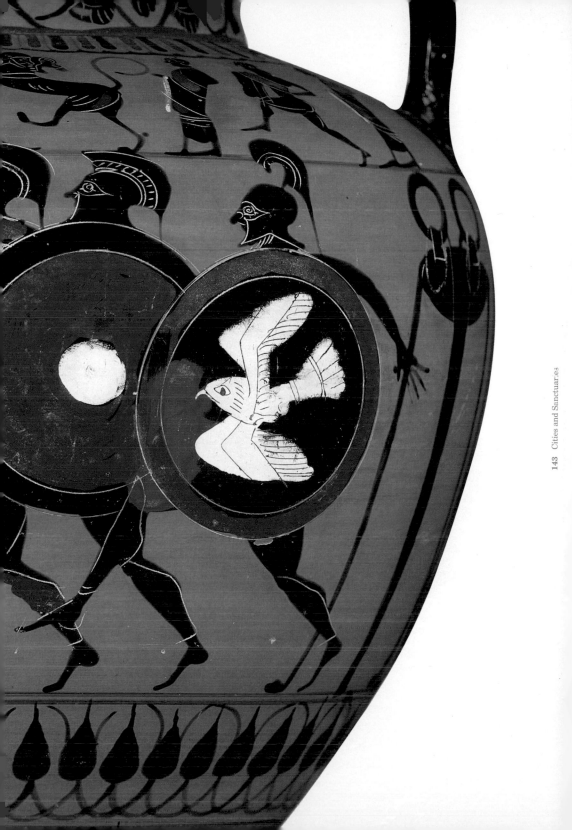

not fight (slaves, women and foreigners) were excluded. One city above all others in Greece pioneered this political development. Since this city dominates any account of Greek art, it now requires our particular attention.

Athens, as Thucydides noted, was an intrinsically flamboyant city: a 'city of images', or, as St Paul would disapprovingly call it much later, a 'forest of images'. Subject to a programme of monumental development during the sixth century, Athens was not a well-planned example of Greek urbanization: it was too organic and fostered notoriously chaotic living quarters. Yet as a centre of activity – political, religious, commercial, academic and artistic – it was exemplary to the rest of the Greek world. Its geological bastion, the Akropolis, had been a Mycenaean palace. Records of mythical kings such as Cecrops and Erechtheus were vaguely associated with this prehistoric past, and one semi-divine hero, Theseus, was singled out as the original bringer of unity to Athens and its surrounding countryside, forming the joint area identity of 'Attica'. In the mid-sixth century BC, the most delicate of Athenian vase-painters, Exekias, tried to imagine what Theseus looked like, and came up with not so much the strapping man of action, but a venerable, regal elder; a founding father-figure (86).

So Athens had its Bronze Age past; and, as we have seen, Athenian art indicates that the city suffered no real desolation implicit in the Dark Age period. A date can nevertheless be proposed for the beginning of greater Athenian ambitions, that of 566 BC. This was the year when the city organized its own festival, called the Panathenaia. This festival included musical contests and games, with some events comparable to those already established at Olympia, Delphi, Nemea and Isthmia. It was also a patriotic celebration, bonding the people of Athens and Attica to the divine care of their eponymous deity, Athena. The burgeoning confidence of the city at this time may be illustrated by two justifiably well-known pieces of Athenian art.

The first is a vase, painted around 570 BC (87). It is known
as the 'François Vase', after the man who recovered it from
a tomb near Chiusi in Etruria, in 1844. Exactly how or why it
ended up in an Etruscan tomb is another story. It was made
in Athens by a potter who signed himself Ergotimos and it
was decorated by a painter called Kleitias. The commission
may have been to provide the centrepiece for an Athenian
wedding: the vase is a krater of massive capacity, suitable for
a large party, and although its decoration is comprehensive in
extent and varied in subject, a conspicuous central theme is
the marriage of Peleus and Thetis, the parents of Achilles.

The vase assumes a clientele capable of recognizing and
perhaps connecting its mythical iconography. Dionysos, divine
patron of drinking, is shown appropriately enough on a huge
vessel for mixing wine with water (as the Greeks preferred),
here leading a drunken Hephaistos home to Olympos. From the
central theme of Peleus and Thetis derive other miniature
evocations of the life and death of Achilles. Theseus is on the
vase too, adding an Athenian note: he performs a dance of
thanksgiving to Apollo at Delos, with the unmarried Athenian
boys and girls he has rescued from the captivity of King Minos
on Crete. There may be a covert 'programme' to these and the
other images packed on to the surface of this vase. An obvious
distinctive feature is its literacy. Not only are mythological
figures identified by name, but also many of the objects
depicted too. The script is neat, yet deployed in an engagingly
naïve way, like a child's picture dictionary, as if the painter
were proud and enchanted with this new device of writing and
expected his clients to feel likewise.

A similar sense of the quick and spirited ambience of archaic
Athens is conveyed by our second piece, one of the earliest
marble sculptures (c.560 BC) dedicated on the Akropolis, the
'Calf-bearer' or *Moschophoros* (88). An accompanying inscrip-
tion gives us his name, or at least a sobriquet, 'Rhombos'.
Precociously, it is one of the most satisfying statues ever made.

87
The 'François
Vase',
Athenian
black-figure
volute krater
made by
Ergotimos and
painted by
Kleitias,
c.570 BC.
h.66 cm, 26 in.
Museo
Archeologico,
Florence

Its occasion is not specifically known: calves were sometimes awarded as prizes in athletic contests, and we know of later male beauty competitions in which the winner earned the right to carry a sacred animal around on his shoulders. Alternatively, Rhombos may have wanted to preserve in stone the devoted moment when he took up to Athena's temple a calf for sacrifice. Whatever the motive, the result is a very tender characterization of both a mood and a relationship. Rhombos has been given some of the placid, wide-eyed trusting nature of the calf. Carved from the same block, man and beast seem steadily attuned. On a banal level, this is an early attestation to the cliché that owners grow to resemble their animals.

The political history of Athens during the sixth century BC is only patchily transmitted to us. The archaeology of the city reveals a firm regime from around the time of the foundation of the Panathenaia, and this must be associated with the tyranny of one particular family, the Peisistratids. Many other Greek cities fell under autocratic rule at about this time, and some historians argue that spells of tyranny were the necessary precursors of democracy in the *polis*. Certainly, excavations of the area of Athens known as the Agora (literally, 'market-place', though it was much more than that) have made it clear that Peisistratos and his sons did much to set up the formal structures of civic institutions in Athens, and transformed the religious profile of the Akropolis, too. We shall return to the Agora and its layout in the following chapter; for now, it is enough to note that Peisistratos radically improved the fabric of city life by the provision of fresh running water, efficient drains, regular roads and so on. The effects of tyranny on Athenian architecture, sculpture and even humble vase-painting, however, deserve immediate survey.

To begin at the top, it is not certain that Peisistratos actually lived on the Akropolis himself, but he added a number of buildings to its profile, some of them substantial. It is difficult to be more precise than that, since the Peisistratid

88
The 'Calf-bearer', dedicated on the Athenian Akropolis c.560 BC. Marble; h.165 cm, 65 in. Akropolis Museum, Athens

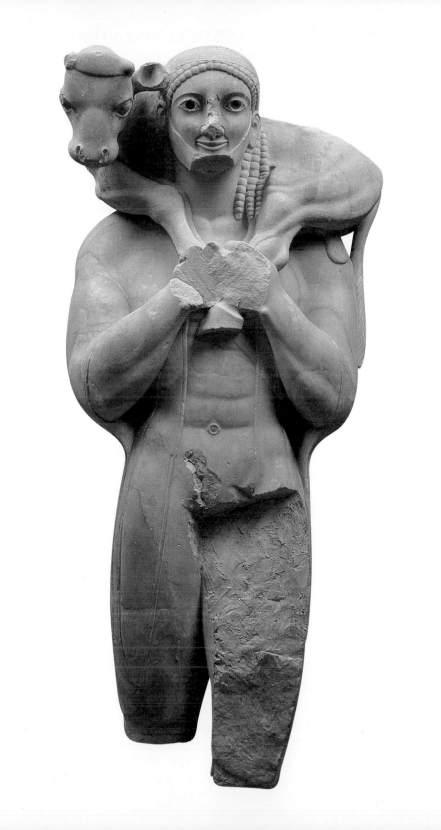

Akropolis was definitively destroyed during the Persian occupation of Athens in 480 BC. Fragments of temple or treasury decoration, mostly in limestone (although under Peisistratos, the nearby marble sources of Mount Hymettos began to be exploited, and marble was also brought in from the islands), give piecemeal indications of the extent of the endowment. Though they come from various buildings within the period, these sculptural fragments show some threads of thematic unity. The figure of Herakles appears several times. On one brightly coloured pediment, Herakles fights a many-headed beast called the Hydra. On another,

he wrestles with a fish-tailed monster. On yet another, he is being introduced to Olympos (89). This is his apotheosis, his transition from mortal to divine. It was the ultimate in heroization: the assumption to heaven as a reward for earthly virtue. The sculpture is so fragmentary that we cannot be sure if the usual sponsor of Herakles, Athena, is actually escorting him here, but he is easy enough to recognize, sporting his lion-scalp headgear. To welcome him is Zeus, in profile, and Hera, shown front-on.

This was a scene popular with vase-painters of the period,

and perhaps understandable enough in the context of a thriving cult of Herakles. Ascension to full divine favour was what everyone hoped for who feasted in honour of Herakles: everyone who became, in cult terms, one of his 'dining companions' or *parasitoi*. There may also have been an element of political persuasion in the popularity of this and other images. Herodotus tells us (I.60) about the time when Peisistratos, as a stunt, dressed up an imposing country girl called Phye ('big lass') in the guise of Athena and rode in a chariot with her up to the Akropolis. Was he pretending to imitate Herakles? We are also told that he

89–90
Pediments
from the
Athenian
Akropolis,
*c.*545 BC.
Limestone;
Akropolis
Museum,
Athens
Left
The Apotheosis
of Herakles,
h.94 cm, 37 in
(at centre)
Right
Detail of the
'Bluebeard'
pediment,
h.71 cm, 28 in
(at centre)

had a bodyguard armed with knotty clubs, as if to follow Heraklean weapon style. Alexander the Great, Mark Antony, the emperor Domitian; these are only a few of the would-be 'strong men' of antiquity who are known to have used the image and persona of Herakles as a means of self-promotion. Though we have no direct attestation that Peisistratos did likewise, there is a suspicious element of favouritism towards Herakles in Athenian painting and sculpture of the mid-sixth-century BC; and we might expect a vigorous tyrant to extol his own achievements in forms of public decoration.

Some scholars, then, pursue this idea of tyrannical propa-

ganda with enthusiasm. A curious tripartite figure from one of the Peisistratid pediments, known as 'Bluebeard', becomes an allegorical representation of three different political factions reconciled by Peisistratos (90). Another pedimental vignette featuring a fountain-house, and perhaps the Trojan story of Polyxena, doubly reminds Athenian viewers that Peisistratos built new fountain-houses in the city and codified Homeric epic for recitation. The marine adventures of Herakles reflect amphibious efforts by Peisistratos to secure the island of Salamis for Athenian control, in opposition to claims from the state of Megara.

It is impossible to substantiate such messages other than by reference to patterns of imagery. Plainly there must have been factors, other than pure fashion, affecting iconographic choice. Take the case of the dispute over Salamis. A small island in the gulf between Athens and the Corinthian Peloponnese, Salamis was geographically closer to Megara than it was to Athens. How could the Athenians convince others (and themselves) of their rightful propriety? Military control was not enough. A validation from the heroic past was necessary. In epic, the local hero of Salamis was Ajax, whose colossal bones were allegedly preserved at a shrine on the island. Athenians claimed that Homer listed the Salaminian contingent at Troy as having fought with the Athenians. The Megarians protested that *their* copies of Homer said no such thing. The Athenians strengthened their claim by setting up a cult chapel to Ajax and also to his sons. Eventually, when the democracy was set up in 508 or 507 BC, Ajax would be made one of the ten founding heroes of the Athenian voting units or 'tribes' (*phylai*), that is, one of the 'Eponymous Heroes' of democratic Athens. Prior to that, however, the artists weighed in with their contribution. A marble group set up on the Akropolis showed Ajax playing dice with Achilles, as if to show Ajax and Achilles as equals. Vase-painters took up the theme:

91
Athenian black-figure amphora painted by Exekias, showing Achilles and Ajax playing dice, *c.*540–530 BC. h.61 cm, 24 in. Vatican Museums, Rome

Exekias did so, most sensitively, on a famous amphora now in the Vatican (91).

Whether he was influenced by Peisistratid designs on Salamis, or general public enthusiasm, or just his own personal affinity with the figure of Ajax, Exekias made the hero a buttress of his figurative repertoire, showing him in various heroic postures: heaving the body of Achilles from the battlefield, for instance, or, as on one of the greatest of all Greek painted vases, about to commit suicide (92). The subtlety of this portrait takes time to appreciate. Other vase-painters before and after Exekias would show the suicide of Ajax at more obviously dramatic junctures; the act of the hero throwing himself on his sword, or the discovery of an impaled body by fellow Greeks. Exekias chose a quieter, but no less intense moment. His armour put to one side, the hero is now naked, alone, crouching and concentrating on the salvage of his own honour. His long fingers press the sand around the hilt of his sword. His eyes are resolute, his brow ploughed with pain. Behind him, a palm tree dips, as if to mirror the sympathy for Ajax that we must all feel.

92
Athenian
black-figure
amphora
painted by
Exekias, show-
ing Ajax
preparing to
commit suicide
*c.*530 BC.
Musée du
Chateau,
Boulogne-sur-
Mer

Now Ajax was not, on the face of it, an easy candidate for public veneration. His characterization by Homer is of a man with more muscle than brains, and his downfall is brought on by an ignoble quarrel between himself and Odysseus, as to who shall inherit the marvellous arms and armour of the dead Achilles. When Odysseus wins that contest, Ajax goes berserk and seeks to slaughter all his fellow Greek chieftains at Troy, but in his blind fury all he succeeds in slaughtering are sheep and cattle in the pen. When he comes to his senses, he realizes that there is nothing left for him to do except take his own life. In Greek law, that was not a very creditable course of action. But heroes, in Greek religion, were active beyond the grave, however they died. In this case, it suited Athens as a *polis* to elevate Ajax: he was useful as a

reinforcement of Athenian claims to Salamis. As such, it made sense for his image to proliferate on all appropriate media and make it seem, accordingly, that he had been dear to Athenians since time immemorial.

The cult structures of Athens were generally institutionalized in the time of Peisistratos and his sons. At nearby Eleusis, the multi-pillared hall known as the *telesterion*, used for the reception of initiates to the 'mysteries' of Demeter and her daughter Persephone, was much enlarged in the mid-sixth

93
Athena from
a temple pedi-
ment on the
Akropolis
(partially
reconstructed),
c.520 BC.
Marble;
h.200 cm,
78⅞ in.
Akropolis
Museum,
Athens

94
Panathenaic
amphora show-
ing Athena,
c.530 BC.
h.62·5 cm,
24⅝ in.
British
Museum,
London

century, and the entire sanctuary reorientated towards Athens. In the Agora, Peisistratos seems to have created the first space for dramatic performances, under the divine patronage of Dionysos: 534 BC is the date assigned to the debut of one chorus-leader called Thespis. To the southeast of the Akropolis, the foundations of a colossal temple to Olympian Zeus were laid out by the sons of Peisistratos. Above all (at least in the topographical sense) was the consolidation of the worship of Athena on the Akropolis.

Locating temples precisely in time and place on the archaic Akropolis remains problematic. The buildings securely assigned to Peisistratos seem on the whole to have been rather compact and diverse, reflecting the fact that more deities than Athena alone were worshipped here. Athena was certainly the focus of a large 30 m (100 ft) temple raised initially under Peisistratos' initiative, though probably not finished until after the end of the tyranny. This 'Athenaion' was built in limestone, with its sculptural decoration in island marble. Such 'upgrading' may have been the result of particular political changes at Athens; but in any case, Athena flourished. On the east pediment, the goddess confronts the giants (93). This is the city's protectress in her finest primordial moment, joining the battle of the gods against the giants. The giants threatened Olympian order on earth: rumbustious, volcanic, the uncontrollable issue of the sky (Uranus) and Mother Earth (Ge, or Gaia), they would pile up mountains to heaven in their ambitious pride or *hubris*. Only one mortal participated in this battle on behalf of the gods, and that was Herakles. He killed a giant called Alkyoneus. The name of the giant killed by Athena varies in the literature: sometimes it is Enkelados, sometimes Pallas, not to mention other alternatives. One strand of the legend, however, may be pertinent here. It declares that when Athena killed her giant, the Panathenaic festival was founded. There are other competitors for the title of Panathenaic founders – Theseus is one – but Athena is probably the most plausible. On the distinctive prize vases awarded to victors in Panathenaic contests, the goddess appears brandishing her spear, the patriotic emblem of every triumph; personal and civic (94).

In Athena's precinct, the Akropolis, sculpture flourished. Much of it was derived from the lead set by sculptors in the Aegean islands, and indeed executed in island marble, but local sculptors experimented boldly with forms and genres. From the mid-sixth-century BC Akropolis comes

an astonishing assortment of figures: sphinxes, dogs, scribes, cavaliers, *kouroi* and winged victory-personifications (*Nikai*), and most especially 'maidens' or *korai*. It is not clear how these should be understood: some may represent priestesses, but more generally they are simply votive gifts to Athena, from male dedicants who regarded them as expressive of both piety and pleasure. The combination of studied purity and eroticism in these figures can only be explained by their function as donations to Athena, donations loaded with the capacity to yield pleasure not only to Athena but to such mortals as glimpsed them too. Brightly painted, their arms extended in postures of either offering or acceptance, the *korai* display all the jaunty subtleties of archaic Greek art. The girl now known as the *'Peplos Kore'* (95–6), for example, eschews fussiness of sculptural detail by her choice of gown – the solid-textured, old-fashioned mantle known as the *peplos* – but compensates for that simplicity with a richness of painted surface detail, of which faint but particular traces survive. (The colour illustration overleaf should be taken as a reminder that most Greek sculpture was once brightly painted.) Some of the Akropolis maidens look as though they may be portraits of actual individuals (97). To say that they are 'individualistic' amounts to admitting that they aspire to no generic image of female beauty; but all attempt to please, if not by facial delicacy then by jewels (earrings and bracelets) or dress-sense (figure-hugging blouses, or chitons, expensively patterned and deeply pleated by use of a drill) or posture (tugging a skirt so that it clings to the legs and reveals essential contours). Most examples from the sixth century BC wear a smile, reflecting the response of both divine and mortal viewers. By the early fifth century, however, this diligent happiness had worn off. One of the last of such dedications, made by a man called Euthydikos about 490 BC, is positively sulky in demeanour (98). Her pouting allure fits well with what some scholars describe as a 'severe style' in

95–96
Peplos Kore,
dedicated
*c.*530 BC.
Polychromed
marble;
h.120 cm,
47¼ in
Right
Reconstructed
and painted
cast of original.
Museum of
Classical
Archaeology,
Cambridge
Far right
Detail of
original.
Akropolis
Museum,
Athens

sculpture, full of crisp edges, as if sculptors in stone were influenced by those working in bronze.

Among the various figures featured in the archaic Akropolis repertoire are two semi-divine heroes, Theseus and Herakles, and two full deities, Athena and Dionysos. Athena's presence is natural enough, but the elevation of Dionysos requires some explanation. A god of foreign origin, he was both beneficent and dangerous. As promoter of wine-making and president of wine-drinking, he was the god 'that causes men to stumble'. In his cult lie the beginnings of dancing, horseplay and formal theatre (see Chapter 6). Those joining his dance might reach a state of ecstasy (*ekstasis*): a being 'out of themselves', a sort of blessed mania. There is some evidence that his worship served as a sort of pressure valve, or regular release, for those sections of Greek society excluded from direct participation in civic politics: women, slaves and foreigners (metics).

Above all, Dionysos inspired the symposium, the 'coming together' of men to talk, listen to music and poetry, and drink. Such women as attended were not wives, but *hetairai*, 'female companions', who provided extra entertainment, some of it sexual. Among themselves, the men fostered a code of relationships that were not only homosexual, but also pederastic, that is older men choosing teenage boys as their partners. The symposium was one of the formally recognized places where pederastic interests could be pursued, with no necessarily shameful associations. Dionysos has been summarized as a lord of misrule, of animal instinct, of life below the navel; in polar contrast to Apollo, one of whose mottoes at Delphi was 'Nothing in excess'. So it was that those participating in the symposium could see themselves as temporarily joining the mythical 'band' (*thiasos*) of the god, as wild and footloose women (maenads), or stomping hybrids of man and horse (satyrs). Since most of the Greek vases surviving in our museums were once used for 'sympotic' purposes of institu-

tional drinking, we cannot be surprised if so many reflect either the symposium itself or else the more generalized world of Dionysos and his gang. One Athenian vase-painter who seems to have worked virtually throughout the years of Peisistratos' tyranny (*ie* from around 560–520 BC), known as the Amasis Painter, has left us with some particularly memorable evocations of the Dionysiac entourage: on one wine-container or amphora attributed to his hand (99–100) we see, in a register above the main panel of decoration, the god himself seated and surrounded by cavorting satyrs and maenads. Below, five chunky satyrs are busy collecting grapes, treading them and pouring the juice into a large storage jar for fermentation, with one, of course, providing piped music.

The symposium was one of the most influential exports of Greek culture. Vases originally produced for it in Athens and other Greek cities were themselves sent abroad, sometimes specifically as 'sets' for the drinking ritual: a krater for mixing the wine with water (a great metal version of this shape reached Vix in France), jugs (*oinochoai*) for pouring and cups (*kylikes*) for quaffing, plus various strainers and ladles. Some of the non-Greek peoples who adopted the wine-drinking culture may not always have followed its rules: the Celts and Macedonians, for example, were lax about diluting the wine. Others, such as the Etruscans, who collected Greek-made vases with particular enthusiasm, capitalized on the ambivalent aspects of Dionysiac imagery. He was a god who promised resurrection to his followers, which partly explains why the Etruscans used his vases for deposition in their tombs.

The afterlife consolations of the Dionysiac cult – one sixth-century BC philosopher declared, 'Dionysos is Hades', as if drinking itself transported you to the Underworld – are perhaps evident on a rare piece of surviving large-scale painting (101). We began with the process of colonization,

101
Panel from the Tomb of the Diver, Paestum, early 5th century BC. Fresco. Museo Archeologico Nazionale, Paestum

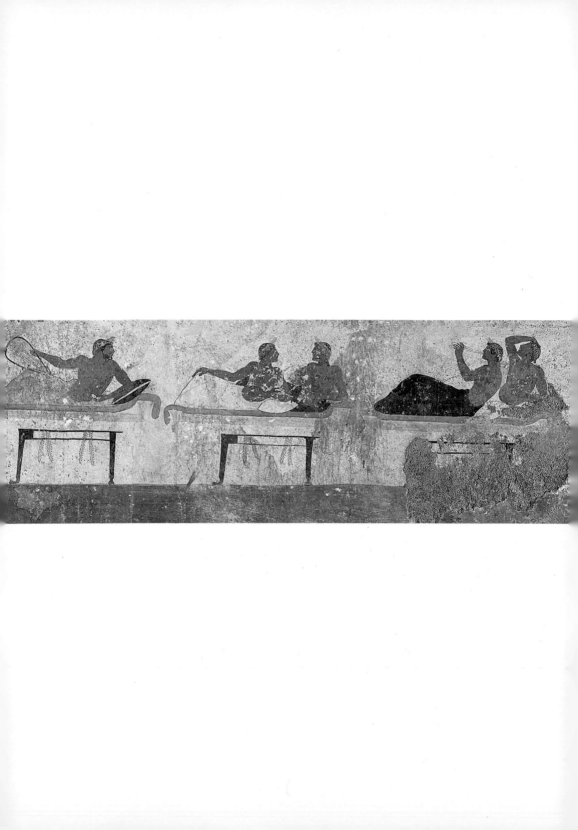

so it is appropriate that this piece comes from the southern Italian colony of Poseidonia (Paestum). It is part of a painted tomb that shows some key aspects of the symposium: not only the drinking from *kylikes*, but also playing a well-known game with them (called *kottabos*), which involved flicking wine around the room at a target (some receptacle, or perhaps someone at the party due for erotic attention). Everyone is garlanded; one couple features the younger partner of a pederastic rapport holding a lyre and receiving attention from his older admirer (whose seniority is indicated by his beard). Retrospective viewers of such imagery may find it riotous, even immoral, but for the Greeks it was a matter of self-defining pride: a culture that they regarded as a part of civilized behaviour.

4

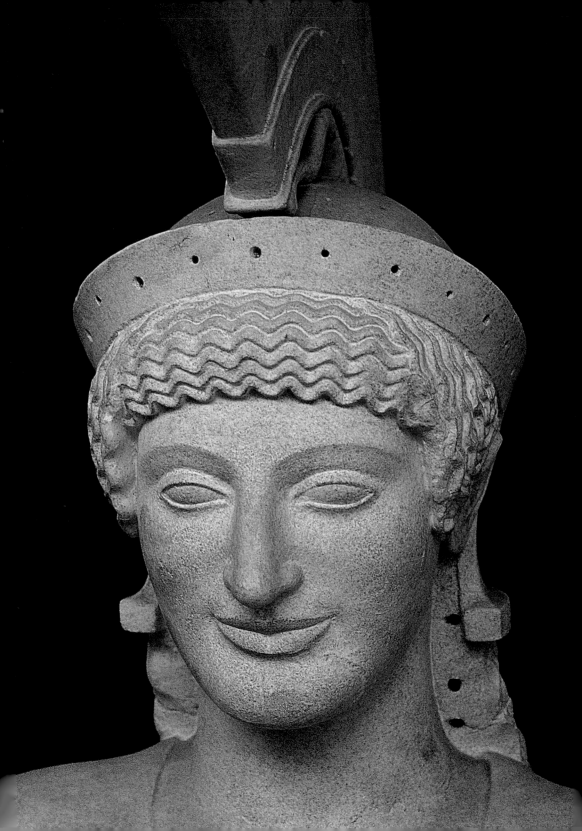

Nothing is worse for a city than a tyrant. It is the primal state, before the establishment of common law. One man rules, and frames the law himself. Equality doesn't exist. But when laws are written down, both poor and rich have the same rights to justice. This is freedom's rallying-cry: 'What man has good advice to give the city? Make it public, and earn a reputation. Non-contributors, hold your peace. For the city's sake, what could be better than that? When the people are the pilots of the city, they control their own destiny.'

This is part of a rousing speech put in the mouth of Theseus by Euripides in his play *Suppliant Women* (429ff). It is highly anachronistic: Theseus, as a proto-king of Athens, is adopting the rhetoric of anti-monarchical ideology, even paraphrasing the opening announcement made before every meeting of the democratic popular assembly (*ekklesia*) in Athens. Such was the pride of the Classical Athenians in their 'invention' of democracy that they made it a part of their civic destiny. Democracy in Athens was not formally established until 508 or 507 BC, after the expulsion of Hippias, son of Peisistratos. The protocols of this democracy may have been initially arrived at more by accident than by design, but as far as the Athenians themselves were aware, this system – *demokratia*, the rule (*kratia*) by the people (*demos*) – was the first of its kind. They vigorously boasted its superiority, as if they knew that it would one day inspire the political system accepted by a global community of nations. Since much of that boasting was expressed in terms of art and architecture, and art historians from the eighteenth century onwards have saluted democracy as a prime reason for the 'greatness' of Greek art, it is our duty to examine the phenomenon.

102
Head of
Athena from
the west pedi-
ment of the
temple of
Aphaia on
Aegina,
*c.*490 BC.
Marble;
h.172 cm,
67³⁄₄ in.
Glyptothek,
Munich

Does art thrive in conditions of relative personal liberty? Theseus, in his dramatic speech, argues that democracy encourages new blood and individual vitality in a city, which to a tyrant would seem threatening. The first scholar to document ancient art, J J Winckelmann (1718–68), believed that an ideology of equal rights among the citizens of Classical Athens directly fostered 'great art'. Though there are serious problems in anchoring Winckelmann's own aesthetics to the chronology of Athenian democracy, his judgement has retained a powerful, lingering influence. Subsequent art historians (for example, E H Gombrich) have coined such phrases as 'the Greek Revolution' or even 'the Greek Miracle' to describe the stylistic changes coincident with or even dependent on democracy. But rather than echo the tempting formula that individual political freedom yields adventurous artistic enterprise, we should first pick our way briefly through the local historical circumstances, beginning with the events that lie behind one of the most powerful icons of ancient art, the statue group of the Tyrannicides (103).

As it stands, this group is in fact only a copy of a copy. Made in Roman times, the group we now see replicates an original group in bronze made around 477 BC in Athens by two sculptors named Kritios and Nesiotes. Sources tell us that they in turn were replacing a group created by a sculptor called Antenor perhaps around 510 BC, a group subsequently removed from Athens by invading Persians in 480 BC. How far Kritios and Nesiotes were aiming to reproduce the original is not clear, but it does seem that the figures were intended as portraits, in which case they are the first official portraits in Greek art.

The subjects are two Athenian men, Harmodius and Aristogeiton. They were not only friends, but partners in a pederastic relationship. The older man, Aristogeiton, is defined by his beard and perhaps by his strikingly protective

103
The
Tyrannicides,
Roman marble
copy of a Greek
bronze original
made c.477 BC.
h.195 cm,
76⅞ in.
Museo
Archeologico
Nazionale,
Naples

posture. Both died in 514 BC, in an effort to rid Athens of the Peisistratid tyranny; or at least, that was the reason they were heroized. The facts of the matter, if they can be called 'facts', are less crystalline, but pursuing the historical circumstances may give us some insight into the motivation for heroizing art in the context of the Greek city.

We encountered Peisistratos in the previous chapter. A tyrant who spent liberally on art and public works, he may not have been unpopular as such, but he crossed at least one important Athenian family, the Alkmaionids, whom he drove into exile. The Alkmaionids signalled their own spending power and

piety by assuming the decoration of a new temple to Apollo at Delphi. But they were waiting to return. On his death in 527 BC Peisistratos was succeeded by two sons, Hippias and Hipparchus. At the Panathenaic festival of 514 BC, Harmodius and Aristogeiton drew swords and assassinated Hipparchus. It seems that they had originally intended to kill the elder brother, Hippias, but found Hipparchus an easier target. In any case, they both nursed grudges against Hipparchus: Aristogeiton, because Hipparchus was repeatedly making overtures to his boyfriend Harmodius; Harmodius, because Hipparchus had lately insulted his sister. In the tumult of the attack, Harmodius was killed himself; and though Aristogeiton escaped, he was later caught and tortured to death by Hippias.

104
Potsherds from Athens bearing the names of candidates for political exile

So much for the event. Should it be labelled as 'tyrannicide'? Not strictly, if we follow Thucydides, whose account of what happened (VI.54–9) stresses that the original motive for the killing arose from a love affair. That is, Harmodius and Aristogeiton seem not to have conceived their plot from noble political motives: if it chanced to develop that way, that was almost accidental, and certainly posthumous.

Nor, strictly speaking, did Harmodius and Aristogeiton directly bring down the tyranny. Things got worse before they got better. Hippias remained in power for another four years, growing ever more malevolent towards his subjects, until a coalition of the exiled Alkmaionids and the Spartan army succeeded in driving Hippias out. It was probably then,

in 510 BC or the following year, that the original statue of Harmodius and Aristogeiton was raised in the Agora.

Following Hippias' expulsion, Kleisthenes, a leading member of the Alkmaionids, set about political reform. The institutions on which 'democracy' depended were apparently put in place around 508–7 BC: ten voting districts, an elected council or senate, 500 strong (known as the *boule*); law courts with juries; and, perhaps, most importantly, a popular assembly (called the *ekklesia*). Whether or not Kleisthenes intended it, populism became rampant. There was even a device installed for regularly expelling any individuals who looked as if they were getting too powerful: citizens simply had to scratch on a potsherd, or *ostrakon* (104), the name of the most ambitious

person they could think of; the person with the most nominations was then automatically ostracized, or sent away from the city for several years to cool his vain-glorious plans. This was how future tyrants were going to be forever thwarted.

The force of this democratic ideology will become more obvious when we look at the development of the Athenian Agora and at town-planning generally in the fifth century BC. For now, we may note that no statue was raised to democracy's presumed architect, Kleisthenes. Instead, a cult built up around the more ennobling, brazen figures of Harmodius and Aristogeiton. Their image enjoyed the distinction of being placed in the heart of Athenian civic life; and we know that laws prohibited the erection of other statues in their vicinity.

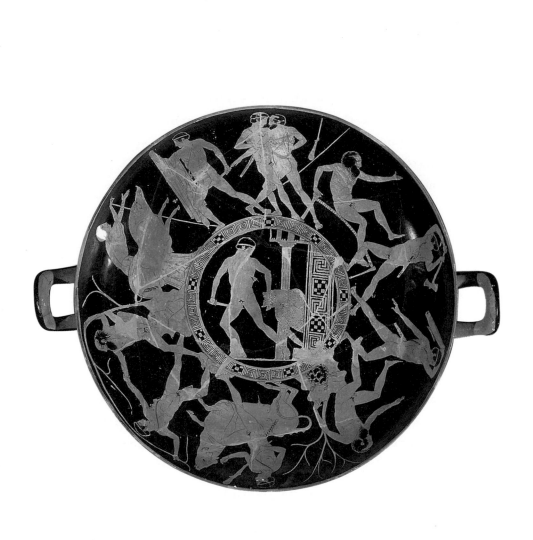

Cynical observers will realize that by fixing the birth of democracy on these supposed tyrant-slayers, Athenians could conveniently erase in vulgar consciousness the role of the Spartan army in expelling the last Peisistratid. The Spartans were their arch-rivals within Greece: to admit a shred of dependence on them would have been hateful to all Athenians. So a fetish was made of the home-grown 'Tyrannicides'. The resonance of their image may be registered throughout the iconographic record of Classical Athens, on vases, coins (105) and other monuments. For example, the striking gestures of Harmodius and Aristogeiton may be consciously or subconsciously mimicked by other Athenian heroes in art, such as Theseus (106 and 125). Theseus himself enjoyed renewed popularity as a 'democratic' hero, perhaps as a reaction against the Heraklean fantasies of Peisistratos. The Tyrannicides group became a talismanic icon for the Athenian democracy.

106
Athenian red-figure cup attributed to the Codrus Painter, showing the deeds of Theseus, c.430 BC. diam. 32 cm, 12⅝ in. British Museum, London

Harmodius and Aristogeiton were cult figures in both the general and precise meanings of that term. To touch them brought luck, to invoke their name had a guaranteed rhetorical effect. Drinkers at Athenian symposia sang maudlin choruses in their honour. How idealized they may be as portraits we cannot tell: they have been given the costume of nudity, and this can be called 'heroic nudity', for Harmodius and Aristogeiton, relatively soon after their deaths, were worshipped as heroes or demigods, as if they were Achilles or Agamemnon. As well as their statue in the Agora, they had a cenotaph in the Kerameikos, where annual offerings were made by the city's war-minister, or *polemarch,* treating the pair like those fallen in battle on behalf of the city.

Foreshadowing, perhaps, the Statue of Liberty in New York harbour, the Tyrannicides represent self-consciously 'democratic' art: art paid for by public subscription and actively symbolizing a political mentality. More subtle reflections of democracy's impact probably escape us. We know frustrat-

ingly little about some of its early protagonists, though we suspect that certain surviving plays from the Athenian stage, such as the *Oresteia* of Aeschylus, allegorize their fortunes. But one example may be given of how democratic ideals were insinuated into the currency of images in early fifth-century BC Athens.

From about 490 BC onwards a number of Athenian vases show, in a very particular way, a small but telling episode of the later stages of the Trojan War. This episode is the dispute over the armour of Achilles. As we saw in the introduction to this book, this was divinely made armour, much to be coveted. When Achilles died, slain by an arrow from the Trojan prince Paris, two Greek heroes made bids for his armour. One was Ajax, the other was Odysseus. In a depiction of their quarrel as it immediately arose, the vase-painter Douris shows us Ajax and Odysseus pulling out their swords and being held back, as if this were a bar brawl, by their friends (107). In between them, on the ground, are piled the helmet, shield, greaves and corselet of Achilles.

But Ajax and Odysseus did not come to blows. On the other side of the cup, Douris shows us how the dispute was settled (108). A table has been set up, with Athena standing by as if to adjudicate. The various Greek heroes have donned long robes and are coming forward to the table. They are depositing what were called *psephoi*, pebbles, or dried beans. These were the same tokens as used in the law courts to establish a verdict. Homer's heroes are, in fact, voting among themselves to see who shall possess the arms of Achilles. Douris dramatizes the result. He shows one pile of pebbles as being visibly bigger than the other and the two respective responses. On the winning side, a figure raises his hands in delight. This must be Odysseus. On the losing side, Ajax turns away in disgust or disbelief, leaning on his staff, with his head in his hands. His days of companionship with Achilles (see 91) have counted for nothing. The upshot of

107–108
Athenian red-figure cup painted by Douris, *c.*480 BC. Kunsthistorisches Museum, Vienna
Above Detail showing the quarrel between Ajax and Odysseus over the arms of Achilles
Below Whole vase showing Greek chieftains voting to decide the allocation of Achilles' arms

this thwarting will be his own self-destruction (see 92).

Douris adds his own touches to this story, as did other vase-painters. It looks as if the interest in the story was generated by some larger medium, though, perhaps a painting or mural in some prominent public place in Athens. As for the story itself, it belongs to that mass of lesser epic narratives which never fully made it into the texts of either the *Iliad* or the *Odyssey*, though that is not to say that it was obscure (on the Athenian stage, Sophocles would use it as a basis for one of his most powerful plays, the *Ajax*). But it certainly seems to have been manipulated to suit the propaganda of democratic values. In the old days (so the message may be construed) you resorted to violence to settle an issue; now, you take it to the ballot box. Presentation of a case rests not on brute force, but on argument, and a facility for making persuasive speeches.

So it was that even Homer's heroes could be drafted in to add heroic respectability to a newly devised political system. With regard to the protocols of voting in the democracy, we cannot tell just how innovatory it seemed at the beginning. We are not sure, for instance, precisely when the secret ballot made its début. There is little doubt, though, that serious regard for and pride in democracy's status was encouraged at Athens. Not only was it the world's first democracy, it was the least representative, too; that is, it had the greatest degree of direct participation from its citizens. Of course, many Athenian residents were excluded by virtue of their gender, or their social or ethnic status. This was not a political Utopia, but for those entitled to citizenship there was always the chance to be directly heard. Political activity was both a right and a duty for these citizens; to be a non-contributor was a sign of eccentricity and unsociability, and anyone who failed to pull his weight within the city was disparagingly referred to as a 'freak', an *idiotes*.

The rendezvous of the popular assembly was eventually a

great debating-bowl carved into the Pnyx, a hillside a little to the southwest of the Agora. Its capacity is estimated at about 10,000. Here citizens met to vote on resolutions put forward by the council, seemingly by a show of hands or sticks (students of Greek vases will often notice that even quite young and healthy men have the long knotty stick as an attribute: it is a badge of citizenship). The real hub of democratic activity, though, was the Agora. Ongoing excavations of this area since 1931 have retrieved not only many of the objects that directly testify to democracy's operations – voting registers, clocks for timing speeches and so on – but they have also clarified certain models of civic architecture whose influence may be felt to this day.

Let us consider the stoa, for instance. The extravagant modern reconstruction of a stoa endowed in the Agora by one of the kings of Pergamum around 150 BC takes us prematurely into a much later period, but it serves as a fine visualization of a form that was established by the late sixth century BC (109). Very simply, the civic stoa was an elongated colonnade designed to provide shelter from fierce sun in summer and from biting winds in winter. Some have described it as a precursor of the shopping mall, because within the colonnade there might be a multiplicity of shops, but it was much more than that. When a group of philosophers, led by Zeno, became known as 'Stoics', it was precisely because their forum for philosophizing was one of the stoas in the Athenian Agora, the Painted Stoa or *Stoa Poikile*, created around 460 BC. This was, as its name suggests, something of an art gallery too (about which more in Chapter 5). It also served as an arbitration centre, a display area for military trophies and a general concourse where sword-swallowers, jugglers and other tricksters would perform.

What brought the citizens to this central area? Not simply a taste for 'piazza life'; they were obliged to congregate. In the

Agora was also located the Bouleuterion, where the 500 city
councillors met; a circular building called a Tholos, where the
executive committee of the council were able to dine, at public
expense; and the Metroon, which was where weights and
measures were established, and archives maintained. There
was also an important group of statues on a long base, known
as the Eponymous Heroes. For each of the ten voting units or
'tribes' (*phylai*) created by Kleisthenes was given a name from
some mythical founding patriarch, and the generic images of
these patriarchs were raised up in central public view.
Presumably, in the cause of fairness, one looked very much
like another. It may be that a reflection of what the statues
looked like is given to us on the east frieze of the Parthenon,
showing groups of cloaked and bearded men leaning venerably
on their staffs (110). The importance of their status as markers
was more functional than artistic. Under the statue assigned
to his tribe, each Athenian citizen looked for news that

concerned him, posted on the high base. It might be notification of a forthcoming cavalry drill, requirement to attend a court hearing, or advance declaration of an issue due to come up at the assembly. Whatever it was, this was a noticeboard that demanded the daily attention of every citizen.

So we can imagine what a close community this must have been. Cutting through the Agora was the processional route of the Panathenaic festival, leading up to the Akropolis, whose precincts were also regularly frequented (120 days of the Athenian calendar were marked as days for various sacred observances). Politics and religion, then, dominated daily life in this community. Beyond the Agora, the city extended in mostly organic and ramshackle fashion; but even poor housing was given its own democratic value. The mid-fourth-century BC orator, Demosthenes, deploring the resurgence of private wealth and greed among his contemporaries, would conjure up the preceding century by specifically referring to the modest lifestyles of even the city's most distinguished generals: 'Any of you who are familiar with the houses of Themistokles or Miltiades or of the famous men of that time can attest that they were no more grandiose than those of normal individuals, while the city's public structures

110
Figures, from
the east frieze
of the
Parthenon,
modern cast of
the marble
original of
c.440 BC.
h.100 cm,
39⅜ in.
Museum of
Classical
Archaeology,
Cambridge

and buildings ... are of such a size and quantity that no later generation can surpass them.'

We shall examine in the next chapter the extraordinary building programmes undertaken by the Athenians in the mid-fifth century. But it is time to return to our question regarding the position of artists at the time of this intense political consciousness. Did it open new conduits of creativity and opportunity?

Democracy alone is quite inadequate as a means of explaining the basis of rapid stylistic change in both sculpture and painting. In vase-painting, for example, technical refinements to draughtsmanship in the black-figure style occurred throughout the tyranny, and a major development occurred at least a decade before the expulsion of the Peisistratids. The black-figure mode of decoration involved painting figures in black on the natural buff background of a fired pot, then etching detail on those figures with a sharp point. Some extra features would be added in white or purple paint, but essentially it was a scratching or incising technique. Then, around 530–520 BC, some painters began experimenting with a different method, which we call the red-figure style. This entailed 'reserving' figures by painting their background black, as if to leave them like inverted silhouettes. Detail was then added within their outlines by means of a very fine brush. Brushstrokes came more freely than incising, and the result is greater naturalism and more ambitious scenes, though not necessarily more complex compositions. Probably the most poised achievements in this style are the simple, single-figure studies attributed to the Berlin Painter, who allows the metallic tectonics of a shiny black vase to highlight his obsessive anatomical finesse (111).

Important technical developments in sculpture also pre-date democracy's arrival. The march of the marble *kouroi* towards increasingly naturalistic appearance proceeded regardless of any shifts in political regime, whether at Athens or elsewhere.

111
Athenian red-figure amphora attributed to the Berlin Painter, showing Herakles, c.490 BC. h.52·2 cm, 20½ in. Martin von Wagner-Museum, Würzburg University

112
'Piraeus
Apollo',
c.510 BC.
Bronze;
h.192 cm,
75⅝ in.
Archaeological
Museum,
Piraeus

113
Sculpture
from Cape
Artemision,
c.450 BC.
Bronze;
h.209 cm,
82⅜ in.
National
Archaeological
Museum,
Athens

Hollow casting of bronze, first practised at workshops on the island of Samos in the late seventh century BC, continued tentatively throughout the sixth, with sculptors generally content to produce in bronze the sorts of statues that could just as well be produced in stone. A figure of Apollo (112) recovered from Piraeus, the port area of Athens, may include an element of deliberate old-fashionedness, as if to stress the unchanging venerability of the god, but it is essentially unambitious in pose. But confidence grew. Though few Greek bronzes survive (they were vulnerable targets for melting down, first by conquering Roman generals, then by iconoclastic Christians or Turks), it is clear from literary and epigraphic records that by the early fifth century, bronze was the pre-eminent medium for freestanding statuary. The technicalities of the production of a large-size bronze figure are too complex to broach here, but it is enough to recognize that

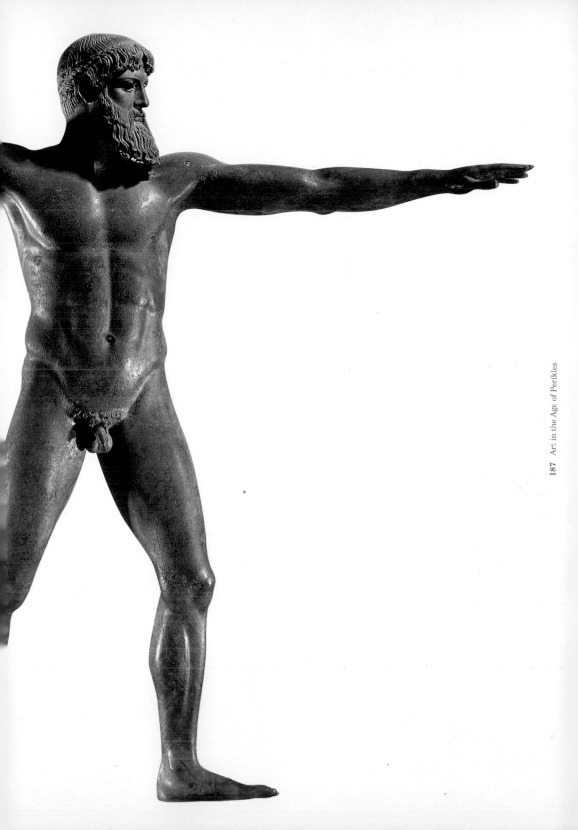

what made bronze attractive to the sculptor was its relative lightness. Since figures were ultimately hollow, they could be easily moved about; more importantly, this lightness enabled postures to be created which would have been prohibitively dangerous to execute in marble. The star-like shape of the bronze god found at Cape Artemision (113) – probably Zeus launching a now missing thunderbolt – would not have been possible in marble. Unsightly struts would be needed to support such broadly extending arms: one jolt in transport, one chisel-blow too much, would be enough to cause such a length of marble to crack.

Marble continued to be used, especially for temple decoration, but marble sculptors could not ignore the brisk, neat effects that could be achieved in bronze. At the Temple of Aphaia on the island of Aegina, an island famous in antiquity for producing a particularly fine alloy of bronze, a compromise was reached by leaving many details of the pedimental decoration (which seems to show a sally to the East by Herakles and other heroes) to be picked out in bronze. The figures are punctured generously with holes for the attachment of such metal accoutrements as weapons, armour, jewellery and the like (see 102). Arguably, the clean-edged influence of bronze can be traced in the delineation of the warriors on the pediments, though some, stretched out in the agonies of death (114), also profit from the natural gravity of marble.

Those sceptical of any link between democracy and style will be gratified to learn that the most distinguished of all surviving bronzes from early fifth-century BC Greece, the Delphi Charioteer (115), is known to have been commissioned by a tyrant. Autocracy flourished in some of the Greek colonies, and the charioteer commemorates a victory at the Pythian games of Delphi in either 478 or 474 BC by Polyzalos, tyrant of Gela in Sicily. Apart from the figure, a bundle of reins and a few equine fragments are all that remain of what must

115
The Delphi
Charioteer,
dedicated by
Polyzalos of
Gela at Delphi,
*c.*475 BC.
Bronze;
h.180 cm,
70⁷⁄₈ in.
Archaeological
Museum,
Delphi

once have been a highly impressive group on display at
Delphi. The charioteer has halted, but his attention is still
alert, emphasized by the gaze of his inlaid eyes. The respec-
tive effects of bronze and marble may be judged by compar-
ing this charioteer with a marble figure, also from a western
Greek setting, similarly dressed in a long girdled gown (116).

Some scholars over-stress the technical liberation created
in sculpture by the advances in bronze-casting. To say
that bronze encourages more plasticity of form because it
depends on a model made of clay is misleading, because
marble sculptors also worked with full-scale terracotta
models to guide them. The truth is that for both bronze
and marble figures, and indeed for painting too, there was
a premium on realizing naturalistic effects. The predominant
reason for this may be loosely described as religious, given
the firmly anthropomorphic tenets of Greek cult: art in
the setting of sanctuaries was required to convince its view-

ers of potential animation. Yet, taken another way, it may
be seen as the index of a profound humanism. If we can
draw again on the work of Euripides, the opening image
of his *Iphigeneia in Tauris* presents Orestes, the son of
Agamemnon, as the last standing pillar of a collapsed house:
'The columns of a house are sons.' Looking around the build-
ings of a city, especially its central or sacred spaces, any
fifth-century Greek would have appreciated the savour of
that image. Columns, columns everywhere; columns ranged
in lines two deep, a quasi-phalanx of soldiers; and before and
beyond the columns, numerous statues of the city's men, like
a standing, symbolic army.

The development of the male nude in fifth-century Greek art
is related to several social factors, in addition to whatever
aesthetic considerations were in force. In Athens and certain
other city-states, for example, we have evidence of male
beauty competitions, in which the dominant criterion for
assessing 'fine manliness', or *euandria*, was bodily tone and
shape. It was not extraordinary for men to take exercise
naked, in more or less public places. The Greek word *gymna-
sion* means simply 'a place where people go *gymnos* [naked]';
and the presence of a gymnasium was one of the defining
characteristics of what made a city in Greek terms (see
Pausanias, X.4.1). Running, wrestling and generally 'working-
out' were integral components of education. It is no surprise
that when Plato sought a site for his school, he chose an
area by one of the prime suburban gymnasia of Athens, the
Academy. 'A sound mind in a healthy body' is a translation
of a Latin satirical phrase, but it is definitely related to a
central principle of Greek education.

Artists had, therefore, plenty of opportunities to witness
directly the reality of a well-muscled torso, complete with six-
fold corrugations at the abdomen, and that distinctive ridge
marking the juncture of thighs and midriff which is known
anatomically as the iliac crest. Modern athletes exhibit just

116
Figure from
Motya, west
of Sicily,
c.470 BC.
Marble;
h.181 cm,
71⅜ in.
Museo Civico,
Marsala

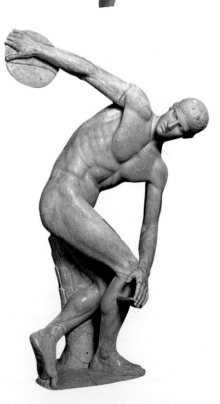

117
'Kritian Boy',
dedicated on
the Athenian
Akropolis
*c.*490–480 BC.
Marble;
h.86 cm,
34 in.
Akropolis
Museum,
Athens

118
'Discobolos',
Roman marble
copy of a Greek
bronze original
by Myron of
*c.*450 BC.
h.155 cm,
61 in.
Museo
Nazionale
Romano, Rome

such features, and we see the *kouroi* gradually acquiring them, until the last of the genre, the so-called 'Kritian Boy' (117), exhibits almost completely organic and 'natural' form. He is very likely an athletic victor, the bloom of his youth frozen in marble for posterity. Literary sources tell us that one sculptor working in the first half of the fifth century BC, called Myron, even managed to capture a sprinter in bronze, 'just as he was in full flight'; an impressive achievement for a modern photographer, let alone an ancient sculptor. Though none of Myron's actual bronzes survive, Roman marble copies of his 'Discobolos' (118) convey to us a fraction of his ability to convert sporting motion into fixed postures.

Those who look carefully at the anatomy of the Classical nude as it developed into the mid-fifth century will note certain features whose definition would, in fact, defy any amount of training. One is the continuation of the iliac crest around the back of the figure, to divide the rear aspect as emphatically as the front; another is the descent of the spinal cord into a dimple, rather than a pad. Nature never designed humans with these features. This is where the obsession with a symmetrical, highly ordered work of art overtook the wish to 'deceive' viewers with an illusion of reality. Since Classical Greek art is celebrated for its naturalism, this is an almost paradoxical feature, and one that deserves explanation.

By the mid-fifth century BC a sculptor called Polykleitos, from Argos, was gaining, like Myron, a reputation for his statues of athletic victors. Again, no original examples of his work survive, though it is clear from both literary and archaeological sources that the Romans admired it deeply. A Graeco-Roman source tells how Polykleitos made two statues of the same subject, one of which he executed according to his own principles, the other of which he did in public view, inviting comments and suggested improvements from visitors to his studio. When both statues were exhibited, of

course, the one that the public preferred was the one that Polykleitos had done according to his own rules rather than their promptings (see Aelian, *Varia Historia*, XIV.8). By this account, Polykleitos was a principled artist, 'a fighting highbrow', in the words of art historian Kenneth Clark. Disappointingly, however, we can do no more than assemble a few fragments of his high principles. The knowledge that his works were nothing if not micro-precise makes this unusually frustrating.

Our best snippet of information about Polykleitos, and it is no more than that, comes from a second-century AD medical writer, Galen (*De Placitis Hippocratis et Platonis*, V.448). Galen is in the course of explaining certain doctrines of a late third-century BC Stoic philosopher, Chrysippos. He writes:

Chrysippos holds that beauty does not consist in the elements [by 'elements' are understood the properties hot, cold, dry and moist] of the body, but in the harmonious proportion of the parts – the

119
Spear-carrier, Roman marble copy of a Greek bronze original by Polykleitos of *c.*440 BC. h.212 cm, 83$\frac{1}{2}$ in. Museo Archeologico Nazionale, Naples

proportion of one finger to another, of all the fingers to the rest of the hand, of the rest of the hand to the wrist, and of these to the forearm, and of the forearm to the whole arm, and, in short, of everything to everything else, just as described in the *Canon* of Polykleitos. Polykleitos it was who demonstrated these proportions with a work of art, by making a statue according to his treatise, and calling it by the same title, the *Canon*.

We can just about make sense of this description of Polykleitan aims. The basic principle is one of continuity, with each section of the body relaying a fraction of itself to the next section, hence Galen's summary of this accumulation as 'of everything to everything'. Yet we can do little to reconstruct in detail the ratios that Polyklcitos specified in his book. Putting ourselves in front of a marble copy of his best-known bronze, the 'Spear-carrier' or 'Doryphoros' (119), the main difficulty is that we do not know where to begin. At which point do we first place our calipers and plumb lines? And were the statues of Polykleitos ever copied with the absolute accuracy required to transmit his own original measurements?

'A well-made work is the result of numerous calculations, carried to within a hair's breadth.' 'The work is trickiest when the clay is on the nail.' The literary memorabilia of Polykleitos, probably extracted from his *Canon*, suggest a good deal more than the basic system of ideal human proportions summarized by the architectural historian Vitruvius (*De Architectura*, III.1.2–7) and famously made graphic by Leonardo da Vinci (120). According to this basic system, the length of a man's foot should be one-sixth of his height, the span of his outstretched hands should equate to his height and so on. On account of its presumed precision, what the *Canon* of Polykleitos sought to achieve has often been explained in terms of mathematical elegance. Some scholars presume the influence of the philosopher Pythagoras and his followers, who 'supposed the elements of numbers to be the

elements of things', and proportion to be 'the bond of mathematics'. Yet it must also have been anthropometric, based, that is, on measurements of the body, not on some absolute, external matrix; and organic, which means that the system was flexible enough to accommodate female as well as male figures, young as well as old.

Elusive as the actual *Canon* is, it is probably most accurately evoked by art historian Erwin Panofsky, who reckons it

120
Leonardo da Vinci, 'Vitruvian Man', showing the Vitruvian scheme of human proportions, *c.*1485–90. Pen and ink; 34·3×24·5 cm, 13$\frac{1}{2}$×9$\frac{5}{8}$ in. Galleria dell' Accademia, Venice

121–124
The Hephaisteion (formerly known as the Theseum), Agora, Athens, *c.*460–450 BC
Right
Exterior
Following pages
Exterior detail of entablature. Details of the polychromed interior decoration of the ceiling and cross beams (as reconstructed and published by Gottfried Semper in 1878)

to have proceeded on the basis of 'organic differentiation' and reminds us that the *Canon* sought, in Galen's words, the definition of what 'constitutes beauty'. As such, it was unlike the ancient Egyptian system for figures, whereby a grid was laid out and the human form mapped onto it according to where noses, legs and feet should be. Rather, Polykleitos started with a figure – a successful athlete, perhaps a winner of a male beauty contest – and

tried to work out how the constituent parts of this body, officially or socially saluted as 'beautiful', related to each other. In this way, in the words of Panofsky, Classical Greek art 'opposed to the inflexible, mechanical, static and conventional craftsman's code of the Egyptians an elastic, dynamic and aesthetically relevant system of relations'.

In the context of the democratic city, whose young men were like ranks of columns, Polykleitos appears to have created a concept of the human body articulated as a four-square construction. The honed male body became as predictable, then, as the units of Doric architecture (see 63), the iliac crest forming, as it were, an entablature of the loins. It is worth observ-

ing that the Doric order itself approached a virtual 'canonization' at just the time of Polykleitos, as is evident from one of the most intact temples in Greece, the Hephaisteion (121). Placed on a small rise on the west side of the Athenian Agora, its architects endeavoured, like Polykleitos, to underpin satisfying form with a set of regular proportional relationships. So for those armed with tape measures, the temple yields a ratio of 9:4 between its width and the height of its columns, and again 9:4 of its length to its width. The sculptural decoration, whether consciously or not, echoes certain compositions that in themselves must by now have been counted virtually 'canonical': for example, Theseus fighting in a Tyrannicide pose (125). And enough traces of the

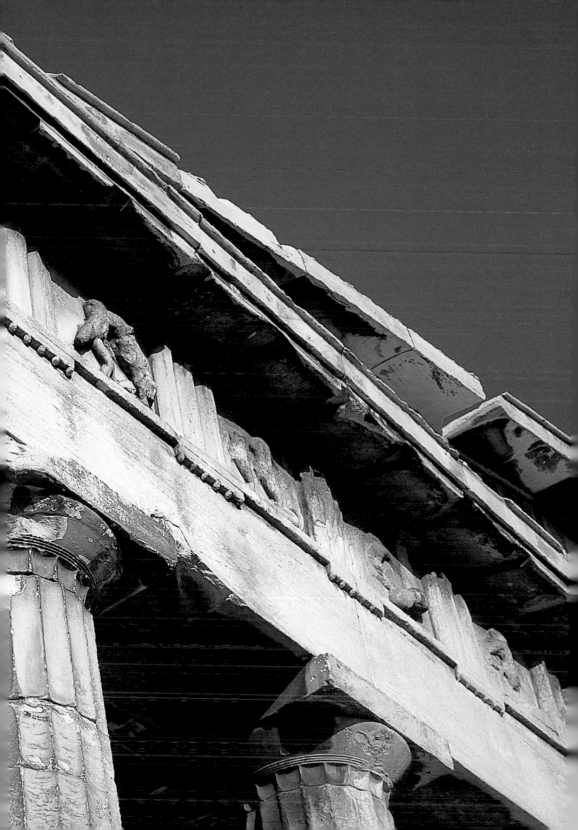

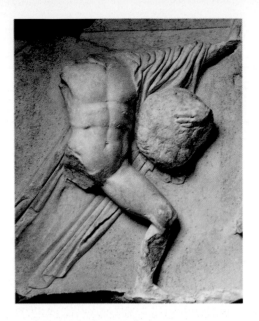

original paintwork survive for us to reconstruct the vivid poly-
chromy that once adorned the temple's architrave (122–4).

The extension of mathematical and geometrical interest to
urban planning seems inevitable at this time. Very ancient
examples of orthogonally planned cities can be found in Egypt
and the Near East, but such urban layouts as have been
revealed in archaic Greece (for example, Zagora) indicate few
tendencies to be other than organic. Rigorous impositions of
order are accredited entirely to one man, Hippodamos, styled
as a 'measurer' (*meteorologos*) by vocation. He may have made
his mark as early as 479 BC, when his home town, Miletus,
which had been destroyed by the Persians in 494 BC, was
rebuilt according to the straight lines and central axes of a
gridiron. The excavated revelation of Miletus (126) impression-
istically confirms what is called 'Hippodamian' planning. More
focused confirmation comes from the port of Piraeus, where
inscribed boundary stones (*horoi*) have been recovered, attest-
ing to the division of the planned area into functional zones.
According to Aristotle (*Politics*, II.5), Hippodamos believed
that, within the compact and predictable parameters of a grid-
iron, the city ideally ought to be divided clearly into quarters

125
East frieze
of the
Hephaisteion,
detail perhaps
showing
Theseus in
'Tyrannicide'
fighting pose
against the
Centaurs,
*c.*450 BC.
Marble;
h.85 cm,
33½ in.
Agora, Athens

126
Plan of the city
of Miletus, as
laid out in the
early 5th
century BC

500 m

of specific use – residential, religious, commercial and military – with a central area reserved for public or democratic institutions. In reality, the cognitive compartments of the ancient Greek mentality (if one can generalize so broadly) can hardly have allowed such strict divisions. As we have noted, the Athenian Agora alone must have accommodated and even blended all four functions. Hippodamos may have been a dreamer: his approach was certainly satirized on the Athenian stage by a raving surveyor in Aristophanes' *Birds*, who tries to impose a radial plan on the earth's upper atmosphere. It is tempting to think of him as yet another mid-fifth-century BC Greek addicted to geometry, but it should also be borne in mind that his sort of rationalization of urban layout was particularly appropriate for democratic constitutions and was perceived as such by ancient authors (see, for example, Diodorus Siculus on the planning of the Panhellenic colony of Thurii in 444 BC: XII.10.7). After all, Hippodamian planning effectively 'levelled' the citizenry; and its divisions were not intended to disrupt communality, but rather to consolidate it.

We have mentioned the Persian destruction of Miletus. This anticipates our next chapter. Historically, no sooner than Greek democracy was established, it found itself threatened by an expanding and emphatically monarchical Persian empire. The military response to that challenge belongs to a particular historical narrative. The enlistment of art in the struggle, on the other hand, has guaranteed it a much wider symbolic significance.

5

For a story to qualify as a myth it should, to be precise, have
no basis in any actual events (unlike a legend). For a story
to qualify as history it should, to be precise, relate to actual
events, or at least profess to do so. Of course we rarely speak
so precisely. And neither did the Greeks, to whom we owe
both the concept of myth (*mythos*, a 'fable') and of history
(*historia*, literally 'knowledge gained by inquiry'). 'Myth'
can be used to denote any sort of narrative with a fictional
element, though we now prefer to reserve it for the more
powerful fictions that influence our lives. In postmodernist
concepts of 'history', there is virtually no history that does
not mythologize, by imposing essentially simple 'grand
narratives' on essentially complex and dishevelled collec-
tions of events.

In fact the Greeks anticipated postmodernism. They
coined the conglomerate term *mythistoria*, 'myth-history';
aware that even historians who set out to be rigorous in
distinguishing the natural from the supernatural, the
impartial from the biased, the plausible from the fantastic,
were prone to embellish a chronicle with literary or poetic
devices. When Homer devised words for deities such as
Apollo and Aphrodite, he unashamedly used direct speech:
he was flagrant in his fantasy of 'actually' being there in
the interactive world of Troy and Olympos. In the mid-fifth
century BC, Herodotus, the so-called 'father of history',
naïvely narrowed the distance between the real and the
imaginary, allowing for the creations of mythology to have
some sort of relatively recent existence in the world. A few
decades later, Thucydides declared that his account of
the Peloponnesian War would be so lacking in fabrication
as to risk the reader's boredom, but admitted that in report-
ing speeches, he would mend the gaps in his own or the

127
Figure of
Apollo from
the west pedi-
ment of the
temple of Zeus
at Olympia,
c.460 BC.
Marble;
h.315 cm,
124 in.
Archaeological
Museum,
Olympia

collective memory by inventing suitable words.

With Thucydides there is at least the ideal of 'pure' history, in the sense of a chronicle untainted by partisan or careless authorship, and in a sense designed to distinguish the narratives of history from the narratives of mythology. But it took a philosopher with more scientific than literary interests to clarify the nature of this distinction; or rather, subvert it. This was Aristotle, whose fragmentary notes on the art of fiction, known as the *Poetics*, originally delivered as lectures in Athens around 330 BC, have exerted more influence on Western 'creative writing' than any other book of literary theory.

Section IX of the *Poetics* is where the vital distinction is established. Aristotle has been discussing the nature of myth and its deployment by the poets. He proceeds:

It is not the poet's business to tell what *has* happened, but the kind of things that *would* happen – what is possible according to probability or necessity. The difference between the historian and the poet is not the difference between writing in prose or in verse (the works of Herodotus could be rendered into verse, and that would still be history). The difference is that history tells what has happened, and poetry the kind of things that would happen. It follows therefore that poetry is more philosophical [*philosophoteron*] and of higher value [*spoudaioteron*] than history. For poetry tends to universalize; history, to particularize.

This passage naturally delights poets. What has it to do with artists? The answer is that if the words 'art' and 'artist' were used wherever Aristotle speaks of 'poetry' and 'poets', we would have an extremely effective explanation for the decoration of some of the greatest surviving monuments of Classical Greece: the temple of Zeus at Olympia, the temples of Athena Parthenos and Athena Nike on the Akropolis and the temple of Apollo at Bassae. This is not to mention other monuments, such as the Persian Colonnade at Sparta, the

Painted Stoa and the Hephaisteion in Athens, and a great
many minor images from the fifth century BC; nor the
important projects elsewhere (for example, at Halicarnassos
and Pergamum in Asia Minor) that were subsequently
indebted to these Classical patterns of symbolic design.
The fact is that this fifth-century BC symbolism was like
Aristotle's idealizing poetry. Art was generated by historical
circumstances – predominantly, and often directly, by the
war with the Persians – but it largely abandoned any effort
to record the particularities of that struggle. Instead, it
sought images of universal value, by abstracting and general-
izing the war's events.

Our task, then, is to retrieve the intentions of the symbolism
operating here. Before we attempt to do so, however, we
may salute the integrity of Aristotle's analysis. In effect,
he predicted that the Classical Greek playwrights, who
undoubtedly wrote their plays with contemporary and local
situations in mind, would gain the audience of posterity by
virtue of universalizing their stories. If Euripides had writ-
ten soap operas concerning the lives of particular Athenians
– revolving, say, around the eminently dramatic figure of
Alkibiades, the friend of Sokrates and a skilled but maverick
strategist in the Peloponnesian War – few people today would
want to see them. As it is, the works of Euripides and others
are regularly staged throughout the world. That is not out
of antiquarian interest, but because by casting their 'histo-
ries' as myths, the playwrights distilled the elements of
perpetual interest. They dramatized, as it were, basic studies
of human psychology.

That is a broad generalization, with some important excep-
tions. For instance, in his play of 472 BC, *The Persians*,
Aeschylus, who is said to have taken part himself in two key
encounters with the Persians, could not resist including an
account of one of them, the naval victory off Salamis in 479 BC.
Artists too would stray into documentary mode where

patriotism demanded. The designers of the Painted Stoa
in the Athenian Agora, for instance – a trio of muralists
called Polygnotus, Mikon and Panainos – included a panel
that showed the battle of Marathon. It depicted, according
to a later witness, the mainly Athenian force 'engaging with
the Persians ... as the picture progresses, the Persians are
retreating, pushing each other into the marsh; then, at the
edge of the painting, their waiting ships, and Greeks attack-
ing those trying to get away in them. The picture also shows
the hero called Marathon ... Theseus, rising up out of the
earth; Athena, and Herakles ... and the leading general
of the day, Miltiades, and the war minister Kallimachos'
(Pausanias, I.15.1–3). This panel ended a series that included
evocations of Greek battles against Amazons and Trojans;
there seem to have been no markers of separation between
the mythical encounters with Amazons and Trojans and the
'historical' event of Marathon, which took place in 490 BC.
'Historical', that is, if it can truly be said to be so when
actual protagonists, such as the Athenian leaders Miltiades
and Kallimachos, were apparently juxtaposed with the
figures of divine or heroic assistance imaginatively added
to the Greek cause.

The investment of contemporary meaning into a familiar
scene of myth was doubtless common practice: so common
as to be taken for granted by most Greek writers of the time.
We rarely possess written confirmation for the links we
might want to make between historical events and their
allegorical representations, but it would be strange if artists
refrained from this sort of oblique comment. A particularly
vivid account of the taking of Troy, for instance, probably
painted during the decade of 480–470 BC, has been attrac-
tively identified as just such a case of implied contemporary
relevance. On the shoulder of a water jar (128), the epic
seizure of Troy is grimly outlined. The central image is terri-
ble (129): the old king Priam is being hacked about the head
by Neoptolemos, the impetuous son of Achilles, while on his

lap dangles the mutilated body of his grandson, Astyanax. On one side, women shelter in vain by the ironically martial statue of Athena; on another, a Trojan lady picks up the only weapon left to her, a grinding pestle. At either end the young and old are being hustled away: there is Aeneas, carrying off his father in a sort of fireman's lift.

This is what happens when a city falls: vengeful, spiteful slaughter (compare 53). No matter that it is being done, in mythical terms, by Greeks. The point is that the 'barbaric' details of the sack of Troy were well known to the viewers of this vase. The suggestion is that, since it was painted in

128–129
Athenian red figure water jar by the Kleophrades Painter, c.480 BC. Museo Archeologico Nazionale, Naples
Right
Detail showing the seizure of Cassandra
Far right
Detail showing the assault on Priam by Neoptolemos

Athens not long after Athens itself had been sacked by invading Persians, those viewers made the connection with their own experience.

A very brief summary of the course of the Persian wars will be helpful at this point. During the second half of the sixth century BC, a great amalgamation took place in the East of two large ethnic units, the Medes and the Persians. They came under the command of the dynasty known as Achaemenid (descended from one Achaemenes), and this dynasty had empire-building ambitions. Under Kings Cyrus the Great (r.559–530 BC) and Darius I (r.522–486 BC), the combined

Medes–Persians – who for the sake of convenience we shall refer to simply as Persians, though Greek writers often specify the difference – advanced into Ionia. By 492 BC Darius was in a position to launch an attack on the Greek mainland. His forces progressed to occupy Euboea within two years. They were guided by the aged exiled tyrant Hippias to a landing-point in the bay of Marathon, 42 km (26 miles) to the north of Athens. An Athenian infantry force of about 10,000 men hurried up to face them. They were joined by a battalion from nearby Plataea in Boeotia, but not by the Spartans, who pleaded religious commitments. Despite a great disparity in numbers (the Persian force is estimated at around 90,000), the Greeks launched an attack. The Persians were caught by surprise and had to retreat. According to Herodotus, 6,400 Persians lost their lives in the marshy plain of Marathon, compared with only 192 Athenians. Those 192 were, as we shall see, almost instantly promoted to the official status of heroes.

But the Persians returned. Ten years later, led by Xerxes (who ruled from 486 to 465 BC), an even more numerous contingent (estimated at around 300,000) marched into Greece via Thrace, Macedonia and Thessaly. At a mountain pass just north of Delphi, called Thermopylae, the advance was halted: now it was the turn of the Spartans, under Leonidas, to be heroic. But this time the Persians prevailed. The Athenians evacuated their city. By the autumn of 480 BC Xerxes was installed on the Akropolis, whose temples and statuary his troops desecrated at their leisure. Then he engaged the Greeks by sea off the island of Salamis and lost; and lost again at the land battle of Plataea. His long withdrawal began. The Athenians created a defensive league to protect the Cyclades and Ionia from further attack and regained control of Aegean waters piecemeal, but not until 449 or 448 BC was peace with the Persians finally settled.

This little excursus contains the basic elements of events that generated a vast, perhaps disproportionate, quantity of artistic commemoration. Even the austere Spartans were moved to erect a colonnade in honour of their resistance to the Persians. As for the Athenians, they were faced with the wreckage of their own city. They both effaced this trauma by heightening their earlier triumph at Marathon, and yet emphasized it by leaving much of the wreckage exposed for thirty years until peace was concluded. Only then did a programme of reconstruction, steered by the statesman Perikles, seriously begin on the Akropolis, with the inception of work on the Parthenon in 448 BC. Elsewhere, the expression of anti-Persian anger rapidly became codified into a system of symbolic images.

The first monumental evidence for this system may be embodied in the decoration of the temple of Zeus at Olympia (130). Deep in the heart of the Peloponnese, undisturbed by the Persians, it seems an unlikely place for a commemorative project. Indeed, the subject of its front gable is a local story: on either side of a central Zeus, the cast of a sculptural drama explaining how the hero Pelops came to this part of Greece is assembled (see 168–9). The metopes of the temple

130
Reconstructed drawing of the east end of the temple of Zeus at Olympia

131
Metope from
the temple of
Zeus at
Olympia, show-
ing Herakles
shouldering
the earth while
Atlas fetches
the golden
apples of the
Hesperides,
c.460 BC.
Marble;
h.160 cm,
63 in.
Archaeological
Museum,
Olympia

132
Metope from
the temple of
Zeus at
Olympia, show-
ing Herakles
returning to
Athena with
the birds of
Lake
Stymphalos,
modern cast of
a Greek marble
original made
c.460 BC.
h.160 cm,
63 in.
Museum of
Classical
Archaeology,
Cambridge

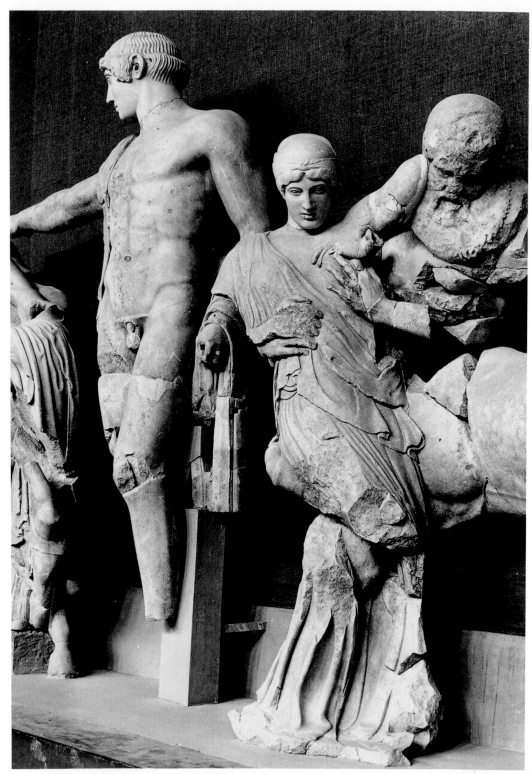

are likewise attuned to the Panhellenic piety of the site: they illustrate some of the many Labours of Herakles around the Greek world, such as his fetching of the apples of the Hesperides (131), or his riddance of the Stymphalian birds (132). Since there was only space for twelve metopes, these became eventually so famous that they were deemed to represent the Twelve Labours of Herakles (though as these two examples show, the hero can do nothing without the help of a girlish Athena). It is on the west pediment of the temple that we may propose a parable of contemporary events. Here, a full brawl is on display (133). The central and commanding figure of Apollo (127) has not yet established order. It is ostensibly a mythical fight, between a primal Greek tribe called the Lapiths and their horsey neighbours, the Centaurs. Invited to a wedding, the Centaurs attempted to abduct the bride and other Lapith women. This is not a local myth (its traditional setting is northern Thessaly). It may have a slight link with the temple via Zeus, whose Lapith son Perithoos was the groom at the wedding. Sculpturally, it is an extremely bold attempt to freeze violence: anger and pain are for the first time carved as furrowed brows and gaping mouths (134). In the context of a sanctuary where combat sports were part of the regular festival, this may seem like some reflection of athletic endeavour. Yet the moral of the myth was always clear enough. The bestial Centaurs were forces of disruption; threats to the order and civilized sanctity of Greek institutions. In the decade following the Persian vandalism of the Akropolis, it seems reasonable to see at least a nuance of contemporary relevance in the choice of this theme to decorate a new temple.

We cannot go beyond a guess at Olympia. Despite many years of excavation at the site, we do not even know who funded the temple of Zeus, though the west pediment sculptures were attributed to an Athenian, Alkamenes. We can, however, put together a plausible set of reasons why Centaurs might

133
Sculptures from the battle between Lapiths and Centaurs from the west pediment of the temple of Zeus at Olympia, c.460 BC. Marble; h.315 cm, 124 in (figure of Apollo). Archaeological Museum, Olympia

134 Overleaf
Detail of the struggle between a Lapith and a Centaur from the west pediment of the temple of Zeus at Olympia, c.460 BC. Marble. Archaeological Museum, Olympia

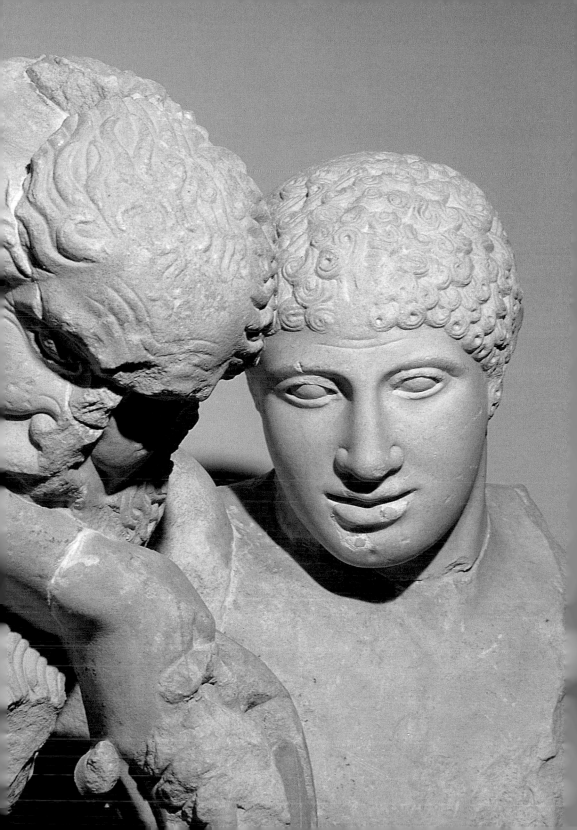

symbolize Persians in this period. For one, the horse-loving
Persians appear to have actually likened themselves to the
beasts, and thought it amusing that the Greeks were terrified
by the likeness (see Xenophon, *Cyropedia*, IV.3.17–22). For
another, Classical Greek poetic characterization of the
Centaurs draws attention to their *hybris*, their over-
stretching insolence; the same fault, in Greek eyes, which
brought down Xerxes with all his huge army. More tenuous
suggestions can be added: Centaurs were shown by fifth-
century artists as fighting with uprooted trees, as if referring
to the Persians' deliberate destruction, during their occupa-
tion of Attica, of valuable olive groves. What is certain is that
the image of Greek fighting Centaur – even specifically Greek
infantry soldier fighting Centaur (135) – became a common
motif in various media during and after the Persian wars.
In monumental sculpture, apart from Olympia, it figures
most memorably on the Hephaisteion, on the metopes of the
south side of the Parthenon (136) and on the frieze of the
temple of Apollo at Bassae (137).

Further mythical metaphors for the Persians were developed.
The association of the Persians with Centaurs reduced them
to the level of animals. The association of Persians with

Amazons reflected another sort of perceived inferiority: it denigrated them as women. If myth-making reveals deep-seated cultural traits, then the misogyny of Greek culture is fully exposed by the invention of the Amazons. An all-female tribe, situated somewhere on the eastern fringes of civilization (like the Persians), they invariably fought on horseback (like the Persians), using bows and arrows (like the Persians) and wearing soft caps and leggings (like the Persians). Their most serious encounter with the Greeks was when, during the time of Theseus, they landed at Marathon (like the Persians) and stormed the Akropolis (like the Persians).

Of course, there are many elements in the Amazon mythology which do nothing more than mirror the Greek (male) fear of women in control. For instance, to facilitate their prowess with bows and arrows, the Amazons would amputate their right breasts, as if to spurn any mothering role (they met men of a neighbouring tribe purely for procreation purposes and discarded any male infants born to them). This seems to have been too bizarre for the artists as they never show it (*eg* 139).

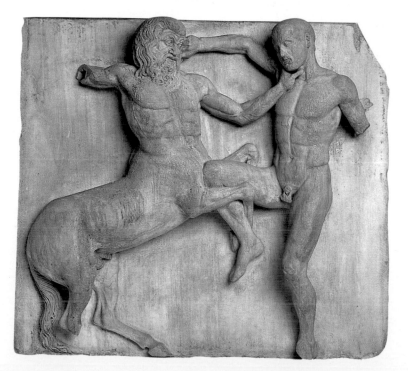

136
Metope from the south side of the Parthenon, showing a Centaur and a Lapith in combat, *c.*445 BC. Marble; h.133 cm, 52⅜ in. British Museum, London

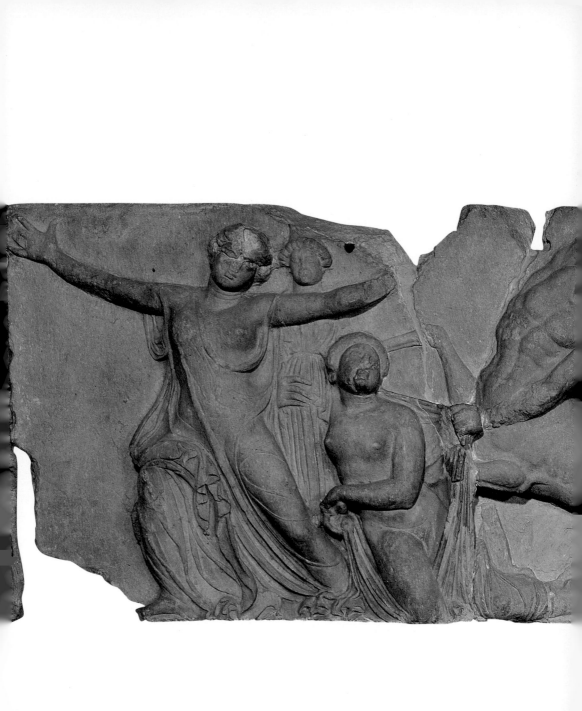

137
Frieze from the
temple of Apollo at
Bassae, showing
Lapiths battling
Centaurs,
c.420–410 BC.
Marble; h.64 cm,
25¼ in.
British Museum,
London

Elements of the myth certainly pre-date any Persian associa-
tions, but the accumulation of Amazon images during the
Persian wars is persuasive of a particular symbolism. It may
be that the battle of Greeks against Amazons as depicted on
the Painted Stoa in the Agora is reflected in a series of
Athenian vase-paintings of the mid-fifth century BC (138).
These feature some complex entanglements and show that
no gentility was indulged towards the Amazons on account
of their sex (though the fable was that when Achilles killed
the queen of the Amazons, he fell in love with her; and
Theseus would make another Amazon queen, Hippolyta, his
consort). The pseudo-Persian garb of the Amazons is undeni-
able. Another possible source for popularizing the image
(and symbolism) is a chapel, or *heroon*, near the Agora dedi-
cated to Theseus. In the course of pursuing the Persians after
the successes of Salamis and Plataea, the Athenian leader
Kimon had explored the island of Skyros, where Theseus was

supposed to have died. Kimon came back to Athens with the exhumed bones and armour of a man of great stature and declared these to be the remains of Theseus. Though the resultant shrine, the 'Theseum', has yet to be located, we are told that it was decorated with three mural paintings. One showed Theseus visiting the deities of the ocean, as if to reflect the marine command then being established in the Aegean by the Athenians. Another showed Theseus battling with the Amazons, repelling the oriental invaders. The third showed Theseus coming to the aid of the Lapiths against the unruly Centaurs. When one thinks of the many deeds of Theseus that could have been chosen to adorn his Athenian shrine, for example his trials with the Minotaur and the labyrinth in Crete, the focus on Centaurs and Amazons seems surely determined by their contemporary value as emblematic Persians.

Thus the symbolism was consolidated. The metopes of the west side of the Parthenon excerpted combatants from the Greek–Amazon tussle. The exterior relief decoration of the shield of the (now lost) colossal cult statue of Athena Parthenos, designed by Pheidias around 440 BC, evidently situated the battle on a precipitous slope (140), which must allude to the Amazons once mythically besieging the Akropolis. At Bassae, some twenty years on, perhaps the Persian significance of the Amazons was beginning to fade: the sculptors seem to have been more absorbed by the exploration of violent diagonal movement and the effects – heroic, dramatic and erotic – of drapery flying around male and female bodies in such violent poses (141). But the Amazons had securely joined a genealogy of offenders against the sacred civilization of Greece. First, the giants assailed Mount Olympos; then came the Centaurs and the Amazons; then the Persians. To universalize the Greek victory, artists simply called on the predictable figurations of this genealogy. So it is that although there are plenty of images related to the Persian wars, we have no seriously 'realistic' representation

140
Reconstruction of the shield of the Athena Parthenos, original c.440 BC. Royal Ontario Museum, Toronto

141
Frieze from the temple of Apollo at Bassae showing Greeks battling Amazons, c.420–410 BC. Marble; h.64 cm, 25¼ in. British Museum, London

of them. Roman commemorative art would be quite different, seeking to document the logistics, machinery and particulars of war (as on Trajan's Column, for example). Greek commemoration reduced – or elevated – war to its mythical, almost abstract nature. Order versus chaos, good against evil: the timeless sanctions of human conflict. The chauvinist basis of the choice of antagonistic symbols is revealed in a saying attributed to the sixth-century BC 'father of philosophy', Thales of Miletus, who considered himself lucky on three counts: 'Firstly, that I was born a human being, not an animal; secondly, that I was born a man and not a woman; and thirdly, a Greek and not a barbarian' (Diogenes Laertius, *Lives of Eminent Philosophers*, I.33). This triple blessing says it all. Beasts, women and barbarians all come together in the Centaurs, Amazons and Persians.

There was, as we noted, a period in which the Athenian Akropolis was partially left in the spoiled state caused by Persian occupation. Damaged statues were collected up and buried (giving future archaeologists a convenient assemblage of pre-480 BC material), but little new building was attempted. It seems as though a new temple to Athena had been conceived after the success of Marathon in 490, but had got no further than a basis of half-erected columns by the time of the Persian occupation. Thereafter, the politics of reconstruction are not clear. A dubious historical source tells us about an agreement, the so-called 'Oath of Plataea', taken by the Greek allies in 479 BC, whereby the impieties of the Persians were to be left visible. In Athens, Kimon, who was the son of Miltiades, the general who had inspired the victory at Marathon, promoted the Painted Stoa and the Theseum, both outside the Akropolis. He also probably sponsored the erection of a monument to Marathon at Delphi a little before his death in 450 BC. Standing near the Athenian Treasury at Delphi, it consisted of thirteen bronze statues, attributed to Pheidias, standing on an inscribed base. These statues were a gathering of Athenian tribal heroes, demigods

142
Statue A from Riace, attributed to Pheidias, c.450 BC. Bronze; h.198 cm, 78 in. Museo Nazionale, Reggio Calabria

(Theseus), gods (Apollo and Athena) and one 'historical' figure, Miltiades. It has been argued that two bronzes recovered from the Italian coast near Riace were once part of this group (142–4); further, that one of them, known cautiously as 'Statue B', may be the heroized portrait of Miltiades. Certainly, he once wore a helmet tipped back on his head, in the fashion of a general commemorated by the Athenian democracy; and it looks on the basis of style that both statue A and B must come from some ensemble set up in the mid-fifth century BC, so this is an attractive suggestion. But the really grand celebration of victory in Athenian art and architecture was yet to come.

The egalitarian ethos of Athenian politics, monitored more or less by the process of ostracism, did not preclude the rise of dominant individuals. So long as they could handle supporters and opponents with skill, such men could direct collective decisions by personal initiative. Perikles was one such man. He rose to his position of influence after Kimon's death, on the eve of settlement with the Persians. The tribute gathered from the Greek cities in the Aegean and Ionia as a guarantee of Athenian naval protection had originally been stored at the Panhellenic island sanctuary of Delos. Probably around 454 BC those funds were transferred, ostensibly for greater safety, to Athens. They continued to come in after the negotiation of peace with the Persians, in order to maintain a defensive network for the future. But Perikles saw an alternative or complementary use for them. He would divert them to the monumental aggrandizement of the Athenian Akropolis.

As a massive and expensive project, this may have had something to do with purely political manœuvres. A programme of public spending is usually a ticket to popularity (though Perikles was not without his critics, who accused him of flashily festooning Athens like a high-class prostitute, when he should have been attending to defence). The project was

143
Statue B from Riace, attributed to Pheidias, c.450 BC. Bronze; h.197 cm, 77⅝ in. Museo Nazionale, Reggio Calabria

not, however, launched in splendid isolation. The Athenians had a matter of status to demonstrate. At Persepolis, 4,830 km (3,000 miles) away, Darius and Xerxes and their successors were creating a huge ceremonial and imperial centre, laid out on a terraced eminence. Greek diplomats who visited Persepolis came back with stories of its size and stateliness; more importantly, Greek sculptors and masons were recruited or compelled to carry out the Persian designs, and they would have transmitted direct impressions of its scale. Who were the winners of the fifth-century contest for power in the Aegean? The 'defeated' Xerxes decorated a great

144
Detail of 143

145
Frieze from the Apadana at Persepolis, detail showing a procession of gift bearers, c.460 BC

146 Overleaf
The Akropolis, Athens, showing the Parthenon in the centre and the Propylaea and temple of Athena Nike on the right, c.440 BC. The Hephaisteion is in the foreground. Photographed in the late 19th century

reception hall, the Apadana, with row upon row of the forces at his command, and multiple processions of vassals bringing tribute to his throne (145). The Persians had been a nomadic people, with a patchy previous record of monumental design. Here they asserted a permanent hegemony. A response from Athens was called for, if Athens considered herself the head of a competing empire. It came in the spectacular form of the Periklean Akropolis (146–7).

The diversion of funds to this project amounted to virtual extortion, or a protection racket; but the collective energy

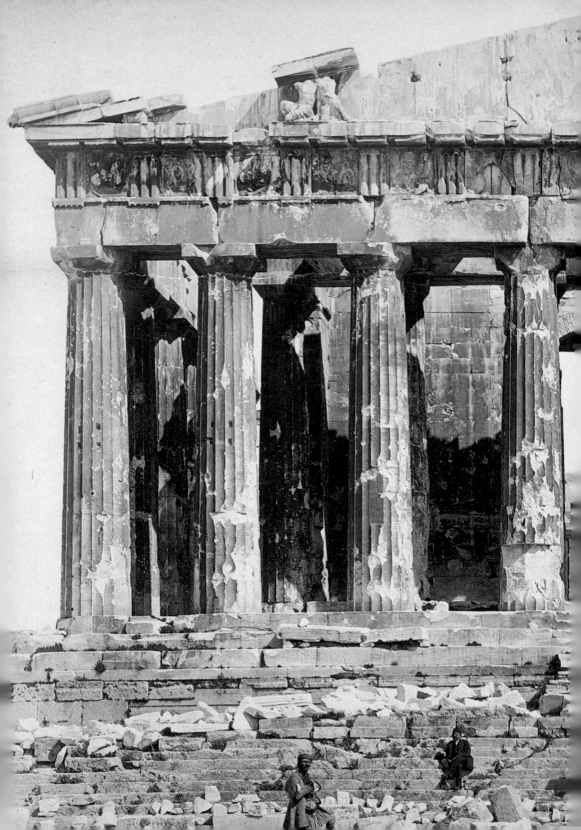

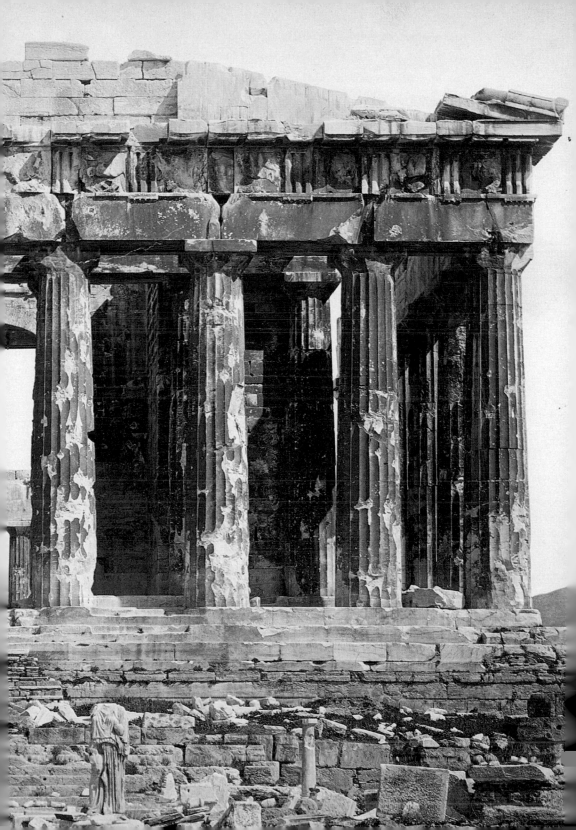

harnessed by Perikles decently veils that fact. It is worth quoting in full a passage from Plutarch's *Life of Perikles*, which expansively describes the breadth of the undertaking:

Military service brought good pay to the young and the strong. But as he did not want the undisciplined artisan class to be excluded from the rewards of military success, nor benefit from them while remaining idle, Perikles carried motions in the assembly for all sorts of great building and craft projects; so the civilians at home would share in the largesse of public funds no less than the warship crews and the men in the garrisons. The raw materials were stone, bronze, ivory, gold, ebony and cypress wood. To fashion them were a host of craftsmen: carpenters, moulders, coppersmiths, stonemasons, goldsmiths, ivory-specialists, painters, textile-designers and sculptors in relief. Then there were the men detailed for transport and haulage: merchants, sailors and helmsmen at sea; on land, cartwrights, drovers and keepers of traction-animals. There were also the rope-makers, the flax-workers, cobblers, roadmakers and miners. Each craft, like a commander with his own army, had its own attachments of hired labourers and individual specialists organized like a machine for the service required. So it was that the various commissions spread a ripple of prosperity throughout the citizen body.

There was undoubtedly a measure of sheer extravagance here. The passage to the western side of the Akropolis, where the Panathenaic way zig-zagged up from the Agora, was monumentalized into not just one imposing doorway (*propylon*), but a five-fold system of entrances known as the Propylaea (148). The architect Mnesikles not only flanked these entrances with porches and colonnades, but also allowed himself a very high degree of specification, using marble throughout, with coffered ceilings and so on. The width of the gateway was considerably larger than required by the road it was meant for. As if to stress that this was a

147 Previous page
The Parthenon, Athens, c.440 BC. Photographed in the late 19th century

148
The Propylaea, Akropolis, Athens, c.440 BC. Photographed in the late 19th century. The fortification tower has since been removed

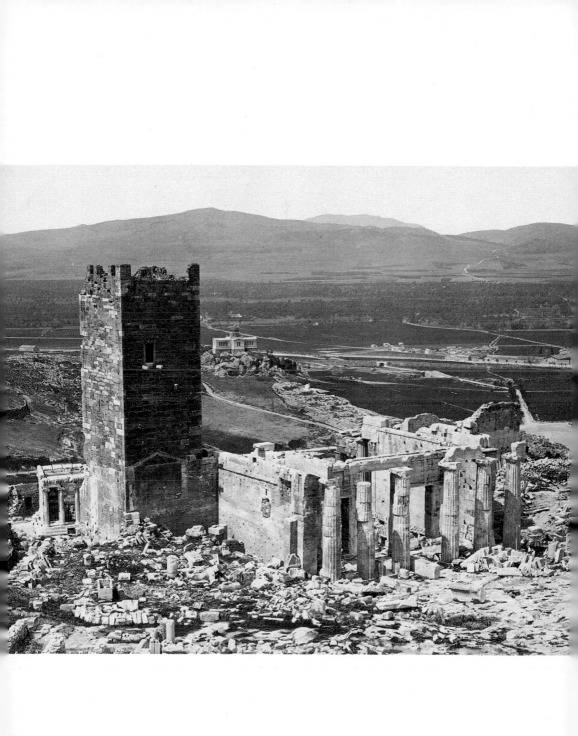

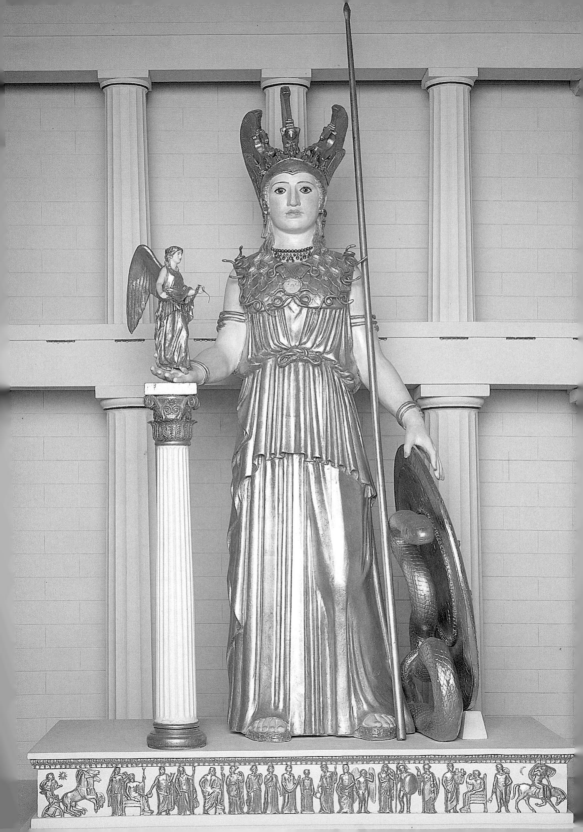

place for lingering, not simply transit, Mnesikles included a
north wing picture-gallery (*pinakotheke*), where paintings on
boards were hung above a dado.

The statue of Athena Parthenos entrusted to Pheidias was
similarly luxurious, though we can only conjure up its
original effect by reconstructing copies or models of it (149).
A number of ancient souvenir copies have survived: the
best is the 'Varvakeion' statue in Athens, done in marble and
standing just over 1 m (3 ft) high. A larger marble version,
which once stood in the Library at Pergamum, although
not a copy as such, probably best captures the dignity of
the statue (150).

149
Model of
Pheidias's
Athena
Parthenos,
original
*c.*440 BC.
Royal Ontario
Museum,
Toronto

150
Athena from
Pergamum,
*c.*175 BC.
Marble;
h.310 cm,
122¹⁄₄ in.
Pergamon-
museum,
Berlin

We are told that forty-four talents of precious material were invested in the drapery alone of the Parthenos. The ancient Greek talent is equivalent to around 26 kg (over 50 lb); if by 'precious material' we assume gold, the total weight of gold on the statue was 1,144 kg (around 2,500 lb); worth millions in current terms. This is why it is tempting to see the statue as a virtual figured treasury, and easy to understand both the ancient rumours that Pheidias was put on trial for embezzlement, and the statue's vulnerability to depredation. How many Athenians actually got to glimpse the Parthenos is open to question. Those that did, saw a figure at once comforting and threatening. Athena's warrior status was implied by her helmet, from whose visor sprung winged horses; the spear resting against her left shoulder; and by the female victory figure, flourishing a wreath, in her extended hand. In the myth-history of Athens, and specifically of the Akropolis, Athena – to whom most Athenians would colloquially refer as 'the goddess' – was protective beyond the usual limits of maternal instinct. She had her shawl with its aegis, the awesome gorgon's visage; and her shield, propped up by the 'snake that guards the home'. So she nurtured the city, its mythical founders and all its manhood past and present. At the same time, she encouraged the model behaviour of the citizen women, by her title-claim to chastity and the voluminous style of her dress (the 'sensible' Doric *peplos*).

Pheidias explored every available space on this statue for extra figurative decoration. On the inside of the shield, he showed the gods against the giants. Athena's part in the cosmic defeat of the giants was an almost obligatory part of her iconography, and every year the *peplos* woven for the senior cult statue of the Akropolis, the little old Athena Polias ('of the city') statue carried some sort of god-versus-giant imagery. Here Pheidias chose to show the giants storming Mount Olympos itself. On the shield's exterior, as we have seen, there were Amazons. Then on the sandals of the statue

there were scenes of Lapiths fighting Centaurs, unsurprisingly enough. The most innovative scenes on the Parthenos were the reliefs along its base, which evidently featured the birth of the first woman, Pandora, in the company of twenty Olympian witnesses. Early Greek mythology presents Pandora, like the Biblical Eve, as man's downfall: by the fifth century BC this astringency had been tempered. Pandora may have been considered tangential to this statue because she too is a *parthenos* or 'maiden', who will be dressed by Athena, just as, in turn, the citizen women of Athens provide the *peplos* for Athena.

Was the Parthenos a cult statue as such? The place that was her shelter and seat, the Parthenon, remains enigmatic. It defies description in terms of its cult functions. Ancient writers tell us next to nothing about any role it may have played in the Athenian religious year and precious little about its decoration (the first writer even to mention that the Parthenon has a sculpted frieze is a fifteenth-century traveller from Italy). So it is tempting to treat the Parthenon's decoration as functionally redundant. Where was the altar of this temple? There was a colossal statue housed here, but why did another temple, the Erechtheum, have to be built to house the small, older image of Athena Polias? Can the Parthenon be termed a 'temple' at all?

The dimensions of the columns of the Parthenon were specially doctored to accommodate a viewer from a certain distance. By a device known as *entasis*, the columns were carved wider in the centre in order that they should not look (according to a natural optical distortion) concave. In fact, the architects of the Parthenon built in a host of 'refinements' to make the temple appear beautifully symmetrical, a paragon of Classical order. So, as far as regards the columns, these are not only outwardly curving in the middle, but also tapered towards the top and inwardly slanting. The extent of such sophisticated distortions only becomes clear

when the temple is transferred to the drawing board (152).
The objective, of course, was not the actual but the apparent
balance of measurements and proportions.

Otherwise the Parthenon was a work of art not really consid-
erate of those wanting to see it. The frieze particularly so:
positioned on the exterior wall of the inner temple chamber,
boxed in and almost 12 m (40 ft) above the floor, no one on the
ground could comfortably secure a proper view of even
sections of it (151), let alone the whole (as is now deceptively
easy, given the eye-level, all-round display of most of the
frieze at the British Museum).

151
The
Parthenon,
Athens,
c.400 BC.
West side

152
Diagram
showing the
curvature built
into the colon-
nades of the
Parthenon
so that they
appear straight
when seen
from below

Works of art, however, are not necessarily bound to care whether
anyone sees them or not. Painted tombs exist for supernatural
viewers; carved columns, rising beyond natural eyesight (such
as Trajan's Column in Rome), broadcast the power of pure re-
dundance. Just as the sculptors of the figures on the Parthenon
pediments took care to finish those rear parts of their statues
that no viewer at ground level would ever be able to see, so the
creators of the frieze worked according to the specifications
of the 'ideal spectator': a deity, perhaps; or, dare we imagine,
some potential creature of posterity who will one day trans-
port all the sculptures into the sacred scrutiny of a museum.

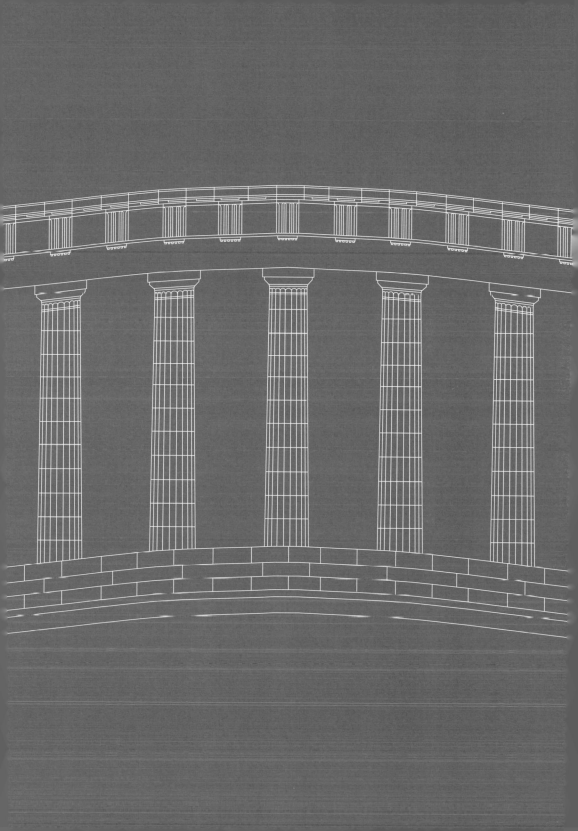

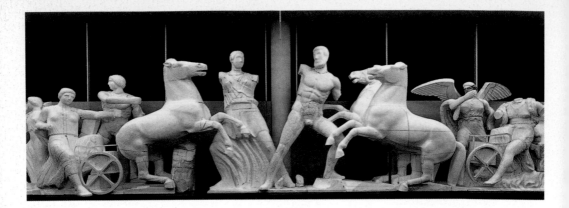

The metopes were the first to be carved, in the mid-440s BC. As we have already seen, they may be read as being invested with a mythical symbolism that exalted Greek or Athenian order over those who would challenge it. On the east side there were episodes of the gods versus the giants. On the west side, the Amazons; on the south, the Centaurs, and on the north, now in poor state, vignettes of the taking of Troy.

Approaching the Parthenon from the Propylaea, the most obvious element of sculptural decoration was the temple's west pediment (153). It has survived only fragmentarily, but appears to show Athena contesting the possession of Attica with Poseidon. The two deities asserted rival claims on the territory: Poseidon, with a strike of his trident, produced a miraculous salt spring; Athena, with a touch of her spear, an olive tree. The adjudication was performed by other divinities and ancient Attic hero-kings such as Cecrops. Both salt spring and olive tree were on show to visitors in antiquity; though the olive tree had been burned by the Persians, it was said to have sprung back to life when the Athenians returned from Salamis.

As for the opposite east pediment, we are no better informed by ancient commentaries. The central sculptures evidently showed the birth of Athena. Hers is a bizarre genesis, not easily translated into stone: she must appear, all martial and fully formed, from the head of Zeus, thanks to an axe-

153
Reconstruction of the west pediment of the Parthenon, original c.435 BC. Antiken-museum, Basle

154
Head of the horse of Selene, the Greek moon-goddess, from the east pediment of the Parthenon, c.435 BC. Marble. British Museum, London

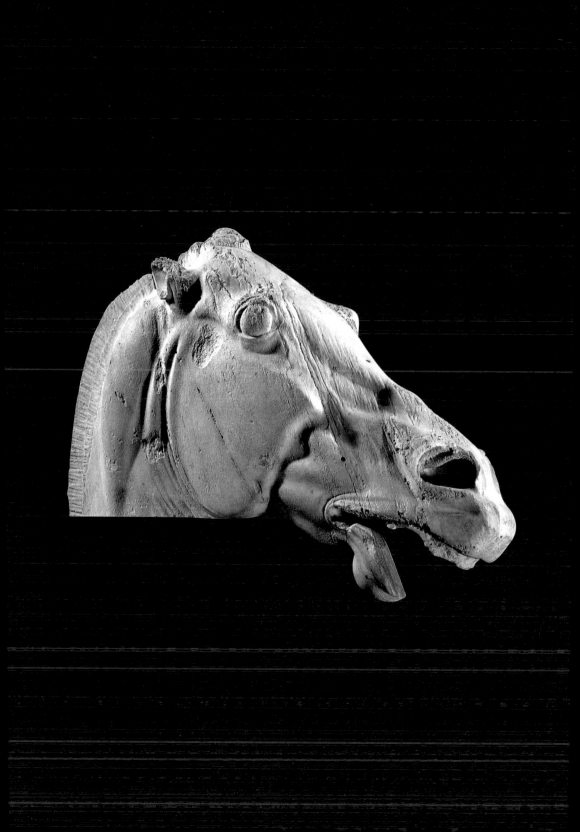

blow of Hephaistos (and Zeus must appear unharmed by all this). Deities witnessing the act should register astonishment and delight, and the cosmic forces acclaim it too (154). To the Athenian viewer, the obvious importance here was the arrival of Athena, the city's protectress. To them, Athena was *Promachos*, 'Front-line fighter', and *Sthenias*, 'Mighty'; more endearingly, *Bouleia*, 'of the Council', and *Kourotrophos*, 'Child-rearer'. When she became *Parthenos*, 'the Virgin', is not clear: the temple began to be named in that fashion only in the fourth century BC.

The identities of the circumstantial figures on the east pediment are still subject to scholarly debate. To take just one, the toned but languid male nude reclining on his left elbow (155) has been nominated as Ares, Theseus, Dionysos and Herakles; a sobering index of just how tenuous is our modern grasp of ancient iconography. The groups of sensuously relaxed female deities are not much more certain (156). In fact the identities of these pedimental figures as devised by Pheidias may have been obscured or forgotten within a couple of decades. We may even wonder whether the executive sculptors of this work, and those who paid them for it, knew exactly what programme they were supposed to be following. Inscribed building accounts that relate to the frieze of the Erechtheum, carved in the 420s BC, are disturbingly anonymous in this respect: figures singled out for piece-by-piece payment are identified by posture, not name. So this or that sculptor was paid for whatever figures he had executed: 'the man leaning on a staff', or 'the chariot, the youth and the horses being harnessed'. Such phrases could so easily describe figures from the Parthenon frieze.

Familiarity with these marbles (now known as 'The Elgin Marbles') as works of art, then, is no guarantee of our actually knowing what they are. How perplexing their images can be is demonstrated most fully by the frieze. It has been argued that the Parthenon frieze attempts in several

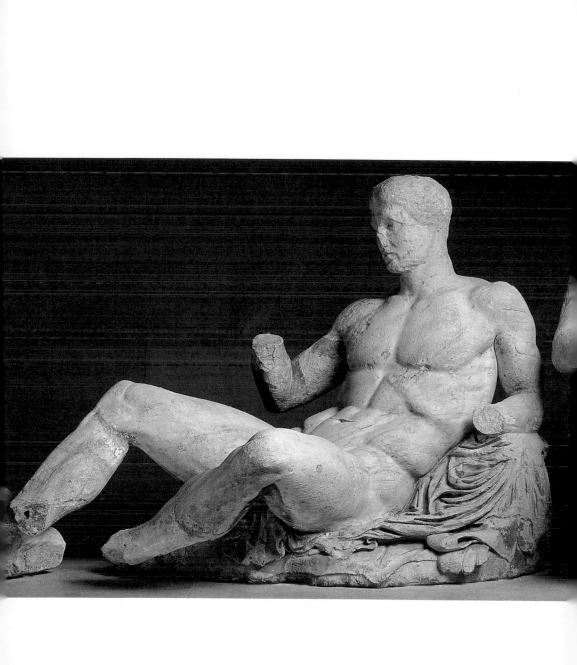

156
Female deities
from the east
pediment of
the Parthenon,
*c.*435 BC.
Marble.
British
Museum,
London

157
A cavalcade
from the north
side of the
Parthenon
frieze,
*c.*440 BC.
Marble;
h.106 cm,
41¾ in.
British
Museum,
London

158
Youths with
water jars
from the
north side of
the Parthenon
frieze,
*c.*440 BC.
Marble;
h.106 cm,
41³⁄₄ in.
British
Museum,
London

159
Central
portion of the
east side of
the Parthenon
frieze,
*c.*440 BC.
Marble;
h.106 cm,
41³⁄₄ in.
British
Museum,
London

respects of both style and design to mirror or challenge the
reliefs at Persepolis, in particular the reliefs of the Apadana.
But as much difference as similarity is stated. Though the
Parthenon frieze seems orientalizing in terms of its steady
processional solemnity, it displays some of the key self-
defining elements of Classical Greek form. The athletic nude
or semi-nude musculatures (157), the figures turning to front,
side and back with equal facility, the controlled rhythms of
movement within the procession, such as restless horses and
frightened heifers; these stamp the frieze with its own ethnic
singularity. If echoes of Athenian public sculpture, such as
the Eponymous Heroes, are also included (see 110), then that
singularity may be even more narrowly defined as the prod-
uct of the city of Athens. Mere glimpses of the frieze, then,
would have induced a heightened sense among Athenian
viewers of their own civic identity. Where the Apadana
reliefs show vassal states trailing along with tribute for the
Persian monarch, the Parthenon frieze shows the unmistak-
able signs of religious ritual being performed: the carrying of
water jars (158), libations, trays of cakes and honey, and

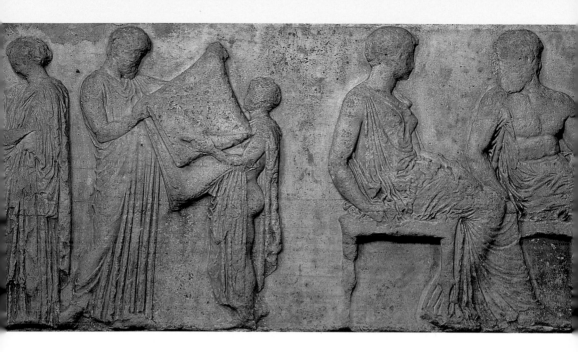

other items of sacrificial paraphernalia. Given that the Parthenon stands topographically at the head of the route of the Panathenaic procession, the theory, first advanced in the eighteenth century, that the Parthenon frieze depicts the Panathenaic procession seems reasonable. Celebrated annually on the date assigned as Athena's birthday, and every four years with a specially full-blown version (the 'Greater Panathenaia'), this festival would appear a natural enough theme for representation. The central portion of the east frieze, which would face viewers as they approached the inner entrance to the cella occupied by the statue of the goddess, has traditionally been taken to show an important episode of the Greater Panathenaia (159): the antique olive-wood image of Athena Polias was given a new *peplos* on this festival, and the folded garment being exchanged in this image is therefore reckoned to be just that.

But there are difficulties. In no sense can the frieze be treated as a 'realistic' depiction of a particular year's festival: the presence of twelve Olympian deities seated near this supposed '*peplos* incident' is enough to destroy any hope that

we are dealing with a rare piece of Greek documentary art. Also, several important elements of the Panathenaic procession as recorded in the literature are missing: for instance, files of foot-soldiers and girls carrying laden baskets. An unconvincing suggestion is that the frieze shows us an early, undeveloped celebration of the Panathenaia, perhaps the very first festival.

The most attractive interpretation so far arrived at, though it is far from being definitive, draws on an episode in Athenian myth-history about which we would know virtually nothing, save that it is mentioned in a fragmentary papyrus transcribing lines of a mostly lost play by Euripides, the *Erechtheus*, probably performed at Athens in the 420s BC. The play's tragic nexus is more or less as follows. King Erechtheus, legendary early king of Athens and adoptive favourite of Athena, was threatened by a force of Thracians led by Eumolpus, offspring of Poseidon. With Eumolpus poised to invade Attica, Erechtheus consulted the oracle at Delphi and was was told that in order to ensure victory he must sacrifice one of his daughters. In the fragments of Euripides' dramatization of this dilemma, the wife of Erechtheus, Praxithea, supports her husband, declaring how fine it is for women, as well as men, to be prepared to lay down their lives for the sake of the city. Indeed, the other daughters of Erechtheus volunteer to die as well. The sacrifice was performed, and Erechtheus duly prevailed.

Following this tale, the central scene of the Parthenon's east frieze thereby becomes a sombre, and intensely patriotic, revelation of sacrificial preparations. Erechtheus, dressed as a priest, holds up the wrapping in which the sacrificial victim will be conducted to an altar. His wife turns to face another of their daughters, coming perhaps with another cloth, or a ceremonial knife on the cushion held above her head.

A reading of the Parthenon frieze that aligns it within the mythical proto-history of Athens has much to recommend it, especially when we remember that Erechtheus was shortly to have his own temple on the Akropolis. Such an interpretation can accommodate the presence of Olympian deities, and the assembly of the components of sacrifice. The cavalcade of horsemen then becomes a projection of the army of Erechtheus, mustering perhaps in a celebration of their victory (160).

With regard to this cavalcade, there is a curiosity to note concerning their numbers. The frieze has not survived complete, and some juggling of participants in the cavalcade is inevitable; but according to one estimate, the number of heroized figures involved here comes to 192. Is this coincidental with the number of Athenians who fell at the battle of Marathon? If not, then it must be a delicate and plangent touch from the designer of the frieze, perhaps mindful that veterans of the battle of Marathon were still hobbling around Athens and cherishing their military honour. Then history and myth are here conflated to such an extent that those who heroically defended Athens against invasion by the Persians in 490 BC were mingled with that mythical force commanded by a king prepared even to forfeit his own children for the city's sake.

Since we do not have access to the mind or blueprints of Pheidias, we shall never apprehend all the original significations of his scheme for the Parthenon's decoration. Regrettably, neither do we possess any traces of the handbook once written by one of the architects of the Parthenon, Iktinos, but it is instructive to follow his presumed progress. For the Parthenon, he juxtaposed the Ionic and Doric orders in an extremely harmonious way: though the exterior uses eight columns instead of the usual six, it is 'canonical' Doric in its proportions, solid and assuring; the interior, Ionic, more suitable (with its slimmer columns and frieze)

to inner decorative elaboration. After working on the
Parthenon, it seems that Iktinos was commissioned to
design a temple in the mountainous part of the Peloponnese
known as Arcadia. The commissioning city was a small one,
Phigaleia. The apparent occasion, in 429 BC, was the
Phigaleians' deliverance from plague: accordingly, the
temple was to be dedicated to Apollo in his capacity as
a healing god (*Epikourios*), and oriented in the direction
of his senior sanctuary at Delphi.

The result, at the still remote site of Bassae, is one of the
world's most satisfying examples of architecture matching
its landscape, a harmony captured by both photographers
and artists (161–2). In some respects this temple is more
crude than the Parthenon: built mainly out of local lime-
stone, without the 'refinements' now expected of Doric
design, its narrow, elongated dimensions (six front columns
by fifteen along the side) give it an archaic posture. Yet it
harboured some internal surprises. We have already noticed
details of the frieze, with its Centaur and Amazon combats.
In terms of subject there was nothing original: but what was
original was the situation of the frieze on an inner-facing
wall, supported by the tall Ionic columns of the cella. Raised
in a torch-lit interior, the florid diagonals and bold carving
of the relief should be regarded as consciously stark, not
a sign of provincial ineptitude. A further surprise awaited
those who advanced towards the innermost shrine of the
temple, the *adyton*. Here, unusually, light was admitted
by a door cut into the east side. What was illuminated
was not, it seems, a cult statue of Apollo, but a new sort
of column. The reconstruction of this part of the temple is
far from settled, but it may have been a lone first example
of a new order: the exuberant, flowery capital that we call
'Corinthian' (163).

Legend has it that the inspiration for the Corinthian capital
came when an architect in Corinth noticed the grave of a girl

161
The temple of
Apollo at
Bassae,
c.430–420 BC

162
Overleaf
Edward Lear,
*The Temple of
Apollo at
Bassae*, 1849.
Pen, brown ink
and water-
colours on
paper;
29·1×46·5 cm,
11½×18⅜ in.
Ashmolean
Museum,
Oxford

who had died just before her marriage. Her nurse had
marked the grave with a basket of her precious possessions,
and laid a tile on top of it to keep it in place. In time, an
acanthus plant had grown up from the base of the basket,
pushing up the tile with its vigorous tendrils. Hence the
bursting acanthus foliage of the capital. The suspiciously
fanciful nature of the story may be tempered by the context
of the use of the column here: if it did indeed have funerary
associations, then it was suitable for a temple built out of
gratitude for the relief from mortal illness.

We may conclude this chapter with a return to Athens, where
the development of the Akropolis continued beyond the time
of Perikles (who succumbed in 429 BC to the same plague that
Bassae marks), though at a less frenetic pace. By now the city
was embroiled against Sparta, and the grinding vicissitudes
of that civil war provided little to celebrate. Nostalgia for
former victory days was irresistible. The asymmetrical collec-

green push
dark oak Holly

gray stones &

Bassæ
18 March 1849 — 1849
Noon

163
Corinthian
capital from
the temple of
Asklepios at
Epidauros, 4th
century BC.
Marble;
h.66 cm, 26 in.
Archaeological
Museum,
Epidauros

tion of chapels we know as the Erechtheum was probably begun in 421 BC and not finished until 405 BC. The various cults housed in this temple buttressed the earliest myth-history of Athens: our general ignorance of this myth-history is confirmed by our failure yet to understand fully what is depicted on the external frieze of the building. Its best-known feature, the Caryatids of its south porch (164), remain imperfectly understood. This is despite a history lesson concerning the Caryatids from the Roman architectural commentator Vitruvius. Suppose, says Vitruvius in his *De Architectura* (I.5), that someone asks why an architect has replaced columns with 'marble statues of long-robed women, which are called Caryatids'. This is a cue for a display of historical erudition. Caryatids are thus called because during the Persian wars, the Peloponnesian city of Caryae was one of those Greek states which sided with the Persians. After beating the Persians, the Greek allies turned upon Caryae. The menfolk they killed; the women were put into slavery, however 'high-born' they were. The architects of the time symbolized the women's shame with 'Caryatids': stone figures of the heavy-laden women, whose punishment would then be remembered over centuries.

Vitruvius tends not to be believed in this; we know nothing about this place called Caryae and its betrayal of Greece, and in any case other Ionic buildings (such as the Siphnian Treasury at Delphi) had used female figures as columns, with no overtones of punishment. But in the current of nostalgic propaganda at Athens, with the city's speech-makers constantly using the old success of Marathon as a measure with which to inspire or berate their contemporaries, we may wonder if Vitruvius is not right after all in his explanation. A feeling of decayed glory certainly pervades the decoration of the smallest surviving temple on the Akropolis, the temple of Athena Nike, an Ionic gem poised on the southern bastion above the Propylaea during the late 420s BC (165). Being Ionic, the temple carried a frieze above its architrave on all four sides. Though it has survived poorly, a tentative consensus on what the frieze represents can be mustered: on the east side, a gathering of gods, with Athena probably central; on the south side, Greeks fighting orientals (some go so far as to identify this as the battle of Marathon, with the scheme possibly echoing the precedent set in the Painted Stoa); and on the west and north sides, battles that appear to show Greeks against Greeks; maybe battles of the Peloponnesian War, perhaps then reflecting Athenian anger at the prevailing collusion between Sparta and Persia.

The structurally unusual feature of the Nike temple is its decorated parapet or balustrade. The reliefs from this parapet show Athena, assisted by various *Nikai* (female victory figures), vigorously conducting bovine sacrifice and arranging piles of armour as trophies. Though there was patently some inclination on the part of the sculptors to dwell on the femininity of Athena and her companions – the erotic possibilities of low-cut and wayward drapery are fully explored, as one girl, for instance, stoops to adjust her sandal (166) – there is no ladylike delicacy at this sacrifice. The bulls are wrestled to the ground: at least one is shown having its throat slit. This is a full-blooded victory celebration, perhaps

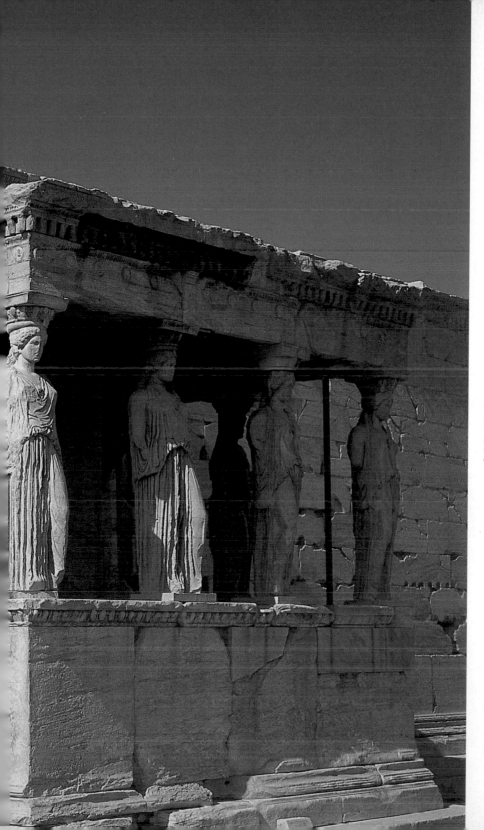

164
Caryatids on
the porch
of the
Erechtheum,
Akropolis,
Athens,
c.420 BC

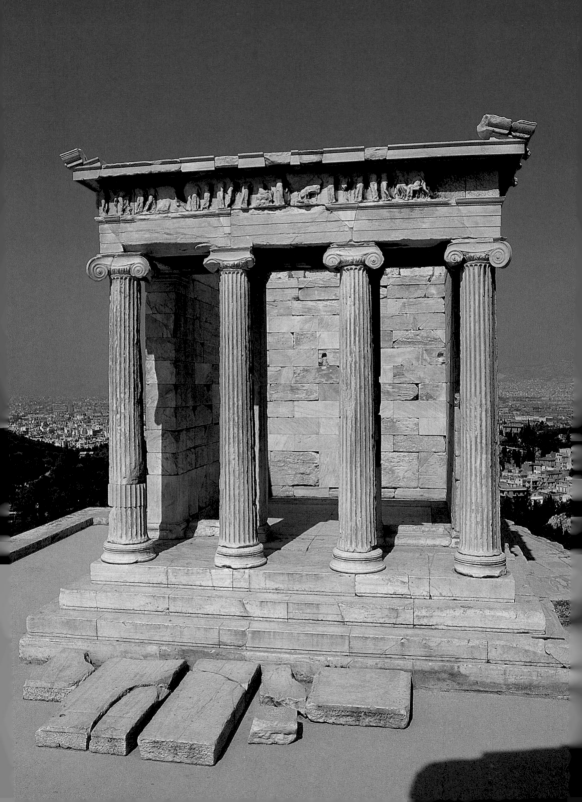

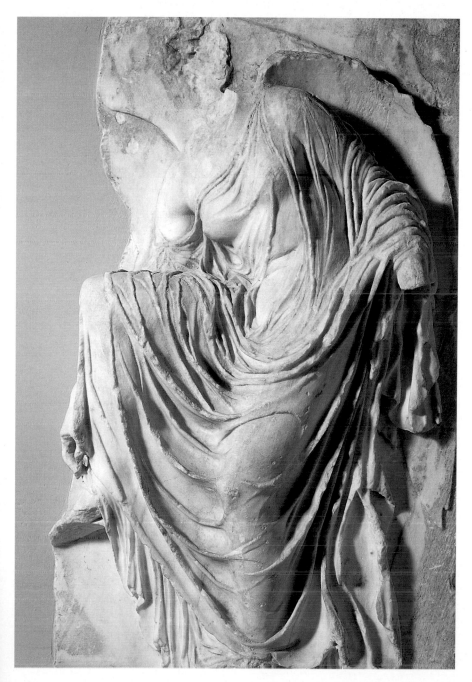

intended to evoke immediate post-fighting rituals on the battlefield itself. But which victory, which battlefield? Within a few years of the carving of such confident scenes, the Athenian fleet would be sent disastrously to Sicily, where it was destroyed by the old Corinthian colony of Syracuse. Could it be that the victory associations of the temple of victorious Athena were those of fifty or sixty years before: Marathon, Salamis, Plataea? If so, then the Athenians were, so to speak, living in the past. In an ethos which generously tolerated the overlap of past with present and myth with history, that seems pardonable enough.

6

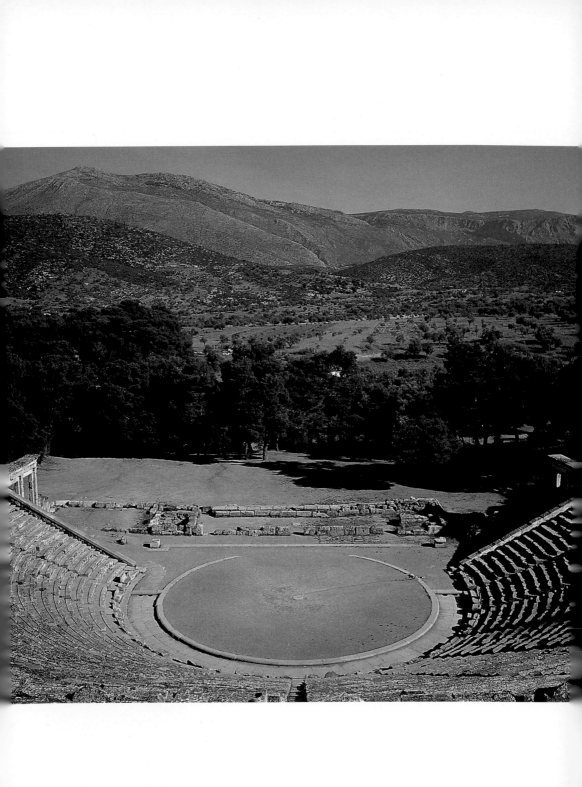

'All the world's a stage.' The expression is Shakespearean; the
sentiment, ancient Greek. As it occurs in the reported sayings
of two fourth-century BC philosophers, Anaxarchus and
Monimus, this sentiment could be reasonably paraphrased
as 'All the world's a stage-painting.' Its philosophical ramifi-
cations of cynicism and scepticism – implying that our experi-
ence of life is a continuous vanity, that we know nothing
about reality – need not detain nor discourage us here. Its
force as a metaphor, however, points us towards a context of
Greek art which demands our attention: the theatre.

In very general terms, recognizing a 'theatrical' element in
Greek art relies merely on the impressionistic judgement
that figures in a given 'scene' are, as it were, frozen in a
mime. From the fifth century BC onwards, as the theatre
became an integral part of the culture and layout of most
Greek cities, we should stay alert to this sensation. For an
early example of its effect, we may return to Olympia and
consider the sculptures of the east pediment of the temple
of Zeus (121–3).

There is a powerful story being 'enacted' here, resonant
with both local mythical interest and Panhellenic signifi-
cance. The fable (or one version of it) goes as follows. King
Oinomaus of Elis (the territory in which Olympia lies) had
a much sought-after daughter, Hippodameia. He had been
warned by an oracle that he would be murdered by who-
ever married his daughter. So the numerous suitors of
Hippodameia were challenged to a chariot race, which they
lost on pain of death; and since the horses of Oinomaus were
magically swift horses, all suitors perished, until Pelops, son
of Tantalos and grandson of Zeus, arrived. Pelops conceived
the plan of bribing the king's charioteer, one Myrtilos, to

167
The theatre at
Epidauros,
c.350–300 BC

substitute the lynch-pins holding the wheels of the king's chariot to its axle with wax replicas. As the king's chariot gathered speed, the wax pins would melt, and the king would be thrown from his vehicle. This duly happened. The king was thrown and died; Pelops gained Hippodameia, but then he refused to honour the bribe. Accounts differ as to what the bribe was: money, or the favours of Hippodameia herself. In any case, Pelops had the charioteer Myrtilos drowned, to silence him. And as Myrtilos was being removed, he laid a curse; a curse on the family of Pelops. This is the family that we know as the 'House of Atreus'. Pelops had two sons, Atreus and Thyestes. They quarrelled viciously over the sovereignty of their allotted city, Mycenae. Atreus served Thyestes with the cooked flesh of his own children; Thyestes left Mycenae and later spawned (by incest) a son called Aegisthos, who returned to the city. Mycenae had then passed to the absentee rule of Agamemnon, son of Atreus. Aegisthos seduced Agamemnon's wife, Clytemnestra, helped her murder Agamemnon when he returned from Troy, and was then himself killed by his stepson, Orestes. We could continue this tale of blood, guilt and fury further, but perhaps the point has already been proved: in time, a high price was paid for the original crime of Pelops.

The local interest here obviously involves the origins of chariot-racing – an important event in the ancient Olympic Games – and the involvement of Pelops, whose heroic tomb was worshipped at Olympia and who was eponymous to the entire region of the Peloponnese. The Panhellenic interest lies in the curse, for the House of Atreus stocked a museum of tragedy for general edification. The fifth-century playwrights who explored the eventual results of the charioteer's curse were as popular in the Greek colonies as they were in Athens. This was the genesis, the first point of departure, of a cycle of stories that all theatre-going Greeks would know, including those well-known dramas that survive on the modern stage, such as the *Oresteia* of Aeschylus, the *Elektra*

168
Figures of Pelops, Zeus and King Oinomaus with wife and daughter from the east pediment of the temple of Zeus at Olympia, c.460 BC. Marble. Archaeological Museum, Olympia

of Sophocles and the *Iphigeneias* of Euripides, which all ulti-
mately derived from the House of Atreus curse.

With that in mind, why should the sculptural presentation
of the chariot race (168–9) not look curiously like a stage
tableau? This could almost be the actors taking a curtain
call, or the cast assembling for their introduction to the audi-
ence. There is no attempt at 'telling the story' in any contin-
uous or active manner. There is King Oinomaus, with his wife
and daughter; there is Pelops. They all studiously avoid each
other, facing towards us – the viewers – yet absorbed in their
own grave destinies. There are the two chariot groups, plus
retainers; and in the extreme angles of the pediment, two
sinuous personifications of the rivers that bisect the site of
Olympia, the Alpheos and the Kladeos. This is, like any clas-
sic Greek tragedy, a narrative in anticipation. To achieve the
'cleansing' or purging effect (*katharsis*) of a proper tragedy,
the viewer has to know what will happen. Then, rather than

169
The daughter of Oinomaus from the east pediment of the temple of Zeus at Olympia, c.460 BC. Marble. Archaeological Museum, Olympia

be distracted by twists of plot, the viewer can concentrate on how the story unfolds: its emotional loading. At Olympia, the key clue to this anticipatory knowledge is provided by the figure of an old seer (see 1), who clutches his fist to his face in an almost ham attitude of foreboding. He knows the upshot; he sees beyond the immediate success of the guileful Pelops. His gesture betokens the full, impending, horrific force of this story.

To project 'theatricality' of this nature on a set of statues carved around 470–460 BC is not unduly speculative, when we consider the extent to which, by then, theatre influenced the lives of the Greeks. In Athens, it had become virtually an instrument of democratic debate, a complement to the citizens' assembly. Performance by individual speakers in the concave bowl of the Pnyx was closely akin to appearing in the auditorium of Dionysos on the slopes of the Akropolis. Pleading in the law courts, to a jury composed

of sometimes over a thousand members, similarly called for a studied repertoire of effective flourishes and a stentorian voice. The development of a week-long annual springtime drama festival in Athens, the City Dionysia, not only involved all male citizens, but outsiders too. Slaves, foreigners and probably women also were admitted to witness the programme of plays celebrated in nominal honour of Dionysos. The origins of the festival, and of the various specific forms of drama it contained, are too complex to investigate here in any depth. We may simply note that three types of drama evolved from the original, perhaps rural-based revels of Dionysos. There was comedy: derived from the *komos*, a phallic dance performed by actors in masks and padded costumes, which might feature abusive songs, with the sanction of Dionysos as lord of misrule. There was tragedy: 'goat song' (*tragoidos*), perhaps mimicking the mythical death of Dionysos and reflecting the unity of humans and animals in his band of followers. And there was the satyr-play, the most elemental sort of ecstatic, knockabout farce, in which actors shamelessly disguised themselves as satyrs (half-man, half-horse or goat) and transformed the stage into a microcosm of capering subversion. In the festival setting, the satyr-play was light relief; and serious writers of tragedy such as Sophocles and Euripides were also able and expected to turn their hand to the genre.

What is important to register is that the Athenian theatre, from the early fifth century BC onwards, was neither elitist 'high culture' nor some kind of leisure-time entertainment. Audiences were large (up to 14,000) and – being expected to sit through three or four plays a day – they had stamina and discrimination. The playwrights competed keenly for prizes, awarded according to audience response. Various civic functions were discharged in between the plays themselves, and considerable sums of public money went into the cost of productions. It was an activity which involved

a high degree of civic and religious participation.

Like the conceptual origins of drama, the early development of the Greek theatre as an architectural space is difficult to trace, but its established form is familiar enough to tourists of Greek sites all over the Mediterranean. Best represented by the late fourth-century BC example built at Epidauros (167), the most immediately striking feature is the capacity for a large audience to be able to see the action. The Greek *theatron* indeed means 'viewing place'. At Epidauros, very democratically, every member of the audience has an equal chance of seeing what happens in the circular performance space known as the *orkhestra*. (The acoustics of this particular theatre are legendarily phenomenal too: someone sitting on the uppermost benches is supposed to be able to hear a pin drop on the *orkhestra* floor).

Orkhestra originally implied a space for dancing; some scholars believe that it might echo the shape of a threshing-floor and so betray the rustic roots of Dionysiac cult. (*Drama*, in Greek, implies basically 'thing done', and the early things done in honour of Dionysos certainly entailed dressing-up, dancing and music.) Access to the *orkhestra* was by two angled entrances (*parodoi*), and this was how the poetic 'commentary team' of a Greek play, the Chorus, came on. The open-air setting must often have added to the atmosphere of any diction; especially at Athens, where actors in the theatre of Dionysos will have been able to indicate up to the temples on the Akropolis. An elongated rectangular platform was later added, the *proskenion*, for the display of painted backdrops. This was generated by the practice of having a *skene* (literally, 'tent') behind the *orkhestra* where actors might change. In due course, the *skene* was monumentalized into what might often be a two-storeyed stone building. The function of this stage building in tragedy was far more than a changing-room: since the decorum of Greek drama generally curtailed the

explicit enactment of violence, there had to be a place
from which such violence could be reported. Once the
skene became a solid construction, actors could be placed
on the roof or appear at windows of a second storey, often
to impersonate deities. Already in the fifth century, play-
wrights were making use of a crane apparatus capable of
winching actors up aloft (the *deus ex machina* device), and
also a type of rolling or rotating platform (the *ekkyklema*),
which Euripides especially exploited, for suddenly revealing
an interior.

As a sophisticated fifth-century institution, then, the theatre
directly involved artists for stage design. Though at a basic
level this might involve no more than painting sheets which
could be quickly draped over a standing frame, such design
was of substantial importance for the wider development of
Greek art. This is because the art of painting stage sets,
called *skenographia*, became synonymous with the mastery
of perspective.

So little survives of large-scale Greek painting that it
might seem futile to pursue this matter further, but it is
worth summarizing the theoretical knowledge that we
have regarding *skenographia*. This is the word used by
those sceptical fourth-century philosophers when they
claim that 'things that exist [*ta onta*] are like stage-
painting'. In his *Poetics* (Section IV) Aristotle says that this
skenographia was introduced first by Sophocles; Vitruvius,
in the preface to Book VII of his *De Architectura*, gives us
the name of one Agatharcus, a stage-painter who not only
designed sets for Aeschylean tragedies, but also wrote a
treatise on the practice of *skenographia*. Vitruvius makes it
clear that the interest of this treatise to philosophers was its
implications for optical physics. Stage-painting/perspective
he defines elsewhere (I.2.2) as 'the sketching of the front
and of the retreating sides and the correspondence of all the
lines to the point of the compasses'. Its effect, he says, is that

170
The theatre at
Syracuse,
possibly built
by Democopos,
5th century BC

'although a building is drawn on a vertical flat façade, some parts of it may seem to be withdrawing into the background, and others standing out in front'.

The 'discovery' of the mathematical principles of perspective is usually accredited to artists and architects of the Italian Renaissance, notably Filippo Brunelleschi (1377–1446). But perhaps 'rediscovery' would be the more appropriate word, for Vitruvius was known to Renaissance scholars (and imaginatively illustrated in 1545 by Sebastiano Serlio). Moreover in these remarks about *skenographia*, Vitruvius is certainly stating, albeit without much elaboration, the fundamental law of pictorial perspective, which demands that receding lines be drawn to a central vanishing point. That this law was properly explored by Agatharcus in the fifth century BC is unlikely: the geometrical formulations of Euclid's *Optics* came later (around 300 BC), and Vitruvius probably incorporated them as a matter of course. Still, we are left tantalizingly starved of direct evidence for the achievements of perspective in Athenian stagecraft. There are minor allusions to it in vase-painting: witness a fragment showing a statue of Athena before the 'backdrop' of her temple (171), or another piece which uses the device of *skenographia* to depict the *skene* itself (172). The illusion-istic paintings done on Roman walls by much later Greek

171
Fragment of an Athenian red-figure krater, showing a statue of Athena in front of a temple, c.400 BC. Martin von Wagner-Museum, Würzburg University

painters (see 238) may reflect the generally absorbed lessons of stage design, but cannot transmit the vital conspiracy of a Greek city's performance culture.

Athens was the prime mover in shaping the institutional structure of the theatre. Once developed, the model was rapidly adopted by other Greek states. We have already mentioned (see Chapter 3) the appetite for Athenian drama in the colonies, specifically at Syracuse. Some of the most spectacular theatres in the Greek world are those built in Sicily (at Syracuse, the benches of the theatre are carved straight from the natural rock; 170), and it is no surprise that theatrical influences are felt so strongly in the imagery of vases painted in these western settlements. Vase-painting in Athens itself declined during the late fifth and early fourth centuries BC, as Athenian military and economic power also weakened after the Peloponnesian War (officially concluded in 404 BC). In the western colonies, however, the art prospered. Steady demand was assured by the local custom of placing vases in tombs.

The cult of Dionysos, with its emphasis on dance, drinking and release, seems a highly life-loving religion, but we should remember that it also had funerary significance, for Dionysos promised his followers resurrection from death. In myth, he himself (like the Egyptian deity Osiris) had been

torn apart, but reassembled. In the *Bacchae*, the play by Euripides which conveys most effectively the frenzy and appeal of Dionysiac cult, the god may show himself by bursting up from the ground. This is his mystery, which his initiates might share. So for vases placed in tombs, there was no dissonance of images, so long as Dionysos exerted one or several of his various roles. The painters of such vases in Sicily and southern Italy (where centres of pottery production are traditionally located in Apulia, Campania, Lucania and Paestum) regularly called on theatrical scenes to supply their decoration; to such an extent, in fact, that our knowledge of Greek drama has been significantly increased by the range of allusions made on these vases to plays whose texts have either not survived, or else survived only piecemeal.

All three types of drama are represented. Comedy gains much coverage, especially a style of farce known as *phlyax*, which featured actors in grotesquely padded outfits. The kind of parody such comedies relied on was certainly irreverent in Greek terms; by ours, it would also be regarded as deplorably sexist and racist too, not to mention its penchant for making a stooge of anyone with a physical disability.

173
Paestan red-figure bell krater painted by Asteas, showing *phlyax* scene, *c.*340 BC. Vatican Museums, Rome

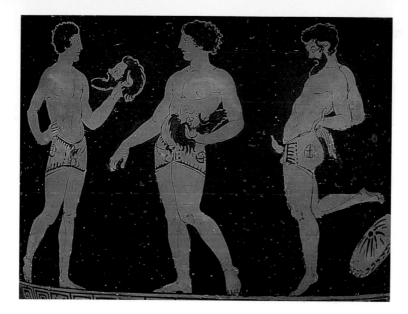

One typical vase-painting (173) extracts a moment from some mythical burlesque, in which Zeus (the old man with a ladder on his head) is making his notorious nocturnal visit to the mortal queen Alkmene. In mythology, this can be a perfectly serious episode: Zeus ravishes Alkmene, and the eventual outcome of a night of passion is Herakles. Here, it is plainly absurd. The bejewelled Alkmene is framed in a window, like a decked-up prostitute; Hermes, the messenger god, points up to her with his little lamp, as if Zeus were too senile to see quite where he was going. The next move is surely that Zeus swings the ladder round and sends Hermes flying.

Satyr-plays are less commonly represented, and they may themselves have yielded to these *phlyax* farces in terms of public popularity, but an Apulian wine-mixing bowl gives a very clear image of three actors preparing themselves for satyr parts (174). Two have yet to put on their masks, but have already girded themselves with the furry loincloth and inflated phallus of the standard stage satyr. A third is fully attired, complete with frisky equine tail, and already practising a mincing step or two.

175
Sicilian red-
figure calyx
krater showing
Adrastos,
c.340 BC.
h.40 cm,
15³⁄₄ in.
Museo
Archeologico
Eoliano, Lipari

As for tragedy, it seems that the works of Euripides enjoyed
most favour overseas and were regularly staged in the
colonies throughout the fourth century BC. In two plays by
Euripides, the *Phoenissae* and the *Suppliant Women*, there
are vivid descriptions of a quarrel in the mythical palace of
Adrastos at Argos, between two princes, Polyneikes and
Tydeus. This is the quarrel that is dramatically depicted on
a Sicilian mixing bowl of around 340 BC (175). The bearded
king Adrastos steps between the two young men; the story
was that he had divined that they were destined to be the
husbands of his daughters, who must be the two women
watching from the door. With the columns and the door half-
ajar, the mock architecture of a stage setting is strongly
implied here, though that is always difficult to determine
when, as it were, vase-painters show us a scene of a scene.

So these southern Italian vases are rich in imagery directly
indebted to the theatre. Another minor art deserves mention
too in this respect: terracotta figures. Generally, the 'coro-
plasts', makers of moulded clay statues (or more often, stat-
uettes), were held in lower esteem than sculptors in stone and
bronze. But what their work lacked in rare skill it made up
for with sheer ubiquity. As votive offerings and souvenirs, or
even little household idols, terracotta figurines were traded
in vast quantities. Many are forgettable in form and style,
but among exceptional examples are those figurines derived
from the theatre. In mid-fourth-century BC Athens the entire

cast of a play could be collected in a single series of terracottas. The genre which lent itself to such representation was comedy, because throughout its literary development at Athens and elsewhere, comedy relied on caricature types. Such types were easily duplicated in these goblin-like figurines, with their evilly grinning mouths and hunched, bulbous bodies. Reeling drunkards (176), nagging peddlars (178), greasy cooks, crabbed fishwives – the aggressive distortions embodied here were the same as those paraded on stage – always ready to mouth the uncouth or unheroic sentiment. Just as when Homer wants to create a cowardly character (Thersites) at Troy, he presents that character in demeaning physical terms ('pointy-headed', with scrubby beard, warped shoulders and so on: see *Iliad*, II.211–69), so the comic stage accommodated a set of predictable buffoons, defined by their appearance even before they opened their mouths.

Caricatures in Greek art can be spotted among the work of the late sixth-century BC Athenian red-figure vase-painters; but the sort of caricatures we find in the terracottas of the fourth century lead us beyond the realm of scorn and jokes, and beyond the theatre too. The question arises: if these are caricatures, then what constitutes a character, or, to put it more strongly, a portrait? This question is not easy to answer in any period of art, but requires some discussion here.

176
Drunken pair,
c.375–350 BC.
Terracotta;
h.14 cm, 5½ in.
Staatliche
Museen, Berlin

The conventions of the Greek theatre required actors to use masks. In fact, the Greek word for a mask, *prosopon*, meaning literally 'what meets the eye', is the same word for 'face' and indeed 'character in a play'. Whatever the implications of that verbal ambiguity for Greek psychology, the fixed and corrugated forms of the dramatic mask (177), worn by all actors from the early fifth century BC onwards, inevitably affected modes of facial expression in art .

A tentative touch of the stage mask is surely felt at Olympia, where, in the west pediment sculptures of Centaurs against Lapiths (see 133–4), slightly gaping mouths make silent

177
Reconstructions of Greek theatre masks

178
Figurine of a peddlar or tramp,
*c.*375–350 BC.
Terracotta;
h.12 cm, 4³⁄₄ in.
Staatliche Antikensammlungen,
Munich

screams. When the same subject was done on the Parthenon metopes, the mask-like treatment of faces, especially those of the Centaurs, is perceptibly bolder (see 136). That sculptors should borrow from the theatre stylized means of delineating expressions of pain, anger, happiness and so on was particularly sensible when their work had to be viewed from a fair distance. One of the leading sculptors of the fourth century, Skopas, is distinctive precisely on these grounds, despite the paltry relics of his work. Battered heads from figures he produced for the temple of Athena at Tegea (179) betray that same transfixed woefulness as the tragic mask.

It was not only the theatre that fostered the categorization of character types. The clinical medicine schools established in the fifth century BC by Hippocrates and others were developing the concept of the four 'humours' or dispositions, whereby humans are divided into fourfold types according to whether they retain a preponderance of blood, phlegm, black bile or yellow bile in their bodies (they will be respectively sanguine, phlegmatic, melancholic or choleric in nature). Others were classifying types of physiognomy, and speculating on links between men and animals. At a literary but popular level, a former student of Aristotle, called Theophrastus, composed in 319 BC his *Characters*, a series of sketches of personality types. It was evidently a common after-dinner game, to specify traits of recognizable types, good and bad. Only the bad survive in Theophrastus: Mr Nasty ('covers you with spittle when he talks'), Mr Thick-skinned ('loves to sing in the public baths'), Mr Superstitious ('if a cat crosses his path, won't take another step until some-one else goes first'), Mr Garrulous, Mr Arrogant and so on.

179
Head by Skopas from the west pediment of the temple of Athena Alea at Tegea, c.340 BC. Marble; h.31 cm, 12¼ in. Archaeological Museum, Tegea

180
Bust of Perikles, copy of an original of perhaps c.425 BC. Marble; h.48 cm, 18⅞ in. British Museum, London

The Greeks were not the ancient pioneers of portraiture in art. Egyptian art provides many examples of the genre, arguably a good deal more 'realistic' than any Greek portrait. But the advent of portraits in Athens is a phenomenon hedged with very particular social and political circumstances. We have already come across the first supposed civic portraits, the Tyrannicides (see 103). With its fear of individual self-promotion, the Athenian democracy was understandably reluctant to tolerate the public portraiture of any living

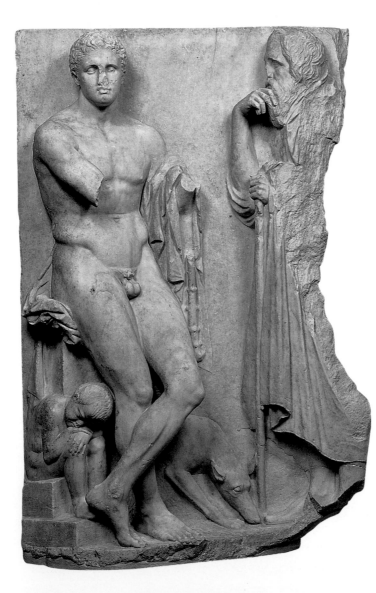

181
Gravestone
from Athens,
c.340 BC.
Marble;
h.168 cm,
66⅛ in.
National
Archaeological
Museum,
Athens

182
Gravestone of
Dexileos from
Athens,
c.394 BC.
Marble;
h.175 cm,
68⅞ in
Kerameikos
Museum,
Athens

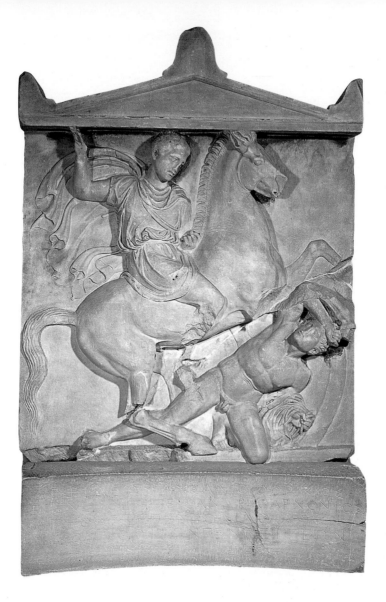

person: like the Tyrannicides, 'portraits' were posthumously raised, in honour of those who had served the state well. Military commanders (*strategoi*) were singled out for this honour and were usually defined in their role with a helmet, tipped back and with its visor raised (180; see also 144). Other individuals might be commemorated at their graves with figurative headstones (*stelai*), and shown shaking hands with bereaved partners, or cast for remembrance as the prize-winning athlete (181) or the gallant cavalryman

(182). But, as with the Tyrannicides, in no sense can we suppose that these 'characters' actually sat for their features to be recorded. The study of Greek portraits through Roman copies rather obscures the issue, but it is likely that nearly all of the original images were created posthumously. So there is both an evident tendency and good cause for idealization.

It has been said that Greek portraits, like the characters of Greek drama, 'all spring from the same interest in that intricate phenomenon – the human individual'. In fact, individuality is *not* what marks a Greek portrait, but rather its effacement. Just as the Greek stage fostered a cast of stock types, so the makers of portraits assimilated their subjects to broader categories of physiognomic definition. One of the first allegedly 'realistic' portraits in Greek art is an image said to represent the victorious admiral at Salamis in 480 BC, Themistokles (183–4), but this full-faced, bull-necked character looks suspiciously like the contemporary representations of Herakles (as on the metopes of Olympia; see 131 and 132), and no doubt that heroizing

183–184
Portrait bust
of Themistokles,
Roman copy
of a mid-5th
century BC
original.
Marble;
h.26 cm,
10¼ in.
Museo Ostiense,
Ostia Antica

185
Bust of Homer,
copied from a
type created
perhaps in
the 2nd
century BC.
Marble;
h.28 cm, 11 in.
Musei
Capitolini,
Rome

186
Portrait of
Plato, copy of
an original
perhaps of the
late 4th
century BC.
Marble;
h.35 cm,
13³⁄₄ in.
Fitzwilliam
Museum,
Cambridge

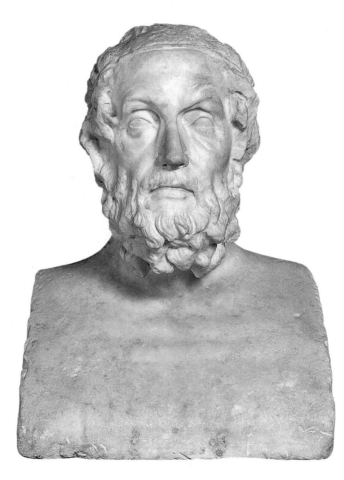

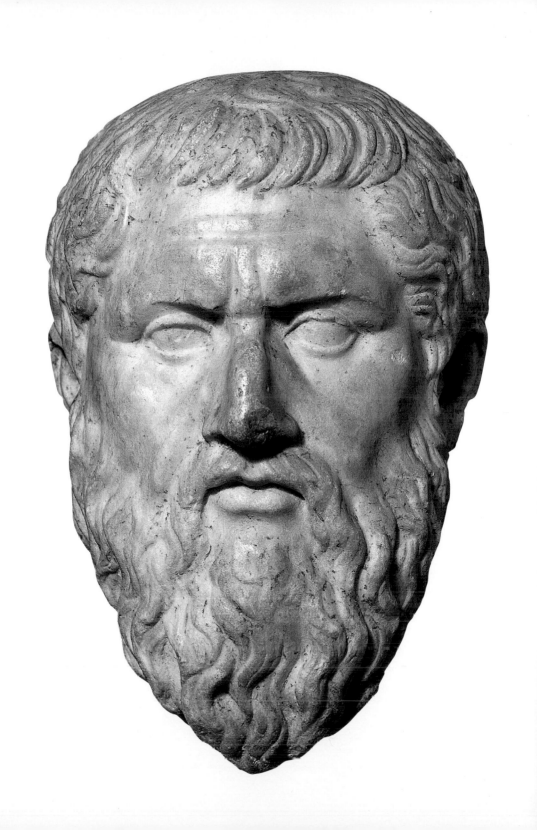

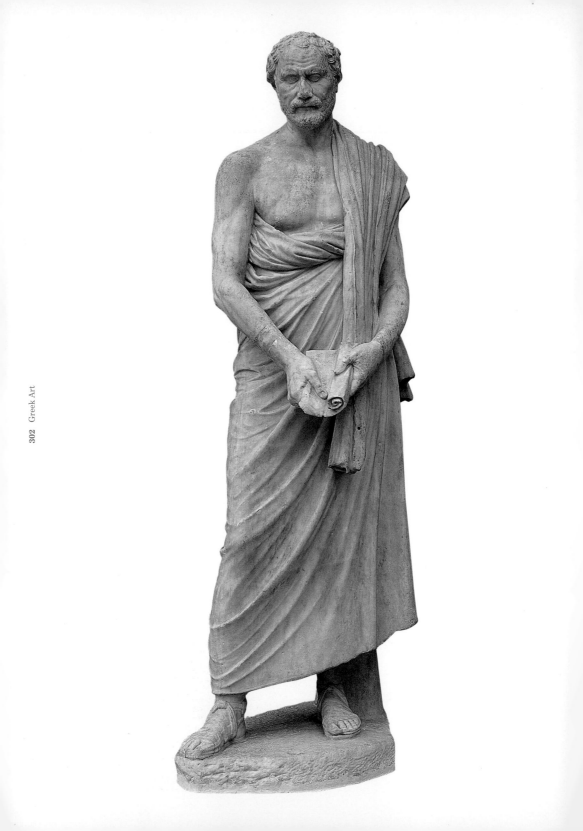

ambivalence of identity was deliberate.

So it is that Greek portrait makers, by the fourth century BC, felt easy enough about creating an identikit for the centuries-dead (if he ever existed) Homer (185). He was the stock bard, whom the 'portraits' of all other poets and playwrights must more or less resemble or impersonate. The stock general was already established, as an image of responsibility which conformed to a civic office, no matter who held that office. Stock philosophers followed, with their generically knitted brows (186); stock orators too, like Demosthenes, brooding and explosive (187). Of course, it is still more or less possible to distinguish one bearded Greek worthy from another, and there are exceptions to the typecasting: Sokrates, for example, was famous in his lifetime for a stubby, satyric appearance, and this is certainly conveyed by the images created of him after his martyrdom in 399 BC (188 and 189). Even intellectuals connived in the daily drama of self-presentation. By the end of the fourth century BC,

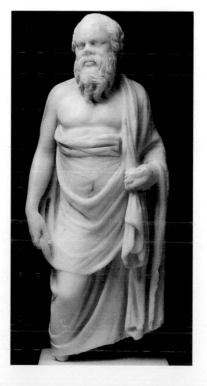

187
Demosthenes,
copy of an orig-
inal probably
made in
Athens
c.280 BC.
Marble;
h.202 cm,
79½ in.
Ny Carlsberg
Glyptothek,
Copenhagen

188
Sokrates,
statuette
perhaps of the
2nd century
BC. Marble;
h.27 cm,
10⅝ in.
British
Museum,
London

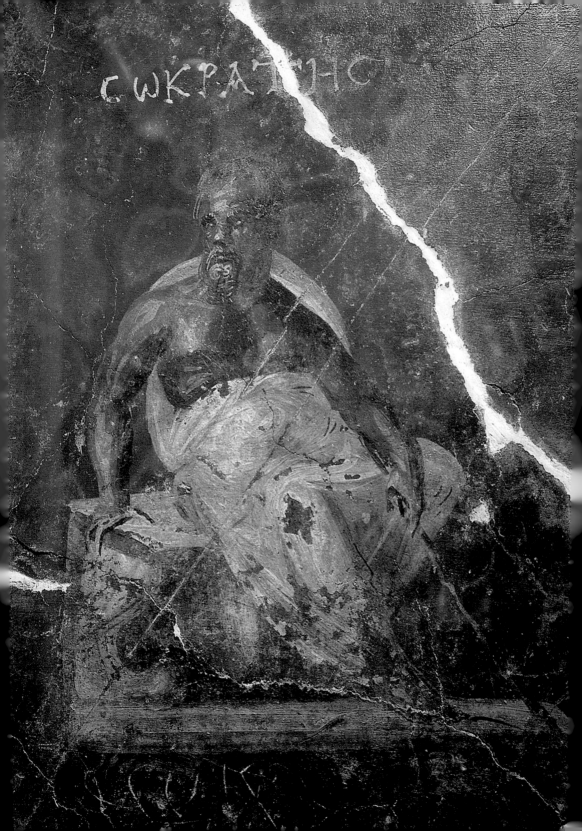

190
Apollo the
Lizard-slayer,
copy of an
original by
Praxiteles of
c.350 BC.
Marble;
h.149 cm,
58¾ in.
Musée du
Louvre, Paris

191
Hermes and
the infant
Dionysos,
attributed to
Praxiteles, but
possibly a late
4th-century
BC copy.
Marble;
h.215 cm,
84¾ in.
Archaeological
Museum,
Olympia

convention in aesthetic and religious matters. His image of
the god Apollo, for example, chose to show the noble benefac-
tor of order as an idle boy, spearing lizards on a tree trunk
(190). Inspired perhaps by the Athenian custom of initiating
children into wine-drinking at an early age, his image of
Dionysos went for an even more juvenile moment, showing
Dionysos as a petulant infant in the arms of Hermes, origi-
nally reaching out for a bunch of grapes that Hermes held
teasingly aloft (191).

Praxiteles' most impertinent statue, it seems, was the
Aphrodite of Knidos. Around 360 BC, the people of Knidos,
an old Spartan colony on the coast of Caria in Asia Minor,
decided to build themselves a new city. They laid it out in
terraces on a headland and constructed a double harbour.
It was natural enough for a port-city to foster the cult of
Aphrodite, traditionally goddess of fair passage for sailors
and merchants, and at Knidos she was worshipped with the
epithet *Euploia*, 'safe voyage'. But the cult statue chosen for

a popular philosopher called Bion, once a pupil of the same
Theophrastus who compiled the *Characters*, was using the
metaphor of the professional actor to encapsulate his own
formula of cynicism, fatalism and hedonism. 'Adapt yourself
to prevailing conditions as sails are adapted to the various
winds,' he preached. 'Just as a good actor plays with equal
conviction the prologue, middle and conclusion of a play,
so should the good man play the various stages of his life.'
Himself the offspring of a fishmonger and a prostitute, Bion
wandered the Greek world with this message of self-suffi-
ciency – (*autarkeia*) – sedulously flaunting, no doubt, the
stock role of the peripatetic and self-sufficient sage.

The pursuit of this theme into the grander arena of what
anthropologists call the 'theatre state' – the studied pomp
and ceremonials of monarchical regimes – will have to await
the next chapter. The point to be made here is that the
success of the theatre as a vehicle and expression of Greek
culture had a profound effect not only on the form and
subject matter of art, it also allowed for artists themselves
to join the cabaret of professional 'types'. While it is
anachronistic to speak of the Bohemian lifestyle in antiquity,
personality cults were gathering around artists by the early
fourth century BC. Parrhasios the painter, for instance,
became famous for parading around in a purple cloak, with
a gold wreath on his head. Such anecdotes prove by their
very generation a set of social expectations for artistic
behaviour; and if we examine the testimony to the work of
this period's leading sculptor, Praxiteles, we shall find some
evidence that he indeed 'played up' to such expectations.
For one, he had plenty of money as a result of his skill.
Indeed, documentary sources tell us that Praxiteles was one
of the 300 wealthiest men in Athens in his time. For another,
he enjoyed a celebrity-style sex life: various gossipy stories
can be matched up to demonstrate that the artist maintained
a mistress, called Phryne, who was a widely fêted beauty,
rarely out of scandalized comment. Finally, Praxiteles flouted

189
Sokrates,
painting from
a Roman house
at Ephesus, 1st
century AD.
Fresco;
h.32 cm,
12½ in.
Ephesus
Archaeological
Museum,
Selcuk

the focus of prayers by mariners visiting Knidos became a cult statue in more than a strictly religious sense. The story is related by Pliny (*Natural History*, XXXVI.4.20–21), in the course of his review of the career of Praxiteles:

The greatest work of this sculptor, indeed one of the greatest sculptures in the whole world, is his Venus, which many people have sailed to Knidos to see. Praxiteles in fact made two statues, which he put up for sale together. One of them was draped, and because it was draped was preferred by the people of Kos, who had first choice of the statues (which were offered at the same price). They thought this the decent thing to do. But the statue they refused was taken instead by the people of Knidos, and it was this statue which became renowned. Later, King Nicomedes [of Kos] tried to buy it from the Knidians, promising to discharge their enormous state debt. But the Knidians resolutely held onto their statue, and rightly so: for it was this work of Praxiteles which made Knidos famous. The shrine in which it stands is openly constructed in order to allow the statue of the goddess to be viewed from every angle, and they say that the goddess encouraged this herself. And indeed the statue is equally marvellous whichever way you look at it.

So it seems that Praxiteles tested the prudishness of his

192
The Knidian temple of Aphrodite, as reconstructed by Hadrian at his villa at Tivoli, 2nd century AD

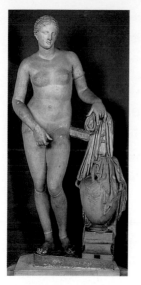

193
The Aphrodite
of Knidos,
Roman copy of
an original by
Praxiteles of
c.350 BC.
Marble;
h.205 cm,
80¾ in.
Vatican
Museums,
Rome

clients with a fully nude figure of the goddess, and rivalry
between the neighbouring states of Knidos and Kos worked
to his favour. Pliny's claim that Praxiteles' statue put the
new Knidos on the map is belatedly confirmed by numerous
Knidian coin issues of the Roman period showing a nude
Aphrodite by a vase. Archaeological confirmation of the
statue's celebrity had to wait until 1969, when excavations
revealed a curious circular Doric temple at the western end
of the uppermost terrace. It consists of eighteen columns
raised on a stepped base, with an inner perimeter wall,
which may have been low enough for visitors to peer over,
or perhaps could be entered via a door. A base was found in
the centre of the enclosed area, of suitable dimensions to
support Praxiteles' statue as we know it from rather stodgy
Roman copies (193). There is no trace, alas, of the original,
which although it was marble, will not have survived either
Christian or Turkish desecration. Two inscriptions, however,
were recovered from elsewhere in the city, both incomplete,
but one clearly referring to Praxiteles and Aphrodite, and
the other perhaps defining Aphrodite as 'naked' (*gymne*).
There is little doubt that this is the temple which housed
the statue. What confirms the identification is the exact

resemblance of its design and circumference to the copy of the Knidian temple created by the Roman emperor Hadrian at his villa at Tivoli (192).

A literary account of a visit to Knidos in the second century AD makes it clear that the precincts of this little temple were a fragrant and luxuriant orchard, a garden dominated by myrtle trees, entangled with ivy and vines. Such was the romantic ambience engineered for Aphrodite's devotees. The statue itself, as Pliny says, was to be viewed from every angle, and the rotonda design of the temple was plainly intended to facilitate this all-round appreciation. A number of writers record stories about young men falling in love with the statue, and even attempting to copulate with it: it seems, squalidly, that the stains left on the statue by those unhappy attempts themselves became tourist attractions.

Whether in fact this was the first nude Aphrodite is not clear. The reason for its notoriety may have been more based in the rumour that Praxiteles had passed off as his vision of Aphrodite a full-body portrait of his mistress Phryne. But what is of significance to us here is the 'staging' of a work of art. The statue of Aphrodite at Knidos was the reason for the existence of the temple: it actually dictated the design of the temple. There was an altar nearby, and doubtless libations were poured and sacrifices conducted in honour of the goddess, but her religious presence has been virtually supplanted by a statue that is aware, so to speak, of its status as a work of art.

This is a major departure. It is made conspicuous by the subsequent obsession of Western (male) artists and Western (male) viewers with the female nude, which misleadingly makes Praxiteles the progenitor of what is called 'the male gaze' (the truth is that Greek viewers were usually more voyeuristic about naked men than naked women). We become aware not only of the artist as an impresario, but of a culture of viewing that is essentially bound up in

194
Capitoline Aphrodite, Roman copy of an original made in the 3rd or 2nd century BC. Marble; h.193 cm, 76 in. Musei Capitolini, Rome

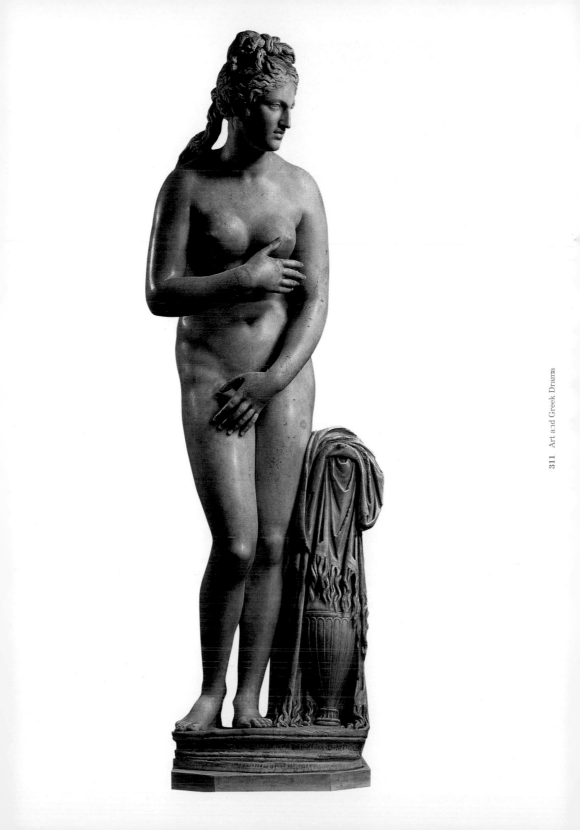

195
Aphrodite,
detail from a
Paestan red-
figure and
polychrome
amphora,
late 4th
century BC.
h.91 cm,
35¾ in.
Museo
Archeologico
Nazionale,
Paestum

performance. The Aphrodite of Knidos is not unknowingly espied by her viewers; she is aware of being watched. Which is why, like so many other Aphrodite-types devised in the wake of Praxiteles (194), she makes the counter-productive gesture of 'shielding' those parts of her supposed to be 'private'. Representations of Aphrodite will often show her in the act of preening herself for her appearance to the world (195); self-referentially, incised Greek and Etruscan bronze mirrors will often show Aphrodite and her circle making themselves pretty, 'putting on a face'. According to their own accounts, the Greeks knew whom to accredit with the origins of such cosmetic adornment. It was none other than the legendary Thespis, founding-father of the profession of acting in Greece. He was the very first person, perhaps, to regard the world as a stage.

7

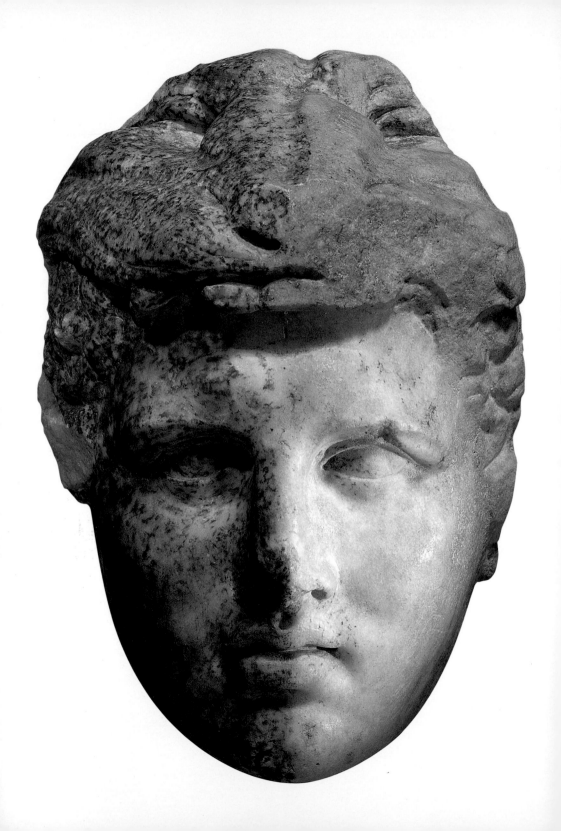

The River Beas rises in the Himalayas. Known anciently
as the Hyphasis, it is one of rivers that waters the Punjab
area of India, between the Indus and the Ganges. In 326 BC
Alexander the Great (356–323 BC) arrived at its banks
with his army. This was the eastward culmination of a
march of over 17,700 km (11,000 miles), and a sustained
campaign of conquest that had covered the Black Sea, Asia
Minor, Egypt, Arabia, Persia and Bactria. The Indus valley
was the latest addition. But the Beas bulged with the same
monsoon rains that had sodden the troops for months.
There was an exhausted reluctance among the army to
go further. Alexander himself was enthusiastic, however.
He urged them to take the next step:

196
Alexander the
Great dressed
as Herakles,
*c.*330 BC.
Marble;
h.24 cm, 9½ in.
Museum of
Fine Arts,
Boston

You all know that if Herakles, my ancestor, had gone no further
than Tiryns or Argos, or the Peloponnese, or Thebes, he would
never have earned the glory which transformed him from a man
into a god or demigod. Even Dionysos, divine from birth, faced
terrible tasks – and we have outstripped him … Onward, then:
let us add to our empire the rest of Asia.

Stirring as these words might be, here distilled from a
longer speech (see Arrian, *Life of Alexander*, 5.25), they failed
to persuade. Alexander's officers shared the men's feeling
that they had reached their limit and told him so. His immed-
iate reaction was to retire to his tent and sulk for two days.
When he emerged, a cheer rose up at the message he deliv-
ered. The time for withdrawal had, he agreed, been reached.

But the troops had a job to do before they left. They were
divided into twelve sections. Each section was assigned to
build an altar to one of the Olympian deities, 'as thanks to
those who had brought them victoriously so far and as a
memorial of all they had been through together'. These

were to be mega-altars, taller than the highest towers and massively broad too. Then, the troops were to build a mock camp, three times the actual size of the one they were using, and surround it with an enormous, deep ditch. Huts were to be constructed, with beds over 2 m (8 ft) long and feeding stalls twice the usual size. Colossal suits of armour were to be made and deliberately abandoned; massive bits of cavalry equipment too. It must look as if a regiment of giants had made and inhabited the camp; and that they had refrained from crossing the river by choice, not necessity.

This story of the huge altars and camp left at the Beas by the retreating Alexander is cobbled together from different historical sources and probably apocryphal (no archaeological traces of either altars or camp have ever been found in this area, now part of West Pakistan). But it makes a tidy paradigm for the topic of Alexander's impact. He was always going to be tagged 'the Great'. He knew what sort

of impression he wanted to leave on the world. 'Larger than life' is a simple, colloquial way of phrasing it. More precisely, Alexander aspired to semi-divine or even divine status. Not just a hero: a god.

The ruse of the mock colossal camp seems, on the face of it, childish. Who did he think he was deceiving? But we should remember that great size, heroism and godhead were becoming normally associated by the fourth century BC. The colossal cult statues created by Pheidias and others in the fifth century BC were outdone by statues that no temple could contain. Alexander's personal sculptor, Lysippos, made massive images of Zeus and Herakles for the colonial town of Tarentum in southern Italy. His pupil, Chares, made the now-lost wonder known as the Colossus of Rhodes, a bronze image of the sun god standing over 30 m (100 ft) high at the entrance to the harbour of Rhodes. No trace of the colossal statues made by Lysippos survives, but a substantial marble version of a 'weary' Herakles by Lysippos made in the Roman period (197), gives some idea, perhaps, of the stature of men intended by the relics left in India.

Herakles was claimed as a mythical ancestor by Alexander, as his speech at the Beas confirms; so too Achilles, with further divine associations provided by Dionysos, Apollo, Zeus and diverse gods from the non-Greek world. In the course of this chapter we shall see how such associations and permutations were modulated in the image of Alexander. In order to measure his impact, though, we shall have to be

197
'Farnese Herakles', Roman version of the 'Weary Herakles' type created by Lysippos, c.200–220 AD. Marble; h.292 cm, 115 in. Museo Archeologico Nazionale, Naples

198–199
Portrait head of Alexander wearing the ram horns of Zeus-Ammon, late 4th century BC. Tourmaline; diam. 2·4 cm, 1 in. Ashmolean Museum, Oxford
Below left Impression
Below right Engraved gem

careful to maintain a certain detachment from the man
and his charisma. *Charisma* is a Greek term, which can lose
its religious significance in English usage, but the sense of
being 'specially favoured' with divine grace, as well as the
general implication of personal magnetism, suits Alexander.
Accounts of his life, however honest or demystifying in inten-
tion, universally acknowledge the extent to which he ruled
by virtue of his personality, his presence. Yet we are also
told that he tightly controlled the making of his own image.
He entrusted painting to Apelles, sculpture to Lysippos and
gem-engraving (and perhaps coin portraits too) to Pyrgoteles

200–201
The 'Alexander
Mosaic' from
the House of
the Faun at
Pompeii, 2nd
century BC.
272×513 cm,
107×201½ in.
Museo
Archeologico
Nazionale,
Naples
Left
Detail showing
Alexander
Right
View of the
whole mosaic

(198–9). Where then shall we locate the boundary between
the man and his fabricated image?

In the considerable scholarship on Alexander's image, there
is a tendency to isolate one or two pieces of art connected
with Alexander and treat them as 'realistic'. This is the case
with the best-known reflection of a painting of Alexander,
the mosaic preserved from Roman Pompeii (200–201). This
highly detailed mosaic is believed to copy, very faithfully,
a painting made perhaps during Alexander's lifetime, or
else within a decade or two of his death. In turn, the painting
is supposed to show, like an historical document, a battle

between Alexander and the Persians. It is already a danger-
ous sign of imprecision that those who allege 'realism' in this
painting dispute whether it was the battle of Issus in 333 BC
or of Gaugamela in 331 BC; at both, Alexander prevailed over
the Persians led by Darius III. The more we examine the
details of this picture, the more it appears a masterpiece not
of realism, but imaginative propaganda. Alexander fights on
recklessly without his helmet: he is wide-eyed (200) and,
although in the act of spearing a member of the Persian
cavalry, obviously intent on attacking the Persian king
himself. Darius, however, has wheeled his chariot round.

The tall lances of his numerous troops are shouldered for
retreat. He turns, horror-struck, to glimpse the hero-warrior
sowing panic among his bodyguards. He is a study in the
loss of nerve. In the chaos of the scene, there are many skil-
ful painterly touches, such as the stricken face of a falling
Persian, reflected in his shield, and the artist has cleverly
dramatized the moment of a battle when fighting yields to a
rout. But the stage props (such as the blasted desert tree) are
no more than that: stage props. The costumes look authentic,
but when examined closely, those of the Persians are suspi-
ciously ornate and effeminate (the horseman being speared

by Alexander wears earrings and sequined trousers, for example). In short, this is a fine example of Alexander-adulation in art. We shall find many more examples of the same genre in Hellenistic iconography.

'Hellenistic' is not to be confused with 'Hellenic', which means simply 'Greek'. In the history of Greek art, 'Hellenistic' is a term used to describe a chronological period, whose parameters are generally fixed as the death of Alexander in 323 BC and the battle of Actium in 31 BC (when the future emperor Augustus defeated his fellow Roman Mark Antony and the Egyptian queen Cleopatra). 'Hellenistic', however, is not a category of art that was recognized in antiquity. *Hellenistes* was the term used by the writers of the Greek New Testament to describe a Jew who used Greek as a language of convenience (*Acts of the Apostles*, 6.1). Its application in history and art history has always been to distinguish a more cosmopolitan culture from the pure 'Classical' of the fifth century BC.

So the concept of a Hellenistic period in art is entirely modern. A dictionary definition of 'Hellenistic' as 'following Greek modes of thought or life' is generally acceptable. In art, however, it denotes not only the influence of Classical Greek style and subject on non-Greek, or the cross-cultural marriage of styles, but also a set of 'mentalities', which, along with various vague applications of art-historical terms such as 'Baroque' and 'Rococo', are used to describe what happens in the Hellenistic period. These terms can seem bewildering, and will be avoided here; a sketch of the historical background is more vital.

Whether it originated with Alexander the Great or with his father, Philip II, who became ruler of Macedon in 359 BC, the end of 'Classical Greece' and the beginning of the 'Hellenistic world' is a phenomenon traditionally explained in Macedonian terms. The question of how far the Macedonian kings considered themselves Greek is delicate.

202
The Mausoleum of Halicarnassos, as reconstructed by Kristian Jeppesen. Mausoleum Museum, Bodrum

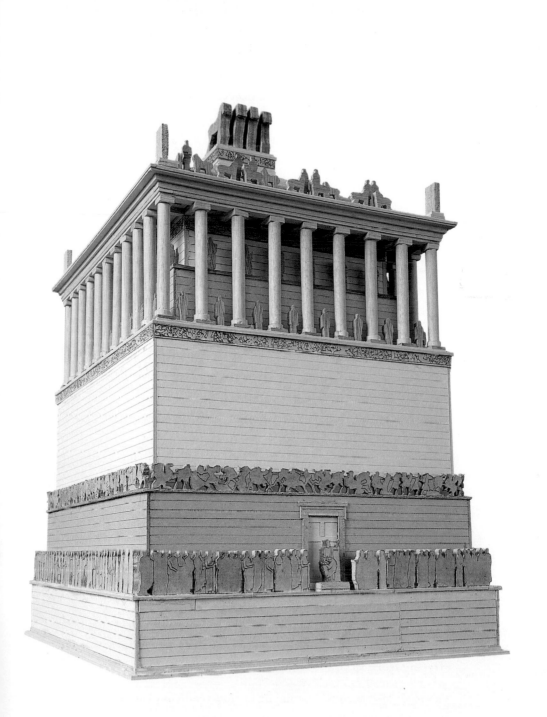

Traditional histories assert that the Macedonians effectively 'conquered' Greece. The battle of Chaeronea, in 338 BC, when Philip II and his eighteen-year-old son Alexander crushed a combined Athenian and Theban army, is usually given as a fixed point of Greek subservience to the Macedonians. At the same time, Philip endowed Olympia with a family statue group that suggested a Macedonian attachment to the Panhellenic world. Previous Macedonian monarchs had hosted Euripides at their court, and Alexander's personal tutor was none other than Aristotle. Undoubtedly the cultural ambitions of the Macedonian dynasts in the fourth century BC were directed towards Greece, and the phenomenon of Alexander makes Hellenistic art easy to explain. In his baggage were Greek works of art, in his retinue were Greek artists. Therefore, Greek art and artists were an imposing influence on all those areas that came under Alexander's control. But if 'Hellenistic' implies Greek artists working on non-Greek commissions, we are bound to begin our account of Hellenistic art not in Macedonia but in Asia Minor, and at a slightly earlier date than is usually allocated for the 'Hellenistic' period.

203
Figure of a Nereid from the Nereid Monument (eleven statues were originally placed between the columns of the monument), c.400–390 BC. Marble. British Museum, London

The coastal area of Asia Minor, now the southwest shores of Turkey, maintained, throughout the wars between Greeks and Persians, a sort of independence; if not political, then at least cultural. Regions such as Caria and Lycia inevitably served as buffer zones, in terms of the meeting of Greek and Asiatic minds. Alexander himself would sweep through them in the 330s BC, incorporating them into the Macedonian empire. But his arrival did not revolutionize patterns of commissioning official art. There was already a tradition of offering work to Greek artists.

The most spectacular testament to that tradition is the Mausoleum of Halicarnassos (modern Bodrum). The Mausoleum was a colossal tomb-monument (202), and takes its name from its honorand, Mausolus. Mausolus was satrap

of the region of Caria. To describe the office 'satrap' as 'governor on behalf of the Persians' is accurate enough, but should not be taken to imply that this Mausolus was a Persian puppet. He was born of a local dynasty called the Hekatomnids (one Hekatomnos preceded Mausolus as satrap), and when he assumed rule *c.*377 BC Mausolus determined that the cultural orientation of his country should face westwards to Greece, rather than eastwards to Persia. As part of this policy, he founded a new capital as a fortified port at Halicarnassos, previously a modest settlement. Here he encircled a new orthogonal grid of streets with city walls 7 km (4 miles) long, built a palace for himself at the harbour entrance, and planned his enormous tomb so that it would be in full view of all those who sailed by Halicarnassos.

Some ancient writers ascribe the tomb to Artemisia, wife of Mausolus, who is said to have organized an epic funeral, or *agon*, for her husband after his death in 353 BC. But Artemisia survived Mausolus by only two years, scarcely enough time to complete such a complex project. The chances are that Mausolus, like those Roman emperors who subsequently designed and built their 'mausolea' during their own lifetimes (such as Augustus and Hadrian), actually conceived his colossal tomb as an integral part of his new city. As the official founder of 'new' Halicarnassos, Mausolus knew that Greek tradition would allow his commemoration or even cult in the centre of the city. He was also aware of other traditions, both local and foreign, which would legitimate both the scale and ostentation of this monument.

Locally, there was the tradition of the family tomb which heroized both husband and wife and an accumulation of their ancestors. Such tombs were especially prominent in the neighbouring area of Lycia, where powerful individuals would commission Greek sculptors to execute memorials that combined what the Greeks would have called a *heroon* with a gallery of ancestors (*syngenikon*). The best-known of these Lycian tombs is what we call the Nereid Monument from Xanthos, raised as a sort of temple in the early fourth century BC and now reassembled in the British Museum (204). Whom it honours, we do not know, but we presume that whoever it was saw himself as a second Achilles – hence the Nereids (203), mythical marine girlfriends of Achilles' mother, Thetis – and had his military triumphs extensively figured in the friezes of the monument. The decoration of the frontal pediment is pure dynastic vanity: the apparent pair of deities at the centre of the pediment are likely to be none other than the deceased Lycian magnate and his wife.

Inspiration for the form of the Mausoleum may have come from further afield. In structure it looks indebted to the plinth and podium arrangement of the tomb of the sixth-

204
The Nereid
Monument,
c.400–390 BC.
Marble;
h.807 cm,
317⅞ in.
British
Museum,
London

century BC Persian king Cyrus, at Pasargadae. The stepped slopes of the roof seem to recall the pyramids of the Egyptian pharaohs at Giza. However, the columns of the Mausoleum are in the Greek Ionic order, and for the decoration of his tomb, like the Lycian chiefs, and indeed the Persian kings, Mausolus called in Greek sculptors. Later sources speak of several 'great masters' brought over for the commission: the names of Skopas, Bryaxis, Leochares, Timotheos and Praxiteles are mentioned, and there is supposed to have been a sort of competition between several of these sculptors, each one taking a different side of the monument. On

205
Lion from the
Mausoleum at
Halicarnassos,
c.360–350 BC.
Marble;
h.150 cm,
59 in.
British
Museum,
London

206
Tomb-painting,
late 4th
century BC.
Fresco.
Kazanluk,
Bulgaria

stylistic grounds this has so far proved impossible to demon-
strate, and attributing the various and numerous fragments
of the Mausoleum's decoration to named sculptors is likewise
a fairly fruitless exercise. Whoever they were, the sculptors
called to Halicarnassos were as capable as any on the Greek
mainland, and, in terms of a programme of images, they pan-
dered to their patron's Hellenizing tendencies, while amply
satisfying his obvious megalomania.

The sculptures are in so many fragments that it is difficult to
establish precisely how they might once have been arranged.
The following description more or less matches the proposed

207
One of the four
horses, made
in the
Hellenistic
period, and
subsequently
placed on the
façade of the
Basilica of San
Marco, Venice.
Bronze;
h.240 cm,
94½ in.
(originals in
the Museo
Marciano,
Venice)

reconstruction (202). On top of the stepped pyramidal roof, there was a four-horse chariot. Possibly there was a rider in this chariot: some suggest Mausolus himself, others propose Helios, the sun god. Another candidate is Herakles, whose apotheosis took place in a chariot and whom Mausolus (in company with Alexander and various other ancient despots) may have claimed as his ultimate ancestor. Such chariot quadrigas were to become standard emblems of royal power. The bronze horses now in Venice (207), which some believe to have been made by Alexander's sculptor Lysippos, come from one of the many Hellenistic groups of this sort; a similar group is figured in the painted tomb of a fourth-century BC Thracian dynast (206).

Around the base of the chariot group there was a frieze depicting Greeks against Centaurs, which is typically Classical. At the foot of the sloped roof, there were patrolling lions (205): perhaps an oriental touch, though by now lions were a standard part of the Greek repertoire too. Below the roof was a colonnade of thirty-six Ionic columns. On the inner wall of this colonnade was a second frieze, showing chariot-racing: a remembrance, perhaps, of the Homeric-style games that marked the funeral of Mausolus. Some freestanding figures, possibly ancestors of Mausolus, may have stood between the columns.

Immediately below the colonnade is a third frieze. This is the largest and best preserved, and shows Greeks fighting Amazons. This treatment of a familiar theme withstands comparison with any of its mainland Greek predecessors: sharp postures of combat, strikingly outlined against a simple background of shields and flying cloaks (209). The Amazon myth (as discussed in Chapter 5), apart from adding to the Hellenic appearance of the Mausoleum, may also have had some family pertinence. We are told that the family of Mausolus claimed to possess, as a sacred relic, the axe of Hippolyta, queen of the Amazons. Perhaps some epic was

208
'Artemisia' from the Mausoleum at Halicarnassos, c.360–350 BC. Marble; h.267 cm, 105⅞ in. British Museum, London

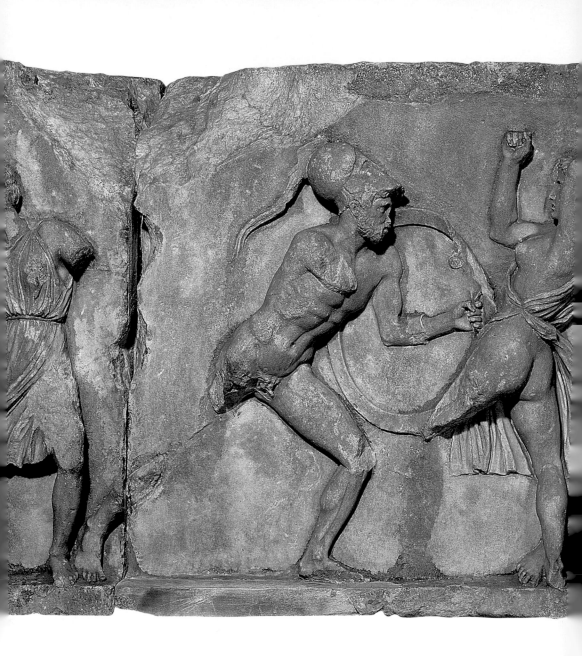

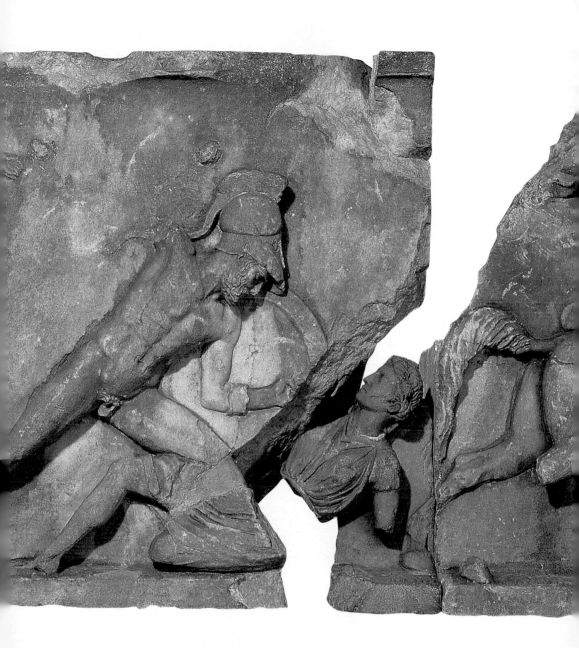

209
Amazon frieze from the
Mausoleum at Halicarnassos,
*c.*360–350 BC. Marble;
h.90 cm, 35⅝ in.
British Museum, London

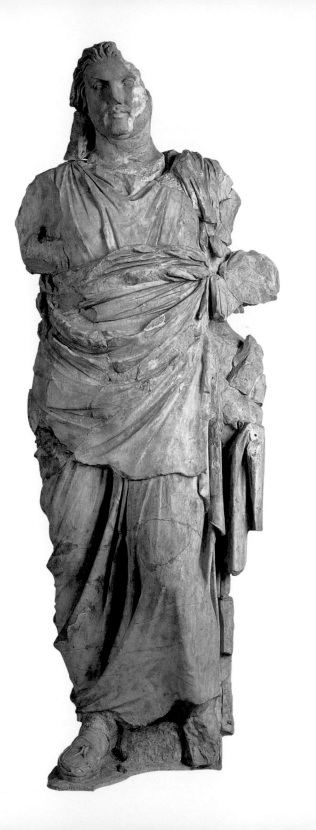

composed for Mausolus, linking his ancestors with the heroic seizure of this axe. Finally, towards the base of the podium, there were sculptures in the round, apparently at two levels and on two scales. The over life-size figures include a pair usually identified as 'Mausolus' and 'Artemisia' (208 and 210), though it is not certain that they represent the royal couple.

Excavations of the royal chamber underneath this excessive monument have revealed traces of an equally excessive cremation. Only a few of the tomb treasures survived subsequent pilfering, but a vast deposit of bones of sacrificed animals was found at the chamber's entrance, adding archaeological substance to the literary tradition of a funeral for Mausolus conducted in Homeric style.

210
'Mausolus'
from the
Mausoleum at
Halicarnassos,
c.360–350 BC.
Marble;
h.300 cm,
118¼ in.
British
Museum,
London

This is more than mere pretension to Greek culture on the part of an Asian dynast. What the Mausoleum amounts to is an overt, architectural manifestation of what we know as 'ruler cult'. The worship of an autocrat as a god becomes one of the defining characteristics of the Hellenistic period. It had been a tenet of Classical Greek self-definition not to prostrate oneself before any mortal: fifth-century Greek ambassadors to the Persian court doggedly refused to comply with the custom of kneeling before the king, saying that this humbling gesture (which they called *proskynesis*) was reserved for the gods. When Alexander absorbed the Persian empire, however, he adopted some of the regal institutions, including prostration at his presence. Greek sources speak of its controversial nature and of the collective disquiet when, a year before his death, Alexander gave the order to all the Greek cities in his control to set up his worship as a god. We are told that when Alexander's painter Apelles painted Alexander *keraunophoros*, 'wielding a thunderbolt', as if he were Zeus himself, he was reprimanded by the sculptor Lysippos for going too far. Yet it is difficult to assess quite how powerful a charge of impiety could be at this time.

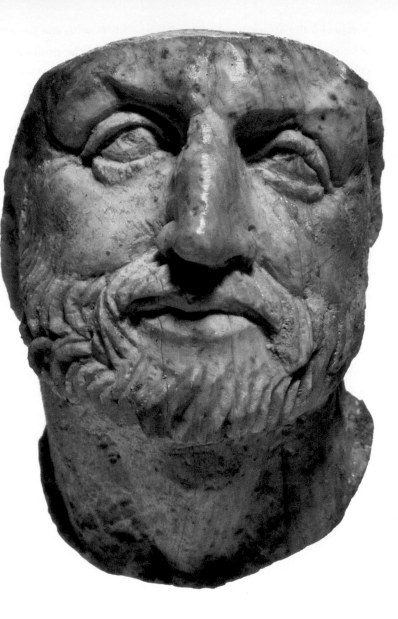

What is clear is that artists were now recruited as integral
components of the royal machine. Without portraits, statues
and coins, ruler cults would be literally unthinkable and
practically unworkable.

Anthropologists have a word for what Mausolus anticipated
and Alexander practised. It is the 'theatre state': the studied
pomp and pageantry that all successful monarchies need to
devise for the sake of their longevity. Louis XIV of France,

'the Sun King', whose rule extended for a remarkable seventy-two years (1643–1715), remains perhaps the supreme maestro of the theatre state (or its protagonist, since from the age of four onwards he was highly dependent on a team of advisers). Yet it is significant that his own self-inflating characterizations were Apollo, Herakles; and Alexander. Like the emperor Augustus, Louis XIV used Alexander not just as a talisman, but also as an example of how to orchestrate the perfomance of personal rule. The question for us here is: how much credit for his propaganda can actually be assigned to Alexander? At one time the answer would simply have been: a great deal. However, it now looks less straightforward. This is partly due to discoveries at the site of Vergina, in the region of Thessaloniki. Vergina is probably to be identified with the Macedonian city of Aigai: excavations have revealed a courtyard-style palace of the fourth century BC, and an extensive cemetery that includes the evident burial tumuli of the Macedonian royal family. In 1977 a barrel-vaulted and painted tomb beneath one of these mounds was discovered, claimed to be the tomb of Alexander's father, Philip II. Philip was assassinated in 336 BC, actually in a theatre, we are told: perhaps the little theatre below his successor's palace. If indeed this tomb is his, he was buried in full 'theatre state' style. Among the rich circumstances of his deposition were some twenty miniature ivory images, including what appear to be some portraits of him and his family. His own portrait (211) may be judged by

an unusual complement: the reconstruction of his face, from the remains of a skull, by forensic experts (212). If that constitutes a reasonable likeness, shall we assume that the little head plausibly identified as Alexander – just twenty years old when he assumed his father's place – gives us an equally approximate image? If so, then it has to be said that the fabrication of Alexander the Great was in hand at the outset of his reign. To what degree he consistently matched the quality of his projected image we shall never know. What is of importance to us is the apparently early date of such an image. The Vergina find implies that a basic portrait type was established almost as a part of Alexander's dynastic grooming, even as preparation for his grand expansion of the Macedonian empire in the east. More generally, it forces us both to reassess the sophistication of art in the service of Hellenistic rulers and to take account of the myth-making ambitions of Macedonian kings prior to Alexander.

It was an earlier Alexander, Alexander I of Macedon (reigning from around 495 until 450 BC) who seems to have generated something like a propaganda programme for himself and his successors. Though it is not entirely clear in its details (and perhaps never was), the heroic genealogy of Alexander I invokes a son or kinsman of Herakles, called Temenos, who in turn produces Perdiccas, a founding king of Macedonia: hence the ensuing dynasty may be known as Temenid and given a Greek or Dorian affiliation. The mythology accompanying this genealogy ascribes some Persian adventures to Perdiccas, however, and probably reflects the political balancing-act that Alexander I maintained through the Persian wars. On the one hand, he offered either help or no resistance to the Persian invaders, and on the other he extended his formal friendship with the Greeks by qualifying for the Olympic games and allegedly supplying Greek forces with useful information about Persian movements before the battle of Plataea (479 BC). Ruler of a region that the Greeks tended to characterize as uncouth, Alexander I

213
Head of young Alexander from the Athenian Akropolis, c.340–330 BC (possibly a copy). Marble; h.35 cm, 13¾ in. Akropolis Museum, Athens

promoted the fiscal credibility of Macedonia through a centralized mint, producing coins whose images of hunting and horsemanship may have owed something to Persian royal iconography. A later successor, Archelaus (who ruled from around 413 to 399 BC), would adopt the Persian standard of coin weight, while calling on the image of Herakles

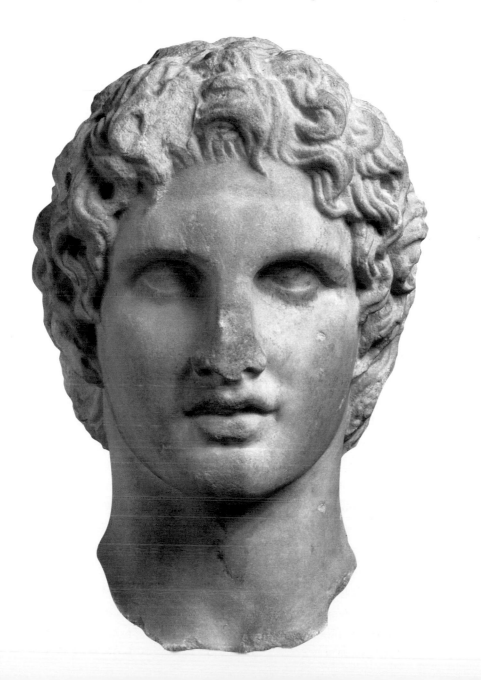

for mythical validation on those coins. Already in the fifth century, then, a basis was laid for what we recognize as ruler cult: the divine right of kings. While Herakles was not a very original choice as forefather of the Temenids, he was by the same token an effective Panhellenic hero-god; and it was at the Panhellenic sanctuary, Olympia, which according to one tradition was founded by Herakles, where Philip II set up a tholos-shaped shrine to himself and his family, shown in gold and ivory images, close to the temple of Zeus.

We do not know what the young Alexander looked like in this Philippeion. The statues were attributed to a sculptor called Leochares, whose hand has been identified in a fine marble image of the young Alexander from Athens (213). The historical tradition maintains that Alexander eventually settled on Lysippos to execute all of his portraits. Only this sculptor, apparently, possessed the finesse (*akribeia*) to render faithfully the king's charisma: his 'melting gaze', 'leonine mane' and 'tilted neck'. Others, in their effort to convey those commanding features, tended somehow to compromise their subject's heroic manliness.

Here we must admit a problem. Surveying the range of Alexander images, most of us will soon find ourselves able to recognize his essential features. A powerful profile, full lips, a gaze that is somehow both far-off and penetrating; and above all, a head of hair that is thick and dishevelled in the most fetching, face-framing fashion. At the same time, we might feel reservations about accrediting just one sculptor with these portraits; or, given that they may often be copies, or 'new' portraits done posthumously, believing that they all stem from a single prototype. If indeed Lysippos created some standard image, the evidence points to a rapid diffusion and weakening of that original type. Consequently, we may question just how profound was Alexander's control over the reproduction of his own image. Putting aside these doubts, however, a

pattern for Alexander's image can be demonstrated. The following ingredients can certainly be isolated.

Firstly, Alexander was a great warrior. He was the outstanding general of antiquity, and his personal courage is constantly highlighted by historians. Asia was called his 'spear-won land'. The mosaic from Pompeii (see 200–1) is one example of the promotion of this image. At least one statue type, possibly owed to Lysippos, shows Alexander as a cavalier on a rearing horse. Alexander's military acumen was demonstrated while he was still young, at Chaeronea. He thought of himself as a second Achilles (from whom his mother, Olympias, claimed descent), to the point of making a pilgrimage to Troy and paying his repects to his Homeric alter-ego. As for his descent from Herakles, this was made overt in some portraits: one shows him, still youthful, endowed with the lion's scalp, the invariable attribute of Herakles (see 196).

Secondly, Alexander possessed a naturally commanding presence. Physically, he was not large, but his eyes inspired devotion from all those in his presence. Directed heavenwards, they brimmed with 'diffuseness' and moisture. They generated ecstasy because they contained so much of what the Greeks called *enthousiasmos*, or 'divine inspiration'. So in his portraits, Alexander is often shown like some muscular saint, transfixed and transfigured by his vision of greater things. When philosophers told him that this world was only one of many worlds in the cosmos, he wept: he was trying so hard to be master of one.

Thirdly, Alexander was, like Louis XIV, a 'Sun King'. It was said that those parts of the world not visited by Alexander never saw the sun. He possessed the looks and extravagant hairstyle associated with Helios the sun god. This facilitated his progress in the East and Egypt, where the sun was a deity, and in any case the symbolism predated Alexander in Macedon. The Macedonian kings used a radiant sun as a

214
Chest from the
tomb of Philip
II at Vergina,
*c.*330 BC. Gold;
h.20 cm, 8 in.
Archaeological
Museum,
Thessaloniki

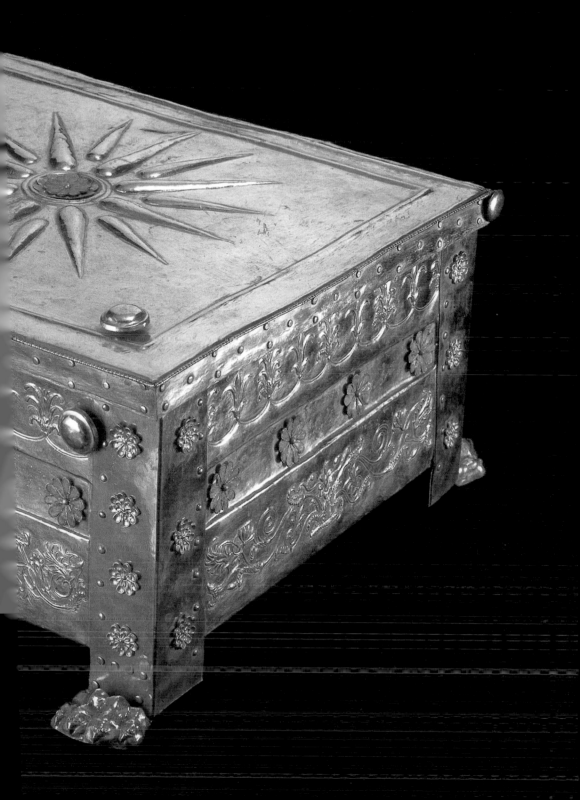

regal emblem: indeed, one of the finds from the tomb of
Philip was a solid gold casket whose lid carries a splendid
sun-burst motif (214).

Finally, Alexander – whose name means literally 'intimidat-
ing to men' – was both assimilated to the lion as a beast, and
championed as a lion hunter. For his portraitists, Alexander's
thick and tawny mane of hair was the most important phys-
iognomic sign of his lionhood. It fitted perfectly with existing
expectations of royal imagery. The exterior fresco of Philip's
burial chamber at Vergina presents a scene of lion-hunting
(215), in which perhaps portraits of both Alexander and his
father can be picked out. (Though damaged, the painting
indicates, like the other Vergina frescos – including a power-
fully cursive evocation of the rape of Persephone – the very
high quality of Classical Greek wall-painting.) The regal
hunting motif, again long-established in oriental iconogra-
phy, was repeated in mosaics at the other Macedonian royal
centre, Pella (216).

The force of this lion-like, lion-hunting image is fully felt
on the misleadingly named 'Alexander Sarcophagus' now
in Istanbul, which probably contained the remains of King
Abdalonymus of Sidon (217). Abdalonymus was a local
princeling who had been down on his luck until Alexander
'liberated' Sidon from the Persians after the victory at
Issus in 333 BC. Abdalonymus seems to have acknowledged
his benefactor accordingly on the reliefs of his own coffin.
There are scenes of battle (perhaps Issus) between
Macedonians and Persians, but there are also scenes of
Persians and Macedonians hunting together, probably in
a royal game-park (*paradeisos*).

Alexander's strain of megalomania is obvious enough and
receives nice confirmation in a story told by Vitruvius
(in the preface to Book II of *De Architectura*) of a budding
Macedonian architect called Dinocrates, who first gained
Alexander's attention by dressing up as Herakles, then made

215
Young lion
hunter,
perhaps
Alexander,
from Philip's
tomb at
Vergina,
*c.*330 BC.
Fresco.
Archaeological
Museum,
Thessaloniki

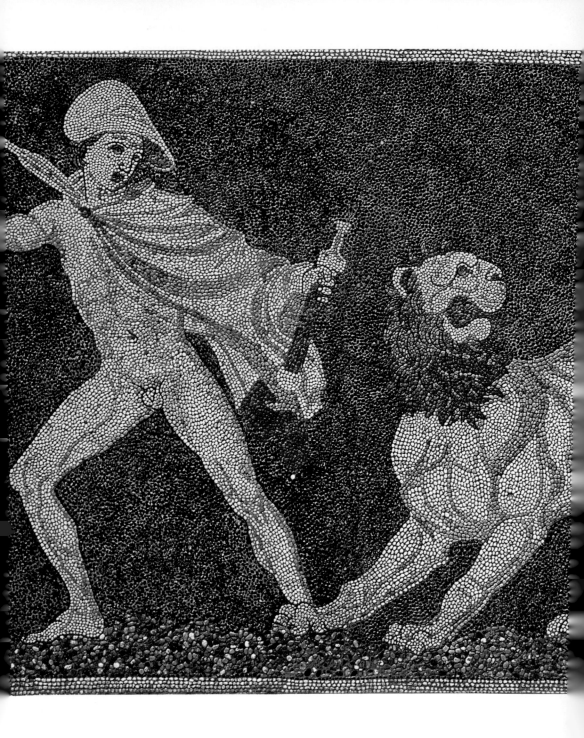

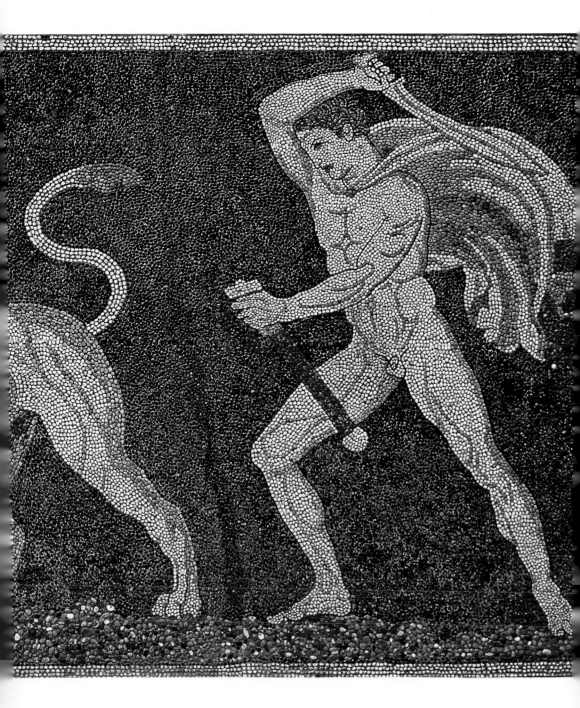

216
Lion hunt, possibly featuring
Alexander, from Pella, late 4th
century BC. Pebble mosaic;
h.163 cm, 64¼ in.
Archaeological Museum, Pella

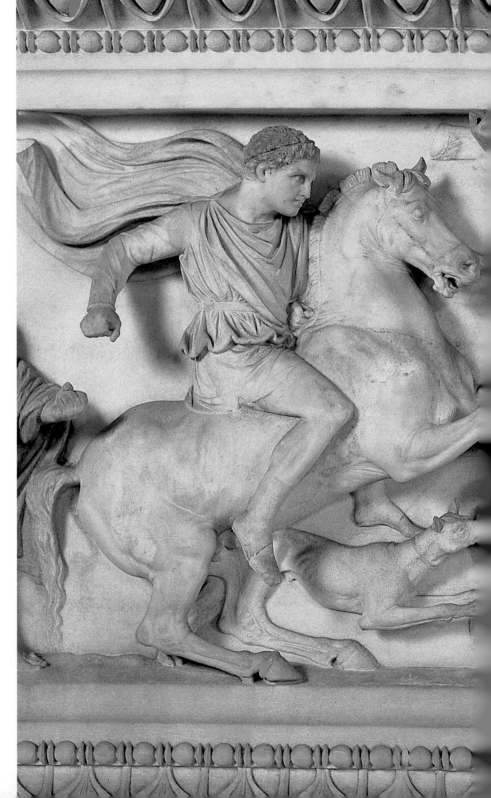

217
'Alexander Sarcophagus', detail showing Alexander and Persians in a combined lion hunt, from Sidon (Sayda), late 4th century BC. Marble; h.69 cm, 27 in. Archaeological Museum, Istanbul

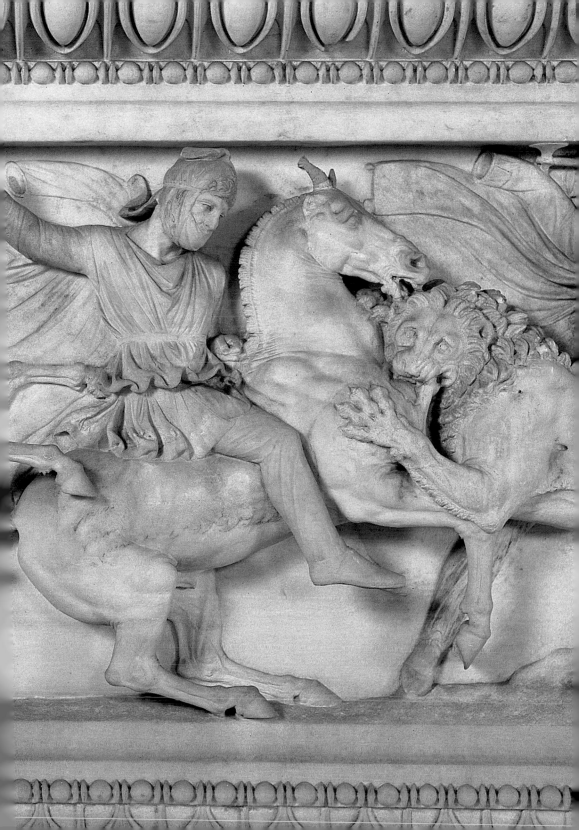

a proposal to carve Mount Athos in his likeness (219). The idea was that Alexander should be shown holding a city in his hand. In principle, Alexander liked the concept, but saw some practical difficulty in arranging the agricultural economy of the city's immediate hinterland. He entrusted Dinocrates, however, with the planning of his city in the Nile delta: whose name, 'Alexandria', made no pretence about who controlled its destiny.

Again we must ask: how do we measure Alexander's impact? We know that he followed the pattern of administration set by his father and forefathers. That is, he devolved responsibility to a circle of power-sharing colleagues who were deemed 'companions' (*hetairoi*). This creates problems for anyone trying to gauge Alexander's own control over his image. For example, numismatists do not agree on whether Alexander issued coins bearing his own self-portrait. Alexander's coinage seems generally homogeneous; many of his issues carry what the Greeks would broadly recognize as an image of the enthroned Zeus, holding an eagle and sceptre, but this image could double up as various foreign deities or heroes: as Gilgamesh in Babylon, Baal in Cilicia, and Melquart in Syria and Phoenicia. The accompanying image of Herakles wearing a lion's scalp was likewise an ecumenical imprint and easily assimilated to the portrait features of Alexander himself. Otherwise, Alexander allowed his subject-kings and satraps to issue their own images locally. Understandably enough, they drew on Alexander's leonine features to validate their own right to power (218). It was not so much Alexander, then, who made numismatic capital of his image, but his successors. Since the role of these successors is actually inextricable from the propagation of Alexander's image, and the consolidation of 'Hellenistic' styles, we must now turn in their direction.

Alexander died young, in Babylon, of an illness possibly compounded by heavy drinking, even alcoholism. His

218
Tetradrachm of Alexander minted by Ptolemy I, showing Alexander wearing the attributes of Dionysos and Zeus-Ammon, c.318 BC. Silver. British Museum, London

219
Pierre Henri de
Valenciennes, *Mount Athos*
Carved as a Monument to
Alexander the Great, c.1796.
Oil on canvas; 41·9×91·5 cm,
16½×36 in.
The Art Institute of Chicago

'companions' and generals then became his official 'Successors' (*Diadochoi*), for whom his image served as a natural amulet. According to their local spheres of influence and military experience, they divided up Alexander's empire among themselves. With varying success, they then attempted to create their own dynasties. It was in the early period of this process that Alexander's Successors relied most heavily on his image, imitating his appearance as an essential element of ruler cult. Before we examine the programmes of art and architecture commissioned by one of these post-Alexander dynasties, the Attalids at Pergamum, it is worth outlining the style of this ruler cult as it is manifest from the various parts of the 'Hellenistic' world.

The prize possession was Egypt. Rich, easily defended and with a native population already used to saluting Alexander as son of the sun god Amun-Ra, or (as a Greek–Egyptian hybrid) 'Zeus-Ammon', Egypt went to a close Macedonian colleague of Alexander, Ptolemy, who would in due course be styled as Ptolemy I Soter, 'the Saviour'. When Ptolemy heard that a massive funeral caravan was setting out from Babylon, to transport the body of Alexander back to Macedonia for interment in the royal tumuli at Aigai, Ptolemy intercepted the cortège and redirected it. He claimed that Alexander had wanted to be buried at the oasis sacred to Zeus-Ammon at Siwah and accordingly hijacked the golden sarcophagus containing Alexander. In the event, the place of deposition (and cult) was first Memphis and ultimately Alexandria, though the tomb has not been found.

One of the most sensitive pieces of Ptolemaic homage to Alexander is the series of reliefs that decorates a chapel added to the ancient temple at Luxor (220). These scenes show Alexander enjoying the same formal relationship with the Egyptian deities as any pharaoh; and more importantly, there is no break in style or symbolism from what had gone before in the long history of this temple. To anyone unable to read

220
Alexander with the god Amun, detail from a granite relief shrine in the temple at Luxor, Egypt, possibly begun during Alexander's lifetime, completed after *c*.320 BC

the hieroglyphics in the cartouches that relate to the reliefs, Alexander could just as well be one in a long line of pharaohs whose divine right was to govern the course of the Nile.

The Ptolemies fit a general pattern. Another Macedonian general of Alexander, Seleucus, converted his governorship of Syria into a dynastic basis for further ambitions. Seleucus asserted a special relationship with Apollo, claiming that it was Apollo's oracle at Didyma which had instructed him not to return to Macedonia, but stay in Asia. His coinage from about 300 BC was stamped with the wreathed head of Apollo or the god's prophetic tripod; and he conspicuously endowed the sanctuary of Didyma and the nearby city of Miletus. A fragment of inscribed verse from Erythrai on the Lydian coast makes explicit the divine ancestry: 'Praise with hymns at the libations of Apollo of the dark hair his son Seleucus, whom the god of the golden lyre himself begat; praise him and forget not.'

In Macedonia itself, Alexander's own family did not survive internal struggles for power. Eventually the country was ruled by a dynasty known as 'Antigonid', after its seizure by the son of Antigonus Monophthalmus ('the One-eyed'). Antigonus Monopthalmus was a senior general on Alexander's staff and arguably the only Successor who might have reunited Alexander's empire. His son Demetrius inherited aggressive ambitions, which were embodied in his sobriquet, Poliorketes – 'besieger of cities' – but he reserved a tender attitude towards Athens, which the Athenians repaid with gushing flattery. They hailed Demetrius as a protective deity, a brother of Athena and a second Dionysos. In 290 BC a special Athenian chorus welcomed Demetrius to the city in the most fulsome terms: they declared him to be 'pre-eminent in beauty', radiant as the sun (with his friends for stars) and 'the only true god'. Other gods (so this hymn went) were made of wood or stone and consequently impassive and unresponsive to prayers. Demetrius was better than them, since he was a living manifestation of divine power.

Like Alexander, Demetrius called on divine kingship to buttress his own highly flamboyant rendition of the theatre state. Emboldened by his success in a major naval engagement with Ptolemy off Cypriot Salamis in 306 BC, he assumed a trident and posed on his coins as the son of Poseidon, divine ruler of the waves. Very likely it was Demetrius who funded that dramatic statue known as the Nike of Samothrace (221). Samothrace, a mountainous island in the north Aegean which the Macedonians considered theirs, offered a naturally spectacular site for architectural endowment. It was in the portico of the elevated sanctuary of the great gods that this massive winged victory was displayed, shown as if she were alighting on the prow of a ship. The sculpted prow itself was set in a pool of water, whose surface must have been ruffled by offshore breezes. The political motivation for such extravagant sculpture is

221
Nike of Samothrace, c.300 BC (though dates assigned by others may run as late as 31 BC). Marble; h.200 cm, 78⅞ in. Musée du Louvre, Paris

plain enough. Just as individual city-states used to compete for glory at sanctuaries, so we now find individual autocrats trying to outdo each other at mutually sacred sites. Other parts of the sanctuary at Samothrace, for example, were handsomely laid out at the cost of the Ptolemies.

The notion that some sort of artistic decline set in after Alexander is difficult to support on anything other than purely subjective grounds. Figured vase-painting, admittedly, was no longer a medium of much interest, but other decorative arts, such as glassware and cameos, reached new levels of both technical and imaginative sophistication (222). Styles of sculpture may seem relatively static: a piece such as the Nike of Samothrace may be (and has been) plausibly dated by its style to anywhere between the late fourth and the late first centuries BC. Yet in terms of complex composition, range of subject matter, variations in scale and pure technical ambition, there is nothing decadent about sculpture in this period. The ambitions and pretensions of many monarchs ensured that; but pride of place must be allocated to the Attalids of Pergamum.

When Alexander died, he had amassed substantial reserves for the Macedonian treasury, due largely to booty seized from the Persians. All in all, this amounted to a massive total, estimated in modern terms as many billions of pounds. Not surprisingly, Alexander's Successors quarrelled over its possession and division. At the battle of Issus in 301 BC, Lysimachus, a Macedonian ruling in Thrace, contested the booty with Antigonus, a Macedonian fighting in Asia Minor for his dominions there. Supported by Seleucus, Lysimachus prevailed. Much of the treasure he took up to Thrace; but a portion he left in Asia Minor, to be guarded there by a deputy governor, one Philetairos, son of a Macedonian general called Attalos. The place chosen for safekeeping the treasure – 9,000 talents, whose value may be impressionistically conveyed by pointing out that all the

222
Cameo portrait
of Ptolemy II
and his wife
Arsinoe, 3rd
century BC
or later
Roman copy.
Onyx;
15·7×11·8 cm,
6⅛×4⅝ in.
Hermitage
Museum,
St Petersburg

gold on the colossal statue of Athena Parthenos amounted
to a mere 44 talents by comparison – was a natural strong-
hold in territory assigned to Lysimachus. That stronghold
was Pergamum.

Philetairos was a diligent curator. He held on to his
entrusted bullion when Lysimachus died; and he held on
to it equally carefully when the erstwhile ally of Lysimachus,
Seleucus, was assassinated in 281 BC. Eventually there was
dynastic confusion about the status of Pergamum and its
precious contents. Since Philetairos had taken precautions
to arrange suitable defences, he might claim that Alexander's
old treasure was safer with him than with anyone else.
Pergamum was nominally under Seleucid supervision,
but when Philetairos died in 263 BC, another safe pair of
local hands took over: his nephew, Eumenes. In the next
two decades, this Eumenes effectively made Pergamum
independent within Asia Minor; and though he never actually
assumed the kingly title, we know him as 'Eumenes I', the
effective creator of the Attalid dynasty.

That is a summary account of the emergence of Pergamum, but will help our understanding of how a relatively small province became one of the great cultural centres of antiquity: a second Athens. The site was a natural fortress (which is what the Greek *pergamos* means). Then it was the basis for constructing a marvellous city, complete with its own akropolis, theatre and so on (223). Since the kings of Pergamum were god-like, of course, their own residences blended with the city's temples. The treasure so scrupulously guarded was used either to finance mercenaries, or else to buy off enemies who could not be dealt with on the battlefield. And what is important to us is that the Attalids also liked to invest in art.

The model for the city was the Athens of Perikles, and Athena was chosen as Pergamum's guardian goddess. Cults of Athena Nikephoros ('Victory-bringer') and Athena Polias ('of the City') were instituted; some Pergamene version of the Panathenaic festival also seems to have been created. Over a library stocked with Classical Athenian texts, copied onto parchment (derived from the eponymous term *pergamentum*, or *pergamenum*), a marble copy of the Athena Parthenos presided (see 150). Schools of philosophy gathered here, after the Athenian model; and so too, of course, did the artists.

Like Classical Athens, Attalid Pergamum felt itself to be exemplary of the civilized life; and like Classical Athens, Attalid Pergamum was beleaguered by enemies perceived as barbarians. For the Attalids, these were not the Persians, but the Gauls. In terms of artistic symbolism, those Gauls could be directly descended not only from the Persians, but also from such mythical prototypes of barbarism as the Amazons and the Giants.

The term 'Gauls' is misleading. *Galati* or 'Galatians' is how we should strictly describe them. They were groups of central European Celts who around 300 BC began to migrate

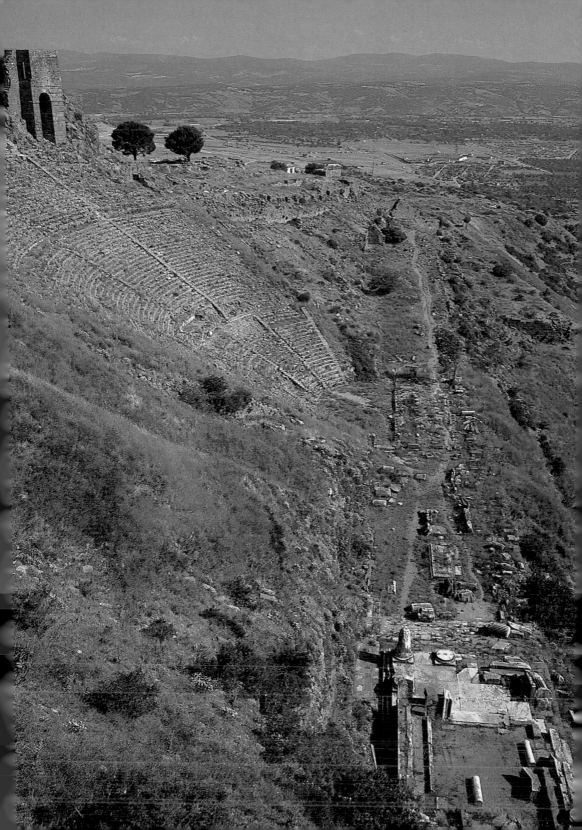

more or less down the course of the Danube and through the Balkan peninsula. Eventually they settled in an area uncomfortably close to Pergamum, an area which became known as Galatia. They are recorded as having attacked the sanctuary of Delphi in 280/79 BC. Though their aggression might be harnessed by hiring them as mercenaries, these Gauls troubled various Hellenistic kingdoms through most of the second century BC. It appears that around 240–230 BC Attalos I met them in battle in his territory. The portraits of Attalos I, who ruled from 241 to 197 BC, strongly suggest a would-be Alexander (224). A shortage of Alexander-style documentation means that we do know how serious a battle this was: since the Pergamenes were not averse to buying off their enemies when it was expedient to do so, it may not even have been much of a fight. It was nevertheless commemorated as a great victory in the Pergamene sanctuary of Athena Nikephoros. A statue group comprising three bronze life-size figures was set up. Two figures were those of a Gaul and his wife: having killed his wife (in order to prevent her capture and violation), the Gaul is heroically turning his sword on himself (225). The third figure is the statue we know as the Dying Gaul (226).

224
Portrait of
Attalos I of
Pergamum,
c.240–200 BC.
Marble;
h.39 cm,
15⅜ in.
Staatliche
Museen, Berlin

As we shall see in the final chapter, the political and ideological links between Pergamum and Rome are essential to understanding the continuity of the Classical tradition in art. The shared Celtic identity of the enemies of both Pergamum and Rome made the transference of statuary commemorating triumph over Gauls almost natural: so it was that the Dying Gaul could migrate to Rome as a symbol of the triumphs of Julius Caesar over the Gauls in Gallia, or what is now France. However, that is a later recontextualization. The original Attalid group was set up in a more specifically Hellenizing spirit. The Dying Gaul is a compound of mythical and actual perceived barbarism. Despite the features added to specify his ethnic identity – the distinctive Celtic torc or golden choker,

the moustache and the curved battle-trumpet – he is also generalized with the tousled hair of a satyr and the twisting body of a giant. He is the threat to the civilized order of which Pergamum considered itself the bastion.

The rule of the next Attalid, Eumenes II, lasted from 197 to 160/59 BC, and in this period there was extensive remodelling of the citadel at Pergamum. Eumenes was a keen book-collector and built the library; he also added the theatre and gymnasium to the city. It was probably under his sponsorship, some time after 168 or 166 BC, that the Great Altar of Zeus was raised. Now in Berlin, the friezes

225
The Gaul killing his wife and himself, copy of an original of *c*.220 BC. Marble; h.211 cm, 83⅛ in. Museo Nazionale Romano, Rome

226
The Dying Gaul, copy of an original of *c*.220 BC. Marble; h.94 cm, 37 in. Musei Capitolini, Rome

that decorated this altar constitute the most ambitious project of Greek sculpture since the Parthenon (227).

Unlike the Parthenon frieze, however, the sculptural programme of the Great Altar was readily visible. The subject is easily summarized, too. It shows the primordial battle of the gods against the giants. Since this was mythically the establishment of supremacy by Zeus and his fellow Olympians over the earth's undisciplined, aboriginal inhabitants, it might be considered as a perfectly suitable subject to decorate a place where Zeus was worshipped. But the proximity of the library at Pergamum and the supposed

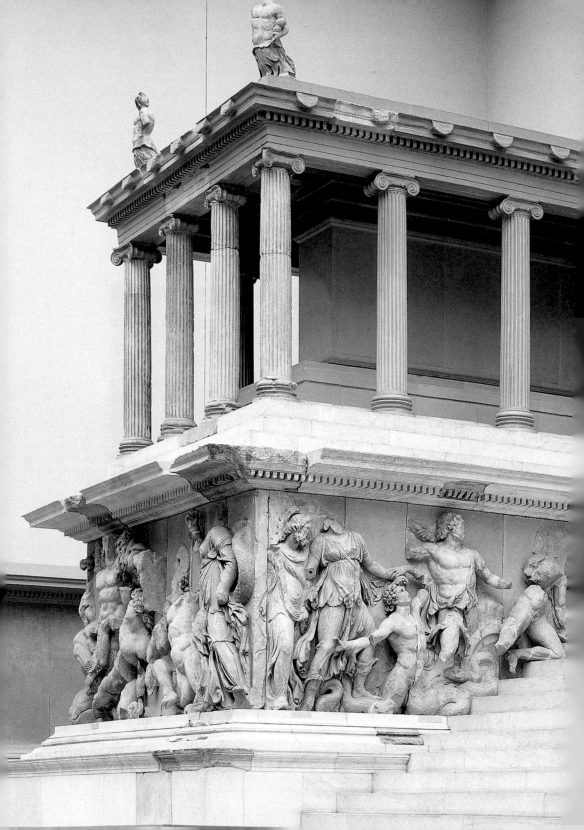

influence of court philosophers have encouraged scholars to speculate on literary sources and allegorical meanings. One suggestion is that the seventh-century BC cosmological poems of Hesiod supplied the theme. Another would have the struggle permeated with metaphors of philosophical concepts of divine destiny. The traces of names for the giants involved may imply some textual guide at the elbow of the frieze's designer. However, as with the Parthenon frieze, no ancient account of the Great Altar illuminates us: we cannot even propose a name for a master designer, though sixteen executive sculptors have left their identities on the work.

In some versions of the myth of the gods against giants, it is Athena's birth that either precipitates or coincides with the struggle. In that case, the Athena-worshipping Pergamenes may have enjoyed seeing their goddess in action. It is even more likely, however, that the Pergamenes appreciated the physiognomic affinities shared by these mythical insolent giants and their actual aggressors, the Gauls. What the viewer receives from the frieze is an impression of tumult, but a tumult in which the faces of the Olympians are uniformly calm, and those of the giants contorted. This depicts a battle in which the superiority of one side over another is absolute. As the Attalids were supreme patrons and had actually employed mercenary troops to effect their victories, there was no place here for any depiction of the citizen body of Pergamum itself. The divinely inspired Attalids could relate directly to the Olympian deities, who fight using their customary attributes. So we see Artemis as mistress of the animals, dancing over the torso of a flattened giant, her pet lion sinking its teeth into the nape of a failing challenger (228). The giants are unchored to the earth by their snake-tailed bodies, defining them as reptilian; frequently we see them being pulled by the hair, raging but essentially impotent. Though a one-sided battle, any chance that this action could become tedious is avoided

227
The Great Altar of Zeus from Pergamum, view of the west section c.165 BC. Marble. Pergamon-museum, Berlin

228 Overleaf
Hekate (second from left) and Artemis (just seen, far right) in action, a detail from the east frieze of the Great Altar of Zeus from Pergamum, c.165 BC. Marble; h.228 cm, 89⅞ in. Pergamon-museum, Berlin

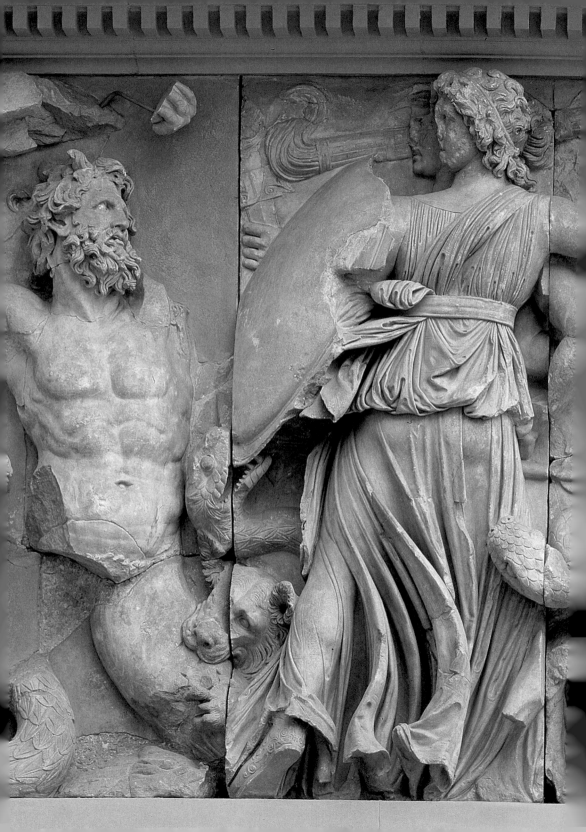

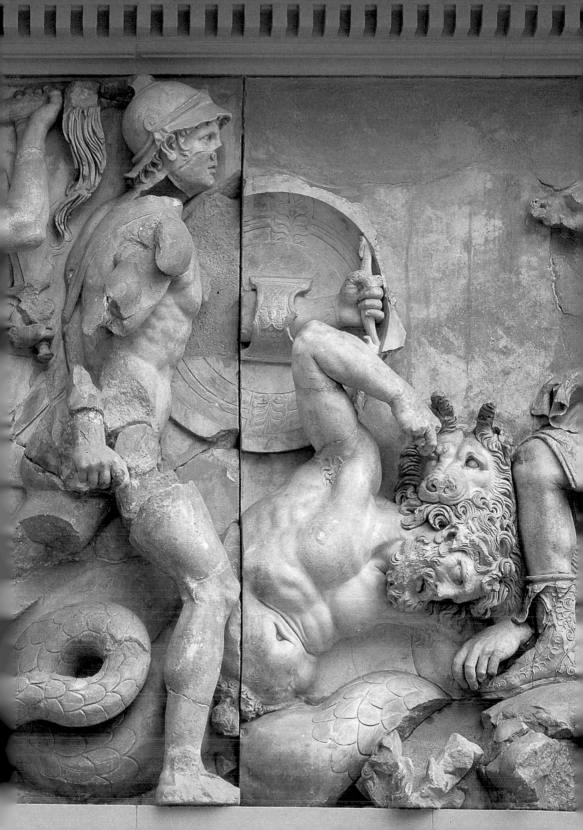

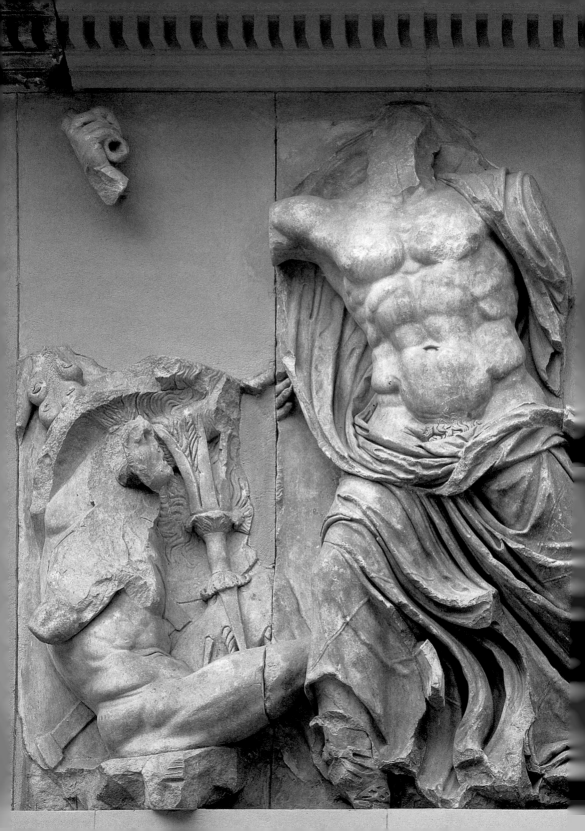

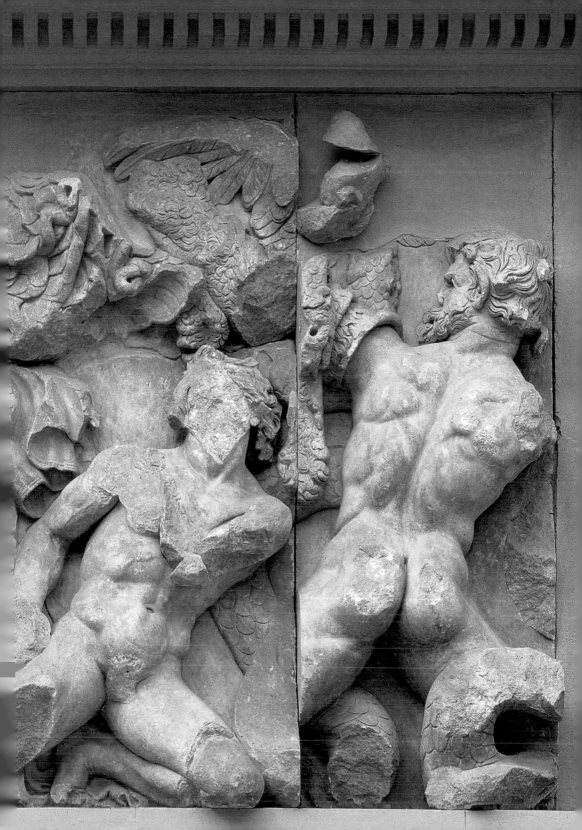

by the dynamic and trenchant style of carving here. The torsos of both gods and giants are treated like rugged landscapes in themselves (229). The combat immediately involves the viewer on approach, by appearing to spill off the edge of the relief and onto the altar steps (227).

Up the altar stairs, a quieter inner relief explained the heroic and divine dynastic origins of the Attalids. Sure enough, Herakles is among the recognizable survivors on this now incomplete minor frieze, which presents an almost continuous narrative of the early history of Pergamum's prehistoric founder, Telephus. The details of the adventures of Telephus, a foundling either fathered or launched on his way by Herakles, can be partially reconstructed from literary sources. Perhaps what is most important about them is the marginal involvement of Telephus with the Trojan War, where he appears alternately as a victim and an ally of the Greeks. Such mythical equivocation would suit the Attalids very well: for their pro-Greek cultural attitudes had to be increasingly balanced with a foreign policy oriented towards a new rising power in the west: Rome. If the Romans were consolidating their own myth-history and tracing their origins from the Trojan side of the Trojan War, then it made sense for the Attalids to align themselves as old neighbours in the Troad region.

Friendship with Rome was pursued by Attalos II (160–138 BC), but still the Athenian connection was maintained. It was Attalos II who endowed Athens with a new stoa along the east side of the Agora (see 109), around 150 BC. A discreet token of Eastern influence was signalled by the 'Pergamene' capitals of this stoa, using Asiatic palm-leaf designs. For the kings of Pergamum to make their presence felt in Athens was not new. Attalos I had added himself to the Eponymous Heroes group in the Agora; but Attalos II was particularly generous towards the city that was Pergamum's cultural model. On the Athenian Akropolis itself, there was a

Pergamene donation of statues representing four separate (but symbolically connected) battles: the gods against the giants, the Athenians against the Amazons, the Athenians against the Persians at Marathon and the Pergamenes against the Gauls (see Pausanias, I. 25.2). Unfortunately, Pausanias tells us only that 'Attalos' made the donation, without specifying which Attalos; and though he gives some idea of the scale of the figures (about half life-size), he does not indicate their quantity. On the basis of copies, it has been estimated that each combat group consisted of about fourteen figures, making a total of at least fifty figures altogether. It is presumed that the figures Pausanias saw were bronzes, since one was reportedly blown into the Theatre of Dionysos below by a freak wind; but in Pergamum there may have been a full set of marble replicas.

Attalos II was a brother of Eumenes II and campaigned against the Gauls during the reign of Eumenes, from 168 to 167 BC. Possibly this Attalos raised the Athenian groups prior to his actual monarchy, in which case a date of some time after 167 BC seems likely. Whatever the precise date, there is no doubting the ideological links affirmed by the quartet of battles. Each one seems to have included utterly prostrate corpses of giants, Amazons (230), Persians and Gauls. Triumphant figures, some on horseback, were also repeated; and figures kneeling pathetically, sheltering themselves from blows. It is as if each victory was sanctioned by the same universal, moral justification. The giants threatened the primal order established by the gods, and they were put down. The Amazons threatened prehistoric Athens, and they were repulsed. The Persians threatened historic Athens, and they too were beaten back. Finally, the Gauls threatened Pergamum, Athens of the East; and thanks to Attalos, they joined the same fate as their predecessors. This 'Lesser Attalid Group' (as it is called, to distinguish it from the earlier monument of Attalos I featuring the Gaul killing his wife and himself and the Dying Gaul)

was patently programmed by someone who had studied patterns of symbolism in Classical Athenian iconography (the friezes of the temple of Athena Nike, for instance, and the paintings of the Painted Stoa: see Chapter 5). The fact that a Pergamene king was able to count on a second-century BC audience able to recognize a genealogy of civilization-versus-barbarism images says much about the strength of the symbolism created in the Classical period.

The conclusion of our survey of Hellenistic art must naturally rest not with Athens, but Rome. Attalos II was succeeded by Attalos III, reckoned to be a petty and unhappy king. After five years in power (138–133 BC) he died childless. In his will, he closed the Attalid dynasty. He bequeathed Pergamum and all its possessions – including the nucleus of the treasury entrusted to Philetairos 100 years previously – to Rome. In retrospect, it was the act of a wise or at least a realistic monarch. Pergamum had already joined forces with the Romans campaigning against Macedon in 168 BC at the battle of Pydna, where the Romans under L Aemilius Paullus prevailed. Attalos III looked to a future that was likely to be Roman, and pure foresight may have impelled him to antici-pate the eclipse of his little kingdom.

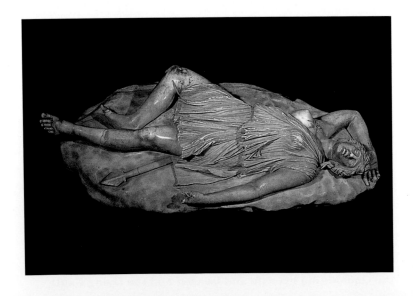

One statue arguably summarizes this predicament: the Laocoön (231). What we see of this group today is an accomplished marble copy of what must have been a bronze original. The copy was made of Italian marble, probably in the time of either Augustus or his successor Tiberius. It may be that the commission to make the copy came directly as a result of the popularity of the epic poem celebrating Rome's Trojan origins, Virgil's *Aeneid*. In Book II of his epic, Virgil puts a vivid description of Laocoön's fate into the mouth of his hero Aeneas, recounting the desperate events that caused his emigration from Troy. This is the occasion of the Wooden Horse, which the Greeks surreptitiously left as a 'gift' for the Trojans (see 53). It was Laocoön, a Trojan priest, who declared that he did not trust the Greeks even when they came with gifts, and who cast a contemptuous lance at the horse's flank. Then, while Laocoön is preparing a sacrifice by the shore, his doubts appear to be severely punished: as Aeneas recalls, 'two giant arching sea-snakes' suddenly reared out of the sea, 'with blazing, bloodshot eyes, and tongues which flickered and licked their hissing mouths'; they foamed onto the beach, heading for Laocoön. First they seized his two sons; then they coiled around Laocoön, binding him 'in the giant spirals of their scaly length ... His hands strove frantically to wrench the knots apart ... His shrieks were horrible and filled the sky, like a bull's bellow when an axe has struck awry.' (*Aeneid*, II. 201–27)

According to the plot of a Classical play (now lost) by Sophocles, Laocoön was punished for an act of sacrilege. At Pergamum, in this sculpture, his act of defiance has been translated into heroism. For sound patriotic reasons, as much as any aesthetic response, the Romans admired this statue. Laocoön may be considered a hero of Rome's myth-history: despite his punishment, he at least had spoken his mind. After all, he was right, for the Wooden Horse indeed brought disaster on Troy (see 128–9).

231–232
Overleaf
Laocoön, marble copy of a bronze original probably made at Pergamum c.150 BC. h.184 cm, 72½ in. Vatican Museums, Rome
Left Sculpture group
Right Head of Laocoön

230
A dying Amazon from the 'Lesser Attalid Group', Roman copy of an original made c.160 BC. Marble; l.130 cm, 51¼ in. Museo Archeologico Nazionale, Naples

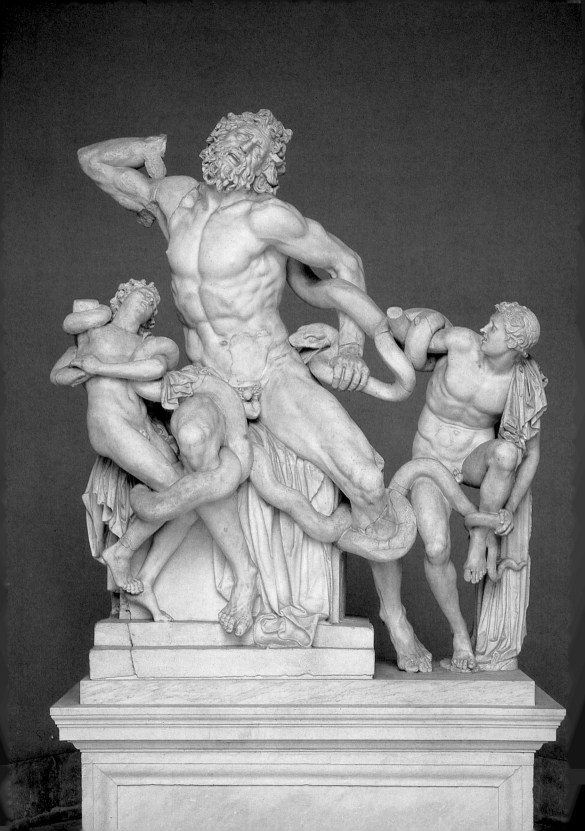

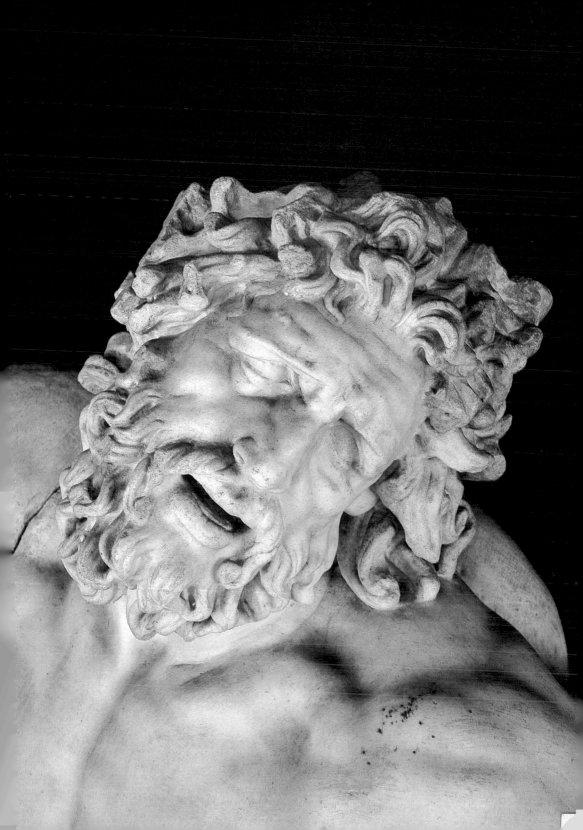

The marble Laocoön was one of the first statues to be excavated in modern times. It was dug up in Rome in 1506, and it is said that Michelangelo himself was present when it came to light. For half a millennium the agonized features of the dying priest (232) have exerted themselves on viewers from all over the world and have been subject to aesthetic debate, imitation, allusion and commercial exploitation. Though much of it has perished, much Greek art remains, in the galleries of the collective imagination, or in what some call the 'social memory': that baggage of myths and images we somehow know, even if we cannot always be precise about *how* we know. The process of the survival and recovery of Greek art cannot be detached from an account of the art itself, and it is with this process that we shall close.

8

Tourism is often imagined to be a phenomenon of the twentieth century. This is a false impression. Mass tourism may be a relatively recent development, but tourism itself is an antique habit. What do tourists do? They go to foreign places and experience (to a greater or lesser extent) foreign cultures. The aims of the tourist will naturally vary from place to place, but tourism in the Mediterranean is well defined in its objectives. In Greece, Turkey and Italy, what tourists want to see are relics of the past. To accommodate this desire, a substantial 'heritage industry' has evolved. It is an industry, however, with an extremely long history of its own.

The basis for some sort of heritage trail in the Aegean was laid down as early as the eighth century BC, when old Mycenaean tumuli were made the focus of local hero cults (see Chapter 1). The supposed graves of Homeric heroes excited eighth-century Greeks almost as much as they would the nineteenth-century German archaeological enthusiast Heinrich Schliemann, who claimed the credit for locating Troy in 1872. But Schliemann only *relocated* Troy. The ancient Greeks knew where it was. Alexander the Great went there to pay homage to the spirit of Achilles, from whom he claimed maternal descent. There were temples and shrines: things to do and see. The difference was that the ancient Greeks, unlike Schliemann, preferred not to excavate. Perhaps they realized how threatening to fantasy such a project might turn out to be.

So an awareness of the culture of the past was not lacking in Greece, and some evidence can be mustered to demonstrate that, while refraining from excavation as such, certain relics and *objets d'art* from the past were used to buttress

233
Sphinx from the collection of Sigmund Freud, late 5th or early 4th century BC. Terracotta; h 18 cm. 7 in. Freud Museum, London

and illustrate this heritage. In addition, it was a generally recognized rule of war in antiquity that precious cultural possessions were liable to seizure by the victors. So although there was no 'art market' as we would understand it in ancient Greece, the spoils and booty of war were in conspicuous circulation. Sanctuaries such as Delphi and Olympia were groaning with them. Their value was largely determined by the weight of precious materials used in their manufacture – particularly gold and silver, but also ivory, amber and so on – but in time, authorship also came into consideration. We have already seen how certain works of art acquired fame, or even notoriety: the Aphrodite of Knidos (see 193), for example, was bid for by a rival state. In due course, this enhancement of value by virtue of a signature or an attribution turned Greek art into the stuff of investment and connoisseurship. Consequently, tourists were joined by collectors; 'museums' soon followed.

This process was hastened by the Roman conquest of Greece in the second century BC. Rome had asserted herself as the controlling power in Italy during the fourth and third centuries BC, where southward expansion meant that she absorbed 'Greater Greece': the old colonies clustered towards the heel of Italy and in Sicily. She had also annexed the highly Hellenized cities of Etruria. Her involvement with the Greek mainland came first as a result of assisting Greek city-states against the Macedonians; and then, having formally annexed Macedonia in 146 BC, absorbing those city-states into a Rome-controlled province. Greece was subsequently used as a battleground for Roman civil conflicts during the first century BC, as various army commanders struggled for absolute power of the Roman republic. Greek art suffered badly in this period. Certain generals, such as Sulla, paid their troops with coins made from melting down Greek bronze statues. Less destructively, others ransacked Greek sanctuaries for the glittering prizes which would look good in a triumphal procession

234
Andrea Mantegna, *The Triumph of Caesar* series, canvas II, showing a procession of booty, *c.*1475. Tempera on canvas; 268×279 cm, 105½×107⅞ in. Hampton Court Palace, Surrey

back in Rome. We have some detailed descriptions of these triumphs, making it clear that works of art were part of public expectation and state enrichment. Though they compromise on historical detail, the evocations of such a triumph by the Renaissance artist-scholar Mantegna are credible in atmosphere (234).

Remaining under Roman jurisdiction until the Roman empire itself dissolved in late antiquity, Greece was always subject to the depredation of its art by unscrupulous individuals, though the places where art was mostly stored, the sanctuaries, continued to function. Several emperors – Caligula and Nero are two – are known to have raided sites such as Delphi and Olympia, and several local governors, most flagrantly a first-century BC character called Verres, abused their power in amassing private collections of Greek statues and other artworks. Even archaic little Corinthian vases, unearthed from tombs after the Romans sacked Corinth in 146 BC, became collectable. Back in Rome, there were some purists who regarded the premium put on Greek art as pernicious and effeminate, contrary to what they perceived as the tough Roman national identity. But such voices of disapproval had little influence. In Rome, a culture of collecting and discernment of Greek art was well established by the end of the first century BC. Tourism to the Roman-controlled Greek world was becoming a recognized form of education or self-improvement.

Julius Caesar seems like the archetypal, tough Roman fighting-man, but he valued his Greek art. Apart from his commission of copies from the Pergamene monuments of victory over the Gauls (see 226), he is recorded as having spent a large sum on a painting of Ajax and Achilles by one Timomachus of Byzantium. Then there is his eventual successor, first of the official 'Caesars', Augustus. Augustus aimed to transform Rome into a city made of marble, like the Athens of Perikles. He sought to construct the illusion of

235
'Apoxyomenos' (Scraper), Roman marble copy of a bronze original made by Lysippos, c.320 BC. h.205 cm, 80³⁄₄ in. Vatican Museums, Rome

a democratic city-state for his subjects. Accordingly, he laid out colonnades, built new temples and refurbished old ones, and created a highly Classicizing forum, complete with copies of the Caryatids from the Athenian Erechtheum. The style of his public sculpture programme is usually described as 'Neo-Attic', implying the use of fifth-century Athenian motifs and mannerisms. Augustus must also have collected Greek 'Old Master' paintings: we are told (Suetonius, *Life of the Deified Augustus*, 75) that at dinner parties he would turn pictures to the wall before his guests arrived, then stage an auction for them, with blind bidding. Guests might pay well over the odds or come away with a good bargain; in any event, the anecdote testifies to an ambience in which the leading men were expected to be informed about Greek art and its value.

Then there is the successor of Augustus, Tiberius. One story about him perhaps reveals that discrimination about what was 'fine art' went beyond (or below) a well-educated Roman élite. Tiberius coveted a statue by Lysippos, the figure of an athlete scraping himself (235). It was on public display, and Tiberius had it removed to his own bedroom. The outcry was such that he had to return the statue to its public place. The people considered it a collective possession.

236
Partially reconstructed group from Sperlonga, showing the blinding of Polyphemus, early 1st century AD. Marble and plaster; h.c.350 cm, 137⅞ in. Museo Archeologico Nazionale, Sperlonga

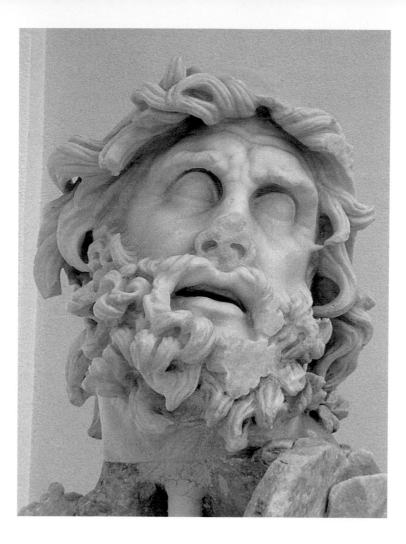

It was probably Tiberius who commissioned one of the most
imaginative displays of Greek art ever conceived. He had a
villa on the coast at Sperlonga. The name suggests a cave
(the Latin for cave is *spelunca*), and in the 1950s a cave was
indeed discovered to be part of the villa complex. It had been
converted into a capacious dining room. Sea water flowed
into the cave, and a system of paths led to an artificial island,
where those dining would recline on couches. Around them,
set in appropriate natural niches, or on other artificial
islands in the water, were dramatic sculptures or sculptural
ensembles, on a colossal scale. The largest, and highly suit-
able for the cave, showed Odysseus and his men driving their

stake into the eye of the giant Polyphemus (236; for the story, see Chapter 2). Other themes were Odysseus rescuing a sacred statuette of Athena from Troy; Odysseus lifting the body of Achilles from the battlefield; and, set in the water, a violent scene of the dog-headed sea monster Scylla, attacking the ship of Odysseus and his companions (as related in Homer's *Odyssey*, Book XII). Roman historians allude to a personal penchant on the part of Tiberius for the figure of cunning Odysseus (237), which may have dictated the common element to this programme of interior decoration. Vitruvius (VII.6.2) also mentions that the 'wanderings of Odysseus' were a popular choice of subject for the paintings that decorated Roman walls at the time. However creative Tiberius may have been in the design of his semi-marine dining room, though, we remain unsure whether he started with the space and then ordered the statues; or even whether the statues are originals. What is certain is that Greeks made (and signed) them, and that the Sperlonga pieces should be counted as 'Greek' rather than 'Roman' art.

The Romans fostered a concept of absolute 'masterpieces': *nobilia opera*, or 'great works', as they called them. The archaeological fruits of this connoisseurship have been gathered at sites around the Roman Empire, such as the villa of Herodes Atticus at Astros, or Hadrian's villa at Tivoli. Emperors varied in their passion for collecting or copying such pieces: none was quite so ardent as Hadrian (ruling from 117 to 138 AD), who earned the nickname *Graeculus* ('Greekling') on account of his fondness for Hellenic art, architecture and general culture. The dissemination of old Greek masterpieces was conducted so thoroughly that many Romans of ordinary status must have lost direct consciousness that the images surrounding them were of Greek pedigree. Most art made to Roman order was executed by artists of Greek origin. We speak of 'Roman wall-painting', of which such unusual quantities were preserved in the cities under the volcano Vesuvius, which erupted in 79 AD. But the paint-

ers of the walls of houses in Pompeii and Herculaneum were, if not ethnically Greek, at least Greek-trained. Consequently, we suspect that many of the now lost 'masterpieces' of Classical and Hellenistic Greek painting are reflected in these frescos, especially when the general scheme of decoration seems to 'frame' a particular scene or vignette. We have already noted one such imitation in mosaic, from the House of the Faun in Pompeii (the 'Alexander Mosaic': see 200–1). There must have been many more, even if we do not have direct proof of the originals which inspired the copies. Any depiction of Greek myth or epic, such as Thetis being shown the armour of Achilles by Hephaistos (238), is likely to owe part or all of its composition to an older Greek painting. There are many such scenes, even in comparatively modest houses.

Even Romans who retained little aesthetic interest in Greek art could feel satisfied when surrounded by its images. These were the trophies of civilization, of high culture, and they had passed to new masters. Pergamum, 'Athens of the East', had been bequeathed with all its books and art treasures to a rightful inheritor. Hadrian would erect an arch in Athens that declared: 'Once, this was the city of Theseus. Now it is the city of Hadrian.' The sentiment of an inherited or acquired standard of civilization was, as we shall see,

a motive for future predators of Greek art. But before we leave the Romans, we should consider the nature of travelling abroad in the Roman Empire.

One name is especially important here: Pausanias, whose *Travels around Greece*, written around 150 AD, has been regularly referred to throughout this book. Prior to Pausanias, however, we should note a curious and lesser-known predecessor of his, Apollonius of Tyana. Apollonius was a long lived, widely travelled and widely respected sage of the first century AD, whose story was told with admiring imagination by a second-century AD writer called Philostratus. From Tyana (in Cappadocia, Turkey) Apollonius wandered freely, not only around Asia Minor and the Mediterranean, but also Persia, India and Egypt. His five-year tour of Asia Minor was done under a vow of utter silence, but otherwise he commented openly on the places that he visited and gained a reputation for performing miracles. His biography as it is elaborated by Philostratus is not quite a travel guide, but it is packed with the sort of episodes and discussions that a tourist would enjoy. Apollonius became something of a guru on account of his asceticism, and his expertise in religious matters often led him to criticize the conduct of ritual at Greek sanctuaries. He was nevertheless a stout defender of the Greek manner of representing the gods, and this is what makes him an important figure for students of Greek art. Apollonius records with approval, for example, that in India the locals had taken to anthropomorphic depictions of their gods, following the Greek fashion. Indeed, it is the case that in the Gandhara region of the Indian subcontinent, where Alexander the Great had reached, the Buddha and his companions were visualized in an evidently Greek style (239). Apollonius chastises the Egyptians for worshipping images of hawks and dogs; but he is sympathetic to a young man who has fallen in love with the statue of Aphrodite at Knidos and wants to marry it. Pheidias and Praxiteles, as Apollonius explains to

239
Vajrapani, guardian of the Buddha, dressed in a lion skin, like Herakles, and holding a thunderbolt, like Zeus, in a relief from Gandhara, 1st century AD. Stone; h.54 cm, 21¼ in. British Museum, London

his Egyptian colleagues, had shown everyone the true and proper dignity of the heavenly deities. The sanctuaries where their work was displayed were therefore not simply museums, but destinations of genuine pilgrimage.

In his sensibility for the religious enchantment of Greek art, Apollonius sets the scene for Pausanias. Pausanias, like his near-contemporary Plutarch (who served for thirty years in the priesthood at Delphi), maintained a serious interest in ritual behaviour. Though he is sometimes considered a gullible traveller, ready to swallow any tale the locals feed to him – one of his favourite verbal tags is *hos legetai*, 'as it is said' – Pausanias does come across as an honest and uncomplicated witness, whose religious reflexes are still lively. So we have a valuable testimony regarding the ancient significance of Greek art. While Pausanias is writing about statues or paintings that may have been made up to a millennium before he saw them, the importance is that their function was more or less intact. That is, tourism was not yet secularized. This makes for a discourse of appreciation that deserves our brief notice. Here, for example, is Pausanias approaching the Parthenon (I.24.4):

Here there are statues of Zeus, one made by Leochares, and the other called Zeus of the City [*Polieus*], whose traditional sacrifice I shall now describe (though not its legendary origins). Upon the altar of Zeus Polieus they place barley mixed with wheat and leave this unguarded. The ox they have ready for sacrifice goes up to the altar and nuzzles the grain. A priest whom they nominate as 'ox-slayer' dispatches the beast, drops his axe and runs away. The other priests, pretending they do not know who did the act, then put the axe on trial. The ritual is as I describe it.

What we see here is a dual response on the part of Pausanias. Part of him is interested in the question of attribution, which is why he tells us that one statue of Zeus was made by a sculptor called Leochares. The other part of him is concerned with the religious functions of the place he is

visiting, so he describes the bizarre performances ordained in front of the statue of Zeus Polieus. Who made the statue of Zeus Polieus? We are never told. Pausanias switches his interest, as he does whenever possible, to an alternative question: what was the statue of Zeus Polieus for? As we see, he devotes more space to answering that second question. When it comes to talking us through the sculptural decoration of the Parthenon itself, he has remarkably little to say: perhaps precisely because it was just 'art', with no great surviving ritual traditions attached.

Pausanias' book can still be carried around with profit by modern tourists in Greece. Despite his occasional slips, scholars remain indebted to Pausanias for the trouble he took to describe those works of art which have now completely perished. Not just great paintings and murals, such as those in the meeting-house of the Knidians at Delphi or of the Painted Stoa in Athens; but also the many sculptures in wood and bronze, which no amount of excavation will ever retrieve. For within a century or two after Pausanias came a steady and widespread vandalism of the sites where Greek art was displayed. Delphi had survived sacking by Persians in 480 BC and the Gauls in 279 BC, not to mention outrageous thefts by Nero around 60 AD, but the sanctuary, like all others in the Greek world, could not withstand the rise of iconoclastic Christianity in the fourth century AD.

Still, before Delphi's official closure in 390 AD by the emperor Theodosius, some of its artworks had been 'saved': for example, an enormous bronze tripod dedicated by the Spartans after the battle of Plataea (479 BC) was removed to Constantinople (now Istanbul). This transference was probably effected around 330 AD by the creator of Constantinople, Constantine (c.285–337 AD). As the first Roman emperor to confess the Christian faith, Constantine was surprisingly keen to have pagan statuary installed in his new capital on the Bosphorus (which was based at the former Greek colony

called Byzantium). His bishops were critical of the number of naked bodies on display, but perhaps Constantine realized that if his city was to be taken seriously, like Athens or Pergamum or Rome before him, then it needed the assurance of a 'cladding' of Classical art. After all, Rome, the city he had abandoned, is reckoned to have hosted, by the third century, a statue population of about half a million. This means roughly one statue for every two people. Constantine may even have tried to transfer some of the colossal cult statues of Greece to Constantinople, and perhaps achieved what the Roman emperor Caligula attempted, but failed to do: to move the statue of Zeus from Olympia (see 8). There is a theory, so far unproven, that the image of Christ 'Ruler of All' in Christian imagery from Constantinople is based on the Olympic image of Zeus. What statues were preserved in Constantinople, however, stood little chance of survival when the city was taken by Muslim Turks in 1453.

What of all those statues in Rome? Apart from the destructive occupation of Rome by the Goths in 410 AD and the Vandals in 455 AD, most of these statues were subject to a continuous local holocaust. Bronzes suffered their usual fate in furnaces, and Medieval Romans found that marbles, too, had some use. If marble is heated to a sufficient temperature, it will produce lime, useful for cement. The processing of statues into building lime is recorded at Rome as late as 1443. Not all Classical statuary suffered in the Middle Ages; on the basilica of San Marco in Venice there is a set of bronze horses, which were almost certainly taken from Constantinople in 1204, during the Fourth Crusade (see 207). They are recorded in Venice in 1364. But this is an exceptional case; it was not until the start of the phenomenon we know as the Italian Renaissance that attitudes towards Greek art swung from destructive to protective.

On the eve of the Renaissance, a merchant from Ancona, on the Adriatic coast of Italy, became seriously distracted from

his entrepreneurial activities. He became obsessed, around 1420, with compiling a book which he called a *Commentary on Ancient Things*. 'I was driven', he declared, 'by an ardent desire to see the world, to seek out those monuments of antiquity ... and put down on paper what is, day by day, falling into ruin because of the long assault of time and the carelessness of men, yet which deserves to be remembered.' This merchant, called Cyriacus, may be regarded as the pioneer of the new attitude. Between 1434 and 1448 he travelled extensively around Greek areas. This was only a decade or two prior to the invasion of Greece by the Turks (or Ottomans, as they are often called). When he visited Athens, he found the Parthenon consecrated as a church to the Virgin Mary and the Hephaisteion dedicated as a chapel to St George. But there was still much to see. The pity is that very little of Cyriacus' *Commentary* itself has survived.

Thanks to individuals such as Cyriacus and the infectious enthusiasm then current for rediscovering the culture of ancient Greece and Rome, it is in the early sixteenth century that we have our first notice of excavations dedicated to finding antique statuary. In Giorgio Vasari's *Life of Giovanni da Udine*, we are told how the young Giovanni (1494–1564) went digging in the ruins of the palace of Titus, 'to find statues' (*per trovar figure)*; and it was from the palace of Titus, overbuilt by the baths of Trajan, that the Laocoön group (see 231) was recovered in 1506, allegedly in the presence of Michelangelo. Contemporary scholars would have known of Pliny's high esteem for the Laocoön, and the matching of Roman literary esteem with an excavated object ensured immediate celebrity for the Laocoön. It was put in a niche in the statue court of the Vatican's Belvedere (which literally means 'lovely to see'), and artists paid homage to it as they were increasingly bound to do: by sketching in front of 'great works'. Although certain popes worried about nudity, and periodically insisted on the application of fig leaves over male genitalia, some of the first pieces of antique sculpture

**240
Giovanni
Paolo Panini**,
*Imaginary
Gallery of
Roman Art
('Roma
Antica')*,
c.1755.
Oil on canvas;
186×227 cm,
73¼×89⅜ in.
Staatsgalerie,
Stuttgart

collected in Renaissance Rome were female nudes, including the 'Aphrodite of the Lovely Buttocks' (*Kallipygos*). Vatican ecclesiastics were among the keenest collectors of such art. The Farnese family, including Pope Paul III (1468–1549) and his grandson Cardinal Alessandro Farnese (1520–89), were particularly assiduous: from the ruins of the Baths of Caracalla, which lay on their own property, they salvaged some spectacularly large pieces of Hellenistic-Roman production, notably a colossal marble Herakles (see 197) and a massive group showing the sons of Dirce attaching their mother to a rampant bull.

In the 1530s, Francis I of France communicated some of this new archaeological passion north of Italy. But the Vatican maintained control of collecting sculpture from Rome and environs, though very little that was not Roman or Hellenistic had yet come to light. This remained true well into the eighteenth century: Roman finds were considered to constitute the definitive gallery of antiquities (240). Greece itself was little visited; and it was not visited at all by the first scholar to construct a history of ancient art, the German J J Winckelmann (1718–68).

241
Belvedere Torso, perhaps the wounded Philoctetes, c.50 AD. Marble; h.142 cm, 55⅞ in. Vatican Museums, Rome

Greece was considered dangerous because of bandits. In any case, Winckelmann, not part of the aristocracy, perhaps could never have afforded to go. He settled in Rome in the employ of Cardinal Albani (1692–1779), who had sponsored the rich excavation of Hadrian's villa at Tivoli. On the basis of what had been amassed at the Vatican so far, Winckelmann felt able to construct a systematic account, the *History of Ancient Art* (first published in 1764), covering the art of Egypt, Greece, Etruria and Rome. There is some evidence for sublimated homosexuality in his aesthetics: his appreciation of Vatican pieces such as the Belvedere Torso (241) and the Apollo Belvedere (242) may indeed be invested with a measure of personal desire. And why not? But he also proposed a more impartial condition for assessing

'great art' from antiquity. Of all the ancient art he surveyed, he declared, the Greek was the best, because it had been created in circumstances of political 'liberty'.

As it happens, none of the pieces of Greek art that Winckelmann particularly admired, including of course the Laocoön, can be placed chronologically in the period or location where he would have liked them to be, that is in the fifth century BC, and preferably in Athens. Still, the sentiment was a valiant one and resurfaces from time to time in

242
Apollo
Belvedere,
Roman copy of
an original
made
c.330 BC.
Marble;
h.224 cm,
88¼ in.
Vatican
Museums,
Rome

243
*Napoleon
Bonaparte
Showing the
Apollo
Belvedere to
his Deputies,*
c.1799.
Etching;
16·3 × 20·9 cm,
6½ × 8¼ in

modern appreciations of Greek art. For all its inadequacies (some of which were recognized at the time), Winckelmann's work had a swift and extensive influence in Europe and beyond. It especially nourished strong interest from aristocrats in France, Britain and Germany, for whom the idea of the 'Grand Tour' was developing either as a means of completing their education, or a way of keeping them out of mischief for a year or two. Rome became not only an important staging-post for such leisurely and free-spending tourists, but a major clearing-house for what those tourists required: souvenirs. Some may have been duped with

replicas, but generally there were enough originals of ancient art to supply the market.

From the mid-eighteenth century onwards, for about fifty or sixty years, the history of the discovery and collection of Greek art can be charted alongside the fortunes of the various European nations and their respective aristocracies. The prestige status of Classical statuary may be recognized by a list of what Napoleon Bonaparte and his revolutionary French forces confiscated in Italy when they invaded in 1796. From Venice they gathered the horses of San Marco (see 207); from the Vatican, all the celebrated pieces, including the Laocoön, the Apollo Belvedere, and the Belvedere Torso. These were transported back to Paris overland, lest the English navy pounce on them: and when they were deposited in the Louvre in 1798 (243), a banner proclaimed:

Monuments of Ancient Sculpture. Greece gave them up:
Rome lost them:
Their fate has twice changed:
It will not change again!

Fate decreed, however, that after Napoleon's defeat at the battle of Waterloo in 1815, the looted material was returned.

A change in taste was imminent, brought about, partly, by Napoleon's occupation of Italy. Two British artists, James Stuart and Nicholas Revett, had ventured to Greece and Asia Minor in the mid-eighteenth century and published in 1762 the first volume of their handsome account of *Athenian Antiquities*. They were funded by a gentlemen's club, the Society of Dilettanti, formed in 1733 with the express purpose of furthering knowledge about Classical remains. They published, with a new meticulous care, what was to be seen in Athens and elsewhere, especially with regard to architecture. They produced more than just pedantic record-ings of dimensions, however. The first cogent interpretation of the Parthenon frieze, for example, was made by Stuart

and Revett. Incidentally, they demonstrated that the difficulties of travelling in Turkish-occupied Greece might be regarded as more of an adventure than a nuisance. Since Napoleon had taken Italy, and France was at war with Britain, the British aristocrat needed a new destination to complete his education. So Greece became, literally, viable. One of those who desired the 'Grecian gusto' described by Stuart and Revett was Thomas Bruce, 7th Earl of Elgin. He occupied a rather gloomy ancestral home at Broomhall in Fifeshire, Scotland, and thought he might combine a diplomatic posting to Constantinople with an expedition to Athens, to collect some sketches and plaster casts of architectural mouldings that would ennoble his stately home.

The Elgin story is now well documented. Elgin deputized an Italian artist and factotum called Giovanni Battista Lusieri to supervise what turned into a wholesale stripping of whatever Parthenon sculptures could be removed, plus other sundry pieces from the Athenian Akropolis. Permission of sorts – to take 'one or two bits of stone with figures or inscriptions' – was gained or bribed from the Turkish authorities in Athens (1801); Elgin's flirtatious wife enlisted the assistance of the British navy, and after a series of mishaps the sculptures arrived back in London. The financial burden of the operation ruined Elgin, though the British government eventually purchased the sculptures, now to be seen in the British Museum. Romantics castigated him, most vehemently the poet Byron (1788–1824). Rich enough to visit Greece at will, and carve their signatures into its picturesque relics, wayward gentry such as Byron resented Elgin's simple-minded thoroughness in 'rescuing' the Parthenon sculptures from general degradation. The most serious damage to the Parthenon had been done in 1687, when Venetian forces launched a bomb at the temple, then serving as a Turkish ammunition store. More recently, the temple has been seriously damaged by local pollution in Athens. That is not to say the sculptures should not be returned, but

it provides a gloss of at least an accidental justification for Elgin's behaviour.

Elgin wrote, in 1831, that he had taken the Parthenon marbles 'wholly for the purpose of securing to Great Britain, and through it to Europe in general, the most effectual possible knowledge, and means of improving, by the excellence of Grecian art in sculpture and architecture'. There was some initial excitement at their arrival, and there can be no doubt that the display of the Parthenon sculptures at the British Museum caused a minor revolution in taste for Greek art. However, there was also some initial hostility, on the grounds that the figures were damaged and incomplete, but resistance soon crumbled. The preference for 'finished' Roman copies of Greek originals – fully reflected in the collection of Charles Townley (244) now reconstituted at the British Museum – passed out of fashion. The emblems of Periklean Athens were adopted as emblems of Queen Victoria's British Empire. Like Pergamum and Rome before her, London bolstered her position as a capital city by calling on the iconic guarantee of the Classical Greek style.

It was not a comprehensive Neoclassicism, as the Gothic Revival was to prevail, for example, in the building of the

244
Johan Zoffany,
Charles Townley's Library at 7 Park Street, Westminster,
1781–3. Oil on canvas;
127×99 cm,
50×39 in.
Towneley Hall Art Gallery and Museums, Burnley

245
Pierre Vignon,
Façade of the Madeleine, Paris,
completed 1842

246
Karl
Friedrich
Schinkel,
*Design for a
Palace at
Orianda in the
Crimea*, 1838.
Pen, ink and
watercolours
on paper;
48·5×49·4 cm,
19×19½ in.
Charlottenhof,
Potsdam

British Houses of Parliament. Nor, of course, was it confined
to London. In Paris, Napoleon took over what was originally
intended by King Louis XIV to be a church, with a great dome
like the Pantheon in Rome, and converted it into a colon-
naded war memorial much more like the Parthenon in
Athens. This was the Madeleine (245). It says much about the
flexibility of the Classical model that after Napoleon's death,
proposals for the use of the building ranged from library,
senate house, law court, bank and even railway station (even-
tually it reverted to a church). In Germany, meanwhile, the
Classicizing influence of Karl Friedrich Schinkel (1781–1841)
was considerable (246). Like other architects and scholars,
Schinkel was much impressed by the revelations made in the
1830s, by J I Hittorff and Gottfried Semper, that ancient
architecture (not to mention sculpture) had been polychrome
(247). Modern viewers accustomed to the chill purity of naked
marble can still be shocked by the traces of gaudy colours
on Greek temples and statues, but there is no doubt that poly-

247
Gottfried
Semper,
*Reconstruction
of the
Parthenon*,
c.1834.
Watercolour
on paper.
Semperarchiv,
Eidgenössische
Technische
Hochschule,
Zurich

chromy was ordinary ancient practice. Columns and other undecorated parts of a building would have been given a beige or tawny wash, to reduce their glare in the bright Aegean sunlight. Decorated portions were a feast of paint-work and gilding, waxed over for protection against the elements. Those nineteenth-century artists who enjoyed painting 'archaeological' evocations of Classical life equally welcomed this discovery (248).

The paintings of the walls of Pompeii and Herculaneum had been known since the mid-eighteenth century. But what of the paintings on Greek vases? Painted pottery was largely disregarded by the plunderers of late antiquity and the Middle Ages and stood a vastly higher chance of survival than painted panels of wood. Sundry finds had been noted by early eighteenth-century scholars, such as the Abbé de Montfaucon in France, with his monumental and multi-volume collection entitled *Antiquity Explained and Represented in Figures* (first

248 Overleaf
Sir Lawrence
Alma-Tadema,
*Pheidias and
the Frieze of the
Parthenon*,
1868. Oil on
panel;
72·5×109·2 cm,
28½×43 in.
City of
Birmingham
Museum and
Art Gallery

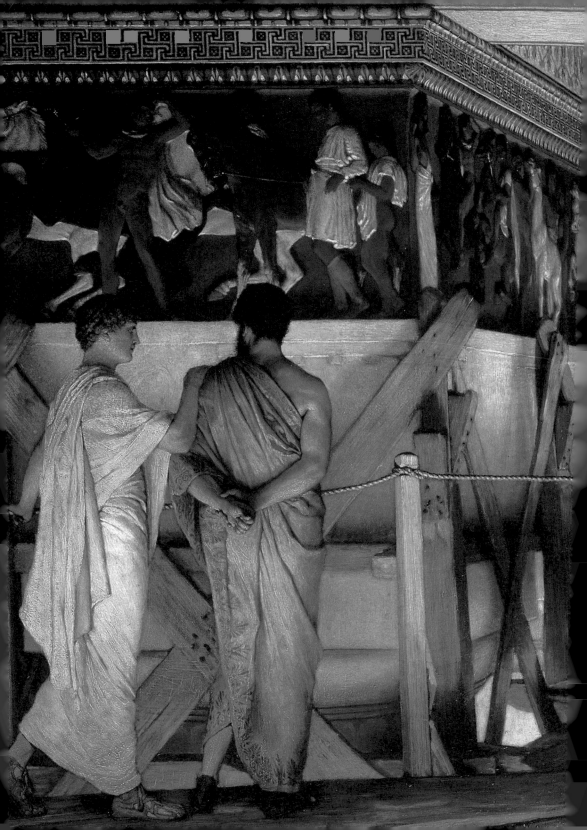

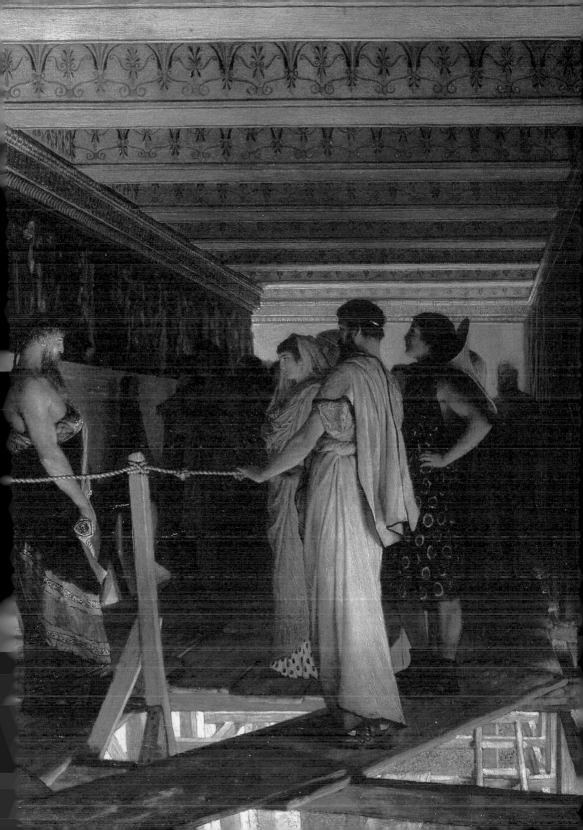

appearing in 1719). But there was understandable confusion about the provenance of ancient vases, since Italy – not Greece – was yielding most of them, to begin with, predominantly from the cemeteries attached to the Greek colonies in Campania and elsewhere. Sir William Hamilton, the British envoy in Naples at the end of the eighteenth century, gathered a large sample of vases from this source (249). A further and even richer source was Etruria. During the sixth, fifth and fourth centuries BC, the Etruscans had imported many thousands of vases from Greece: not only from Athens, but from Corinth and Sparta too. Some Greek painted vases were expressly designed for Etruscan customers; others were apparently produced for symposia at home, used once, then taken off by westward-bound merchants to be sold secondhand in Etruria. The Etruscans had new uses for them, the primary one being tomb

249
C H Kniep,
Excavation of a
Tomb near
Naples, 1790.
Engraving.
Frontispiece to
Sir William
Hamilton's
Collection of
Engravings
from Ancient
Vases of Greek
Workmanship,
1791–5

furniture. Sealed underground in one of the half million or so tombs that honeycomb Etruria, a Greek vase was, as the poet John Keats (1795–1821) put it, in his 'Ode on a Grecian Urn', like an 'unravish'd bride', the 'foster-child of Silence and slow Time'. Until, that is, the modern tenant-farmers of Etruscan territory found that their ploughs kept collapsing through the roofs of the tombs. One area, around the old Etruscan city of Vulci (in the northern part of what is today Lazio), proved particularly riddled with such tombs. The owner of the land in the 1820s (then, as it happens, Lucien Bonaparte, the brother of Napoleon) realized that a crop of Greek vases was more valuable than wheat and set up excavations. Trade with Grand Tourists was naturally brisk: unlike sculptures, vases were readily portable to one's stately home. But scholars were monitoring the rapid pace of discovery too. In 1829 a German, Eduard Gerhard, gathered like-minded individuals into an association committed to studying the vases emerging from Vulci and elsewhere, and this association was the basis of a scholarly centre located in Rome: the German Archaeological Institute, today still the senior and best-equipped place for the study of Classical art and archaeology.

The year 1830 was a momentous one for Greece: it marked the end of Turkish occupation and the birth of Greece as a modern nation-state. In 1837 the Greeks formed their own Archaeological Society. The rhetoric of national identity called stridently on images of the past, which represented at least a former ethnic if not political unity. Foreigners were still admitted to conduct excavations on Greek soil, but henceforth the fruits of excavation belonged to the new Greek nation. Huge foreign-funded projects – at Delphi, Olympia, Mycenae and Knossos, for instance, and more recently, the Athenian Agora – belong to this period when finds began to be kept in the country. The basis was thus constructed for the most valuable industry of modern Greece: tourism.

Whether the museums are in Greece or not, the fact remains that Greek art in museums is dislocated art: art a long way from its intended situation and reception. To claim that modern museums have assumed the hushed atmosphere of a temple hardly offsets this fact. A statue that was once the focus of a cult, for example, requires a very sympathetic effort of vivid imagination on the part of the modern viewer for its appreciation. Take the Demeter of Knidos in the British Museum (251). Unearthed from her Knidian sanctuary

250
G G
Kilburne,
*The Demeter
of Knidos as
once displayed
among the
sculptures
from the
Mausoleum of
Halicarnassos
in the British
Museum*,
c.1880.
Watercolour on
paper;
15·8×23·3 cm,
6¹⁄₄×9¹⁄₈ in.
British
Museum,
London

251
The Demeter
of Knidos,
c.340–330 BC.
Marble;
h.147 cm,
57⁷⁄₈ in.
British
Museum,
London

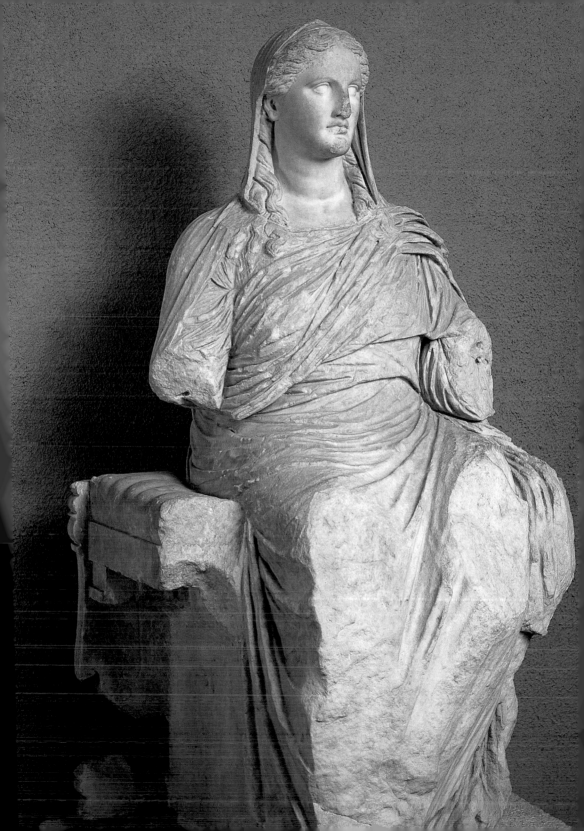

in 1858, when raids on Turkish sites could still be legally mounted, she has sat in the museum as an example of serene female beauty, of skilled marble workmanship, of deep-channelled Classical drapery (250). But successful idolatry requires more than that from the viewer. Demeter is to be approached as Demeter: the mother whose daughter was snatched to the underworld, the governess of corn and the fruits of the earth, the controller of seasonal change. In a world of scientific rationalism, rekindling not belief but simply a *sense* of ancient belief is made ever more difficult.

Yet there are those for whom Greek art symbolizes changeless states of mind. For Sigmund Freud (1856–1939), the very process of archaeological excavation was like his own practice of psychoanalysis, digging down to layers of truth not evident on the surface. His own collection of antiquities included pieces of Greek art which shaped his classification of what he took to be universal types of human psychology (see 233). For modern architects, too, the Classical orders represent a very solid and enduring means of making a statement. Whether reacting against them, or quoting from them, the effect is the same: Greek temple design is taken to represent order itself. In the twentieth century, both Fascists

253
The Dipylon Head,
c.600 BC.
Marble;
h.44 cm,
17⅜ in.
National Archaeological Museum, Athens

252
Henry Bacon,
The Lincoln Monument, Washington, DC, completed 1922

254
Sir John
Beazley,
former
Professor of
Classical
Art and
Archaeology
at Oxford,
at work *c.*1960.
Beazley
Archive,
Ashmolean
Museum,
Oxford

and Communists have drawn on this legacy; but since the Greeks invented democracy, it is not surprising that the most regular use of Greek architectural forms has been in those countries most proud of their democratic heritage (252).

Modernist art movements, oppressed by the size of the legacy of Greek art, have periodically rebelled against its status. As long ago as 1804 William Blake (1757–1827) asserted that 'we do not want either Greek or Roman models if we are but just and true to our imaginations', a sentiment more or less echoed by the Futurists, Dadaists and others of the twentieth century. But Greek art is not only resilient to swings of aesthetic mood or fashion: the range of styles encompassed by its development means that it anticipates certain features of Modernism as much as those of Neoclassicism. The sculptor Henry Moore (1898–1986), for example, deplored the holy status accorded by his teachers to late Classical masters such as Praxiteles; but the anonymous maker of an early sixth-century BC *kouros* (253) was, on the other hand, Moore's natural soulmate.

This account of Greek art has been written according to no strict theoretical method. A general guiding principle has been that we stand a better chance of comprehending Greek art if we inform ourselves about Greek history, literature and religion. But even that is not a necessary condition for *enjoying* Greek art. One final statement, of dogmatic nature, is however worth making. Progress in the study and understanding of Greek art has been irregular over the centuries, but all that has been written about Greek art which is worth reading has come from those who followed a basic precept: this is art which deserves to be looked at with patience (254). It was created to technical criteria we may repudiate, and in cultural circumstances we may never understand. It has been around for centuries. But it is still capable of yielding new illuminations.

&

Glossary

Technical terms have mostly been explained as they occur in the text. This list collects many of these terms and includes others commonly used in discussions of Greek art. For figures of Greek myth and religion the reader is referred to the brief biographies which follow, or to a handbook of mythology.

Adyton Small inner shrine sometimes added to the back of a temple **cella**.

Aetiological Tracing origins or roots.

Agora Market-place; central civic area of a Greek city.

Akropolis 'High citadel'; in most Greek cities, an elevated area reserved for temples.

Akroteria 'Flying figures' placed on pedestals on the top and corners of a **pediment**.

Alabastron (pl. alabastra) Small, usually pear-shaped flask used for perfumes and essences.

Amphora (pl. amphorae) Large lidded jar used for wine or oil storage.

Anthropomorphic Taking human shape.

Apotheosis Elevation to divine status.

Archaic Literally, 'old'; strictly the period c.650 BC to c.480 BC.

Architrave Beams above columns; lowest part of the **entablature** on a Greek building.

Aryballos (pl. aryballoi) Small, usually round perfume or oil flask.

Attic Relating to the city and territory of Athens; the region of Attica.

Bronze Age The period c.3000 to 1000 BC.

Caryatid Female figure supporting an **entablature**.

Cella The principal room of a Greek temple.

Chiton Woollen tunic or shirt, generally sleeveless.

Chorus Strictly, a dancing group; in the theatre, a choreographed band of commentators or 'involved spectators' who performed in the **orkhestra**.

Chous (pl. choes) Dumpy-shaped jug, often decorated with scenes of children (children were given their first taste of wine from such jugs).

Chthonic Pertaining to the underworld, especially underworld deities such as **Hades** or **Persephone**.

Classical Used in art-historical chronologies to define the period c.480 BC to c.350 BC, but otherwise means the entire Greek-Roman period (as in 'Classical Civilization').

Colossus Originally meaning a 'double' of a person or being; eventually denotes a statue of over life-size scale.

Dark Age The period c.1100 to 800 BC.

Dinos Large, round-bottomed bowl, requiring a separate stand.

Entablature Includes all parts of an architectural order above the columns.

Entasis Convex tapering of a column.

Eponymous Giving a name to something or somewhere.

Geometric The period c.900 to 750 BC.

Gymnasium Literally, place where one goes naked. As today, a place set aside for physical exercise and training.

Helladic Used of the **Bronze Age** period as it occurs on the Greek mainland.

Hellenistic Using Greek modes of style, expression or language; in art-historical chronology, conventionally covers the period of 323 BC to 31 BC.

Heroon Shrine for worship of a hero.

Hetaira (pl. hetarai) 'Female companion'; professional escort or hostess, with sexual favours also implied.

Hoplite Foot soldier, with full-face helmet and large circular shield, who fought in the interlocked unit known as the **phalanx**.

Hydria (pl. hydriai) Three-handled jar, used for carrying water.

Iron Age The period c.1000 to 1 BC.

Kalpis Water-carrying jar similar to a **hydria**.

Kantharos Drinking-cup with two high handles; often associated with **Dionysos** himself.

Kore (pl. korai) 'Young girl'; used of marble statues dedicated in the Archaic period, especially on the Athenian Akropolis.

Kottabos Game played at a **symposium**, involving flicking wine from a **kylix** at a target.

Kouros (pl. kouroi) Statue of a young man, used only for the **Archaic** period.

Krater Capacious bowl used for mixing wine with water. Large examples hold around 45 litres (10 gallons). Volute, calyx and bell shapes are subdivisions.

Kyathos (pl. kyathoi) One-handled drinking cup, especially popular in Etruria.

Kylix (pl. kylikes) Drinking-cup; wide and shallow in shape, with two side handles and a stemmed foot.

Lekythos (pl. lekythoi) Tall flask used for carrying oil.

Libation Liquid offering (wine, oil) made at an altar or tomb.

Maenad Female follower of **Dionysos**; sometimes also known as a Bacchant.

Magna Graecia 'Great Greece': the area of southern Italy colonized by the Greeks, often understood to include Sicily too.

Metope Rectangular panel inserted between **triglyphs** of Doric order.

Minoan Crete-based 'palatial' civilization named after legendary King **Minos**, c.1800–1500 BC.

Mycenaean Civilization overlapping with, then overtaking, **Minoan**, c.1600–1200 BC. Name taken from city of Mycenae in the Peloponnese.

Naos Understood in Greek to mean simply 'temple', but now used to mean inner sanctum of a temple, thus overlapping with **cella**.

Nike (pl. nikai) Winged victory personification, invariably female.

Oinochoe (pl. oinochoai) Wine jug with trefoil mouth.

Olpe (pl. olpai) Round-lipped jug.

Oracle Message or instructions understood to come from divine authority.

Orientalizing Showing Eastern influence; chronologically, the period of c.750 to c.650 BC.

Orkhestra Circular 'dancing-space' in the Greek theatre, below the stage.

Orthogonal Planning based on right angles.

Palaestra Area of a **gymnasium** complex set aside specifically for wrestling.

Panhellenic Open to, or involving, the Greek-speaking world.

Paradigm Ideal example.

Pediment Triangular-shaped frontage of a building. Often, but not necessarily, filled with sculptured decoration.

Pelike Sagging-shaped **amphora**.

Peplos Long, sleeveless woollen robe.

Periptoral Building with exterior columns supporting roof.

Phalanx Close infantry formation whose cohesion depended on each soldier partially shielding his neighbour.

Phiale Flat **libation** bowl or saucer, without handles.

Philhellene 'Lover of Greece'.

Pithos (pl. pithoi) Very large storage vessel.

Polychromy Use of many colours in decorating architecture and sculptures.

Propylon (pl. propylaea) Gateway.

Protogeometric The period c.1050 to 900 BC.

Protome The upper part of anything; usually of a human or animal figure, and often attached to a bowl or suchlike.

Psykter Vase filled with ice and placed inside a **krater** for cooling wine.

Pyxis (pl. pyxides) Cosmetics or jewellery holder.

Quadriga Four-horse chariot group.

Rhyton (pl. rhyta) Drinking-horn.

Satyr Mythical male follower of **Dionysos**; composite of man and horse.

Sema (pl. semata) 'Sign' or 'marker'.

Skyphos (pl. skyphoi) Drinking cup with small side handles.

Stamnos (pl. stamnoi) Wide-mouthed, short-necked vessel for wine.

Stele (pl. stelai) Upright stone slab, often a gravestone, or used to carry inscriptions.

Stereobate Base or substructure of a building.

Stirrup jar Mycenaean vase shape, typically with two small handles and a projecting spout.

Strigil Curved scraping implement used by Greek athletes after exercise for cleansing, toning and depilating the skin.

Stylobate Base of columns.

Symposium (pl. symposia) Drinking party, with music, poetry and formalized rules (*eg* mixing wine with water in a **krater**, drinking from **kylikes**, playing games such as **kottabos**). All-male, save for presence of courtesans (**hetairai**).

Thiasos The 'train' or entourage of Dionysos, including **satyrs** and **maenads**.

Tholos Round-shaped building or tomb.

Triglyph Panel with three vertical grooves or bars, alternating in Doric order with **metopes**.

Tripod Tall, three-footed bowl or cauldron, usually bronze, awarded as a prize in athletic competitions, or used for conducting sacrifices.

Tumulus (pl. tumuli) Burial mound, usually with raised earth.

Xoanon (pl. xoana) Old-fashioned wooden statue, usually a cult statue. Examples survived in Greek sanctuaries up to at least the second or third centuries AD, but not beyond.

Brief Biographies of Mythical and Divine Figures

Achilles The outstanding warrior of Greek legend, whose temperamental behaviour during the Greek siege of Troy is the principal theme of **Homer**'s *Iliad*. Artists liked to show his close relationship with **Patroklos**, his duel with **Hektor**, his ambush of the Trojan prince **Troilos**, and various non-Trojan episodes, such as his upbringing by the **Centaurs**, and combats with **Amazons**.

Adonis An eternally beautiful youth whose cult was associated with that of **Aphrodite**.

Adrastos King of Argos, who led the **Seven Against Thebes**.

Aegisthos Lover of **Clytemnestra**, and murderer of **Agamemnon**; he himself was killed by **Orestes**.

Aeneas Divine-born (by **Aphrodite**) Trojan, who left Troy when the Greeks invaded. The legend of his journey westwards became the heroic theme of the foundation of Rome, as elaborated in Virgil's *Aeneid*.

Agamemnon Son of **Atreus**, and ruler of Mycenae or Argos. In **Homer**'s *Iliad*, the overall commander of Greek forces. He was murdered on his return from Troy, along with Cassandra, abducted daughter of **Priam**. His son **Orestes** avenged his murder; but Agamemnon's daughter **Iphigeneia** paid for her father's arrogance with her life.

Ajax Second only to **Achilles** in the Greek contingent at Troy, the stalwart Ajax (or Aias) was the local hero of the island of Salamis. His maniacal behaviour after failing to inherit the Arms of Achilles (a tragedy sensitively explored in the *Ajax* by **Sophocles**) did not prevent his heroization, and status as one of the Eponymous Heroes of Athens.

Amazons Tribe of female warriors, vaguely located in the East, who appear frequently in Greek art and mythology. The Greek fascination with them has been plausibly related to a collective Greek male fear of a world with women on top. Amazons mythically denied the 'traditional' feminine roles of child-rearing and keeping house. In battle they fought (like the historical Persians) on horseback, with bows. Various Greek heroes tangled with them, some amorously (including **Achilles**, **Herakles** and **Theseus**), and Greek artists were

obsessed with them from the early sixth century BC onwards.

Amphiaraus Key (but reluctant) member of the expedition known as the **Seven Against Thebes**.

Andromeda Girl of Ethiopian origins exposed on a rock by her father as a protective device against a sea monster; saved by **Perseus**, who slew the monster and married her.

Aphrodite Goddess of love, sex, beauty and fertility in the Greek world and beyond (she relates to and perhaps derives from the Eastern Astarte), whose cult centred at her supposed birthplace (Cyprus), but pervaded maritime places throughout the Aegean, such as Knidos, where a statue of her by **Praxiteles** earned notoriety for showing (perhaps for the first time) the goddess nude.

Apollo 'The far-shooter' – patron of music, poetry, shepherds and much else, Apollo was imagined as the paragon of manly excellence. His cult at Delphi centred round an oracle, where two mottoes ('Know thyself', and 'Nothing in excess') reminded visitors of an essentially civilizing concept of the god. Archaic statues of young men (kouroi) deliberately mimic or assimilate Apollo's appearance. Following an influential polarity established by Nietzsche, the controlled Apollo is often contrasted with the wayward, unleashing nature of **Dionysos**.

Ares The god of war.

Ariadne Daughter of King **Minos** of Crete, who assisted **Theseus** in his struggle with the Minotaur, but was subsequently abandoned by him on the island of Naxos, where **Dionysos** found her.

Artemis 'Mistress of Wild Things' (*potnia theron*), Artemis was the sister of **Apollo**. Patroness of hunting, promoter of fertility, assistant at female puberty, her cult was often bloody, yet in certain places (such as Ephesus) deeply rooted.

Asklepios Hero-god of healing and medicine. His cult flourished and expanded in the fourth century BC.

Athena Patron goddess of Athens, though she had foreign connections, and was worshipped throughout Greece. Of warlike aspect, yet she doubled as a protectress of women's work and crafts generally.

The story of her birth from the head of **Zeus** was popular with artists; so too her close relationship with **Herakles**.

Atlas One of the **Titans**, who held up the heavens. 'Atlantes' may describe gigantic figures serving as columns in a temple.

Atreus Son of **Pelops**, Atreus inherited a curse which haunted him and his own descendants at Mycenae, including **Agamemnon** and others.

Castor and Pollux The twins known as the **Dioskouroi**.

Centaurs The tribe of half-human, half-equine beasts so frequently featured in Greek art. Usually disruptive and barbaric, and rarely identified as individuals (an exception is Nessos, with whom **Herakles** fought), the only respectable Centaur was Chiron, who educated the young **Achilles**.

Clytemnestra Wife and murderer of **Agamemnon**.

Cyclops (pl. Cyclopes) The tribal name of Polyphemus, the one-eyed giant, whose legend (see Chapter 2) became locally associated with Sicily.

Daidalos Archetypal inventor, artist and technician of Greek mythology, he was said to have created the first 'living' statues.

Demeter Goddess of agricultural fertility, especially grain, and 'bringer of treasures', Demeter is invariably maternal in her image. The most powerful story connected with her cult (especially at Eleusis) was that of her daughter **Persephone**, whose redemption from the Underworld was invested with the symbolism of rebirth and renewal.

Dionysos (Also known as Bacchus). God of wine cultivation and the vintage, bearded and yet effeminate in appearance, Dionysos had a large following in various sections of Greek society. Mythically, the **satyrs** and **maenads** were his sensual enthusiasts, but his cult had its serious side too. Dionysos, himself reborn after mutilation at the hands of the **Titans**, promised immortality: hence his frequent figuration on funerary monuments. A good index of his power is given in **Euripides**' *Bacchae*.

Dioskouroi Twin sons of **Zeus**, **Castor** and **Pollux** (or Polydeukes), usually envisaged as young horsemen, and even in antiquity associated with the stars.

Elektra Daughter of **Agamemnon** and **Clytemnestra**. Her loyalties are usually located with her brother **Orestes**.

Eponymous Heroes The ten heroic-divine 'founding fathers' of the Athenian voting-areas as devised by **Kleisthenes** at the end of the sixth century BC. A statue group of them formed a central meeting-place in the Athenian Agora; they may be represented on the east frieze of the Parthenon.

Erechtheus Mythical early king of Athens, a son of Mother Earth (Ge), but adopted by **Athena**. The story of the sacrifice of his daughters may be figured on the Parthenon frieze.

Erichthonius 'Earth-born' early Athenian, often confused with and perhaps once identical with **Erechtheus**. Erichthonius was born when **Hephaistos** attempted to rape **Athena**: she wiped his semen from her thigh with a rag, and when she threw the rag to the ground, Erichthonios appeared.

Ganymede The 'cup-bearer' of **Zeus**: a lissom shepherd boy seized by the god in the shape of an eagle. The erotic element of the story is adequately suggested by the fact that the word 'catamite' comes from the Latin transliteration of 'Ganymede'.

Giants Primal race of monsters who challenged divine order. Among named Giants are Porphyrion, **Pallas** and Ephialtes. Their battle with the Olympian deities (who were aided by **Herakles**) is known as the 'Gigantomachy', and was a favourite theme of Greek artists from the sixth century onwards. Hence **Athena** gained the name 'Pallas' by her individual defeat of the Giant Pallas. The most spectacular representation of the Giants was on the altar of Zeus at Pergamum, where they are shown with reptilian lower bodies. Not to be confused with the **Titans**.

Gorgon The principal Gorgon was Medusa, whose face was so terrible that it turned onlookers to stone. But she had two sisters too, Sthenno ('the strong') and Euryale ('fast-moving'), who chased **Perseus** after he slew Medusa. The detached head of the Gorgon was widely used as a symbol in decorating temples and elsewhere; as such, it may be known as a 'Gorgoneion'.

Hades Both the presiding deity of the Greek Underworld, and the name of the Underworld itself.

Hecuba Wife of **Priam**.

Hekate Nether-world goddess, associated with spirits, and often worshipped at crossroads.

Hektor Eldest son of **Priam**.

Helen 'The face that launched a thousand ships': beautiful offspring of **Zeus** and **Leda**, she was the wife of **Menelaus** when abducted by **Paris**, and thus the cause of the Trojan War.

Helios The sun god.

Hellen Supposed ultimate ancestor of the 'Hellenes', *ie* Greeks.

Hephaistos The god of fire, volcanoes (after his Latin name, Vulcan), and metalworking.

Hera Wife of **Zeus**; much mythology is generated by her jealousy or anger at her husband's frequent acts of marital disloyalty. She is often depicted as a goddess protective of children, or of women in childbirth.

Herakles The most ubiquitous of Greek heroes, Herakles was a bastard son of **Zeus**, and began his life with mortal status. Later, with the support of **Athena**, he was received on Olympos as one of the divines. The cycle of his heroic deeds ('Labours') is too long and complex to rehearse here, but the choice of twelve such deeds to decorate the temple of Zeus at Olympia ensured their canonical status. His appearances in art, from infancy to old age, are extremely numerous; and as a powerful man ultimately deified, he was an obvious alter-ego for political autocrats including perhaps the Athenian tyrant **Peisistratos**, and certainly **Alexander the Great**, not to mention several Roman emperors.

Hermes The messenger god, Latinized as 'Mercury', he is usually shown carrying a distinctive staff or wand (the *kerykeion*, or *caduceus*), with winged feet. As escort of souls (*Psychopompos*) he had connections with the Underworld. The bearded heads mounted on columns known as 'Herms' were originally intended as representations of the god (and often marked places of thoroughfare).

Hesperides Girls who guarded a tree of golden apples donated by Earth (Ge) to **Hera**. Their garden was located beyond the mountains of Atlas in the western Mediterranean.

Hypnos The god of sleep, twin brother of death (Thanatos).

Ikaros Son of **Daidalos**. He plunged to his death while escaping Crete with his father, who had equipped him with wings. Ikaros flew too high and the sun melted the wax which held his wings.

Ion Founder of the Ionian branch of Greek ethnicity. His parentage varies in the mythology: according to **Euripides'** *Ion*, it was **Apollo**.

Iphigeneia Daughter of **Agamemnon**, condemned to be sacrificed by him; versions of her story say that she was saved by **Artemis**, who substituted a deer or a bear (as at Brauron, in Attica).

Iris Goddess of the rainbow.

Jason Leader of an early band of heroes known as the Argonauts, after their adventures on a ship called the *Argo*. The story

of his love for **Medea** is the central theme of a third century BC poem by Apollonius Rhodius, the *Argonautica*.

Laocoön Aristocratic priest of Troy, who protested at the acceptance of the Wooden Horse as a 'gift' from the besieging Greeks. Two serpents were despatched by either **Apollo** or **Athena** to attack him and his sons for this protest (or, as it seems, insight).

Leto Mother of **Apollo** and **Artemis**; a female member of the **Titans**. The birth of Apollo was claimed as having happened on the island of Delos.

Marsyas An impudent satyr who challenged **Apollo** to a contest of pipe-playing. The loser (inevitably Marsyas) paid the price of being flayed alive. This was a subject made popular in art by (among others) **Myron**.

Medea Lover of **Jason**, she appears in various stories, usually attributed with magical powers, and a murderous temper.

Menelaus The younger brother of **Agamemnon**. The abduction of his wife **Helen** by **Paris** of Troy was the cause of the Trojan War. His presumed palace at Sparta was the focus of a hero-cult from the eighth century BC onwards.

Minos Legendary king of Crete, who kept the hybrid bull-man, known as the Minotaur, in a labyrinth constructed by **Daidalos**. **Theseus** dispatched the beast, to which Minos had been sacrificing Athenian youths. No historical Minos is implied by creating the term 'Minoan' to define the prehistoric Cretan palace culture, though elements of his mythology seem to reflect certain features of the archaeology of Knossos.

Neoptolemos Son of **Achilles**. He sacrificed Polyxena at his father's grave, and when Troy fell, he acted with conspicuous savagery, killing both **Priam** the king and his little grandson Astyanax.

Nereus 'Old man of the sea', father of marine nymphs known as Nereids.

Nestor Aged warrior at Troy. **Homer** places his home at Pylos, which has encouraged archaeologists to speak of a **Mycenaean** site at Pylos as 'the palace of Nestor'.

Nike Goddess or personification of Victory, usually shown as winged.

Niobe Daughter of **Tantalos**, she boasted that her twelve children were equal to or better than **Apollo** and **Artemis**. Accordingly, Apollo and Artemis showered the children with a rain of arrows. Niobe herself died too, or was turned into stone. The piteous subject featured on a number of Greek vases, and on at least one temple pediment.

Odysseus (in Latin, Ulixes or 'Ulysses')
The hero whose adventures are described chiefly in **Homer**'s *Odyssey*, though he appears prominently in the *Iliad* too. A quick and inventive intelligence is his hallmark; in art, from the fifth century BC onwards, he may often be shown wearing a conical cap.

Oedipus Abandoned in infancy by his father King Laius of Thebes, Oedipus eventually fulfills a prophecy which declared that he would kill his father and marry his mother. Incidentally, he rids Thebes of the Sphinx which is plaguing the city – by defeating her in a contest of riddles. But after he has unwittingly married his widowed mother, the truth of their family relationship emerges, and he blinds himself before going into impoverished exile.

Orestes Son of **Agamemnon** and **Clytemnestra**. The story of how he achieved revenge for his father's murder varies, bringing him either credit or terrible guilt.

Orion Giant hunter, identified with a group of stars in the earliest mythology.

Orpheus Master-poet, capable of even taming tigers with his songs, he gives his name to a shadowy religious system known as 'Orphism', whose devotees believed in an eventual redemption from the horrors of the Underworld.

Pallas Name of a giant killed by **Athena**.

Pan Rustic deity or spirit usually associated with the region of Arcadia; cloven-hoofed and horned and generally shaggy in appearance. He can cause 'panic' when malevolent, but is a natural inhabitant of the pastoral world of flocks, caves and piping.

Paris One of the sons of **Priam** of Troy. His abduction of **Helen** caused the Trojan War, in which he plays little part; however, it is his arrow which ultimately slays **Achilles**. 'The Judgement of Paris' refers to an episode when **Hermes** paraded before him the three goddesses **Hera**, **Athena** and **Aphrodite** – and he nominates Aphrodite as the most beautiful.

Patroklos In the *Iliad*, the best friend of **Achilles**. Vase-painters may show the pair as a pederastic couple. The death of Patroklos is what spurs Achilles into furious battle, which will culminate in the death of **Hektor**.

Pegasos Winged horse, born from the decapitated Medusa, particularly associated in mythology with the city of Corinth.

Pelops Son of **Tantalos**, who gave him an unfortunate start in life by serving him as a dish for the gods. The gods brought Pelops to life again, though one part (his shoulder) was found to be missing. It was replaced with a piece of ivory. Pelops then went to Olympia, where he gained a wife at the cost of a curse on his descendants, effectively the 'house of **Atreus**'.

Penelope Wife of **Odysseus**; a model of wifely patience and dutifulness, since during the absence of her husband she repels suitors by diligently attending to her loom.

Penthesilea A queen of the **Amazons**. She was killed in battle by **Achilles**, though he fell in love with her at the moment of her death.

Persephone Daughter of **Demeter** (she is also known as 'maiden', or *Kore*), she was abducted by the god of the Underworld, **Hades**. Demeter protested by causing a crop failure, and negotiated an agreement whereby her daughter would return for half a year, every year. (The story is rationalized as the onset of spring, and germination of plants).

Perseus Slayer of the **Gorgon** Medusa, he also rescued **Andromeda** from a sea monster. He gave the Gorgon's head to **Athena**; the winged shoes he had used were passed on to **Hermes**.

Pirithoos Lapith prince; a close friend of **Theseus**.

Poseidon God of water generally, and sea in particular, he was also deemed responsible for earthquakes. The trident is his usual attribute. In the mythical prehistory of Athens, he contested with **Athena** for possession of Attica – as shown on the west pediment of the Parthenon.

Priam Elderly king of Troy at the time of its siege as decribed by **Homer**.

Prometheus Progenitor of fire, and sacrifice to the gods. He tricked **Zeus** into accepting the fat and offal from animal sacrifice (keeping the best meat for himself). Zeus punished him in various ways: by chaining him to a rock, and have an eagle peck at his liver, which replenished itself as fast as it was pecked; or by creating the first woman, Pandora, who opened a box which contained all the evils that might beset the world.

Pygmalion Cypriot king who created a statue of his ideal woman, and became infatuated with desire for it. **Aphrodite** made the statue come alive for him.

Seven Against Thebes After **Oedipus** left Thebes to his sons Eteocles and Polyneikes, they quarrelled. Eteocles refused to share the rule of the city,

provoking Polyneikes to gather six fellow warriors for an assault on Thebes. It ended in disaster – apart from **Adrastos**, all the Seven perished.

Sisyphus One of the damned in the Greek Underworld, whose eternal punishment is to push a boulder up a hill, only for it to roll back down again.

Sphinx Monster with human head (usually female in Greek art) and lion's body, of Egyptian origin; connected with transporting souls, hence often found in funerary imagery. Generally an effective marker of fear, reverence and foreboding, but also attributed with enigmatic wisdom.

Tantalos King of city of Sipylus and area of Lydia in Asia Minor, whose crime was to give mortals a taste of divine food. His punishment in the Underworld was to be continually offered food and drink which he could not quite reach.

Telemachos Son of **Odysseus**.

Thanatos Spirit or personification of Death. **Hypnos** (Sleep) is his twin brother.

Theseus The special hero of Athens, accredited with many adventures, and the unification or *synoikismos* of Attica as a region. His iconographic popularity increases in the early fifth century, as he was moulded into a hero of the Athenian democracy, and his alleged bones recovered by **Kimon**. The special shrine (Theseion) erected in his honour at Athens has yet to be located.

Titans Primordial gods or forces of nature, the wayward offspring of Heaven and Earth.

Triton Male equivalent of a mermaid.

Troilos A son of **Priam**. He was ambushed by **Achilles** as he watered his horses at a fountain, a theme popular with archaic artists.

Zeus In **Homer**'s formula, 'father of gods and men', and 'cloud-gatherer': the supreme Olympian, guardian of law and justice. In art he is usually bearded and often half-clad. His most celebrated image was at Olympia, the colossal throned figure made in the 430s BC by **Pheidias**.

Brief Biographies of Artists and Other Historical Figures

Achaemenids Greek version of the dynastic name of the Persian royals, from the seventh to fourth centuries BC.

Aeschylus Athenian playwright whose life (525–456 BC) witnessed key events in the city: the fall of the tyrants, the rise of democracy and the Persian wars (Aeschylus himself is documented as having fought at both Marathon and Salamis, and his play, the *Persae*, includes what seem like eye-witness accounts of battle).

Agatharcus Fifth-century BC painter from Samos, said to have designed the first theatrical 'set', for a production of a play by **Aeschylus** (though not necessarily during the playwright's own lifetime).

Alkibiades Colourful protagonist of Athenian history in the last few decades of the fifth century BC; associate of **Sokrates**.

Alexander the Great The name universally given to Alexander III of Macedon (356–323 BC), son of **Philip II**. See Chapter 7.

Alkamenes Sculptor said to have been a pupil of **Pheidias**. Allegedly active in the second half of the fifth century BC, mostly at Athens.

Alkmaionidai Powerful Athenian family, exiled by **Peisistratos**, and instrumental in the reforms which led to a democratic constitution at Athens. **Kleisthenes** was the Alkmaionid who set up the Athenian voting districts in 508/7 BC. A later member of the family was **Perikles**.

Andokides Painter Vase-painter of the late sixth century BC, believed to be a successor to **Exekias**. Vases attributed to him show 'bilingualism', *ie* both black-figure and red-figure techniques of decoration.

Apelles Fourth-century BC painter connected with court of **Alexander**, though his commissions are attested throughout the Aegean world. An ancient description of his personification of Calumny, Envy, Truth and others was influential in the Renaissance.

Aristophanes Comic playwright (*c*.450–385 BC). Acute in political satire, lyrical and bawdy, Aristophanes is (and was) the acknowledged master of 'Old Comedy' at Athens.

Aristotle Philosopher, literary critic and natural scientist, Aristotle (384–322 BC) was at first the pupil of **Plato**, then set up his own school (ultimately known as the Lyceum). His *Poetics* is not the most substantial of his works, but required reading for all those interested in Greek literature and art.

Asteas Leading painter of vases at Paestum (Poseidonia) in the fourth century BC.

Attalids Dynastic name of the rulers of Pergamum, beginning with Attalus I as the first official 'king' in 241 BC.

Berlin Painter Name given to an early fifth-century BC Athenian red-figure vase-painter, whose style is highly precise and spare in its decorative content.

Demosthenes Athenian orator (384–322 BC), who performed with distinction in both politics and the law-courts. His tirades against **Philip** of Macedon became epitomes of personal invective (hence 'Philippics').

Dipylon Master Name given to leading vase-painter in eighth-century BC Athens working on large pots in the Geometric style.

Euphronios Athenian red-figure vase-painter of the late sixth century BC; one of the 'Pioneers' who developed the naturalistic potential of red-figure brush-work (others are Euthymides, Phintias and Smikros).

Euripides Playwright (*c*.485–406 BC). Judged to be the most 'modern' of the classic Athenian tragedians, because of his capacity for psychologically sensitive characterization.

Exekias The Athenian black-figure vase painter, of whom it has been said (by J D Beazley) 'You cannot draw better, you can only draw differently.' Undoubtedly one of the most thoughtful artists in the vase-painting medium, he probably worked from around 550 to 530 BC. His best-known scene is one of **Ajax** and **Achilles** playing dice, on an amphora now in the Vatican.

Herodotus Historian, born perhaps at the end of the sixth century BC, and died *c*.425 BC. His *Histories* contain relatively little by way of comment on art, but remain a highly engaging account of the travels and interests of a good-natured and open-minded individual.

Hesiod Late seventh-century BC poet from Boeotia, whose works contain the earliest evidence for Greek cosmic mythology.

Hipparchus Younger son of **Peisistratos**; assassinated in 514 BC by the so-called **Tyrannicides**.

Hippias Elder son of **Peisistratos**. After banishment from Athens in 510 BC, he sought exile with the Persians and was with the Persians at the battle of Marathon in 490 BC.

Hippodamos Born c.500 BC, his works in town-planning are attested as late as 408 BC. Accredited with the application, if not the invention, of '**orthogonal**' street-gridding.

Hippokrates The father of clinical medicine, active throughout the second half of the fifth century BC.

Homer Despite his senior status in Greek literature, little is known about the supposed author of the two great Greek epics, the *Iliad* and the *Odyssey*. If any historical 'Homer' existed, he must have done so in the eighth century BC. His works conjure up a heroic age vaguely located in what we would call the **Mycenaean** past; but they were not written down until the sixth century BC. (This is also the date of the so-called 'Homeric Hymns'). An imaginary portrait type of the bard reflects the tradition that he was blind.

Iktinos Architect accredited, with **Kallikrates**, with the design of the Parthenon at Athens; also said to be the architect of the temple of Apollo at Bassae.

Isokrates Athenian orator of the fourth century BC. He played a prominent part in the definition of a nationalistic and self-consciously 'Greek' culture.

Kallikrates Fifth-century BC Athenian architect.

Kimon Athenian politician and general. Son of **Miltiades**, he directed campaigns against the Persians 476–463 BC. In the course of these campaigns, he brought back to Athens the alleged bones of **Theseus** from the island of Skyros. There is also a theory that Kimon commenced an earlier version of the Parthenon, which was then upstaged by his political rival **Perikles**.

Kleisthenes The presumed 'founder' of democracy at Athens, due to a series of political reforms enacted during his magistracy of the city in 508–7 BC.

Leochares Fourth-century BC sculptor, accredited with portraits of **Philip II** of Macedon and family at Olympia, and perhaps also responsible for parts of the Mausoleum, and the cult statue of **Demeter** at Knidos.

Lysippos 'Court sculptor' of **Alexander the Great**, and generally a prolific artist of the late fourth century BC. His works included colossal statues, portraits (*eg* of **Sokrates**), and imposing equestrian groups, of which the bronze horses now at San Marco in Venice may be some survivors.

Makron Early fifth-century BC Athenian red-figure vase-painter.

Mausolus Governor of the region of Caria (*c.*377–353 BC). His colossal tomb, the Mausoleum, was perhaps planned by him, but certainly brought into being by his wife Artemisia.

Menander Leading exponent of 'New Comedy' writing in Athens from 321 BC to *c.*290 BC. New Comedy is characterized by its 'kitchen-sink' realism and interest in character; it is less political and less fantastic than the 'Old Comedy' as written by **Aristophanes**.

Mikon Fifth-century BC artist at Athens, accredited chiefly with murals in the Theseion and the Painted Stoa.

Miltiades Athenian statesman and general (*c.*550–489 BC). Though his political career was chequered, his role as a general at the battle of Marathon in 490 BC earned him eventual heroization.

Mnesikles Fifth-century architect responsible for the monumental gateways (Propylaea) on the Athenian Akropolis.

Myron Bronze sculptor, active in the first half of the fifth century BC, renowned in antiquity for his skills of naturalistic representation, and ability to catch movement in solid form (for example, the figure of a sprinter). Knowledge of his work comes solely from anecdotes about it, and Roman copies of statues such as the 'Diskobolos' (Discus-thrower).

Nikias Athenian statesman and general active in the second half of the fifth century BC. He reluctantly took charge of the ambitious Athenian expedition to invade Syracuse in 415–413 BC, and is blamed for its ultimate failure.

Paionios Sculptor attested at Olympia in the late fifth century BC as responsible for a particularly exhilarating Winged Victory figure.

Panainos Fifth-century BC painter accredited with parts of the Painted Stoa and assisting **Pheidias** (his brother, or uncle) with the Olympic Zeus.

Pan Painter Name given to an Athenian red-figure vase-painter who worked in the early to mid-fifth century BC and created a singularly 'Mannerist' style.

Parrhasios Celebrated painter of the fourth century BC, though none of his work survives.

Pasiteles Apparently one of the busiest and most diligent of Greek sculptors working in Rome during the first century BC, he is also said to have compiled a five-volume compendium of the 'World's Great Masterpieces'.

Pausanias Greek traveller, whose 'Description of Greece', a proto-touristic guide, was compiled around 150 AD.

Peisistratos Tyrant of Athens from 561 to his death in 527 BC. His civic works are reflected in the images of contemporary vase-painting (for instance, his building of public fountains), and he funded a number of decorated temples on the Akropolis. It is cogently argued that he saw himself as a second **Herakles** – which would account for the prevalence of Heraklean images in sixth-century BC Athenian art.

Perikles The outstanding Athenian politician of the fifth century BC, to whom the monumental development of the Akropolis is owed. (When challenged over the cost of the Parthenon, he offered to pay for it himself). He is said to have been a close personal friend of **Pheidias**.

Pheidias Probably the most gifted and industrious artist of the the fifth century BC, he was born in Athens around 490 BC and may have died in Olympia shortly after 430 BC. His best works, the chryselephantine statues of **Athena** in the Parthenon and of **Zeus** at Olympia, have perished, but his claim to be regarded as the master-designer of the surviving Parthenon sculptures is strong.

Philip II King of Macedon (359–356 BC), and father of **Alexander the Great**. He laid down the effective strategy and foundation of the Macedonian empire. His tomb has been discovered in the Macedonian royal cemetery at Vergina.

Pindar Poet (518–438 BC) who specialized in celebratory odes for victorious sportsmen.

Plato Pupil of **Sokrates** at the end of the fifth century BC; master of his own school at Athens, the Academy, till his death in 347 BC. His range of philosophic interests was dominated by the quest for moral knowledge, but nevertheless astonishingly broad. It is no exaggeration to say (in the words of A N Whitehead) that all Western philosophy is 'a series of footnotes to Plato'.

Pliny (the Elder) Roman encyclopaedist, whose *Natural History* (completed in 77 AD) contains much scattered information about Greek art and artists.

Plutarch Greek-born writer active in the late first and early second century AD. His copious writings are characterized by immense readability and sympathy for human affairs; he is also a principal source for biographical information on, for example, **Perikles**.

Polygnotos Fifth-century BC painter, attested at Athens and Delphi.

Polykleitos Sculptor from Argos, active in the mid-fifth century BC. His work – all in bronze, apparently – was highly influential, perhaps because he enshrined its principles in a book, the *Canon*, which set out a predictable system of proportions for representing the human body.

Praxiteles Mid-fourth century BC sculptor. Of his works, the Aphrodite of Knidos was most notorious in antiquity; this and others are known by copies, but one original surviving work may be the marble figure of Hermes cradling the infant Dionysos at Olympia.

Protogenes Late fourth-century BC painter, anecdotally remembered as a fierce rival of **Apelles**.

Pythios Architect from Priene, who is said to have designed both the Mausoleum at Halicarnassos and the temple of Athena Polias at Priene, and thus pioneered an 'Ionic Renaissance' in Asia Minor.

Skopas Fourth-century BC sculptor from the island of Paros, whose distinctively tortured expressive style has been identified on remains of figures from the temple of Athena at Tegea. He is also attested as one of the sculptors working on the Mausoleum.

Sokrates Cult philosopher of Athens (469–399 BC). He was caricatured by **Aristophanes** for his persistently inquiring and critical method, yet revered by **Alkibiades**, **Plato** and others. Sokrates was tried and condemned on a charge of corrupting the young and religious subversion.

Sophists Literally 'wise men', but used in particular of professional intellectuals, such as Protagoras and Gorgias, who could make large sums of money peddling their philosophies or techniques of rhetoric.

Sophocles Athenian playwright (c.496–406 BC).

Stesichoros Sixth-century BC poet, apparently of great influence, though very little of his work remains. It is thought to have contained a strong narrative element, and hence influenced early attempts at storytelling in Greek art.

Themistokles Commander of the successful Athenian fleet at the battle of Salamis in 480 BC; later exiled to Asia Minor.

Theocritus Third-century BC pastoral poet.

Theophrastus Pupil and successor of **Aristotle**. Active at Athens from *c*.335 BC.

Thucydides Historian (*c*.460–400 BC). His surviving work documents, with high aims of impartiality and accuracy, the protracted Peloponnesian War between Athens and Sparta (431–404 BC).

Tyrannicides The name given to Athenians Harmodius and Aristogeiton, who in 514 BC assassinated **Hipparchus**, and were commemorated in a statue group first raised perhaps after 510 BC.

Xenophon Athenian-born statesman, cavalry commander and writer (*c*.428–354 BC).

Zeuxis Painter, active in the late fifth and early fourth century BC. His illusionist skills are attested in a story that when he painted grapes, birds tried to peck at them.

Key Dates

Numbers in square brackets refer to illustrations

Dates are mostly approximate

	Greek Art		A Context of Events
3000 BC	Cycladic figurines [9, 12]		
2000	Minoan palaces at Knossos [15–17, 20] and Phaistos; Linear A		
1600	Shaft graves at Mycenae [27–8, 31]		
		1500	Eruption of Theran volcano
1450	Minoan decline; Linear B at Knossos [10]		
1250	Lion Gate at Mycenae; 'Treasury of Atreus' [22–5]	**1250**	'Trojan War'?
		1200	Mycenaean collapse
		1100	Dorian incursions
		1000	Ionian migrations
950	Lefkandi 'heroon', Euboea [34]		
900	Protogeometric pottery [37]		
800	Geometric pottery [38–9, 42–8]	**800**	Phoenician-derived alphabet used in Greece
776	First Olympiad		
		750	Early colonies, *eg* Pithekoussai (Ischia); circulation of Homeric epics
725	Protocorinthian pottery [56–7]		
700	Protoattic pottery; early peripteral temples, *eg* on Samos		
650	'Daedalic' statues	**650**	Greeks in Egypt
625	Corinthian pottery		
600	Doric order established [63]; early Athenian black figure pottery [84–7, 91–2, 99–100]	**600**	Solon 'the lawgiver' at Athens
575	'François vase' [87]		
550	Limestone pediments on Akropolis; Ionic order established, *eg* temple of Artemis at Ephesus; Amasis Painter, Exekias	**550**	Peisistratos tyrant of Athens; tyrannies elsewhere in Greece
525	'Peplos kore' [95–6]; Siphnian treasury, Delphi; 'Piraeus Apollo' [112]; beginnings of red-figure pottery [106–8, 111, 128–9, 135, 138, 171–5, 195]		
510	Euthymides, Euphronios; 'Caeretan hydriai'	**510**	Expulsion of Peisistratids from Athens
500	Aegina pediments [102, 114]	**500**	Democracy at Athens
490	'Kritian boy' [117]; Kore of Euthydikos; Berlin Painter	**490**	Battle of Marathon
480	Destruction of Akropolis	**480**	Persian occupation of Greece; battles of Salamis, Plataea

	Greek Art	A Context of Events
470	'Tyrannicides' by Kritios and Nesiotes [103]	
460	Temple of Zeus, Olympia [1, 127, 130–4, 168–9]; Stoa Poikile, Athens	
450	Work begins on Parthenon	450 Peace with Persians; Herodotus; Perikles
440	Polykleitos; Pheidias: statue of Athena Parthenos [140, 149], then Olympic Zeus [8]	
430	Parthenon [147, 151–2] and Propylaea [148] completed	430 Peloponnesian war: defeat of Athens by Sparta
420	Temple of Apollo at Bassae [137, 141, 161–2]	
400	Erechtheum [164]	400 Trial of Sokrates
380	Temple of Asklepios, Epidauros [163]	
350	Aphrodite of Knidos (Praxiteles) [93]; Mausoleum at Halicarnassos [202, 205, 208–10]	350 Aristotle
330	Lysippos [197, 235], Apelles	330 Macedonian conquest of Greece, then Persia
		323 Death of Alexander
300	'Alexander Mosaic' [200–1]	300 Establishment of Hellenistic kingdoms
		250 Gauls in Asia Minor
230	Original version of 'Dying Gaul' at Pergamum [226]	
165	Great Altar of Zeus, Pergamum [227–9]	165 Rome defeats Macedon
		160 Travels of Pausanias
150	Stoa of Attalos, Athens [109]; original of Laocoön [231–2] at Pergamum?	150 Roman sack of Corinth
		31 Battle of Actium
393 AD	Last celebration of ancient Olympics	
529	Parthenon and Hephaisteion turned into Christian churches	529 Closure of Academy and other Athenian schools
		1435–48 Voyages of Cyriac of Ancona in Greece
		1456 Turks occupy Attica
1506	Excavation of Laocoön in Rome	
		1733 Foundation of Society of Dilettanti in London
1804–11	Transfer of Parthenon sculptures to Britain by Lord Elgin	
		1821–32 Greek War of Independence
1870–90	Excavations at Troy by Heinrich Schliemann	
1873	French explorations at Delphi begin	
1881	German excavations at Olympia begin	
1900	Sir Arthur Evans starts excavation of Knossos	

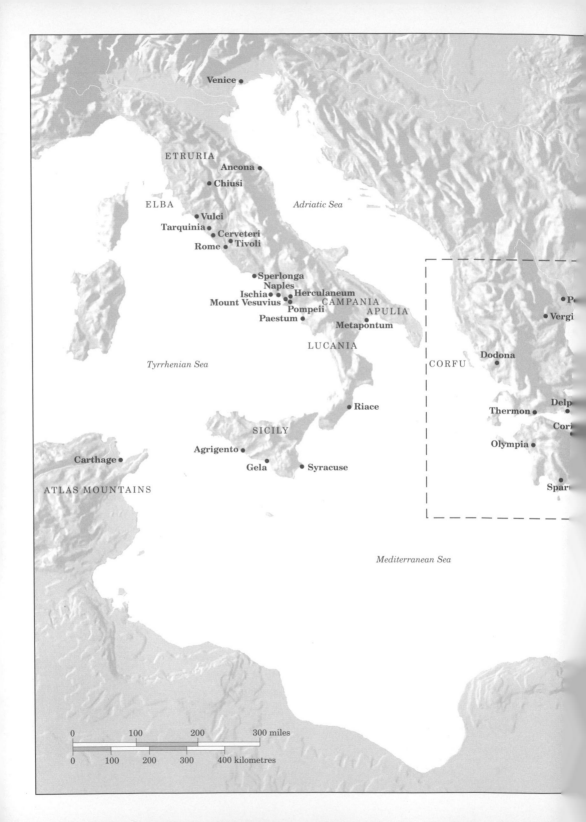

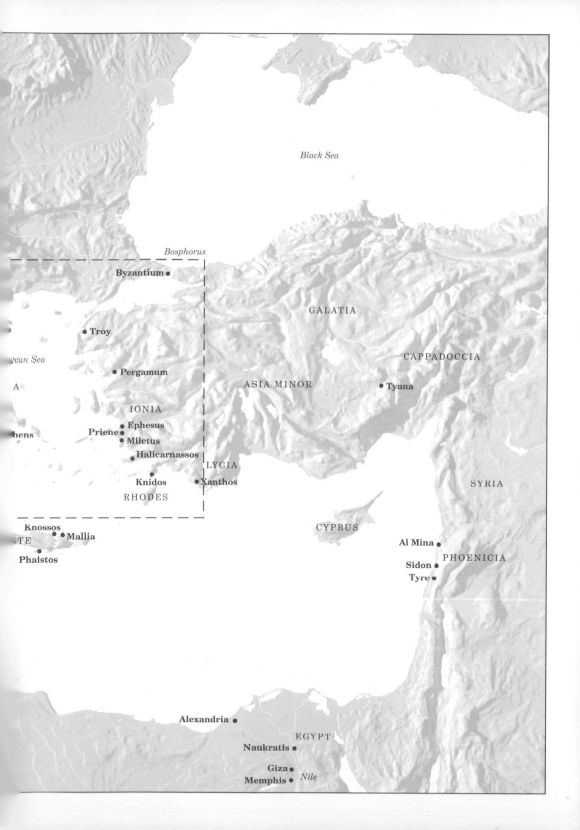

Black Sea

Bosphorus

Byzantium •

GALATIA

• **Troy**

CAPPADOCCIA

gean Sea

A

• **Pergamum**

ASIA MINOR

Tyana •

IONIA

Priene • **Ephesus**

hens • **Miletus**

• **Halicarnassos**

LYCIA

SYRIA

Knidos • • **Xanthos**

RHODES

CYPRUS

Knossos •

TE • **Mallia**

Al Mina •

• **Phaistos**

PHOENICIA

Sidon •

Tyre •

Alexandria •

EGYPT

Naukratis •

Giza •

Memphis • *Nile*

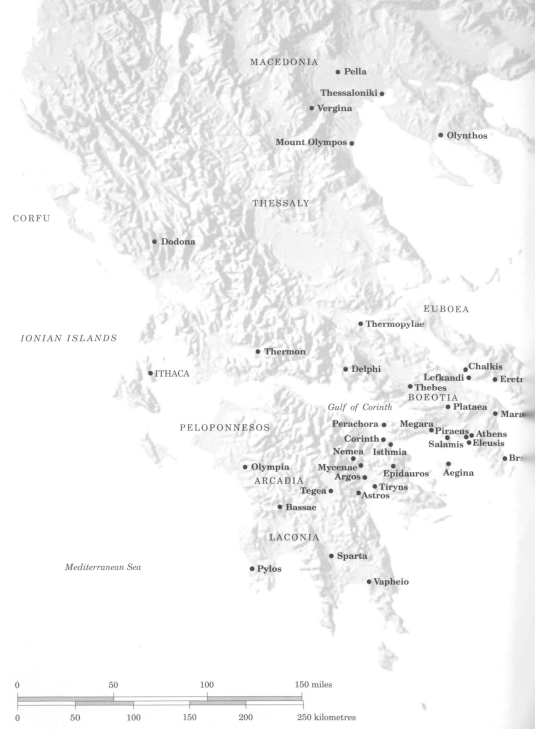

MACEDONIA

● Pella

Thessaloniki ●

● Vergina

Mount Olympos ●

● Olynthos

THESSALY

CORFU

● Dodona

EUBOEA

● Thermopylae

IONIAN ISLANDS

● Thermon

● Delphi

● Chalkis

Lefkandi ●

● Eretr

ITHACA

● Thebes

BOEOTIA

Gulf of Corinth

● Plataea

● Mara

PELOPONNESOS

Perachora ●

● Megara

● Piraeus

Corinth ●

Salamis ● Athens

Nemea ● Isthmia

● Eleusis

● Olympia

Mycenae ●

● Epidauros

Aegina

● Br

ARCADIA

Argos ●

● Aegina

Tegea ●

● Tiryns

● Astros

● Bassae

LACONIA

Mediterranean Sea

● Sparta

● Pylos

● Vapheio

0 50 100 150 miles

0 50 100 150 200 250 kilometres

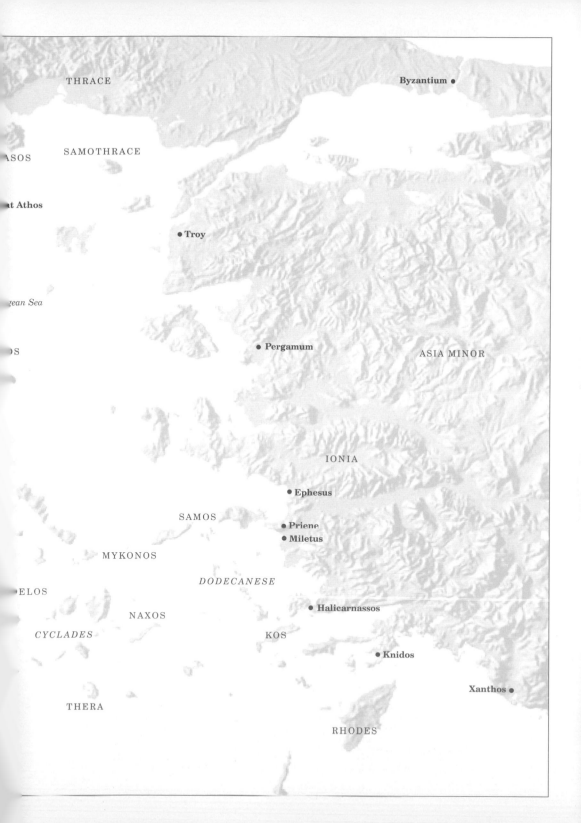

Further Reading

Historical, Social and Archaeological Background

M Bieber, *A History of the Greek and Roman Theatre* (Princeton, 1961)

A Burford, *Craftsmen in Greek and Roman Society* (London, 1972)

W Burkert, *Greek Religion* (Oxford and Cambridge, MA, 1985)

J M Camp, *The Athenian Agora: Excavations in the Heart of Classical Athens* (London, 1992)

P Cartledge, *The Greeks: A Portrait of Self and Others* (Oxford, 1993)

E R Dodds, *The Greeks and the Irrational* (Berkeley, 1951)

F Frontisi-Ducroix, *Dédale: mythologie de l'artisan en Grèce ancienne* (Paris, 1975)

E Kris and O Kurz, *Legend, Myth and Magic in the Image of the Artist* (New Haven and London, 1979)

D C Kurtz and J Boardman, *Greek Burial Customs* (London, 1971)

C Morgan, *Athletes and Oracles: Transformation of Olympia and Delphi in the Eighth Century BC* (Cambridge, 1990)

G Nagy, *The Best of the Achaeans: Concepts of the Hero in Archaic Greek Poetry* (Baltimore, 1979)

J Neils *et al.*, *Goddess and Polis*: *Panathenaic Festival in Ancient Athens* (Princeton, 1992)

F de Polignac, *Cults, Territory and the Origin of the Greek City State* (Chicago, 1995)

J J Pollitt, *The Art of Ancient Greece: Sources and Documents* (Cambridge, 1990)

W J Raschke (ed.), *The Archaeology of the Olympics: Olympics and Other Festivals in Antiquity* (Madison,WI, 1988)

G M A Richter, *A Handbook of Greek Art: A Survey of the Visual Arts of Ancient Greece* (Oxford, 1959, rev. edn, London, 1987)

C Sourvinou-Inwood, *Reading Greek Death: To the End of the Classical Period* (Oxford, 1995)

A F Stewart, *Art, Desire, and the Body in Ancient Greece* (Cambridge, 1997)

Surveys and Special Studies of Periods

1 Prehistoric, Minoan and Mycenaean

O Dickinson, *The Aegean Bronze Age* (Cambridge, 1994)

G E Mylonas, *Mycenae and the Mycenaeans* (Princeton, 1966)

C Renfrew, *The Cycladic Spirit: Masterpieces from the Nicholas P Goulandris Collection* (London, 1991)

P M Warren, *The Aegean Civilisations* (Oxford, 1989)

2 Dark Age, Geometric and Orientalizing

J N Coldstream, *Geometric Greece* (London and New York, 1977)

J M Hurwit, *The Art and Culture of Early Greece 1100–480 BC* (Ithaca, NY, 1985)

S P Morris, *Daidalos and the Origins of Greek Art* (Princeton, 1992)

B Schweitzer, *Greek Geometric Art* (London, 1971)

A M Snodgrass, *The Dark Age of Greece* (Edinburgh, 1971)

J Whitley, *Style and Society in Dark Age Greece: The Changing Face of Pre-Literate Society 1100–700 BC* (Cambridge, 1991)

3 Archaic

H Payne, *Archaic Marble Sculpture from the Acropolis* (London, 1948)

B S Ridgway, *The Archaic Style in Greek Sculpture* (Princeton, 1977, rev. edn, Chicago, 1993)

H A Shapiro, *Art and Cult in Athens under the Tyrants* (Mainz, 1989)

4 Classical

T Hölscher, *Griechische Historienbilder des 5. und 4. Jahrhunderts v. Chr.* (Würzburg, 1973)

G T W Hooker (ed.), *Parthenos and Parthenon* (Oxford, 1963)

I Jenkins, *The Parthenon Frieze* (London, 1994)

K F Johansen, *The Attic Grave Reliefs of the Classical Period* (Copenhagen, 1951)

M Robertson, *The Art of Vase-Painting in Classical Athens* (Cambridge, 1992)

5 Hellenistic

J Onians, *Art and Thought in the Hellenistic Age* (London, 1978)

J J Pollitt, *Art in the Hellenistic Age* (Cambridge, 1986)

A F Stewart, *Faces of Power: Alexander's Image and Hellenistic Politics*, vol.2 of *Hellenistic Culture and Society* (Berkeley, CA and Oxford, 1993)

6 Art, Myth and Myth-history

D Castriota, *Myth, Ethos and Actuality: Official Art in Fifth Century BC Athens* (Madison, WI, 1993)

J B Connelly, 'Parthenon and Parthenoi: a Mythological Interpretation of the Parthenon Frieze', *American Journal of Archaeology*, 100 (January 1996), pp.53–80

E D Francis and M Vickers, *Image and Idea in Fifth-Century Greece: Art and Literature After the Persian Wars* (London, 1990)

H A Shapiro, *Myth into Art: Poet and Painter in Classical Greece* (London and New York, 1994)

Architecture

J J Coulton, *Greek Architects at Work* (London, 1977) pub. in USA as *Ancient Greek Architects at Work* (Ithaca, NY, 1977)

A W Lawrence, *Greek Architecture* (Harmondsworth, 1957, rev. edn, 1983)

J Onians, *Bearers of Meaning, The Classical Orders in Antiquity, the Middle Ages and the Renaissance* (Princeton, 1988)

V Scully, *The Earth, the Temple and the Gods* (New Haven and London, 1979)

J B Ward-Perkins, *Cities of Ancient Greece and Italy: Planning in Classical Antiquity* (London, 1974, new edn, New York, 1987)

R E Wycherley, *How the Greeks Built Cities* (London, 1949, 3rd edn, 1969)

Sculpture

S Adam, *The Technique of Greek Sculpture in the Archaic and Classical Periods* (London, 1966)

J Boardman, *Greek Sculpture: The Archaic Period* (London, 1978)

—, *Greek Sculpture: The Classical Period* (London, 1985)

D L Haynes, *The Technique of Greek Bronze Statuary* (Mainz, 1992)

C C Mattusch, *Greek Bronze Statuary: From the Beginnings through the Fifth Century BC* (Ithaca, NY, 1988)

G M A Richter, *The Portraits of the Greeks* 3 vols (London, 1965, abridged and rev. by R R R Smith, Oxford, 1984)

C Rolley, *Greek Bronzes* (London and New York, 1986)

R R R Smith, *Hellenistic Sculpture* (London, 1991)

N J Spivey, *Understanding Greek Sculpture* (London, 1996)

A F Stewart, *Greek Sculpture: An Exploration*, 2 vols (New Haven and London, 1990)

Painting

M Andronikos, *Vergina II: The 'Tomb of Persephone'* (Athens, 1994)

E Keuls, *Plato and Greek Painting* (Leiden, 1978)

M Robertson, *Greek Painting* (Geneva, 1959)

Painted Pottery

C Bérard *et al.*, *A City of Images* (Princeton, 1989)

J Boardman, *Athenian Black Figure Vases* (London, 1974)

—, *Athenian Red Figure Vases: The Archaic Period* (London, 1975)

—, *Athenian Red Figure Vases: The Classical Period* (London, 1989)

R M Cook, *Greek Painted Pottery*
(London, 1960, rev. edn, 1997)

F Lissarague, *The Aesthetics of the Greek Banquet* (Princeton, 1990)

T Rasmussen and N J Spivey (eds), *Looking at Greek Vases* (Cambridge, 1991)

B A Sparkes, *Greek Pottery: An Introduction* (Manchester, 1991)

—, *The Red and the Black: Studies in Greek Pottery* (London, 1996)

A D Trendall, *Red Figure Vases of South Italy and Sicily* (London, 1989)

Other Minor Arts

R A Higgins, *Greek Terracottas*
(London, 1967)

C M Kraay, *Greek Coins* (London, 1966)

G M A Richter, *Engraved Gems of the Greeks and Etruscans* (London, 1968)

V Webb, *Archaic Greek Faience: Miniature Scent Bottles and Related Objects from East Greece, 650–500 BC* (Warminster, 1978)

D Williams and J Ogden, *Greek Gold: Jewellery of the Classical World* (London, 1994)

The Greek Legacy

J Boardman, *The Diffusion of Classical Art in Antiquity* (London, 1995)

R and F Etienne, *The Search for Ancient Greece* (London and New York, 1992)

F Haskell and N Penny, *Taste and the Antique: The Lure of Classical Sculpture 1500–1900* (New Haven and London, 1981)

I Jenkins, *Archaeologists and Aesthetes in the Sculpture Galleries of the British Museum 1800–1939* (London, 1992)

P Tournikiotis (ed.), *The Parthenon and its Impact in Modern Times* (Athens, 1994)

D Traill, *Schliemann of Troy: Treasure and Deceit* (London, 1995)

Index

Numbers in **bold** refer to illustrations

Acknowledgements

Thanks are due to the editorial and design staff at Phaidon who shaped this book; and in particular to Susan Rose-Smith, who undertook the procurement of photographs with true fighting spirit (and great care).

Photographic Credits

AKG, London: 227; American School of Classical Studies, Athens: 125; Ancient Art and Architecture Collection/Ronald Sheridan: 70, 74, 78, 170, 177; Antikenmuseum, Basle, photo D Widmer: 153; Archaeological Museum, Epidauros: 163; Archaeological Museum, Istanbul: 217; Archaeological Museum, Thessaloniki: 211, 214; Archaeological Receipts Fund, Athens: 26, 30, 49, 53, 61, 77, 80, 88, 90, 131, 168, 179, 191; Archaeological Service of Dodecanese, Museum of Kos: 36; Art Institute of Chicago, restricted gift of Mrs Harold T Martin: 219; Ashmolean Museum, Oxford: 3, 16, 55, 162, 198, 199, 254; Bibliothèque Nationale, Paris: 51, 243; Bildarchiv Preussischer Kulturbesitz, Berlin: 150, 176, 224, 228, 229; Birmingham Museum and Art Gallery: 248; Bridgeman Art Library: 233, 244; British Museum, London: 10, 33, 48, 68, 94, 105, 106, 136, 137, 141, 154, 155, 156, 157, 159, 160, 180, 188, 203, 204, 205, 208, 209, 210, 218, 239, 250, 251; British School at Athens: 35; Peter Clayton: 20; Corbis UK: photo Gianni Dagli Urti 103, photo Adam Woolfitt 252; Fitzwilliam Museum, Cambridge: 184; Sian Frances, photo Michael Dyer Associates: 8; Sonia Halliday Photographs: 25, 109, 121, 164, 165, 167, 189, 207, 223, photo James Wellard 145; Robert Harding Picture Library: 28, 31, 122, photo G. Kavallierakis 71, photo Roy Rainford 89; Institut für Geschichte und Theorie der Architektur, ETH, Zurich: 247; Kunsthistorisches Museum, Vienna: 107, 108; André Laubier, Paris: 245; Lund University Antikmuseet: 86; Manchester University Museum, Department of Archaeology: 212; Martin von Wagner-Museum der Universitat Würzburg, photos K Oehrlein: 99, 100, 111, 171, 172; Mausoleum Museum, Bodrum, courtesy Professor C Jeppesen, photo Thomas Pedersen og Poul Pedersen: 202; The Metropolitan Museum of Art, New York: purchase, gift of Darius Ogden Mills and C Ruxton Love and bequest of Joseph H Durkee, by exchange, 1972, 6, 7, Cesnola Collection, purchase by subscription, 1984–76, 42, Rogers Fund, 1910, 43, Rogers Fund, 1921, 44, Fletcher Fund, 1932, 65, gift of John D Rockefeller Jr, 1932, 139; Mountain High Maps, copyright © 1995 Digital Wisdom Inc: pp.434–7; Musée du Château, Boulogne-sur-Mer/Photo Devos: 92; Musées Royaux d'Art et d'Histoire, Brussels: 135; Musei Capitolini, Rome, photo Antonio Idini: 185; Museo Archeologico Eoliano, Lipari: 175; Museo Archeologico Nazionale, Naples: 119, 128, 129, 197, 200, 201, 230, 238; Museo Nazionale, Agrigento: 138; Museo Nazionale Romano: 118, 225; Museum of Classical Archaeology, Cambridge: 21, 24, 60, 67, 95, 102, 110, 123, 124, 146, 147, 148, 161, 192, 206; Museum of Cycladic and Ancient Greek Art, Athens, Nicholas P Goulandris Foundation: 9, 11, 12; Museum of Fine Arts, Boston: 196; Nicholson Museum of Antiquities, University of Sydney: 174; Ny Carlsberg Glyptothek, Copenhagen: 187; courtesy of M R Popham: 34; RMN, Paris: 45, 59, 83, 190, 221; Royal Collection, copyright Her Majesty Queen Elizabeth II: 234; Royal Ontario Museum, Toronto: 140, 149; Scala, Florence: 75, 101, 142, 143, 144, 194, 226; Soprintendenza Archeologica per l'Etruria Meridionale, Rome: 56, 57; Soprintendenza Archeologica per la Toscana, Florence: 87; Spectrum Colour Library: 22, photo J Aston 15, photo Dallas and John Heaton 72; Dr Nigel Spivey: 102, 116, 195, 236, 237; Staatliche Antikensammlungen und Glyptothek, Munich: photo Heinz Juranek 5, 47, 84, photo Studio Kopperman 4, 64, 85, 114, 178; Staatsgalerie, Stuttgart: 240; Studio Kontos, Athens: frontispiece, 1, 2, 13, 14, 17, 18, 19, 23, 27, 29, 32, 39, 50, 66, 69, 73, 81, 82, 93, 97, 98, 112, 113, 115, 117, 127, 132, 134, 151, 158, 166, 181, 182, 213, 215, 216, 253; Christopher Tadgell: 220; Vatican Museums, Rome: 91, 193, 242, photo A Brachetti 232, photo T Okamura 241, photo M Sarri 231, photo P Zigrossi 173, 235

Phaidon Press Limited
Regent's Wharf
All Saints Street
London N1 9PA

First published 1997
Reprinted 1999
© 1997 Phaidon Press Limited

ISBN 0 7148 3368 1

A CIP catalogue record for this book is
available from the British Library.

Typeset in Century Schoolbook

Printed in Singapore

Cover illustration Horse of the moon-
goddess Selene (see p.251)